INTER *Swindon College*

The role of the 'visual' and of human perception is increasingly being seen as central to an understanding of the contemporary human condition. *Interpreting Visual Culture* brings together the writings of some of the leading experts in art history, philosophy, sociology and cultural studies. Ranging from an analysis of the role of vision in current critical discourse to discussion of specific examples taken from the visual arts, ethics and sociology, this edited collection presents the latest material on the interpretation of the visual in modern culture.

Topics covered include:

- The hermeneutics of seeing
- The visual rhetoric of modernity
- The drawings of Bonnard
- Recent feminist art
- Practices and perceptions in art and ethics

Divided into three main sections, each beginning with an introductory chapter outlining the main topics under discussion, this comprehensive and engaging book will be essential reading for students of sociology, cultural studies and art history.

Contributors: J.M. Bernstein, Nicholas Davey, Chris Fisher, Michael Gardiner, Diane Hill, Chris Jenks, David Michael Levin, Michael Phillipson, John A. Smith, Nigel Whiteley.

Ian Heywood is Principal Lecturer in Fine Art at Leeds Metropolitan University. **Barry Sandywell** is Senior Lecturer in Sociology at the University of York. Previous publications include *Logological Investigations* (1996).

INTERPRETING VISUAL CULTURE

Explorations in the hermeneutics of the visual

Edited by
Ian Heywood and Barry Sandywell

London and New York

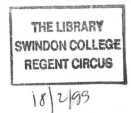
First published 1999
by Routledge
11 New Fetter Lane, London EC4P 4EE

Simultaneously published in the USA and Canada
by Routledge
29 West 35th Street, New York, NY 10001

© 1999 Selection and editorial matter, Ian Heywood and Barry Sandywell;
individual chapters, the contributors

Typeset in Galliard by Keystroke, Jacaranda Lodge, Wolverhampton
Printed and bound in Great Britain by Redwood Books, Trowbridge, Wiltshire

British Library Cataloguing in Publication Data
A catalogue record for this book is available from the British Library

Library of Congress Cataloging in Publication Data
Interpreting visual culture : explorations in the hermeneutics of
vision / edited by Ian Heywood and Barry Sandywell.
p. cm.
Includes bibliographical references and index.
1. Aesthetics. 2. Vision. 3. Hermeneutics. 4. Art—Philosophy.
I. Heywood, Ian. II. Sandywell, Barry.
BH39.I57 1999
111'.85—dc21 98-23767
CIP

ISBN 0-415-15709-9 (hbk)
ISBN 0-415-15710-2 (pbk)

CONTENTS

List of illustrations vii
List of contributors viii

Introduction: explorations in the hermeneutics of vision ix
IAN HEYWOOD AND BARRY SANDYWELL

PART I
Rethinking the visual in contemporary theory 1

 1 The hermeneutics of seeing 3
 NICHOLAS DAVEY

 2 Specular grammar: the visual rhetoric of modernity 30
 BARRY SANDYWELL

 3 Bakhtin and the metaphorics of perception 57
 MICHAEL GARDINER

 4 Durkheim's double vision 74
 CHRIS JENKS

PART II
Rethinking the visual in art: the challenge to
contemporary theorizing 97

 5 Readers of the lost art: visuality and particularity in art
 criticism 99
 NIGEL WHITELEY

 6 Seeing becoming drawing: the interplay of eyes, hands and
 surfaces in the drawings of Pierre Bonnard 123
 MICHAEL PHILLIPSON AND CHRIS FISHER

CONTENTS

7 The 'real realm': value and values in recent feminist art 143
 DIANE HILL

8 The denigration of vision and the renewal of painting 162
 JOHN A. SMITH

PART III
Towards an ethics of the visual 183

 9 My philosophical project and the empty jug 185
 DAVID MICHAEL LEVIN

10 'Ever more specific': practices and perception in art and
 ethics 198
 IAN HEYWOOD

11 Aporia of the sensible: art, objecthood and
 anthropomorphism 218
 J.M. BERNSTEIN

 Appendix: the original project 238
 Select bibliography 251
 Index 258

ILLUSTRATIONS

Plates

6.1 Pierre Bonnard: *La Seine, près de Vernon* 126
6.2 Pierre Bonnard: *Paysage valloné* 130
6.3 Pierre Bonnard: *Paysage Provençal* 134
6.4 Pierre Bonnard: *Nu à la baignoire* 140
7.1 Rebecca Fortnum: *Performative Utterance* 149
7.2 Rebecca Fortnum: *Where You Are, I Haven't Been* 151
7.3 Emma Rose: *Here and Now* 154
7.4 Emma Rose: *Materiality* 157

Figure

4.1 Durkheim's double vision 87

Table

4.1 Binary oppositions 78

CONTRIBUTORS

J.M. Bernstein is Professor of Philosophy at Vanderbilt University, Tennessee, USA.

Nicholas Davey is Senior Lecturer in Philosophy at Dundee University.

Chris Fisher lectures in Fine Art at Goldsmiths College, University of London.

Michael Gardiner is Assistant Professor in Sociology at the University of Western Ontario, Canada.

Ian Heywood is Principal Lecturer in Fine Art at Leeds Metropolitan University.

Diane Hill lectures in Fine Art at the University of Central Lancashire.

Chris Jenks is Professor of Sociology at Goldsmiths College, University of London.

David Michael Levin is Professor of Philosophy at Northwestern University, Illinois, USA.

Michael Phillipson is Visiting Fellow in the Department of Sociology, Goldsmiths College, University of London.

Barry Sandywell is Senior Lecturer in Sociology at the University of York.

John A. Smith is an artist and writer. He has lectured in Sociology and Fine Art Theory at Goldsmiths College, University of London, and at the University of Lancaster.

Nigel Whiteley is Professor of Visual Arts at the University of Lancaster.

INTRODUCTION

Explorations in the hermeneutics of vision

Ian Heywood and Barry Sandywell

Many of the most creative debates and research programmes in contemporary critical theory, postmodern philosophy, aesthetic theory, deconstruction and cultural studies converge and intersect upon the field of 'visuality' as one of the central, if contested, terrains of modern critical thought. Over the past decade or so we have witnessed a veritable explosion of interest in the phenomenological, semiotic and hermeneutic investigation of the textures of visual experience, and, more broadly in a new appreciation of the historical, political, cultural, and technological mediations of human visual perception in the context of a more 'holistic' and 'reflexive' theory of the human condition. Recently the whole area has received an additional impetus from the impact of a wide range of semiotic theories of representation drawing upon largely continental social and philosophical thought. Indeed we have to speak in the plural of 'hermeneutics of vision' when defining the field of visual culture today. From these different sources it appears that the place of perception and visuality in our understandings of human reality and the 'fate of the visual' in contemporary society and culture have merged to form the context for new alignments, critical projects, and interdisciplinary research in the arts, humanities and critical sciences.

The visual field has begun to be explored with a thoroughness and global understanding unique in the history of human self-reflection. Recent research into the work of seeing, vision, perception, and culture has taken explicitly historical and hermeneutic directions. Indeed, to borrow an expression from Martin Jay, the topic of visuality presents itself as a radical discursive 'force field', 'a non-totalized juxtaposition of changing elements, a dynamic interplay of attractions and aversions, without a generative first principle, common denominator or inherent essence' (1993a: 2). Recent work from sociology and social theory has been at the forefront of this revaluation of visual metaphors and ideas – witness the recent collection of essays edited by Chris Jenks's *Visual Culture* (1995), David Lowe's *History of Bourgeois Perception* (1982), Elizabeth Chaplin's *Sociology and Visual Representation* (1994), Paul Virilio's *Vision Machine* (1994), as well as major texts exploring 'the denigration of vision' in

social thought (Jay's *Downcast Eyes*, the collection of essays edited by David Michael Levin, *Modernity and the Hegemony of Vision* (1993) and the more recent collection edited by Stephen Melville and Bill Readings, *Vision and Textuality* (1995)). In the light of these contributions we are gradually realising the extent to which the project of modernity has been saturated by the problematics of viewing and visualisation. We are also now fully aware that the latter are themselves open to socio-cultural and historical analysis in their own right. It is one of the characteristic features of this developing problematic that there is no simple way of disentangling the social history of perception from the arts of observation and the technologies of visual culture. Indeed an adequate hermeneutics of the scopic regimes of modern European culture needs to 'triangulate' all three of these themes and to invent new forms of interpretative inquiry that advance this understanding on several fronts.

The field of visuality: the approach of this volume

The emergent research field of visuality outlined above may be analysed in terms of four 'levels' or 'orders' of visual phenomena. First, the level of meaningful practices in the life-worlds of everyday life or the routine visual categories at work in organising the structures of practical experience, especially in the taken-for-granted political and ethical practices of envisioning others, of routinised perception and day-to-day social experience, but also the role of visual idioms in those practices which take an analytical interest in the organisations and events of everyday life – the arts, journalism, the human sciences, and so on. Second, the emergence of recent interpretative problematics (theoretical narratives which advocate different 'ways of seeing') with an empirical commitment to exploring the detailed sociology and politics of the visual order – including a range of novel sciences with a commitment to recovering and grounding their work in the perceptual realms of the life-world. Third, the historical formation of the theoretical sciences and the role of critical thought in reflecting upon the social construction of their problems and practices. And finally, at a more meta-theoretical level, the emergence of critical discourses concerned to question and deconstruct the history and implications of visually organised paradigms and the practices, institutions, and technologies these have legitimated. These different types of concern redirect research away from visuality narrowly conceived and focus attention upon the textual and ideological analysis of 'the hegemony of vision' in contemporary culture (Levin, 1993; Lowe, 1982). At this point the phenomenology and hermeneutics of vision are transcended by wider contextual concerns with the problems of the authority and power vested in the dominant visual technologies of Western culture, the role of excluded groups in these systems, particularly the struggles of non-European colonial peoples, women, and working classes in relation to the dominant forms of visual ideology. But 'hegemony' here should not be understood in a one-dimensional and mechanical fashion. As with other social changes, we see the contemporary

situation in terms of differential, heterogeneous, and transformational social practices.

In many respects the increasing centrality of visual culture – especially as this is now mediated through the image technologies of advanced communication in modern societies – has irreversibly encroached upon all other forms of social and cultural debate. Following the work of Richard Rorty, Martin Jay, David Levin, Hubert Dreyfus, D.M. Lowe, David Lyon, and others, we believe that there is a growing recognition of the need to differentiate between different 'ways of seeing' ('scopic regimes', 'discourses and practices of visuality') and cultural forms, and to interrogate critically the problematics of anti- and post-ocularcentric positions in the field of visual experience.

It is necessary to be as clear as possible about where this particular collection fits into this large, emerging research field. We make no claim that the field as a whole is systematically and synoptically represented, or that the full range of issues and problems within the field is systematically addressed. Contributors are only too well aware of the enormous scope of the field, and of the existence of radically different approaches to it. Yet the collection is concerned to open a dialogue within and between some of these diverse positions by exploring some of the consequences of this moment in the developing field of visuality. This is not only from the point of view of theoretical and conceptual concerns but also more specifically with regard to questions arising from the ongoing practice of those concerned with the life of visual experience: including practices of writing, of art, aesthetic criticism, and critical pedagogy.

The essays explore some of the main issues and questions raised by the 'hermeneutic' turn in the study of visual experience and visual phenomena from positions within sociological, cultural and philosophical enquiry. We should be clear that the term 'hermeneutics' does not in the general approach of this volume primarily refer to a specific philosophical tradition or theoretical frame-work; rather, it designates an *analytic* attitude towards the field of experience in which visual experience is approached as a *socio-historical realm of interpretative practices*. The emphasis indexed by the term 'hermeneutics' is placed on the role of visual meaning and interpretation in the contexts of meaningful human action. We accept that all social life is interpretative; indeed that all social practices are definitionally 'significant' (and thus socially organised, historically shaped, and politically informed achievements). From this perspective all signifying practices – whether 'visual' or not – display irreducible hermeneutical characteristics and broadly textual dimensions.

We need to think of 'hermeneutics' in a much more diverse, dialogical and open sense than is often the case. Speaking of cultural mediation and dialogue guards against any simple reductionism in pre-defining the parameters of visual experience as an emerging research field. We thus have no intention of reducing these complexities to a grid of stable positions or set of general principles – along the lines of traditional semiotic or text-based critical theories. In fact the eruption of the problematics of visual experience across a range of disciplines and

practices from sociology to the philosophy of representation, art pedagogy and image technologies requires researchers to adopt much more critical, reflexive and open-ended historical perspectives in the study of the history and diversity of visual culture. We view the essays in the collection as contributions to this ongoing debate. Following the precedent set by Jay in *Downcast Eyes* the essays both analyse and exemplify 'the unfolding of a loose discourse about visuality' (Jay, 1993a: 587). On the other hand, the 'openness' of this hermeneutic seeks to avoid the obvious pitfalls of confusion, muddle and self-indulgence by emphasising the eminently practical problems and questions which prompt authentic acts of understanding in the first place.

It must be stressed then that the collection as a whole does not intend to be a 'statement' or advance a single interpretative position. What the essays do share can be seen, in part at least, as a response to a central theme of Jay's work on visuality. Virtually all the French intellectuals discussed in *Downcast Eyes* 'were extraordinarily sensitive to the importance of the visual and no less suspicious of its implications' (*ibid.*: 588). Reviewing the results of his detailed enquiry into key works by Bergson, Bataille, Breton, Sartre, Merleau-Ponty, Lacan, Althusser, Foucault, Debord, Barthes, Metz, Derrida, Irigaray, Levinas, and Lyotard, Jay suggests 'all these evince, to put it mildly, a palpable loss of confidence in the hitherto "noblest of senses"' (*ibid.*). The essays in this collection have a common commitment to proposing ways of theoretically and/or practically overcoming this 'suspicion' or 'denigration' of vision in contemporary critical discourse.

The essays: issues and themes

The essays are divided into three broad groups. Those in the first group discuss different aspects of the status and role of the visual in contemporary theory; those in the second concern the impact of some recent theorising on the significance of the specifically visual dimensions of visual art; those in the third and final part of the collection explore different approaches to possible connections between the visual and certain ethical questions.

In more detail then, the essays in the first part focus on the role of vision in a number of important theoretical and philosophical discourses. The concern for the visual has been both a resource and, more recently, a critical issue in the work of a number of theorists. As Jay remarks, it must be recognised 'how thoroughly infused our language is by visual metaphors, how ineluctable, to borrow Joyce's celebrated phrase, is the modality of the visible, not merely as perceptual experience, but also as cultural trope' (*ibid.*: 587). This phenomenon has given rise to a series of related themes; among these, the visual as a topic for historical and sociological investigation, the visual as a resource in organising inquiry, and visual experience as an occasion for self-reflexive inquiries to change conventional perspectives and modes of thought.

Among the most important are themes posed by the contested concept and 'grammar' of visuality itself. Why has the privileging of visual perception – often

restricted to the model of a disembodied act of seeing – been treated historically as the paradigm of human awareness? Have other cultures approached the world of objects and events as *spectacles*? Does this narrative prioritising of the visual *spectacle* not tacitly support a hierarchical image of the senses (where visual knowledge arises like a superstructure upon the darker 'ground' of other kinds of sensory experience)? Should these phenomenological and hermeneutical claims not be understood as an influential historical rhetoric of visual representation rather than tacitly ascribed with the status of being a reflection of human experience? What should be included in the realms of 'visuality'? What, indeed, should we signify by the turn towards visual *culture*?

Davie sets the scene for Part I with a defence of philosophical hermeneutics in an area in which it is often taken to be vulnerable: its relationship with the visual. Like much twentieth-century philosophy, hermeneutics places tremendous importance upon language and particularly on its written forms. Famously, for Gadamer, to understand something is to treat it as a text, yet this would seem to limit the capacity of hermeneutics to deal adequately with forms of expression and meaning which have a strong visual or tactile dimension. Davie argues that hermeneutics can embrace visual phenomena – with works of visual art being something of a test case – because its critique of disengaged Cartesian 'seeing' gives it a radically inclusive sense of vision, an expanded and open sensibility. Within the idea of an expanded sensibility, and in a way not dissimilar to other contributors, perhaps Gardiner in particular, Davie explores the issues of 'cross wiring', intertwining and dialogue.

Sandywell extends the examination of the influence of visual concepts and tropes with his outline of the intellectual history of specular conceptions of consciousness, knowledge and identity in the formation of modernity. In the socio-cultural transformations giving rise to and embodied within the modern world a key metaphor, deployed in powerful arguments and movements against older beliefs and practices, casts knowledge and the new kind of self-awareness it required as a kind of 'seeing'. Reflection or theoretical introspection directed at establishing the conditions of reliable knowledge is like 'vision', but here restricted to the mind and thus abstracted from concrete human visual perception and its variety of modalities and contexts. Sandywell's 'logological' investigation, which seeks to set philosophical, scientific and artistic discourses in their sociological, cultural and historical framework, takes Descartes and, more broadly, Cartesianism to be decisive in the shaping of modern thinking and practices with respect to knowledge and identity, in particular the envisioning of a world of controllable or manageable objects shaped for and by the *will to knowledge*. Descartes' reflective philosophy and what Sandywell calls the 'videological form of life' are crucial to the rhetoric of modernity. He explores the efforts of philosophers during the modern period to resolve outstanding problems of the Cartesian model or even to question its assumptions, discussing in particular Hume, Hegel, Marx, Nietzsche, Sartre and Heidegger. Opposed to the rhetoric of reflectivity is the idea of *reflexivity*, which rejects Cartesian, representational

and specular approaches to knowledge, truth and identity and shifts decisively towards the figural, the hermeneutical and the logological. Sandywell also emphasises that a systematic critique of the rhetoric of self-reflection is inextricably linked to a fundamental critique of modern sociality.

The chapters by Davey and Sandywell thus explore the impact of visual paradigms upon the history, background, and orientations of hermeneutic thought (hermeneutics' criticism of Cartesianism, the escape from positivist-empiricist approaches to meaning and reading, the development of text-centred alternatives, and so on). Where Sandywell traces the rise of rhetorical and hermeneutical concerns in modern philosophy, Davey reads the project of hermeneutics as a domain that is open to further thought and reconstruction, transcending the conventional binary oppositions of theory and practice, object and interpretation, subject and object.

There is, argues Gardiner, an overlooked but significant visual aspect to the work of the important Russian cultural theorist Bakhtin. The core of Bakhtin's theory is a social ethics rooted in a broad idea of embodiment which seeks to embrace and engage with all sensory modalities. Despite shifts in his outlook over the course of his life, Bakhtin's interest in the question of the socially and culturally mediated relationship of sensory modalities remained constant, and his novel comparison of exchanges between modalities and exchanges between self, other and nature opens lines of enquiry yet to be thoroughly explored. The challenge for theorising offered by this aspect of Bakhtin's work is that of not sliding back into narrow, hierarchical rankings of sensory modalities, of keeping itself open to the different ways of articulating experience that they offer.

The importance of exploring vision and visuality as a way of engendering a richer and more multidimensional phenomenology of human experience is, then, central to the work of Gardiner and Sandywell (and also of Levin, see below). Vision, once disconnected from the narrow Cartesian ontology of visibility, becomes central to the question of embodiment and experience – to what Levin in his 'Introduction' calls 'our openness to being touched and moved by what we see'.

In the final chapter of this section Jenks seeks to re-open the question of the visual for the classical tradition of sociology. Beginning with Durkheim's seminal writings, Jenks interrogates the notion of a founding vision, a creative act which shaped the infant discipline of sociology. The question raised by Durkheim's legacy is what is it to have a social or moral vision? Jenks discerns two 'visions', two ways of seeing and of practising theory, two forms of life, in Durkheim's work. He argues that the tensions between them are never fully resolved, the later vision of organic solidarity does not replace or subsume that of the mechanical social order. Perhaps the two visions correspond to two dichotomous orders of modernity? Yet the idea of organic solidarity does not just encapsulate one of these orders, it is also the reconciling ideal which Durkheim's poetics strove to bring forth and to witness. Jenks argues, against

postmodernism, that to restore this sense of vision to Durkheim is to reveal the continued importance of classical sociology for late modernity.

The chapters in Part II take up these themes in the context of visual art, in particular the theoretical and critical discourses through which it is interpreted, explained and evaluated: art history and criticism, art theory and its approaches to creative visual practice. In going against the grain of theories denigrating the visual in visual art these chapters challenge the influence of a wide range of contemporary perspectives. The authors place particular stress on the singular and irreducible character of visual experience – for example, in the context of the concrete objectivity of artworks, and the transforming, displacing, and unsettling capacity of art. They also claim that theoretical, social, and cultural questions about the nature and significance of the visual may be posed fruitfully in the context of visual art. The fate of the visual in visual art is then significant for the wider socio-cultural significance of research into visuality itself.

Whiteley is dissatisfied with the seeming inability of much contemporary history and theory of art to deal adequately with visual and semantic specifics of individual works. The current regime of 'theory' often amounts to elaborate ocularphobic readings which treat works of art as unclarified and therefore essentially faulty texts. He does not seek to rehabilitate traditional criticism and theory but, in a broad-ranging review of contemporary writings about art, he finds in some the beginnings of a recognition of visual specifics and the recovery of questions about aesthetic quality, but in others an unjustifiable and ultimately irresponsible rejection of the task of critical perception and thinking. He argues for a new and more serious approach to the idea of 'sensibility' and revisits Sontag's proposal for an 'erotics' of art, as opposed to the over-elaborate theory and interpretation she calls 'hermeneutics', using the word of course in a some-what different sense than is found in the rest of the collection.

There are perhaps two important dimensions of the chapter by Phillipson and Fisher that need to be mentioned here. The chapter seeks to communicate something of what it is to witness, explore and articulate the visual and affective impact of concrete works of art, in this case drawings by Bonnard. The argument begins from and constantly returns to the drawings themselves, thinking through their 'provocations' to routine, everyday ways of seeing, speaking and acting. The works are not treated as 'occasions' for displays of theoretical jurisdiction but are allowed to unpick, displace or frustrate the 'I [and eye] that knows'. There are wider implications still. These drawings, argue Phillipson and Fisher, are drawings of 'nothing', they reflect an obsession with the everyday which is also an exile from it, they are poised transgressively between the sacred and the profane, they are utterly precise refusals to pin anything down. As a refusal of the 'anxiety to fix and clarify' they stand sharply against not only the ocularcentrism of institutionalised, bureaucratic systems of knowledge and control but also against much in the traditions and rhetorical practices of modern social and cultural theory which ostensibly aim to expose and criticise

this regime. What is distinctive of this chapter is the way its insistence on the priority of the specific works of art, to which its again utterly specific plural voices respond, is reflected in the way it is written.

Hill also deals with visual art, particularly in the context of some recent influential feminist theory. While endorsing some of the reasons behind the turn in art history towards such theories as semiotics, poststructuralism, psychoanalysis and ideology critique she detects an implicit belief in the exclusive validity of the theoretical text as a form of expression and communication. This view may itself be a deep, unexamined and ultimately damaging prejudice, and because it leads to works of art being treated as defective texts it calls for further critical reflection. Her analysis of works by some younger women painters, all aware of the new theory and criticism and in some cases explicitly feminist in their outlook, displays a consistent effort to attend carefully to both the specifically visual features of works and to their wider implications, both political and aesthetic. Thus, while Whiteley's chapter raises central questions about the reluctance of art criticism to address 'the visual particularities of individual artworks' and to explore the tasks of 'critical looking' as a dialogue between 'form' and 'meaning', Hill analyses the capacity of the visual in painting in particular to return us to the 'rich, live density of experience', a 'realm' of experience and responsiveness which is occluded by traditional forms of critical reflection.

Smith is primarily concerned with the idea of visual art as it appears in the influential, often polemical, works by Lyotard and Derrida, but also in the more 'neutral' account of ocularcentrism offered by Jay. Entranced by what is essentially an avant-garde version of modernism, leading French theorists have not only 'denigrated' the visual – attacking positivism, empiricism, Cartesian aspirations to a final securing of knowledge through clear and distinct ideas, and social technologies of surveillance – but also, and in some ways paradoxically, tried to detach forms of art from their distinctive media, practices, histories and achievements. Art, required to 'represent' the un-representable, can only do so through an interminable series of deconstructive negations of its *difference*, ironically becoming in the process an extreme formalism. He argues that Lyotard, Derrida and Jay fail to recognise fully the real heterogeneity of modern cultural spheres, specifically its 'scopic regimes'; in this they do not live up to the audacity and radicalism of Merleau-Ponty's efforts to confront Cézanne's 'suicide in sensation'. They fail to see painting *as* painting and thereby evade its profound challenge to their theoretical practices.

In the concluding section the chapters explore the relationships between ethical questions and the visual, particularly as these are realised in works of art. None of these chapters are direct or conventional contributions to ethical theory, nor do they aim to equate or identify moral and aesthetic phenomena. Rather, they seek out issues, experiences, and problems which find resonances across different domains of contemporary social and cultural life, points from which, perhaps from an unexpected angle, the questions of one area may be illuminated by the practices and sensibilities of the other.

David Michael Levin proposes for philosophy, perhaps the most 'abstract' of disciplines, a way of re-envisaging vision, by relating seeing to the experience of touching and being touched. Extending the arguments of Merleau-Ponty and Heidegger, Levin suggests that in order to re-shape theoretical practice the whole notion that the 'highest' forms of thought are the most disembodied must be critically re-viewed, restoring its suppressed tactile, intersubjective dimensions. The ethical, particularly in the context of the life-world, is to be recovered through an understanding of the significance of embodiment. The lessons of jugs and poems may help us more in this task than the apparatus of intricate, formal argumentation.

Heywood revisits the problem of the relationship between visual art and ethics in the context of the current resurgence of interest in virtue ethics and ethical particularism. Endorsing the inevitable plurality of modern cultural forms, any suggestion of convergence of art with ethics is firmly rejected. However, following Murdoch, Nussbaum, L.A. Blum and others he argues that acute perception in everyday life and art gives access to particularity, here understood as the moments and occasions when concretely singular phenomena take on intrinsic value. He argues that the perception of particularity is crucial not only to ethical action but also to many works of visual art, with respect to the work itself, the artist as agent and the process of making. In this, he takes issue with postmodern and deconstructive theories and critical idioms for which perception and particularity are unimportant or have been somehow superseded. In a way similar to Bernstein (see below) – although perhaps less pessimistically – he sets the rising influence of these approaches in the context of the deepening and broadening thrust of technical rationality within late-modern culture.

Finally, Bernstein is concerned with the relationship between philosophical thinking and visual art, in particular with conceptual thought's ultimately nihilistic participation in modernity's accelerating drive towards rationalisation, the liquidation of art and the destruction of sensuous particularity. Some of the best contemporary works are philosophically illuminating and articulate about the fate of art but, by the same token, tragically at odds with art's deep 'anthropocentrism', the cultural and ethical good it had previously sought to embody. While Greenberg and Fried aim to defend this quality in modern art against 'objecthood' and 'theatricality', they fail to recognise that modernity is active even within the practices of the artists they sought to defend. A defence of art requires the recognition of the *aporiai* characteristic of modern culture, and of the art's fate within it.

We hope that these explorations, eclectic in their origins yet we believe strongly interrelated in themes and concerns, will encourage readers to explore further and other ways of overcoming the denigration of vision and visuality, opening lines and dialogues across the complex landscape of a future hermeneutics of seeing. We make no pretence that these provisional investigations exhaust the range of questions and problems characterising the hermeneutics of visuality. For example, little is said about the physiology, psychology, and

genetic history of the senses and consciousness, the detailed history of phenomenological contributions to a theory of perception, the relationship between 'seeing' and the structural organisation of social practices, the impact of the crisis of ocularcentric paradigms in Western thought, the demise of 'vision' with the death of utopian politics and cultural transcendence. Future work needs to develop modes of analysis that would take philosophy beyond logocentric conceptions of human experience and related epistemological paradigms. We need to encourage post-foundationalist research in the techno-culture of visuality, provoke practical interventions that question the dominant patterns of art practice and criticism in a culture dominated by reflective imagery, examine the impact of postmodernisation upon the specular regimes of modern societies, feminist criticisms of phallocentric logics and monological modes of ordering the world, and so on. As one attempt to encounter these developments the following exploratory chapters suggest some of the boundary markers of the 'force field' of visuality in contemporary critical debate.

References

Chaplin, E., *Sociology and Visual Representation*, London and New York, Routledge, 1994.

Jay, M., *Downcast Eyes: The Denigration of Vision in Twentieth-Century French Thought*, Berkeley, University of California Press, 1993a.

Jay, M., *Force Fields: Between Intellectual History and Cultural Critique*, London, Routledge, 1993b.

Jenks, C. (ed.) *Visual Culture*, New York and London, Routledge, 1995.

Levin, D.M. (ed.) *Modernity and the Hegemony of Vision*, Berkeley, University of California Press, 1993.

Lowe, D.M., *History of Bourgeois Perception*, Chicago, Chicago University Press/ Brighton, Harvester Press, 1982.

Melville, S. and Readings, B. (eds) *Vision and Textuality*, London, Macmillan, 1995.

Virilio, P., *The Vision Machine*, London, BFI Press, 1994.

Part I

RETHINKING THE VISUAL IN CONTEMPORARY THEORY

1

THE HERMENEUTICS OF SEEING

Nicholas Davey

Vision is always a task, a task of promise.
David M. Levin, *The Opening of Vision*

On hermeneutics and seeing

With its roots stretching deep into biblical and literary interpretation, what does hermeneutics have to do with the question of *seeing* and with the experience of coming to see what is in a work of art? In response to this question, we will argue that hermeneutical aesthetics does not entail a 'philosophy of art' but a philosophical meditation upon what *happens* to us in our experience of art. Our argument will be presented in six stages. The first will propose that rather than dwelling on the 'subjectivity' of our experience of art, hermeneutical aesthetics seeks to illuminate what philosophical and existential determinants shape our perceptions of art. Rather tellingly, the German word for perceive is *wahrnehmen*, to take or receive as true. Hermeneutic aesthetics focuses on how our experiences of art occasion the appearance of certain *truths*. A major leitmotif of hermeneutic thought is that certain truths can only be experienced subjectively but that fact does not render them subjective. That what we come to see in art cannot be reduced to mere subjectivity depends upon historical and cultural ideas which transcend the subjective and yet achieve personal perceptual instanciations within aesthetic experience. We shall argue that both art and aesthetics reside in the generative tension between sight and in-sight. The second part is devoted to 'Hermeneutics, Language and Visual Understanding'. Hermeneutics' deep concern with language does not subordinate image to word but applies the sensitivities we acquire from linguistic exchange to reveal how our experience of art is no isolated monologue on personal pleasure but a complex dialogical achievement involving the fusion of the horizons surrounding artist, subject-matter and viewer. Part three engages the theme of 'Perception, Meaning and Art'. For aesthetic experience to have a content which can lay claim to being (in part) objective, it must have an ideational content which transcends the subjective limitations of the circumstance and scope of individual perception. Hermeneutics insists that in any reflection upon our experience of art, we must

focus on the question of meaning. Part four approaches the question of 'Art and Its Subject-Matters'. What does a work of art direct us to? Though it might be seen by the mind's eye, what we come to *see* in a work is not necessarily an object which is visually present. Hermeneutic aesthetics emphasises that art works do not merely re-interpret and re-present subject-matters but extend and alter their being. It is in the notion of subject-matter that hermeneutic thought gains an insight into how an art work can transcend the temporal restriction of its historical origin and affect the contemporary world. Part five attends to the question of 'Hermeneutics, Art and Eventuality'. One of the most important contributions which hermeneutics makes to aesthetics involves the argument that in the experience of art, seeing and understanding are not merely passive. To the contrary, the spectator is a condition of what is held within a work coming forth and, furthermore, that revelation can effectively change the subject-matter it discloses. This permits hermeneutic thought to draw a crucial distinction between an artistic representation (*Vorstellung*) and an artistic presentation (*Darstellung*), a distinction which, in turn, completely radicalises traditional conceptions of the relationship between art and reality. To initiate our case, then, let us consider what is held in the two words which mark out our terrain; namely, *hermeneutics* and seeing.

The history of hermeneutics may be divided into three distinct phases. Prior to the late eighteenth century, hermeneutics was primarily concerned with matters of biblical and theological interpretation. Chladenius's works represent the high-water mark of this tradition and its endeavours are far from redundant as the works of Louth and Pannenberg show.[1] Terms which have a critical role in hermeneutic aesthetics – the transcendent and epiphanic – have their derivation in biblical interpretation. Theological hermeneutics still underwrites the basic concerns of contemporary hermeneutics. How does one breathe life back into an ancient text? How is the living spirit to be released from the dead letter? It is perhaps not merely coincidental that Alexander Baumgarten, the father of modern philosophical aesthetics, was also practised in theological hermeneutics.[2] Hermeneutics entered its second phase when Schleiermacher and Wilhelm Dilthey guided it towards a universal method of cultural and social understanding. Schleiermacher's 'technical' and 'psychological' theories of understanding were directed towards grasping a text's meaning both in terms of its formal structures and as an expression of the author's specific intentionality. Dilthey developed Schleiermacher's work into a general theory of cultural understanding which viewed all social acts as the outward expression of a distinctive inner *Weltanschauung* which, once identified, would provide the key to rebuilding and re-experiencing an artist's outlook. Although the psychologistic elements of Dilthey's empathetic theory of understanding are largely discredited, his work continues to be enormously influential. The writings of Anthony Giddens and William Outhwaite still express Dilthey's basic philosophical ambition – to outline what is distinctive about artistic, literary and aesthetic modes of understanding.[3] The third and most contemporary phase of hermeneutics concerns the

4

existential hermeneutics of Martin Heidegger and the closely related philosophical hermeneutics of Hans-Georg Gadamer, idioms of thought which are reflected in the more recent works of Manfred Frank and Odo Marquard.[4] Heidegger insists that hermeneutics is not a matter of interpreting pre-given works. Understanding is not what we aim at, it is what we do. Its categories define what we are: creatures who have a sense of who and what we are because of what we understand. Thus, only because we implicitly understand what it means to be placed in a world, can we come to interpret a work being placed in its world. For Dilthey, a general theory of interpretation led to understanding the specifics of a work. For Heidegger it is the reverse. It is understanding (the categories of our being) which is the precondition of interpretation. In *Being and Time* he argues,

> In interpretation, understanding does not become something different. It becomes itself . . . Nor is interpretation the acquiring of information about what is understood: it is rather the working out of possibilities *projected in understanding.*[5]

The essential dynamic of Heidegger's early hermeneutic thinking moves from an analysis of the objectivities of existence (facticity) through to how we subjectively respond to our ontological condition. Partly because of his admiration of Hegel, Gadamer reverses, but by no means refutes, the direction of Heidegger's thinking. Whereas in an almost Kantian manner, Heidegger constructs an existential analytic before considering matters of subjectivity, Gadamer starts from the immediacies of experience in order to ascertain the 'substantiality' behind them:

> All self-knowledge arises from what is historically pre-given, with what we call with Hegel substance because substance underlies all subjective intentions and actions . . . This almost defines the aim of philosophical hermeneutics . . . to discover in all that is subjective the substantiality that determines it.[6]

As we shall see, Gadamer becomes intensely preoccupied with understanding how that historical and cultural substantiality makes itself visible in an art work. What underwrites both Heidegger's and Gadamer's concern with art is its ability to disclose an understanding of both ourselves and of our being in the world in an immediate, unique and revelatory manner altogether distinct from, but as defensible as, propositional knowledge. How seeing brings us to the intensities of such insights is a leading motif of this chapter.

Nevertheless, rarely do the formalities of historical detail nurture a feeling for what lies within a word. The etymological endeavour so characteristic of Heidegger and Gadamer strives to reaquaint us with the feelings and dispositions a word can contain. Heidegger's conceptual archaeology seeks to recover the

pre-Christian meaning to metaphysical categories in order that we might 'think' anew about the nature of our existence. Gadamer's etymological talents remind us that embedded within words are world-views capable of supplementing and extending our own. Yet whatever particular nuance these thinkers give to the etymological stratagem, its general value is plain. Against the subtler residues of previous speech-created worlds, any contemporary language horizon is advantaged by the force of immediacy and thereby possesses the distorting capacity of ideology. That force can not only blind us to the possibility of alternative meanings (and hence to alternative modes of feeling and being) which flow from the past into our contemporary world but it can also shroud us in the illusion that the world contained within our speech-world is *the* world and not one of many other possible speech-worlds which, as etymology reveals, we are demonstrably connected to. Once we develop an ear for what lies within words, the spell of immediacy's force can be broken. The importance of the philological tactic is not merely that it attempts to retrieve past meanings but that in so doing it frees us from the restriction of having to feel and think solely in terms of our present speech-world. The potentially liberating aspect of this tactic is the recovery or uncovering of other logically possible ways of thinking, of looking at and, hence, of feeling about an issue. What then does the term 'hermeneutic' connect us to?

The word 'hermeneutic' clearly invokes Hermes, the messenger of the Greek gods whose allotted task was to interpret what the gods wished to convey and to translate it into terms mortals could understand.[7] Hermes' predicament addresses all who work with expression, for what is given to us through insight, intuition or revelation has to be understood and then translated into forms permitting others to grasp what we have come to understand.[8] Hermes presides over the tension between the 'seeing' of a truth and the task of communicating it. It is not inappropriate then that he was also the god of those who travel dark and difficult roads.[9] He frequently appeared in the form of modestly phallic stone wayside markers (*herms*) which portrayed him in the company of Aphrodite who had evidently aroused his interest. Hermes was revered for disclosing things at night. How argues that night is indeed his proper provenance, for it is darkness that reveals our need for guidance and thereby allows 'things [to] be seen in a new light'.[10]

The experiences which the myth of Hermes relates concern that strange relation between understanding the nature of our engagement with art and coming to understand the character of our predicament as human beings: our perpetual need for understanding and guidance, our sense of trying to find, follow and keep to a path, the experience of 'being-drawn-on', of 'being-excited-by' the anticipation of where a dedicated route might take us and, finally, the realisation that as human beings we too are not unlike Hermes who is always on the way somewhere but with no place of his own to finally dwell in.

It is not inappropriate that in order to convey his message to mortals, Hermes used words which, like the gods, are notoriously difficult to define. Both extend

and change their meaning through time and, for some, that ambiguousness is the precondition of literary accuracy. Pannenberg's comment that 'it is only because the words of a language are incompletely defined that propositions can be formulated with precise definition' encapsulates a potential philosophy of poetry.[11] The realms of vision offer analogous instances of this fertile relationship between the clear and the opaque.

Alexander Baumgarten, a poet as well as a philosopher, demonstrated how the clarity of a foreground image is dependent upon a *confusion*, a bringing together, of ambiguous background elements.[12] Understanding or coming to 'see' what a work addresses is for Baumgarten a hermeneutical phenomenon in that such 'seeing' is made possible by a secondary field of pre-given understandings or contexts. Nietzsche and Gadamer, respectively, use the optical terms 'perspective' (*Perspektiv*) and 'horizon' (*Horizont*) when speaking of such fields. Optical science even refers to the capacities of peripheral vision to sharply delimit an object of attention. Indeed, Merleau-Ponty encapsulates the point eloquently when he comments, 'The horizon . . . is what guarantees the identity of the object throughout the exploration [of the gaze].'[13]

The analogous relationship between a word and its semantic field and a seen object and its visual horizon reflects the astounding double valence of words which describe perception and cognition. We see an object and yet *see* or do not see what a person is getting at. We strive to be as *clear* as we can. If an argument is *dark* and somewhat *opaque*, we might endeavour to throw some *light* upon it, hoping to achieve an *illuminating* or *enlightening* insight. A surface may offer a cloudy reflection whilst our *reflections* might be *clouded* by *blind* prejudice. We even speak of having our *eyes opened* to a problem so that we might subsequently arrive at another *perspective* or *viewpoint*. Yet, it might be objected, are we not confusing visually related metaphors with the reality of the visual? Should we not distinguish more rigorously between the speech-created world and the visual world which begins where the word breaks off?

There are certain elementary differentiations between sensible and mental phenomena. The seen physical object is a spatial phenomenon whilst that which I might visualise as a spatial object is not itself a spatial object. Beyond this, however, it is very difficult to demarcate visual-oriented language from that which is purely mental in reference. Though we might speak loosely of the seen-image, the image is never in fact the visually observed object. Canvasses may be destroyed but not images. Seeing an image is more an instance of *recognising* what is evoked by an art work, of having something brought to the mind's eye. Ludwig Wittgenstein insists that perception contains a thought-element (we see something as) whilst thinking contains a perception-element (we imagine instances).[14] Indeed, Wittgenstein's remark reflects an ancient ambiguity.

In his analysis of Plato's views of perception (*aisthesis*) and reflection (*theoria*), Waterfield argues that Classical Greek thought contains no definitive evidence to suggest that terms such as *eidos* (that which the mind sees) and *theoria* (reflection) were exclusively cognitive or perceptual in reference.[15] Matters are

no clearer in Latin. The term 'vision' is related to the verb *videre* (to see), but to see meant not just to follow with the eyes but also the seeing of something that becomes visible other than by ordinary sight – hence the terms 'visionary' and 'seer'.

The impossibility of a strict division between perceptual and conceptual terminology might be anathema to those who seek the security of precise distinctions. However, in the case of aesthetics, as Baumgarten reminds us, *confusion* is of the essence not because aesthetic experience is a tiresome muddle but because it is a productive bringing together, a confusion of thought and perception which enables us to *see* the idea embodied in a work and to *see* the work as an instance of that idea. Without such a fusing-with, metaphoric transfer would be impossible. To see a set of scales as the symbolic presence of justice requires a capacity to see a given object as an instance of something that in itself it is not (i.e., a general notion). What damage would the illuminating capacity of art then incur if a strict demarcation between sight and insight were to be imposed?

Two things are clear. Art can neither be a matter of merely producing and looking at tactile sensible objects nor can it be turned into the science of ideas which the Cartesians dreamt of. If art were the former, it would be nothing other than a mindless process of material production and not art. For art to open our eyes to the world it has to do something other than remain in the purely sensible. It has, to borrow a hermeneutic metaphor, to speak, and it can only do so if it successfully enables us to understand that there is something more to be seen in it than what is immediately before the eye. Aesthetic understanding reveals just how correct Kant was when he argued, in another context, that perceptions, sensible intuitions and indeed feelings are *blind*(!) unless they can be brought under and illuminated by an appropriate idea. And yet, were art to deal with ideas alone it would also cease to be art; it would have become philosophy. For art to address us in the particularities of our embodied world it, like Hermes, has to translate the ideas it is concerned with into perceivable instances. Universals must be particularised. Aesthetic experience exemplifies once again the correctness of Kant's insight that concepts and ideas which cannot achieve embodied instanciation remain abstract and empty. Hegel struck the mark with unerring accuracy when he said that *art is not yet pure thought and yet no longer purely material existence.*[16] That art comes to its proper provenance in the metaphoric translation and cross-wiring of ideas and sensible particulars indicates not only how indefensible and insensitively inappropriate are the continued rhetorics of 'theory' and 'practice' within art and aesthetic education but also how appropriate hermeneutic thought is to achieving an intimate appreciation of how art resides within the procreative tensions and interdependencies of sight and insight.

Hermeneutics, language and visual understanding

Contemporary philosophical hermeneutics embraces the conviction that the ability of the said to point to and reveal the unsaid makes linguistic understanding a paradigm case for grasping the nature of artistic understanding. Heidegger's *On the Way to Language* and Gadamer's *Truth and Method* dwell in particular on language's ability to 'say' things over and above the 'said'. Such a thesis causes the hackles of many a practitioner to rise as it appears to cheapen the specialness of intimate aesthetic experience by enclosing it within the banalities of propositional discourse. They would be in illustrious company for Nietzsche doubted whether the complex nuances of intense experience could be faithfully rendered within the clumsy inexactitudes of language. Heidegger too was intensely aware of how thoughtless chatter turned poetic gold into the lead of common cliché. Yet Heidegger was aware that language also functioned disclosively and this recognition underpins the claim of philosophical hermeneutics that what comes to pass in language illuminates the nature of our understanding of art. To illustrate the point let us turn to Gadamer's comments on the nature of conversation.

If language consisted solely in the exchange and analysis of propositions we would be limited to talking only of those sets of assertions which were logically connected or deductively derivable from their primary subject. The aletheic (disclosive) view of language insists, however, that language *also* operates synchronistically. Metaphor, simile and other modes of imaginative juxtaposition demonstrate how subjects which are not logically or causally connected can be bound by nuance or indirect association. Gadamer esteems conversation as paradigmatic of this aletheic dimension of language. When underway, conversation discloses of itself subtleties of association and nuance which logical analysis could not foresee. What is said is not as important as the unsaid which the said *brings to mind*.

The experience of having something brought to mind is for Gadamer an objective occurrence. What is revealed is occasioned by the conversation itself. Were the conversation merely an exchange of subjective preferences no conversation would have taken place, but if it does occur – and this is the crucial point – its participants will have undergone an intimate and *unexpected* alteration in their outlook. This is why Gadamer holds that there is no fundamental difference between experiencing the aletheic powers of conversation and experiencing what art discloses to us. Both occasion events which, contrary to one's willing and doing, disrupt one's self-possession and equilibrium.

That which understanding 'brings to mind' can be considered in two ways: (1) Hermeneutics is not a stranger to a distinction drawn by analytic philosophy between utterance and meaning. If I understand what is said, I distinguish the meaning of what is said from the manner it is conveyed. Hermeneutics makes a similar distinction between the broad 'subject-matter' of a statement or work and the very particular way a painting or poem interprets it. Indeed, it could be

said that *hermeneutic reflection articulates and inhabits the space between meaning and utterance*. Is it not concerned to reveal how art works can point beyond themselves? Does not hermeneutics disclose how the subject-matter an art work brings to mind is larger than what is shown? And yet in disclosing that, does not hermeneutics also reveal the individuality of a work, display its particular way of handling and contributing to its subject matter? (2) Gadamer notes that it is not just words which invoke a subject-matter, but that all speaking brings 'a totality of meaning into play without being able to express it totally' (1989: 458):

> Every word causes the whole of the language to which it belongs to resonate and the whole world view that underlies it to appear. Thus, every word, as the event of a moment, carries with it the unsaid, to which it is related by responding and summonsing.
>
> (Gadamer, 1989: 458)

Elsewhere, he remarks that when one is understood, one is understood not because of what is held within one's statements but because of how what one says leads the listener to dwell on the unsaid, to what one is referring to:

> To say what one means . . . to make oneself understood – means to hold what is said together with an infinity of what is not said in one unified meaning and to ensure that it is understood in this way.
>
> (Gadamer, 1989: 469)

The articulateness of careful verbal utterance resides not in what is declared but in how the declared silently resonates in the mind of the listener the nexus of meaning to which it belongs. Exactly the same holds for the articulateness of the visual image or the musical phrase. The density of either depends upon an ability to invoke, to make luminous or audible their respective visual or sound-worlds.

The use by hermeneutics of linguisticality as a paradigm for getting to grips with the 'event' of understanding focuses on the experience of having something brought to mind and that experience is, in turn, used to unravel our experience of art. It has nothing to do with subordinating art to language but only with pointing out that because of what we know from the instance of conversation, what we undergo when a painting brings something to mind, is neither as exceptional nor as subjective as it often seems. In that aesthetic understanding differentiates the saying from the said, the subject-matter from the inter-pretation, hermeneutics contends that *our understanding of art is as discursive or dialogical as our understanding of language*. Hermeneutics uses the model of linguisticality in order to show that aesthetic experience is not a solitary monologue on private pleasures but is an integral part of a shared discourse concerning the realisation of meaning. Far from subordinating image to word, hermeneutical aesthetics is concerned with the sensitive use of words to bring forth what is held in an image. Though the totality of what is held within a

painting can never be seen in a single glance, it is the word that directs us to what has yet to be seen. Before we address a possible shortcoming in our argument, a conjectural point concerning the relation of seeing and speaking might be considered.

In hermeneutic thought, the notion of having something 'brought to mind' is connected with the idea of being able to see 'beyond' that which is immediately visible. We speak of 'seeing' what an artist 'is getting at' though the subject-matter need not be a visible object. If we never actually see 'beyond' or 'behind' a surface (because we only arrive at another surface), why is it that we have come to ask what is 'behind' a work? Here we can learn from linguistic experience. Both the ability of the spoken word to summons the unspoken and the differentiation between meaning and utterance strengthen the awareness of the difference between what is meant and the many ways of saying it. An analogous distinction applies to visual understanding for we can differentiate between what a work allows us to see (what it brings to mind) and what it makes visible. Would we be able to understand the differentiation between artistic meaning and expression had we not a prior linguistic understanding of that differentiation between meaning and utterance? If the answer is affirmative, all that could be concluded is not that linguistic understanding has a supremacy over visual understanding but only that an understanding of our linguistic experience can deepen our awareness of how and what we come to 'see' in art.

It might be objected that prolonged reflection upon what the subject-matter an art work brings to mind detracts from the immediate visual presence of that work. Not infrequently practitioners express the fear that being drawn into the ideational domains of a work leads them away from a proper concern with how a work is made. We will return to this important criticism, though two brief remarks might be presently made. First, as has been mentioned, the identification of a work's subject-matter does not inevitably lead to a reflective flight from the particularities of a work since, once the subject-matter is identified, it is possible to evaluate and appreciate that work's specific and perhaps unique realisation of that subject-matter. Second, hermeneutic aesthetics does not regard practice and reflection as mutually exclusive. To the contrary, the aspiration of hermeneneutical aesthetics is to draw out and elucidate the implicit reflective elements intrinsic to practice. To conclude, the concern of hermeneutic aesthetics with language has nothing to do with the reduction of aesthetic experience to words but with the use of words to expand and deepen what is held *within* such experience.

Perception, meaning and art

With regard to the question of meaning and perception: because its epistemological roots reach deep into Husserlian phenomenology, hermeneutics is radically empirical in character. Gadamer insists that 'pure seeing and pure

hearing are dogmatic abstractions which artificially reduce phenomena' as 'perception always includes meaning' (1989: 92). This stance strikes hard at both the presuppositions of formalist aesthetics and aestheticism.

Formalist aesthetics reflects its empiricist heritage by supposing a differentiation between, first, the having of sensations and perceptions and, second, the attribution of meaning and value to those sensations. Formalist aesthetics shares with Hume and twentieth-century positivism the belief that we initially experience planes, surfaces, textures and then and only then interpret (project) the significance of those experiences. Thinkers in the mode of Clive Bell would maintain that our immediate aesthetic responses to perceptual form have a primal purity unsullied by the subsequent corruption of intellectual prejudice. The phenomenological tradition in which hermeneutics resides insists, however, that such a demarcation between perception and conception is nothing other than a *falsification* of experience. We do not first experience planes and surfaces moving before our eyes and then judge those phenomena to constitute a smiling face. No, to the contrary, we experience the smile immediately and can subsequently try to contemplate the particular *sensuousness* of a given smile or *wonder* what motives lie behind such a smile.

Gadamer draws on considerable support for his rejection of pure seeing. He says of Aristotle:

> [He] . . . showed that all *aisthesis* (perception) tends towards a universal (*eidos* or idea) . . . even if every sense has its own specific field and thus what is immediately given in it . . . is not universal.
>
> (Gadamer, 1989: 90)

'Aesthetic vision' is not characterised by hurrying to relate what one sees to a universal but it is clear that the sense of such vision is dependent upon a relationship with a universal. We can also cite Wittgenstein, who argues that when I hear a minor chord, I do not want to say that I receive certain stimuli and then recognise it as a minor chord. I hear the minor chord straight away or, as Mary Warnock puts it, my hearing is already modified by the concept.[17] Regarding Wittgenstein's *Philosophical Investigations* she remarks:

> How far can we separate thought from seeing, concept-using from sensing? And if we cannot separate them, how far must we allow not only that concept-using enters into perception, but also that the power of re-perception, of presenting to ourselves perceptual objects in their absence, also enters into concept using? Not separating these things entails both that we must think of perception as containing a thought-element, and, perhaps, that we must think of thinking as containing a perception-element.[18]

The phenomenological basis of hermeneutical aesthetics accords with

Wittgenstein's position and brings to fruition that fusion of understanding and sensibility anticipated in Kant's famous remark in *The Critique of Pure Reason*:

> Thoughts without content are empty, intuitions without concepts are blind. It is, therefore, just as necessary to make our concepts sensible, that is, to add the object to them in intuition, as to make our intuitions intelligible, that is to bring them under concepts.[19]

Hermeneutic aesthetics stands or falls on the possibility of such cognitive and perceptual transfer. It proclaims the extraordinary power of art and aesthetic experience to not only electrify inanimate matter with concepts and ideas but also to allow us to *feel* their presence as if they had been applied directly to us and us alone. If, however, concepts and ideas are not capable of infusing sensibility with intelligible sense, profound feelings and sensations are condemned to being inarticulable.[20] Aesthetic experience would be excluded from the realms of discursive meaning and could not in effect be spoken of. If, furthermore, our perceptual sensibilities were unable to *see* bodies and objects *as* metaphoric carriers of abstract concepts, the art work would be prevented from speaking to and of the world we know ourselves to be in. Sign, symbol and visual metaphor would become inoperable. What hermeneutic aesthetics grasps is not merely that *art is not yet pure thought and yet no longer purely material existence* but that its ability to communicate and transform our understanding depends upon its power both to articulate material existence without dissolving it into pure idea and to apply pure ideas to the particulars of material existence without reducing them to pure material alone. Concerning our general argument, three points arise.

1 The hermeneutic defence of the fusion of meaning and perception offers a decisive objection to those who maintain that perception and cognition are mutually exclusive. If aesthetic properties were devoid of any cognitive content, how could we ever talk about art? Aesthetics would be reduced to an effete aestheticism in which unthinking inarticulateness masquerades (as it has often done) as a 'sensibility of unspeakable delicacy', a clever (but ineffective) manoeuvre to defend aestheticism against the rightful claims of discursive justification.

2 The argument demonstrates that the strict divide between art as a primarily perceptual field and aesthetics as a primarily cognitive concern cannot be easily upheld. To the contrary, if perception is meaningful, art must deal with the realms of *eidos*, with the ideas and concepts that a work directs us to and which transcend the purely practical. This underscores the phenomenological fact that whilst aesthetic experience achieves an intense heightening of our subjective awareness, such experience is also objectively discursive. The ideas perceptually embodied within art are rooted in horizons

13

of otherness beyond those of our immediate subjectivity. Baumgarten and Hegel were only partly right when they declared art to be a '*campos confusionis*', a realm between perception and cognition, a realm which is neither pure thought nor pure material. Their positions do allow the perceptual content of aesthetic experience to be mediated by the cognitive, but because of their prejudice towards the 'superiority' of logic and metaphysics both ultimately regard art as a degraded form of thinking. Hermeneutic aesthetics has no such prejudice. It is concerned with how art is able to occasion in a uniquely immediate way the epiphany of ideas in the material realm of perception and the elevation of perceptual particulars into the transcendent realm of ideas.

3 What Baumgarten and Hegel regarded in aesthetics as the confused, Gadamer accordingly looks to as a specific and productive realm of *fusion*, a melting (*Verschmelzung*) of *eidos* (idea) into the realms of *aisthesis* (perception). The creative instability of fission better describes the process whereby *eidos* charges *aisthesis* with its content and *aisthesis* makes tangible what in itself would be abstract. This generative transposition offers further support for the argument made above that aesthetic experience involves the ability to recognise what we envision in that which we see and to recognise in the particularities of what we see the fuller horizons of what we envision. This underlines the pressing need in contemporary aesthetics for a *kaleidic hermeneutic*, for an understanding of how the interpretive processes and cultural determinants of art enable it to translate ideas into sensible appearance.[21]

Art and its subject-matters

The discussion of meaning in perception brings us to the question of subject-matter. In his assertion that art works direct us to their subject-matter, Gadamer reveals hermeneutic's distinct phenomenological heritage. Phenomenological reflection insists upon consciousness's intentionality, that consciousness is never pure but always *of* something. Consciousness is attention tending towards its object. In German the word *Sache* means concern, pre-occupation or involvement. For Husserl it denotes the object of conscious awareness. This is not a naïve empiricism but a perspectival idealism related to Wittgenstein's notion of aspect-seeing.

Philosophical hermeneutics avoids relativism by insisting that the various interpretations of an art work share a sameness by addressing different aspects of that work's core concern or meaning. 'Every hermeneutical understanding', Gadamer insists, 'begins and ends with the thing-in-itself (*Sache-selbst*).' 'All correct interpretation must let the thing take over' (1989: 236) and 'be confirmed by the things themselves' (1989: 235, 237); that is, by the subject-matters towards which works incline. Referring to Husserl, Gadamer remarks:

Seen phenomenologically, the thing-in-itself is, as Husserl has shown, nothing other than the continuity with which the shades of the various perspectives of the perception of objects pass into one another . . . But [whereas] every nuance of the object of perception is exclusively different from every other one and that the thing itself helps to constitute these nuances, with the nuances of the linguistic views of the world, each one contains potentially within it, every other one, i.e. every one is able to be extended into every other one.

(Gadamer, 1989: 406)

The *Sache* or subject-field which a work (utterance) addresses is 'always more' than any individual expression of it. Speaking more specifically of concepts, Cassirer observes:

The history of philosophy shows us very clearly that the full determination of a concept is very rarely the work of that thinker who first introduced the concept. For a philosophical concept is generally speaking rather a problem than the solution of a problem – and the full significance of this problem cannot be understood so long as it is still in its first implicit state. It must become explicit in order to be comprehended in its true(r) meaning and this transition from an implicit to an explicit state is the work of the future.[22]

Exactly the same argument applies to the inexhaustible potential within a dramatic character or painterly motif. Olivier's Othello extends our understanding of what lies within the character but by no means exhausts its future possibilities. Though Grunewald and Constable cleared new paths to our understanding of landscape, the *motif* transcends them both. Three pertinent consequences follow from this.

First, if, like concepts, the subject-matter of an art work is 'always more' than its instances, an art work can in this respect never be finished. In *Truth and Method*, Gadamer comments, 'all encounter with the language of art is an encounter with an unfinished event' (1989: 99): 'There is no absolute progress and no final exhaustion of what lies in a work of art. The experience of art knows this of itself' (1989: 100). If so, no work can exhaust its subject-matter. There is always something more to be said. No work can claim or be proclaimed to be the definitive expression of a subject-matter, for its implicit 'futureity' is forever open. Now the standing of an art work is not necessarily diminished by recognising that there are always other aspects of its subject-matter to be brought to the inner eye. A work might be valued not just because of the directness whereby it brings its subject-matter forth but because, by doing so, it is also able to assert its own merits in contradistinction to previous exemplars of its type. Picasso's *Guernica* succeeds in bringing to mind the whole genre of war painting but, with its newsreel-newsprint greyness and cubist assemblage

15

of editorially cut and fragmented images, it extends its subject-matter in a disturbingly far-sighted way. Anton von Webern's *Fuge Ricecarte a 6 voci* looks back respectfully to J.S. Bach's *Musical Offering* and reinvokes the whole question of fugue. Yet rather than building its musical argument by giving distinct lines to individual instruments, it assembles each voice via a Klee-like weave of musical colour. Webern simultaneously reinvokes and extends traditional subject-matter. By vitally transforming it, he leaves the constitutive questions of that subject-matter even more transparently open. Far from being an inadequacy, the incompleteness of a work's subject-matter poses a creative challenge: to think on and uncover what has yet to be said.

Second, the notion of a work addressing a transcendent subject-matter, and being assessed in terms of what it invokes, has important practical consequences for aesthetic education. (1) It emphasises the *dialogical* or *discursive* aspects of art practice. If a subject-matter is logically inexhaustible, no party can possess the 'right' or 'correct' view of it. Aesthetic education should involve dialogical exchanges in which different aspects of a subject-matter might be shared. The 'young turk' may be blind to the finer points of received tradition but such lack of tolerance does not refute the possible logical validity of a new stance. Should not the experienced practitioner welcome the opportunity to rethink the premises of their practice? On the other hand, the weight of sheer experience itself does not give it sole rights over the interpretation of a subject-matter. However, it does offer the young and impatient a gentle reminder of there always being other ways of doing things. (2) Once an artist has selected his or her subject-matter, certain very practical questions emerge: 'Is the style appropriate to the subject-matter? Do the chosen images effectively identify the subject-matter or are they ambiguous? Does the work read clearly and, if not, what practical rectification is required?' In other words, the subject-matter provides a criterion whereby we can ask and re-ask questions about the level of seeing we bring to or is required by a work.

Third, the notion of subject-matter helps defend aesthetic experience against the needless charge of subjectivism. There are indeed truths which may only be subjectively experienced, but that these truths only emerge in subjective consciousness does not render them subjective. If we understand the distinction between meaning and expression we will understand that when a work brings its subject-matter to mind it will bring to mind more than is initially seen. We are, in other words, led out of the immediacy of our own horizon and brought to consider other ways of seeing and thinking. Meanings for Gadamer are subject-fields, spaces in which things are related. By entering one subject-field we gain access to others. The implicit networks of meaningfulness which connect the subject-fields of art underwrite art's ability to take us beyond ourselves and out of the initial horizons of our present historical circumstance into others. This is not an apologetics for historical or aesthetic escapism. Reacquainting ourselves with previous interpretations of a subject-matter frees us from being compelled to think and feel solely in terms of our present horizon. The recovery of other

16

logically possible ways of thinking allows us to look at and, hence, to feel differently about an issue. We do not so much *lose* ourselves in the self-forgetfulness of art historical reflection but become more ourselves. Such reflection offers the possibility of recognising in other traditions and practices the otherness of ourselves.

Once the hermeneutic implications of the notion of subject-matter (*Sacheselbst*) are unravelled, aesthetics emerges not as a monologue on solitary pleasures but as a shared discourse concerned with the realisation of meaning. By recognising different traditions of art practice and history, hermeneutical experience exposes the (subjective) limitations of our own ways of doing and seeing. Far from condemning our experience of art as subjective, hermeneutics contends that aesthetic experience opens us to a greater objectivity.

Hermeneutics, art and eventuality

The profundity and seriousness of our experiences of art have been inexcusably marginalised on the basis of an epistemological prejudice. Facts, objects and events belong to the world whilst interpretations, feelings and values emanate from the inner worlds of subjects. Nietzsche and Dilthey were amongst the first to dismantle this prejudice. Nietzsche insisted that aesthetic and moral preferences were indicative of the modes of being we *are*, whilst Dilthey argued that city-scapes, economies, let alone the institutions of art, are not just physically real but effective expressions of the presence of a community's *Geist* (spirit); that is, of its distinct way of living and seeing. For Heidegger the continuously unfolding nature of actuality – the event of Being – does not take place to the exclusion of subjectivity. When an art work brings something to mind, Being (the process of disclosure) discloses itself *within* the subjective. Gadamer similarly regards subjective engagement with an art work as a condition of the coming forth of what is objectively held within it. Once again we can see how appropriately revealing Gadamer's invocation of conversation is as a paradigm of understanding. In order to take place conversations require participating subjects, and yet what occurs (comes to mind) in the course of a conversation certainly emerges from the confines of the conversation but not necessarily from the intentionality of any one of the participants. In the case of aesthetic experience, we can also assert that what arises is not just a matter of an individual's subjective reaction to an ontically independent work. Aesthetic experience is the occasion of an art work commencing and recommencing *its* endless work. Aesthetic experience is not secondary to the work but an event occasioned by the fusion of artist, work and viewer in which pictorial meaning comes forth. This might seem an obtuse argument, but its practical implications are enormous.

How does one engage an art student with what can appear as the irrelevant weight of tradition? Hermeneutic thought quietly intimates that we rethink the question since it is a given of our being that we are born into the living

traditions of language, art and culture. Tradition is not, however, an unthinking conservatism seeking to maintain practices unchanged. Live traditions stand upon unstable continuities of open and unresolved questions. An art tradition lives neither in stasis nor repetition but in the creative turmoil of having to respond in new and different ways to the questions posed by its core subject-concerns. Live traditions are precisely those which are in continuous question. To have doubts about a tradition, its direction, ownership or authority is not in fact to question its relevance, for such queries are the traditional devices whereby a tradition re-evaluates itself. No matter how inward and subjective such questioning might seem, it is nevertheless the occasion whereby a tradition begins to transform and revitalise itself. Hermeneutical thought reminds us of what Goethe and Nietzsche understood so well; namely, that just as the present well-being of our creative faculties is indebted to the nurturing of tradition, so the future well-being of that tradition becomes compromised unless we respond creatively to and thereby renew the questions which articulate and sustain both its and our way of seeing. Just as the part cannot exist without the whole, neither can the whole survive without its parts. A brief comparison of Plato and Gadamer might be helpful in this respect.

Underlying the infamous critique of art offered by Plato in Book Ten of *The Republic* is the assumption that art is at two removes from what Plato believed to be the proper subject-matter of knowledge; that is, the ideas (*eidos*) which, like concepts, transcend their exemplification in nature and art. In presenting us with seductive images of what is purportedly real, the artist's skill tries to persuade us that the representation we see is either real in itself or is of something real. Plato insisted, however, that what is seen as an image of a nude is but an (artistic) interpretation of nature's interpretation of an intelligible timeless object which is the *eidos* or pure form of a human being. Art proffers a corrupt and false coinage. It passes off appearances as the real thing and in so doing takes us further away from the original. The *Sache* of Gadamer can be compared to the *eidos* of Plato in that both logically transcend, and can never be exhausted by, their particular exemplifications; but here the similarity ends. An *eidos* transcends all time. The *Sachen* may transcend a particular epoch but not historical time. They become, emerge in and accrue weight over time; whereas the *eidos* form pure changeless Being. The *eidos* are logically complete: they lack nothing. The *Sachen* are logically open, always susceptible to extension by further interpretation. Furthermore, whereas, for Plato, art removes or distracts us from the *eidos*, art for Gadamer takes us closer to and realises other aspects of a *Sache*. These remarks set in context the crucial difference between these two conceptions.

Whereas the *eidos* exist apart from and are not in any way dependent upon artistic representation for their being, the *Sachen* do not exist apart from the artistic discourses which sustain them. Not only does this argument have important consequences for how we might conceive of the ethical relationship between tradition and creative practice but it enables Gadamer to turn Plato's

aesthetics on its head by suggesting that far from corrupting reality, art allows what is held within actuality to realise itself. Hermeneutic aesthetics completely re-articulates the relationship between art and reality. Gadamer's strategic distinction between representation (*Vorstellung*) and presentation (*Darstellung*) is in this respect crucial.

The traditional notion of artistic representation is awkward. It implies that what art 'shows' is a re-presentation of something independent of the work. The genre of Dutch maritime painting is taken, for instance, to be a visual reconstruction of seascape, whilst abstract paintings represent moods visually. Representation suggests that the work is something other than, distinct from or stands before what it represents. The doctrine is perhaps a late outcome of Plato's critique of art for it too betrays the prejudice that artistic appearance is secondary to the real. The notion of *darstellen* (to present) has altogether another connotation. It suggests a placing (*Stellung*) there (*da*). It hints at that which an art work *presents* or *offers* up. Art's significance for Heidegger was that it occasioned what can only be rendered in English as the 'eventing' of Being. Gadamer is not so much concerned with the metaphysical significance of art's ontology but with understanding what happens in our experience of art. Gadamer clearly embraces Heidegger's broad vision of art. He speaks of 'the event of being that occurs in [artistic] presentation' (1989: 116). Nevertheless, what concerns him more is what 'comes to picture' in a work. An art work occasions the coming forth of its *Sachen*, facilitating its epiphany, its showing, its coming into appearance. Thus, Gadamer remarks:

> The ideality of the work does not consist in its imitating and reproducing an idea but, as with Hegel, in the appearing of the idea itself.
>
> (Gadamer, 1989: 144)

That 'appearing' is not secondary to the subject-matter as it would be in the instance of a Platonic idea, but is, to the contrary, a presentation of the essence itself:

> A work of art belongs so closely to what is related to it that it enriches the being of that as if through a new event of being. To be fixed in a picture, addressed in a poem . . . are not incidental and remote from what the thing essentially is; they are presentations of the *essence* itself.
>
> (Gadamer, 1989: 147)

The importance of this argument cannot be overemphasised. Not only does it carry huge implications for the future status of aesthetics but it also serves to bring our own argument to its culmination.

We suggested above that aesthetic contemplation requires that we treat a cognitive object or subject-matter as if it were incarnated in the physicality of

the work before our eyes and that, therefore, visual metaphoric transfer must entail seeing something as if it were something that it in fact was not. The notions of *darstellen* and of *die Sache selbst* offer a remarkable clarification of this contention. *Die Sache* cannot be exhausted by their particular artistic embodiments and yet cannot exist apart from such embodiments. Thus when we attend to a work's subject-matter, what is *more* than the work *presents* itself *through* the work and thereby finds a place in our world. Gadamer's argument is all the more potent in the case of religious art and iconography where the images are known to lack any objective correlative. The face of God cannot be depicted or represented (*vorstellen*) since no known artist has access to the original and, furthermore, if an absolute God were to exist it would be unlikely to possess facial features characteristic of a species with evolving needs. Such arguments, however, miss the point. Religious art cannot offer literal depictions but occasions for metaphoric transfer. Such art is a classic instance of the tension over which Hermes presides; namely, that between the 'seeing' of a truth and the task of communicating it. If the divine exists, its presence will be non-spatial and non-temporal. Yet for the human mind such a presence is impossible to grasp. Thus for such a presence to show itself, it cannot reveal *its* actual face (it has none) but can only come forth *as* a face. Indeed, for the human being it is invariably the face which reveals the gaze of the other, albeit the face of a transcendent other. Religious art is not a depiction but a coming into picture of a divine presence.[23] The same argument applies to the emergence of aesthetic qualities in art works.

Intimacy, nearness, vivacity, directness, nakedness, inwardness or graciousness are not objects and yet, as phenomenological realities capable of radically reshaping our lives, they are forcefully and effectively present in the world. Because these entities are not objects in the spatio-temporal sense, many have inexplicably judged them to be subjective apparitions, appertaining only to the preferences of the viewer and not to the properties of the viewed object. Gadamer openly accepts that the aesthetic spectator is a condition of a spectacle coming forth (1989: 124) but, as we have seen, he completely rejects the idea that what comes forth is relative to the spectator alone. Although we cannot see nakedness in the same way that we see the naked, or cannot touch nearness in the way I can pick up that which is nearby, we can sense the presence of these qualities and be as profoundly affected by them as by the immediacy of the tangible. By means of art these qualities gain a tangibility of presence which without art's mediation they would not have. By allowing qualities such as privacy to come forth, the art work allows us to see entities in the world which we would not otherwise see. Privacy can only be presented (*darstellen*), not represented (*vorstellen*). In this context, whilst addressing the charge that Degas's pastel images of *femmes à toilette* are voyeuristic, Duncan Macmillan observes:

> He [Degas] is defying social convention to say something deeper, to get closer to the essence of things. And privacy is of that essence. The

privacy at the centre of each of us from which we reach out to the world as best we can. This is what Degas is doing: trying to grip and hold the elusive other even while so clearly knowing it must escape. The strange patterns of his pastels hang forever between certainty and uncertainty *... Erotic is a sadly debased word but it alone catches this union of privacies where mind and sense meet.*[24]

Citing Degas does not imply that the argument concerning *Darstellung* applies only to so-called representational or naturalistic works. To the contrary: the enormous strength of the *Darstellung* argument is that it is just as tolerant and, perhaps, even more revealing of what abstract paintings allow us to *see*. Think for example of the intense nervous *anxiousness* in the paintings of Jasper Johns or of the all-absorbing *solitariness* in the spacious images of Rothko. Art does not therefore entail an escape into an unreal world of subjective appearances, but by translating privacy, nearness or loneliness into the structures of the visible it makes what is already in the world more real in at least two ways. It enables a greater understanding of inner phenomenological realities and, at the same time, activates – makes more real – the subject-matters it deals with.

Nietzsche asserts in *The Will to Power* that art enlivens and increases one's sense of power. Hermeneutic aesthetics would not disagree so long as an increase in power is grasped as an expansion of one's self-understanding and sense of being. The notion *Darstellung* illuminates how aesthetic experience enlivens our understanding. In the present context, it should be noted that images can function not unlike words. Words can name and clarify confused feelings whilst images allow us to see visual likenesses of what we may feel but blindly. Intense inner feelings traumatise, not merely because of their force but because understanding cannot prise open their individuating grip. Art and poetry 'comfort', not as distractions but because the bereft find in Donne's words their particular feelings acknowledged, articulated and illuminated by the wider horizons (*Sachen*) which constitute the literature of loss. Gadamer suggests that art allows 'the reality beyond every individual to become' reassuringly 'visible' (1989: 449). By revealing the *Sachen* which inform *and* reach beyond our initial horizons, art reveals that no matter the intensities of individual experience, when we understand we come-to-stand with others, exchange and perhaps share views of a subject-matter. Aesthetic experience is not subjective but essentially dialogical. What presents itself in aesthetic experience can in effect lead to an extension of our being.

John Berger has sensitively argued that ours is an age of loss and anxiety. Nihilism, scepticism and barbaric technologies have bereaved us of faith in the possibility of meaning. How does one articulate the aching sense of *searchingness* that follows such loss? Though it might drive the eye to scan for the truths it would see, it is not itself a visual entity. We may sense its inarticulate presence but we cannot *see* it. But art does bring us to see what we cannot in and of ourselves see. If we look into the eyes of Salvator Rosa's self-portrait our

inarticulate *searchingness* shines back at us, but articulate, visible, indubitable. The work illuminates not only its subject-matter but our feelings too. In Kantian terms, the subject matter which presents itself through the work by placing our blind intuitions under its ban, allows them to gain their sight. Our understanding, and hence our being, is enlivened. We see, we understand, we become more.

The dynamics of *Darstellung* not only increase the being of the viewer but that of the subject-matter itself. That art should occasion an increase in the being of an *eidos* would have been *anathema* to Plato, but hermeneutical aesthetics asks that the customary dualistic understanding of the relationship between art and reality be set aside.

For Gadamer art facilitates the unfolding (*Werden*) of actuality. This is evident in his 'transformation into structure' argument which develops a case for the efficacy of artistic fiction. The finitude of being dictates that no meaning can ever be complete. Our being is forever fluid, open and undecided. We and everything around us are always underway, for ever in-play. The idea of a complete circle of meaning is a fiction. Art's quest for completeness appears as a lie, though, in the face of such existential indeterminacy, Nietzsche acknowledged it to be a necessary lie. In this context, however, hermeneutical aesthetics offers a more engaging view of aesthetic fiction. The Latin root of fiction relates to the verb *fingere*, meaning to mould or to fashion. Thus the question becomes what does art 'make of' or 'fashion' from the undecided potentialities for meaning within actuality? The argument suggests that if understood as a creative-bringing-to fruition, art does not recover hidden or forgotten truths but perceives in an indeterminate set of meanings an as yet *unrealised* truth. Of course what is realised is not the *whole* truth, since no work can exhaust its subject-matter. Indeed, if the work is read as making such a claim, it remains a fiction in the negative sense of the term. But in so far as the work allows a hitherto unseen aspect of a *Sache* to *become* true, it is fiction in the positive sense of fashioning or moulding. Art brings to completeness that which could not of itself occur without art's mediation. Hermeneutic aesthetics defines 'reality . . . as what is untransformed and art as the raising up (*Aufhebung*) of this reality into its truth' (Gadamer, 1989: 113). Such 'coming into truth' is actual – an event. It is the occasion of a *Sache* revealing another aspect of itself, a becoming more which in turn affects actuality's future unfolding. Via the notion of *Darstellung*, hermeneutic aesthetics inverts the entire Platonic heritage. By bringing to fruition potentialities for meaning hidden within ourselves and actuality, art, far from distorting reality, brings it to an even greater fullness of being.

Conclusion: the hermeneutic vision of art

A question stands at the head of this chapter: what does hermeneutics have to do with the question of *seeing* what is in an art work? In response, we have endeavoured to *show* that hermeneutical aesthetics offers an extended philosophical

meditation upon what *happens* to us in our experience of art. In attempting to elucidate such experience, it unfolds a powerful vision of the transformative power of aesthetic understanding. Because of phenomenology's formative influence upon its development, philosophical hermeneutics is well placed to realise the potential for an interpretive aesthetic in Hegel's remark that art is not yet pure thought and yet no longer purely material existence. Hermeneutical aesthetics contends that art achieves its proper provenance in the metaphoric translation and cross-wiring of ideas and sensible particulars. That the historical ideas and *Sachen* revealed in aesthetic experience are not of our own willing and doing is a mainstay of hermeneutic's case that what we undergo in the experience of art is not reducible to subjectivity. Crucial to that argument is hermeneutic's use of linguisticality as a means to exploring our experience of art. The analogy with conversation reveals how that experience is not an isolated monologue but an elaborate dialogical achievement involving a fusion of the respective horizons of artist, subject-matter and viewer. This concern with language has nothing to do with the reduction of aesthetic experience to the verbal but with the careful use of words to evoke what is held within such experience. Hermeneutics accordingly insists that an examination of the perception of meaning in aesthetic experience is fundamental to the claim that aesthetic understanding is in part objective. For it to be so it must possess an ideational content which transcends the subjective limitations of both the circumstance and scope of individual perception. The invocation of the notion of subject-matter (*die Sache selbst*) is of strategic importance on this and other counts. It offers a way of conceptualising what an art work 'gets at', what it strives to *show* or lead us to. It offers a criteria whereby a work can be assessed in terms of whether it successfully brings forth its subject-matter. The notion points to a dialogical conception of art and aesthetic education, and by reminding us that an art work can never exhaust its subject-matter exposes us to the possibility of ways of thinking and seeing other than those we know. However, it is in the doctrine of *Darstellung* that the notion of the *Sache-selbst* attains its greatest significance. It underwrites the attempt of hermeneutical aesthetics to radically rethink the relationship between art and reality. Hermeneutical aesthetics brings the Platonic denigration of art as a distorter of reality to an end. Instead, it proclaims art as that which 'raises reality to its truth' (Gadamer, 1989: 113). This much we have seen. What of our wider conclusions?

By stressing the event of aesthetic experience, hermeneutic thought reminds us that aesthetics is not a theory which we fore-arm ourselves with and then take to experience. Aesthetic ideas cannot be meaningfully treated as pure theory. To appreciate their meaning they have to be *seen* in exemplification. Though instanciations will never exhaust the potentiality within an idea, only the instance opens us to the existence of other possibilities. Aesthetic understanding, in other words, only begins to take shape when we become deeply involved in the experience of art's instances.[25] That aesthetic understanding commences with, and must always ultimately return to, the sensuously embodied instance

emphasises once again the odiousness of the theory–practice distinction in aesthetic education. Because it defines itself as *the* subject-field which concerns itself with the expressive particularisation of universal concerns, hermeneutical aesthetics is the living repudiation of this sterile distinction. The very meaningfulness of aesthetic experience depends upon it fusing the transcendent realm of ideas (*Sachen*) with the particularities of embodied sensuous existence. Art practice has to recognise that if it is to be an artistic rather than a merely material productive practice, it must engage with the question of content and thereby accept that philosophical reflection is an ineliminable part of its operation. If, similarly, a philosophical aesthetics is to recognise that it is *aesthetic*, it must respond to the practical question of concrete exemplification (application); that is, with how its ideas can be brought into the particularities of sensuous appearance. Hermeneutical aesthetics does not so much apply itself *a posteriori* to our experience of art as operate within it, articulating and extending its reflective components. It is not a question of reflecting on a finished experience but of giving such experience its proper finish; that is, bringing to realisation that which is at play within it. Hermeneutical aesthetics betrays its debt here not just to Hegel but also to Socrates. Does not art play for Gadamer an analogous role to that played by philosophy for Socrates: a midwife to knowledge? Does not aesthetic reflection endeavour to bring to life – to make visible – the meaningfulness which art strives to give birth to? Indeed, is there not a lesson for philosophy here too? Does not aesthetic experience exemplify a broader truth: that only as the handmaid of experience does philosophy give of its best?

Gadamer's notion of *Darstellung* (presentation) poignantly highlights the truth that aesthetic understanding is inseparable from the occasions of its instances. It *is* the moment of revelation, the event of coming to see what is at play within a work. As a mode of *understanding*, aesthetic understanding must be reasonable, coherent and consistent, but because it is *aesthetic* understanding it cannot persuade by reason alone. It has to *reveal* the nature of its claims in the particular instance. The truths of aesthetics are truths whose validity resides in their coming to be *seen*. As a consequence, if this essay succeeds, it will succeed because it persuades not by reasons but by drawing the reader to an experience of *seeing* what is held in our experience of art. Hermeneutic aesthetics once again betrays its debt to the Classical world. Ancient rhetoric was by no means just the study of sophistry and word play. At its core was the realisation that though words can only incompletely convey the complexities of meaning they might resonate, only the very careful use of words can invoke clearly what cannot be clearly expressed. Hermeneutic aesthetics is animated by the same insight. No image can capture (represent) the totality of associations it is connected to; yet, rather than causing us to despair of the impotency of the particular image, the argument lends the latter an overwhelming importance. Only by looking at the singular image do we begin to *see* and engage with what it brings forth (*darstellen*); namely, the whole field of meaning which informs

it. The particular art work allows us to gain sight of that which without art's mediation we could never come to see.

Though aesthetics and aesthetic revelation must focus on the particular instance, the value of aesthetic experience resides in its ability to illuminate, re-interpret, and develop previous experience. Being brought to see a series of earlier experiences differently is, of course, a singular experience, but what we come to see in that experience is not. The solipsistic tendencies of aesthetics and the introversion of art for art's sake are quite properly alien to Gadamer. Hermeneutic thought shares with Dilthey and Nietzsche the belief that existence is without any *intrinsic* (predetermined) meaning. Such metaphysical scepticism does not collapse into nihilism, for the pertinent question concerns how meaningfulness might be built out of experience's continuities. If our experience of art amounts to no more than a series of intense but fragmented moments, the coherence and consistency necessary to possessing an identity, let alone an evolving identity, disappears. Gadamer remarks,

> Basing aesthetics on experience (of the moment) leads to an absolute series of points, which annihilates the unity of art, the identity of the artist with himself and the identity of the person understanding or enjoying the work of art.
>
> (Gadamer, 1989: 95)

The significance of aesthetic experience lies not in its miraculous momentariness and singularity but in the ever-altering continuities of meaning which over time it collectively reveals. The inevitable finitude of human existence means that experience is always partial and incomplete. Yet without that limitation there would be nothing more to learn. Finitude and the partiality of vision are, in other words, the condition of being able to *see* more. Accordingly, in the following passage, Gadamer conveys what is essentially a hermeneutic vision of art:

> despite the demands of the absorbing presence of the momentary aesthetic impression, we recognise that . . . the phenomenon of art imposes an ineluctable task on existence, namely to achieve that continuity of self-understanding which alone can support human existence.
>
> (Gadamer, 1989: 96)

Each aesthetic revelation not only extends the map of our seeing but also, in so doing, alters and extends our sense of self and how we understand our existential concerns and predicaments. Like the navigators of old, we only gain a sense of who we are and where we are going by setting sail, looking back to the headlands of aesthetic experience and charting our place amongst them. For hermeneutics our experiences of art belong to those orders of insight which the

25

myth of Hermes relates: although as human beings we will never *know* our ultimate destination, art, by illuminating and mapping the complexities of our experience, lights up our present course and offers some guidance as to where we might steer towards. And so with regard to our opening question – 'What has hermeneutics to do with our experience of art?' – is there any decisive *reason* for accepting the foregoing arguments and analogies? In aesthetical hermeneutics there can be no last word but, if so, does not the *aesthetic* become all the more decisive? Is it not, after all, a matter of *seeing*?

Notes

1 Chladenius, *Einleitung zur richtigen Auslegung vernunftiger Reden and Schriften* (1742). The following works should also be referred to: Andrew Louth, *Discerning the Mystery*, London, Clarendon, 1983; W. Pannenberg, *Theology and the Philosophy of Science*, London, Darton, Longman and Todd, 1976, and *An Introduction to Systematic Theology*, Edinburgh, T. and T. Clark, 1994 (2 vols).

2 A. Baumgarten, *Texte zur Grundlegung der Aesthetik*, ed. H.R. Schweizer, Hamburg, Meiner, 1983.

3 See F. Schleiermacher, *Hermeneutik: Nach den Handschriften neu herausgegeben und eingeleitet von Heinz Kimmerle*, Heidelberg, Heidelber Akademie der Wissenschaft, 1977; Wilhelm Dilthey, *Selected Writings*, ed. P. Rickman, Cambridge, Cambridge University Press, 1977; W. Outhwaite, *New Philosophies of Social Science, Realism, Hermeneutics and Critical Theory*, London, Macmillan, 1988; A. Giddens, *New Rules of Sociological Method*, Cambridge, Polity, 1993, and *Modernity and Self-Identity*, Cambridge, 1983.

4 Heidegger's 'existential hermeneutic' is embodied in his doctrine of facticity which gains seminal expression in *Being and Time*, trans. Macquarrie, London, SCM Press Ltd., 1962. Gadamer's *magnum opus* is *Truth and Method*, trans. Doepel and Weinsheimer, London, Sheed and Ward, 1989. A substantial bibliography of Gadamer's writings can be found at the end of *Gadamer and Hermeneutics*, ed. Hugh Silverman, London, Routledge, 1991, pp. 311–27. See also Manfred Frank, *Das individuelle Allgemeine, Textstrukturierung und – interpretation nach Schleiermacher*, Suhrkamp, 1985, and *Das Sagbare und das Unsagbare*, Suhrkamp, 1980. For Odo Marquard see *Farewell to Matters of Principle*, London, Oxford University Press, 1989, and *In Defense of the Accidental*, New York, Oxford University Press, 1991. It would of course be proper to also mention the work of Paul Ricouer whose contribution to hermeneutic philosophy has been enormous. However, as his writings have not focused on the question of art in any depth, his thought will not be discussed in this chapter.

5 Heidegger, *Being and Time*, pp. 188–9.

6 Gadamer, *Truth and Method*, p. 302. From now on in the Notes this volume will be referred to as TM and followed by the appropriate page number.

7 See Kurt Mueller-Vollmer, *The Hermeneutics Reader, Texts of the German Tradition from the Enlightenment to the Present*, London, Blackwell, 1985, p. 1. Probably the most erudite outline of the etymology of the term 'hermeneutics' is Gerhard Ebeling's 'Hermeneutik' in *Religion in Geschichte und Gegenwart* (3rd edn), vol. 3, pp. 243–62.

8 All creative-expressive activity is hermeneutical in that it presents an object to be interpreted and understood, but it also depends on being understood. For a fuller discussion of the 'double hermeneutic' see Giddens, *New Rules of Sociological Method*.

9 See Geoffrey Grigson, *The Goddess of Love, The Birth, Triumph and Return of Aphrodite*, London, Constable, 1976, ch. 4, pp. 65–81.

10 See Alan How, *The Habermas–Gadamer Debate and the Nature of the Social*, Aldershot, Avebury, 1995, pp. 7–8.

11 Pannenberg, *Theology and the Philosophy of Science*, p. 207.

12 See N. Davey, 'Baumgarten's Aesthetics: A Post-Gadamerian Reflection', *British Journal of Aesthetics*, Vol. 29, No. 2, 1989.

13 M. Merleau-Ponty, *Phenomenology of Perception*, cited by D.M. Levin, *The Opening of Vision, Nihilism and the Post-Modern Situation*, London, Routledge, 1988, p. 75.

14 For the theme of 'seeing-as' see L. Wittgenstein, *Philosophical Investigations*, 3rd edition, Oxford, Basil Blackwell, 1968, pp. 193–208.

15 See R.A.H. Waterfield's essay in Plato, *Theaetetus*, trans. R.A.H. Waterfield, London, Penguin, 1987, pp. 142–3.

16 A. Hofstadter, *Philosophies of Art and Beauty*, Chicago, University of Chicago Press, 1976, pp. 7 and 409.

17 M. Warnock, *Imagination*, London, Faber, 1976, p. 191.

18 *Ibid.*, p. 192.

19 I. Kant, *The Critique of Pure Reason*, trans. N.K. Smith, London, Macmillan, 1970, p. 93 (A 52, B 76).

20 It should be noted however that the commitment of hermeneutic aesthetics to perception being inclusive of meaning goes far beyond Kant. Whereas the aspect theory of perception and its hermeneutic equivalent acknowledges that thought has a perceptual element and perception a thought element, Kant does not: 'the understanding can intuit nothing, the senses can think nothing . . . These powers cannot exchange their functions' (*Critique of Pure Reason* A 52, B 76). Here we gain a formal insight into the structural nature of Gadamer's opposition to Kantian aesthetics, for, whereas in the case of empirical (scientific) studies Kant allows that 'only through their union (understanding and intuition) can knowledge arise' (*The Critique of Judgement*, trans. J.C. Meredith, Oxford, Clarendon Press, 1978, p. 75). On pages 48–9 Kant also argues, that the aesthetic judgement 'is simply *contemplative*, i.e. it is a judgement which is indifferent as to the existence of an object, and only decides how its character stands with the feeling of pleasure and displeasure. But not even is this contemplation itself directed to concepts; for the judgement of taste is not a cogntive judgement (neither a theoretical one nor a practical), and hence, also, is not grounded on concepts, nor yet *intentionally directed* to them'; in the case of aesthetics he refuses that union. The determining ground of every judgement which is aesthetic 'is the feeling of the Subject, and not any concept of an Object'. Accordingly, Gadamer asks disbelievingly, what, 'is there to be no knowledge in art?' (TM 43) for Kant's separation of powers within the aesthetic, denies art 'any significance as knowledge' (TM 43). What the present argument suggests is that it is not just a hermeneutic ontology of art-experience which can overcome the shortcomings of Kant's non-cognitive aesthetics, but an aspect-theory of perception can also rectify the difficulties with equal effectiveness. Gadamer certainly comes close to Wittgenstein's aspect theory of perception. See in particular his Heideggerian analysis of seeing as seeing-as (TM 90–1).

21 *Kaleidic hermeneutics: kaleidic* (drawn from kaleidoscope); *kalon* (relating to the Greek for beautiful) and *eidos* (relating to the Greek for shape, idea or form). *Kaleidic hermeneutics*: understanding how an idea or subject-matter sensuously presents itself in aesthetic experience. Though he never used the term, Hegel clearly recognised that the 'kaleidic' occurred. His aesthetic proposed that 'art and philosophy may be said to have the same content, since both reveal the absolute, but art is an irreplaceable end in itself, since unlike philosophy it expresses a sensory vision of the absolute . . . [Art] reveals the absolute uniquely in that it reveals it in a sensory way' (see G.W.F.

Hegel, *Introductory Lectures on Aesthetics*, trans. B. Bosanquet, London, Penguin, 1993, p. xxv). Philosophical hermeneutics is more concerned with the cultural and interpretive conditions that have to be in place in order for the *kaleidic* to occur.

22 E. Cassirer, *The Philosophy of Symbolic Forms*, New York, Yale University Press, 1976, Vol. I, p. 1).

23 It is interesting to note that Gadamer – himself a devout protestant – offers an intriguingly ambiguous position *vis-à-vis* the old argument between Protestants and Catholics over the status of religious iconography. On the one hand his argument suggests that the Protestant condemnation of religious iconography as idolatry is faulty. Idols are not depictions and therefore cannot be 'false' gods. If religious iconography is the means whereby the divine appears to us in our terms, such iconography does occasion a divine presence. If so, the Protestants were committing sacrilege when they defaced religious iconography. When, however, early Christians defaced Nordic images they were not necessarily wrong in their understanding of religious iconography, for they understood that images are presences (though, in this instance, of other unwanted Gods). The destruction of the image destroys the ability of that which comes to presence in the image to reveal itself. Where the Protestant would be right, however, would be in his or her insistence that what comes to presence in an image does not come to exhaustive presence.

24 Duncan MacMillan, 'On Degas', *The Scotsman*, Vol. 22, No. VII, 1996, p. 16 (emphasis my own).

25 Aesthetic understanding exemplifies, *par excellence*, Dilthey's notion of the hermeneutic circle. Engaging with an art work entails moving from a meditation upon its parts through to a reflection upon how the whole communicates the idea(s) embodied in the work and from that reflection back to a practical meditation upon how well the work exemplifies those ideas in the detail of its particulars.

Related bibliography

Bernstein, J.M., *The Fate of Art, Aesthetic Alienation from Kant to Derrida and Adorno*, London, Polity, 1993.

Gadamer, H.-G., *The Relevance of the Beautiful*, ed. R. Bernasconi, London, University of Cambridge Press, 1986.

Gadamer, H.-G., *Truth and Method*, trans. Doepel and Weinsheimer, London, Sheed and Ward, 1989.

Gadamer, H.-G. *Kunst als Aussage*, Tubingen, J.C.B. Mohr, 1993.

Heidegger, M., 'On the Origin of an Art Work', in *Basic Writings*, ed. D. Krell, New York, Harper Row, 1977.

Heidegger, M., *Nietzsche. Vol.1. The Will to Power as Art*, New York, Harper and Row, 1979.

Heidegger, M., *On The Way to Language*, New York, HarperCollins, 1982.

Jay, M., *Downcast Eyes: The Denigration of Vision in Twentieth Century French Thought*, Berkeley, University of California Press, 1994.

Kaufman, L., *Perception: The World Transformed*, London, Oxford University Press, 1979.

Levin, D.M., *The Poetic Function in Phenomenological Discourse*, in W. McBride and C. Schrag (eds) *Phenomenology in a Pluralistic Context*, Selected Studies in Phenomenological and Existential Philosophy, Albany State University of New York, 1983.

Levin, D.M., *The Opening of Vision, Nihilism and the Post-Modern Situation*, London and New York, Routledge, 1988.

Levin D.M. (ed.), *Modernity and the Hegemony of Vision*, Berkeley, University of California Press, 1993.

2

SPECULAR GRAMMAR

The visual rhetoric of modernity

Barry Sandywell

Introduction

This chapter belongs to a series of studies of different conceptions of conscious-
ness and self-reflection in the formation of modern thought. In the first section
I explore the rhetoric of 'inner perception' and 'specular reflection' associated
with modern philosophy and exemplified by the Cartesian *cogito*. The second
section analyses the presuppositions of this world-view, in particular the image
of the solitary ego which this framework legitimated. In the third section the
theme of *visual representation* and the *spectatorial* conception of knowledge
are singled out for particular attention. Finally, in the fourth section, I suggest
alternative, non-representational ways of construing experience and knowledge
prefigured by dialogical conceptions of human existence in the thought of some
philosophical critics of modernity. I suggest that this development involves a
paradigm shift from a world-view based upon ocularcentric categories to ways
of thinking grounded in social and dialogical practices.

The specular regime of modernity

> If the classic thinkers created a cosmos after the model of dialectic,
> giving rational distinctions power to constitute and regulate,
> modern thinkers composed nature after the model of personal
> soliloquizing.
>
> John Dewey, *Experience and Nature*, p. 173

The aim of this chapter is to explore the role of visual metaphors in the genealogy
of modern philosophical reflection. I will argue that the mirror game of
the reflective, representational subject functions as a constitutive discourse for
the project of modernity. Like all cultural innovations the specular model of
the mind's eye involved a repression of older paradigms of subjectivity. To forgo
a very convoluted history I will assume that the Cartesian conception of the
cogito's relation to objects was constructed upon the ruins of more ancient

discourses of the subject's relation to itself elaborated from figures of the universe as a cosmos of Forms governed by a teleological *Logos*. The dissolution of ancient dialogism enabled the specular monad to appear as a source of veridical self-evidence and to function as a secure foundation of objective knowledge and wilful liberty (this is also why modernity's 'other' is contained within the utopia of modernization as a condition of its (im)possibility). Modern epistemology constructed its cognitive space by deconstructing the cosmos of autonomous forms of Being underlying what the Russian thinker Mikhail Bakhtin once called 'the official medieval picture of the world' (1986: 97). Once the idiom of specular reflection was accepted as a normal way of speaking about the self's relation to the other, interiority could be imagined as a quasi-visual space for outward-looking cognitive projects. Correspondingly an older dialogical view of existence was displaced in favour of a proprietorial conception of 'objects' constituted through acts of introspective cognition. 'Man' could then be posited as the 'master and proprietor of nature'.

The origins of the mirror-game of egological reflection can be traced to changes in social relations and cultural formations following the religion and culture wars of the Renaissance and Reformation periods. Among the more important elements of the genealogical constellation of early modernity were the collapse of older theocentric and patriarchal forms of social order and authority; the revival and spread of universalist Roman legal precepts which encouraged the secularization of canon law; the expansion of markets and associated 'market rhetorics' of exchange and citizenship; the associated emergence of proto-capitalist forms of socio-economic practices; changes in the social organization of public space–time frameworks (the emergence of 'public spheres', early modern forms of space–time compression, chronotopical arguments for the centralization of political authority, and so on); the creation of modern scientific procedures; and the growth of the bourgeois state and civil society. By the close of the late Middle Ages the expansion of urbanization, commodification, monetary relations, and global markets had fostered new spatial, cultural, and ideological realignments spreading abstract concepts of personal freedom, individualism, deterritorialized mobility, and civic culture to larger groups and circles beyond the traditional élites and governing circles. The increasing velocity of these changes also impinged upon the nature and status of traditional models of selfhood and collective identity, creating deracinated experiences that actively generalized the 'Cartesian anxiety' beyond the borders of philosophy. The modern 'question of subjectivity' – the paradigm of the modern conception of mind – emerged as a historical phenomenon at the intersection of many streams of social, political, and cultural change (Heller, Sosna and Wellbery, 1986). For example, the constitution of *the private sphere* – autonomous individuality as the constitutive category of philosophical liberalism – is inseparable from the material expansion and differentiation of both the 'public realm' of nation-state institutions and the changing divisions of labour and consumption patterns accompanying the breakdown of the medieval corporate order, the decay of Scholastic-Aristotelian

31

metaphysics with its theocratic conception of divine Being, and the crystallization of bourgeois values and associated cultural forms during the Renaissance. Traces of these changes in social relations, forms of life, and virtual identities are still inscribed in the basic chronotopes of epistemic solitude, the scientific cosmology of corpuscular nature, the development of geometrical perspective, and a wide range of secular ideologies of voluntaristic self-assertion and self-reflection grouped under the rubric of *modernity* (Jay, 1992).

It is the Renaissance period where we witness the full retreat of older dialogical concepts of being-in-the-world. Earlier paradigms of political friendship, sacred communality, and ethical experience were replaced by a conception of self as a visible site *within* consciousness. For the moderns knowledge was refigured as an order of visual representations located in a cognitive subject. The mind becomes an inner theatre of *cognitive representations*:

> No truth is more certain, more independent of all others, and less in need of proof than this, that all that exists for knowledge, and therefore the whole of this world, is only object in relation to subject, perception of a perceiver, in a word, representation . . . All that in any way belongs or can belong to the world is inevitably thus conditioned through the subject, and exists only for the subject. The world is idea.[1]

To summarize a complex history: the invention and dissemination of new paradigms of deterritorialized, detraditionalized identity was both a product of and an intervention within a specific constellation of socio-economic, political, and intellectual changes which laid the foundations of modern bourgeois culture. The outcome of these transformations was the emergence of the constitutive language-games of European epistemology celebrating the autonomy of cognitive consciousness.[2] While controversy will continue about how to best characterize the epoch of early European modernity, most interpreters agree that the two centuries between the Renaissance and the Enlightenment marked a paradigm-shift in relation to the dominant religious cosmology inherited from the philosophical tradition of antiquity and medieval Christianity. The outcome of this revolution was a 'man-centred' vision of nature and reality as a totality of *objects*. This presented a stark contrast to Scholastic images of self and world. In the philosophy of an Aquinas or Thomas of Erfurt, for example, the 'act of intellection' was understood as one mode of created being – a realm of 'rational intellect' or 'intelligent soul' – reflecting a divinely ordained Cosmos. The *ens rationis* was viewed as an integral part of the divine order of *ratio* (*ens reale*) and not as a private 'space' of cognition separated from Being or God. From this perspective the exercise of Reason was primarily a religious vocation externalized in public rituals and sacredotal performances. Human reason contains a spark of 'divine light' guiding the soul beyond its animal existence towards a coherent vision of the hierarchical *Universitas*.

32

If the coming of modernity can be characterized as a revolutionary shift from a theocentric cosmos to an androcentric world-view, then the paradigm case of this change occurs in the philosophy of René Descartes (1596–1650). In his *Discourse on Method* we find traditional ontotheological hierarchies self-consciously levelled in favour of more 'democratic' forms of identity: scientific evidence is separated as an autonomous sphere from faith; 'mind' and 'soul' are cut loose from the divine *cosmos* and conflated to form the 'consciousness' of the thinking ego; intellect is separated from the corporeal body; the indivisible spirit is distinguished from the visible plenum of nature; and the autonomous subject begins to relate to its *cogitationes* as the representational mirror of the world (Rorty, 1979). Not surprisingly the modern patriarchal schema of the 'thinking, *conceiving* mind' divorced from a feminized 'world of *receptive* nature' made its appearance in a number of European languages during the early part of the seventeenth century (for example, in the writings of Suarez, Erasmus, Montaigne, Luther, and Descartes). Protestant and reformed Catholic vocabularies of the mind in the work of Francis Bacon (1561–1626) and Thomas Hobbes (1588–1679) in particular helped to determine a philosophical programme by extending the secular rhetoric of mechanical science to the 'unexplored realms' of internalized conscience. Just as the Galilean scientist maps and objectifies external nature, so the exhaustive mapping of the physical world should be completed by a rigorous cartography of the mechanisms of the mind and the workings of moral conscience. Knowledge of the self could now be secured by 'looking inward' into an autonomous sphere of 'subjective ideas'. The self was disembedded from its traditional sites and projected as an autonomous, all-seeing ego (in French seeing (*voir*) and knowing (*savoir*) became all but synonymous); the language of 'value' was transformed into a calculus of utilities and exchange-values; and social and political order could be troped in contractual-libertarian metaphors as an aggregate of 'acts' centred in 'calculative individuals'. Expressed in another way: visual images of mind and nature helped legitimate the idea that the limits of objectivity coincide with the *a priori* limits of *visual representation*. Finally the seventeenth-century idiom of 'inner ideas and thought' was 'transcendentalized' in the tradition of German idealism from around 1770 to 1830 to construct the 'transcendental ego' as the ground of reason and the constituting consciousness of the world.

While it is well known that the rise of the Western self and the visual metaphysics of modern philosophy have definite religious, literary, and aesthetic antecedents, limitations of space force me to restrict my remarks to the Cartesian celebration of *reflection* as the most distinctive human capacity. The subjective turn is the characteristic move made by Descartes (and in all essentials repeated by Locke, Berkeley, Hume, Kant and the *philosophes* of the Enlightenment) in his quest for absolute certainty within the reflective ego he called the *cogito* or thinking substance – the realm of *clear and distinct (relation of) ideas* ('*omne illud verum est, quod clare et distincte percipitur*' or, in Locke's idiom, the

'*connexion and agreement, or disagreement and repugnancy of our Ideas*'). The rationalist norm of certainty is in turn determined by the methodic ideals of mathematical reason and experimental science which formed the twin pillars of Renaissance humanism and the Scientific Revolution. Descartes essentially fused the radical idea of subjective certainty with the methodic ideal of modern physical science to create not merely a new framework of scientific metaphysics, but what can be called the *videological* sensibility of the modern age. For Descartes' successors the philosophical prototype of introspective privacy remains the *Meditations on First Philosophy* (*Méditationes de Prima Philosophia*, 1641) which proudly enunciates the Archimedean fulcrum of modernity, the *a priori* presence of the *cogito* or *mens*: 'je pense donc je suis' ('I think, therefore I exist') – in the interior of my conscious life I am a being which doubts, understands, conceives, affirms, denies, wills, refuses, imagines and feels. The secular stance of the latter half of the seventeenth and first half of the eighteenth century is condensed in the first sentences of the *Meditations*:

> It is some years since I detected how many were the false beliefs that I had from my earliest youth admitted as true, and how doubtful was everything I had since constructed on this basis; and from that time I was convinced that I must once for all seriously undertake to rid myself of all the opinions which I had formerly accepted, and commence to build anew from the foundation, if I wanted to establish any firm and permanent structure in the sciences . . . Today, then, since very opportunely for the plan I have in view I have delivered my mind from every care [and am happily agitated by no passions] and since I have procured for myself an assured leisure in a peaceable retirement, I shall at last seriously and freely address myself to the general upheaval of all my former opinions.
>
> (*Meditation* I)

Following Descartes, the contemplative 'I' is made the focal point of its cogitations, just as the mercantile *bourgeois* formed the fulcrum of commercial transactions, and the Prince the centre of Renaissance courtly life. Descartes' ultimate aim was to destroy the 'philosophy of the Schools' in order to build a new philosophy 'from the ground upward'. And the spirit of the new metaphysics is animated by a vision of the transcendental subject.

Of course, we should note that this rhetoric of seeing/knowing was not the exclusive property of the historical person, René Descartes. The good Bishop of Cloyne, George Berkeley, was equally adept in its use:

> It is evident to any one who takes a survey of the *objects of human knowledge*, that they are either *ideas* actually imprinted on the senses; or else such as are perceived by attending to the passions and operations of the mind; or lastly, *ideas* formed by the help of memory and imagination

– either compounding, dividing, or barely representing those originally
perceived in the aforesaid ways.

(Principles of Human Knowledge: 1)

In fact a survey of the philosophical literature of the period – through Leibniz,
Malebranche, Spinoza, and beyond – reveals parallel rhetorical tropes and motifs
depicting the disembodied, spectatorial subject and its introspective world. Here
the metaphor of the relationship between seeing and the seen proves irresistible.
To witness the truth the reader, like the author, must actively disengage from
the world, experience the full force of scepticism as a necessary propadeutic to
reviewing the universe in 'objective' terms. 'Ideas' located in the soul then
become the sole 'object' of philosophical concern. Descartes combined the fixity
of the ancient concept of mind with the divinity of theological substance to
produce the paradigmatic modern dualism of mind and body. Of course,
Cartesian *scientia* – what Leibniz would call mathesis *universalis* – still inhabited
a world of autonomous substances. Cartesian method placed its faith in the
mathematical mind as the avant-garde of scientific progress – not empirical
observation and experiment but pure intuition and rational self-determination.
In Dewey's words, Descartes' *pensée* 'is the *nous* of classic tradition forced
inwards because physical science had extruded it from its object', just as Locke's
universe of simple ideas is the Greek 'Idea', 'Form' or 'Species' 'dislodged from
nature and compelled to take refuge in mind' (1958: 229; cf. Rorty, 1979:
44–5). The overdetermined word '*idea*' functions as a visual icon which
dialectically joins and separates the philosophical aspirations of Ancient and
Modern thought.

It is no exaggeration to say that the dualist grammar of Cartesian metaphysics
has influenced the direction of philosophical and social thought to the present
day. Descartes is certainly a revolutionary and a modernist, but only in the
qualified sense of transforming and fusing the rhetorical possibilities of inward-
ness articulated by the classical Platonic and Neoplatonic philosophy of the
Nous and the Scholastic language of substances with the language-games of
modern subjectivity forged by Renaissance humanism. What is new about the
subjective turn of modern thought is the fusion of self-reflection and will. It is
the egological *will to knowledge* as a forceful *envisioning* of the world as a world
subject to androcentric domination that is such a singular feature of modernity.

The mind as a theatre of representations

I see clearly that there is nothing which is easier for me to know
than my mind.

Descartes, *Meditation* II

In traditional histories of philosophy Descartes is usually named as the source of
the philosophy of reflection and, therewith, as the 'father of modern philosophy'

and prototypical thinker of modernity. The theme is a constant one from Schopenhauer to Nietzsche, Husserl and Heidegger. From a logological standpoint, however, Descartes is primarily an innovator in a literary genre or rhetoric of self-reflection. Descartes quite literally wrote the novel of modern philosophy as the mind's heroic quest to *witness* the truth of Being. Not surprisingly we find the *Meditations* structured around the mythological 'hero-journey' with its moments of *separation* (from Scholastic orthodoxy, tradition, common sense, etc.), *initiation* during the course of the six Meditations, and *return* empowered by the salutary principles of the 'new philosophy'. The inner sanctum of the spectatorial ego stands opposed to the 'corporeal' demands of 'natural existence' (itself a legacy of the Augustinian dualism of the word and the flesh, culture and nature). Only by wilfully withdrawing into the theatre of the mind can the rational soul master itself (or its 'passions' in the idiom common to Descartes, Hobbes, Locke, Pascal, Rousseau, and Condillac) and prepare the way for autonomous moral action and the rational domination of nature. The universe is reduced to 'representations' ordered by the will of the mathematical intellect.

Two figures of Cartesian thought are particularly significant in this context: the mind as a theatre of ideas and nature as an extended realm of substances. Both images were drawn from the masculinist rhetoric of the 'new science'. 'Nature' is envisioned as a realm of extended substance, the adversary of civilized selfhood which, like a threatening wilderness, needs to be brought under the jurisdiction of the rational self. Nature's vagrant body is to be disciplined by the combined work of scientific analysis, mathematization, and technical control. The 'mapping' of physical space by means of the rules of Renaissance perspective inspired the eighteenth-century passion for geometricizing landscape to create a 'mindscape' of Reason and Order where the bourgeois Ego might find the signature of its own untrammelled powers. We are to envision the rational subject in control of the passions, the mind dominating the body, spirit 'mastering' recalcitrant matter. Historically the idioms of 'reflection', 'speculation', and 'introspection' are derived from images of the mind as a mirror of nature and theatre of impressions. In the cool gaze of inner reflection, the reflecting Ego turns to spectate the mental contents of its own thinking processes. By means of the faculty of cognition or 'mental seeing' we have access to states of mind whose ideational referents are grasped in the mode of indubitable *self-evidence*. Descartes' claim is that the source of apodictic knowledge lies within the sphere of subjectivity. *Theoria* in modern thought carries the connotations of first-person, present-tensed disinterested spectating, a timeless, placeless, distanced relationship to a world of visible objects. Kant would later raise this imagery to the status of a transcendental principle by describing the '*Ich denke*' as the 'synthetic unity of self-consciousness'. The existence of the '*I-think*' with its mental states and ingressive 'ideas' is a truth upon which the whole of mathematics, metaphysics, and moral philosophy can be reconstructed. The *world-in-the-mind* is uniquely determined as a private realm of mental (re)presentations which the mind observes in acts of reflection. 'Self' and 'mind' become synonyms (Hume

uses the expression 'self' and 'person' as synonyms in questioning the basis of our belief in the identity of 'a self or person', *A Treatise of Human Nature*, 1739, Book I, Part IV, Section VI). The contents of the mind are either reflections of a mechanically determined Euclidean world of causal events or are 'pure ideas' implanted by nature. But the 'eye' cannot itself be another such event or out-come of a causal sequence – or the 'inner' and the 'outer' are turned inside out and we are left either in disabling paradoxes or with transcendental scepticism (as Wittgenstein was later to observe, the eye cannot be depicted as part of 'real' visual space).

In all of these respects the *Cogito* is a precursor of the masculinist phantasy of unlimited freedom deriving its power from unveiling the truth – its radical doubt, a figuration of the modern conception of non-situated, perfectly translucent thought. Behind the *Cogito* lies a moral polemic against the whole Scholastic tradition – the true inquirer should reject tradition and community for the clarity and evidence of personally warranted knowledge. By celebrating the inner liberty of rational thought, Cartesianism popularized the image of nature as a causal system subject to the imperial designs of scientific representation. The immediate effect of this way of talking about the epistemic 'I' was to create a range of aporetic 'solutions' to the 'question' of mind and body: *dualist interaction* in the speculative form of mind and body integration in the pineal gland, *Occasionalism* (associated with the theories of Arnold Geulincx (1625–1669), the *Ontological monism* of Spinoza (1632–1677), the doctrine of '*Preestablished Harmony*' (found in Nicholas Malebranche (1638–1715) and G.W. Leibniz (1646–1716), and finally, the *apriorism* of Kant's critical philosophy of the subject and the transcendentalized Subject in the philosophical idioms of German Idealism). The later polarization of nineteenth-century philosophy into a binary 'debate' between Materialism (*res extensa*) and Idealism (*res cogitans*) is a family relative of Cartesian dualism transposed, so to speak, in the direction of the 'attribute of extension' or the 'attribute of thought' (psycho-physical dualism, parallelism, and monism being later variations of the same binary dichotomy).

Cognition now appears as a type of 'inner contemplation' conducted by a solitary meditator. Reflective thinking occurs in an interior space – a *camera obscura* – created by a voyeuristic disengagement from practical life and everyday language. As Ryle observed: 'The mind can "see" or "look at" its own operations in the "light" given off by themselves. The myth of consciousness is a piece of para-optics' (Ryle, 1949: 153; cf. Heidegger, 1977: 115–54). The theatre of the mind, of course, has no place for other minds or relations with other persons. The mind is a solipsistic monad and the world is quite literally 'in the eye of the beholder'. Cartesian dualism explains why subsequent 'resolu-tions' of the Cartesian mind–body problem were grammatically predetermined in monological directions – theological in Spinoza and Leibniz, transcendental in Kant, dialectical and structural in Hegel and Marx, naturalistic in a range of contemporary epistemologies. Consciousness was construed, in Gilbert Ryle's apt phrase, as a ghost in the machine observing its own shadowy images and

reflections (Ryle, 1949). Some of the leading assumptions of this way of talking can now be formulated.

Subject–object dualism

Specular assumptions are most evident in the metaphysical division between soul and body, mind and nature, thinking and extended substance. The subject is depicted as an autonomous ego rationally monitoring the contents of its inner states, separated from the objective domain of phenomenal reality (which is typically depicted as a 'chunked' quantitative plenum of extended matter or corpuscular material bodies). This radical separation of the human from the natural world became the standard view of European rationalism, but it also entered the taken-for-granted assumptions of many currents of post-Cartesian thought. The relation between thought and its object raises the question: How can a *mental* event get 'inside' a *physical* housing? In what sense is the mind 'outside' the phenomenal world? How does a *mind* come to inhabit a material *body*? The Cartesian framework predisposes us to the view that the 'material housing' is a dispensable part of human action, as though 'spirit', 'mind', and 'meaning' could be excised, so to speak, from the lived-body. Today, of course, we no longer talk of mind and body, 'sensory impressions', and 'impressions of reflection', but of intelligence and intelligent machines, of knowledge systems with their 'hardware' and 'software'. Yet the same image of disembodied rationality is alive and well in the implicit ontology of artificial intelligence (AI) and cognitive science.

Mechanistic causality

If material bodies – everyday physical things with their properties and powers – causally affect subjects then nature can be reduced, without essential remainder, to the law-like causal relations of such substances. Traditionally these were modelled upon the actions and reactions of material objects in a mechanical system. The Newtonian–Galilean idea of mechanistic explanation is generalized to all possible phenomenal worlds: the knowable universe is an orderly system of matter in motion subject to invariable mathematical laws. Or as Descartes claimed: 'Give me extension and motion and I shall construct the universe.' The instrumental rationality that is to some degree native to human action is conflated with the procedural rationality of mathematics and deductive natural philosophy. Since the System of Nature is governed and determined by a rigorous causal nexus, 'Man' ('Mankind') now assumes the universal task of understanding the causal fabric of being in order to become 'master and possessor of nature'.

Philosophy of the subject

Mind–body dualism reinforces a particular 'philosophy of the subject' as a windowless monad 'gazing' out upon a mechanical universe. Thus, for example, Leibniz's monads are *perspectives* upon nature, each *representing* the universe according to a singular point of view. As an apperceptive Ego the cognitive, knowing, rational, calculating subject is a mirror of events occurring in the external world. The mind 'haunts' externality, as Gilbert Ryle observed, but is not 'at home' in the world (it is apposite that Leibniz treats 'rational soul' and 'spirit' as synonyms, e.g. in Leibniz, 1989). In the terms of this description the subject does not integrally belong to the natural world, but appears estranged and alienated from nature as the disengaged site of observation and (re)presentation. The phallocentric subject realizes the promise of reason by observing, recording, mapping, and explaining the mechanical order of nature. Mind is somehow 'non-natural' and active, while nature is passive and receptive. These grammatical antinomies would eventually be condensed in the modern expression, 'the external world'.

Introspective representation

Introspection is naturalized as a privileged faculty of self-reflection. Knowledge of 'external reality' is achieved by the ego reflecting on the internal representations of external events in a simulacral quasi-geometrical inner space (scrutinizing ideas, impressions or sense-data gathered before the mind's eye through associative relations of resemblance, contiguity and causation), sorting these into veridical patterns, and deducing law-like regularities. Knowledge of the external world is depicted as a structure of cognitive representation mirroring external nature. Correspondingly, knowledge of other egos is seen as the mind's analogical act of replicating thought processes which are projected upon the *alter ego*.

Correspondence

Given the specular conception of knowing as *witnessing*, truth is understood as evidential cognition (*con-ception*) warranted by the correspondence of ideas and propositions (mental representations) with the ordered furniture of the world (*adaequatio intellectus et rei – Veritas est adaequatio rei et intellectus*). The Scholastic doctrine of 'correctness' still informs this conception of knowledge – whether in Hobbes' version of procedural rationality exemplified by geometrical reason, in Bacon's inductive rationality, in Newton's programme of non-hypothetical scientific reason, in Descartes' and Locke's more instrumental version of reason, in Hume's ambivalent account of the imaginative imposition of structure and relations to sensory impressions, or, finally, in Kant's revisionary formulation of the mathematical ideal reworked as the basis of transcendental logic.

Specular consciousness

We have invoked the central figure of *speculation* throughout this chapter. Intellectual reflection is an analogue of the representation of objects in a mirror. Knowing is an extension of the mind as *speculum*. Knowledge accrues from the mathematically disciplined practice of the objective gaze. The specular self is a mirror of both its own contents and the objective realm of material things – quantifiable entities extended and lawfully determined in a three-dimensional physical grid. The soul is radically different from the body and the world of natural objects. Once in circulation this specular discourse threads its dualistic filaments into the texture of modern scientific culture: knowledge aspires to a fixed 'point of view', 'objectivity' is interpreted as the truth of an absolute perception, the mind adopts a spectatorial role, it inspects (or introspects) its contents, the eye of the soul turns Nature into objects of reflection, mental events, or representations, the world is envisioned as an alien object, and knowledge is interpreted as a faculty of witnessing, gaining a perspicuous truth and insight into things and their necessary interrelations. Moreover, the very success of this narrative makes further exploration of the actual history and dynamics of embodied perception irrelevant. An abstract fiction of seeing displaces and occludes the concrete hermeneutics of human perception. The 'phenomenology of perception' was thus hived off under the abstract problem of cognitive representation – where it has more or less remained to the present day (cf. Merleau-Ponty, 1962). 'Vision' is abstracted from the concrete activities of human perception and presented as a disengaged act of 'mental seeing'. Perception is treated ahistorically as an invariant faculty of the mind. The commonsense world of concrete experience in its diverse modalities is conflated with the narrow band of spectatorial inspection carried out by a disengaged eye – the 'I' of pure reflection tracking and associating its impressions and 'correspondent ideas' (in Hume's words). The visible is not understood as a texture of practical involvements and figural intentionalities, but as a geometrical order of spatial distance through which the free-floating eye inspects the timeless fabric of the universe. Vision, in other words, assumes some of the central predicates of the Judaic-Christian God – it is troped as an ocularcentric 'view from Nowhere', a secular variant of a God's-Eye View of Things.

The Ego 'extrospects' a world of things and 'introspects' its interior life. We have a perfect instance of what Martin Jay has described as a 'de-eroticizing' of the visual order (1992: 181). Phenomenologists have explained this alienation process as a consequence of the occlusion of the pre-reflective perceptual life-world by means of an abstract ideal of mathematical objectivity (Merleau-Ponty, 1962; Husserl, 1970). In more sociological terms, however, the rise of this disinterested conception of cognition is premissed on the divorce of the arts of seeing and saying flowing from Renaissance perspectivism. With the institution-alization of this 'scopic regime' we begin the long history of the dissociation of the figural and the textual, the image and the word – a process which continues to the present day. In Martin Jay's words:

40

Cartesian perspectivism was thus in league with a scientific worldview that no longer hermeneutically read the world as a divine text, but rather saw it as situated in a mathematically regular spatio-temporal order filled with natural objects that could only be observed from without by the dispassionate eye of the neutral researcher.

(Jay, 1992: 182)

Or as Sutcliffe (1968: 21) notes: 'What characterizes the men of the generation of Descartes is above all the will to dominate, to control events, to eliminate chance and the irrational.' Of course specular ideology is only one element in the process of calculative intervention, manipulation, and control. In fact, once the rhetoric of representation has colonized the critical imagination we are, as Heidegger says, already within the age of the scientific and technological world-view with its mechanistic conception of nature as a totality of exploitable resources.[3]

I have suggested that the profane faith in *visual representation* was particularly crucial to the modern interpretation of nature as a mechanistic order. To bring what is present before the mind's eye is to assay 'ideas' for their evidential truth, to make them secure and available for calculative, instrumental projects, to tie them to the mechanical legality of natural causation. Specular dualism not only provided a framework of concepts but more importantly entered the everyday rhetorics of personal identity. The language-games of Subjects 'gazing out' upon Entities already assumed this structure as a self-evident truth. Consider for example the privileging of 'the physical object' as both a resource and a topic of commonsense thinking in everyday life and in more theoretical enquiries. Yet specular realism also eviscerated the 'concrete object' by construing it as an 'object of thought' rather than a 'corporeal object' inscribed in a web of human activities. It is symptomatic of the success of this ontology that when we provide referents for our concepts and judgements we select these from the domain of physical objects: 'The solidity of the epistemological I, the identity of self-consciousness, is visibly modeled after the unreflected experience of the enduring identical object; even Kant essentially relates it to that experience'.[4]

The return of the repressed

It is important to draw a distinction between reflection (*réflexion* as inner thought or the introspective withdrawal into the self) and dialogical reflexivity. I have suggested that reflection-as-introspection is one essential element of a modern epistemological narrative (a *rhetoric of reflection* with notable forerunners in Western videological culture dating back to Augustine's *Confessions*, Descartes' *Discourse on Method* (1637) and the *Meditations* (1641), Hobbes' *Leviathan* (1651) and Locke's *Essay Concerning Human Understanding* (c. 1680–90)). Reflection is a particular rhetorical figure, whereas reflexivity designates the general dialogical matrix of figuration and discourse. Put somewhat paradoxically:

41

reflexivity designates the conditions of the (im)possibility of reflection – what is presupposed but left unexamined by reflection: libidinal existence, intersubjective language, agonistic discourse, and the social world of institutions.[5]

The insistence of the repressed can be seen in David Hume's ambivalent account of personal consciousness in the first decades of the eighteenth century. Hume addressed the problem of the personal identity in the wake of the deconstruction of religious and metaphysical conceptions of the soul's temporal coherence and identity. Once the 'dogma' of causality had been reduced to a pattern of contingent associations, the putative permanency of the self could also be explained in empiricist terms:

> When I enter most intimately into what I call *myself*, I always stumble
> on some particular perception or other, of heat or cold, light or shade,
> love or hatred, pain or pleasure, I never catch *myself* at any time without
> a perception, and never can observe any thing but the perception.

For Hume the 'self' is not a fixed substance to which the sign 'I' is attached but a shifting sequence of impressions. Consciousness is a 'train' of particular thoughts, sensations, imaginings – a *theatre* of impressions: 'The identity, which we ascribe to the mind of man, is only a fictitious one . . . It cannot, therefore, have a different origin, but must proceed from a like operation of the imagination upon like objects' (*Treatise*, Book I, Section VI). The self is but a bundle of impressions.

However, Hume had elsewhere formulated a different account of the self as a dialogical process of individualization. In elaborating this paradigm Hume resorted to *argumentative* rather than *introspective* metaphors of selfhood:

> I cannot compare the soul more properly to any thing than to a
> republic or commonwealth, in which the several members are united by
> the reciprocal ties of government and subordination, and give rise to
> other persons, who propagate the same republic in the incessant
> changes of its parts. And as the same individual republic may not only
> change its members, but also its laws and constitutions; in like manner
> the same person may vary his character and dispositions, as well as his
> impressions and ideas, without losing his identity . . .
>
> (*Treatise*, Book I, Section VI; for the critique
> of causation see *Treatise*, Book I, Part III)

One of the least noticed aspects of Hume's republican metaphor is its dialogical implications. As a republic is often characterized by social divisions and conflicts, so the self is subject to a range of dialogical conflicts and contradictions. Unlike the soliloquizing *cogito*, Hume's model of consciousness draws upon the social realm of practices and institutions (the commonwealth of others, intersubjective conversation, and moral relations as part of the argumentative

42

fabric of the soul). Hume, of course, did not develop an explicit theory of the dialogical self – his images of the social are those typical of his age and were used unreflexively: the *theatre*, the *republican polity*, the *social contract*, and so on. But the intersubjective note is struck: 'mind' and 'soul' are not inner substances, rather 'mindfulness' derives from the stream of sociality, as both a medium and outcome of civic life. In this suggestive metaphor the sources of consciousness are reflexive and rhetorical rather than reflective and ocular. Reflexivity (the republic of discourse) is, as it were, the repressed dialogical ground of the logic of reflection.

The tension between videocentric and logocentric conceptions of mind and society influenced a wide range of thinkers from Adam Smith and Adam Ferguson to Shaftesbury, Hutcheson, Vico, Hamann, Herder, Rousseau, Kant, Hegel, Marx, Schopenhauer, and Nietzsche. But it was perhaps Nietzsche in the nineteenth century who first combined Hume's insight with an explicit concept of communicative desire. Nietzsche answered Hume's problem in the following way. The 'problem of consciousness' – the dream of becoming conscious of one-self – is rooted in the everyday structures of language; but the 'strength' of self-reflexivity

> always stands in proportion to the *capacity for communication* of a human being (or animal), capacity for communication in turn in proportion to *need for communication* . . . Supposing this observation to be correct, I may then go on to conjecture that *consciousness evolved at all only under the pressure of need for communication*.
>
> (Nietzsche, 1974: §354)

Where Marx grounded consciousness and self-consciousness in the differential evolution of modes of production and their related political and cultural practices, Nietzsche saw that these modes are networks of everyday communication and rhetorical self-interpretations.

With this shift of perspective human reflexivity and its modalities are to be explained as socio-historical and linguistic formations:

> Consciousness is really only a connecting network between man and man – only as such did it have to evolve: the solitary and predatory man would not have needed it. That our actions, thoughts, feelings, movements come into our consciousness – at least a part of them – is the consequence of a fearfully protracted compulsion which lay over man: as the most endangered animal he *required* help, protection, he required his own kind, he had to express his needs, know how to make himself understood – and for all that he first had need of 'consciousness', that is to say, himself needs to 'know' what he lacks, to 'know' how he feels, to 'know' what he is thinking. For, to say it again: man, like every living creature, thinks continually but does not know it;

43

thinking which has become *conscious* is only the smallest part of it, let us say the most superficial part, the worst part – for only this conscious thinking *takes place in words, that is to say in communication-signs,* by which the origin of consciousness reveals itself.

(Nietzsche, 1974: §354)

From a different tradition, and drawing upon a different philosophical terminology, Marx formulated a similar semiotic theory of consciousness:

The act of reproduction itself changes not only the objective conditions – e.g. transforming village into town, the wilderness into agricultural clearings, etc. – but the producers change with it, by the emergence of new qualities, by transforming and developing themselves in production, forming new powers and new conceptions, new modes of intercourse, new needs, new speech.

(Marx, 1964: 93)

For Marx, forms of self-consciousness and individuality are historical products unfolded in the communicative capacities and technologies facilitated by definite modes of production and social relationships. Human beings become 'individualized' in the context of particular historical processes and constraints: 'Man is only individualised (*vereinzelt sich*) through the process of history. He appears originally as a generic being, a tribal being, a herd animal . . . Exchange itself is a major agent of this individualisation. It makes the herd animal superfluous and dissolves it' (Marx, 1964: 96).

By rejecting specular epistemology, Marx followed Hegel in stressing the irreducible dialogical dimension of human subjectivity, identity, and agency. Of course, Hume's disarmingly simple insight into the social-imaginary character of consciousness was familiar to both Kant and Hegel. But Kant only turned to these issues in his late work, *Anthropologie in Pragmatischer Hinsicht* (1798). Hegel, on the other hand, incorporated the social theory of consciousness as one of the central assumptions of the dialectic of conscious reflection and recognition in his *Phenomenology of Spirit* (1807). Indeed the 'collective' nature of mindfulness is arguably the leading assumption of his theory of civil society in the *Philosophy of Right* (1820) and related ethical writings.

Hume's deconstruction of the self is also strikingly similar to the non-egological view of consciousness defended by the existential philosopher Jean-Paul Sartre in *The Transcendence of the Ego* ([1936] 1957) and later developed in *Being and Nothingness* ([1943] 1956). Indeed Hume would have appreciated the examples Sartre uses to illustrate de-centred consciousness: 'When I run after a streetcar, when I look at the time, when I am absorbed in looking at a portrait, no I is present. There is consciousness of the streetcar-having-to-be-caught, etc., and non-positional consciousness of that consciousness' ([1936] 1957: 42). Sartre's reflection continues:

On these occasions I am immersed in the world of objects; they constitute the unity of my consciousness; they present themselves with values, with qualities that attract or repel – but I have disappeared, I am nothing. There is no place for Me at this level of consciousness. This is not accidental, it is not due to a temporary lapse of attention, but to the structure of consciousness itself.

(Sartre, [1936] 1957: 48–9)

Sartre's struggle to escape the dualisms of traditional metaphysics dramatizes the paradoxes of a theory of consciousness suspended between the monologic paradigm of egological reflection and the dialogic paradigm of reflexivity. Sartre's phenomenology of the non-positional *cogito* is motivated by a radical antipathy towards the traditional models of the reflective *cogito* and autonomous will. The 'I' is not an ego-substance, a superadded ground, or agency of the will: 'The Me cannot in fact cope with this spontaneity [of consciousness], for the will is an object which itself is constituted for and by this spontaneity. The will orients itself toward states of consciousness, emotions, or things, but it never turns back upon consciousness'. If the *cogito* is not a substantial 'center', nor a power of the will or self-identical intellect, what then '*is*' *consciousness*? By posing the question of self in substantialist terms, however, we continue to misrepresent the problem by avoiding the difficult truth that the experience of consciousness only arises as a retrospective reification of reflection. Two possibilities remained open: either the acceptance of the communicative origins of consciousness or the retreat into a more radical monologism. Sartre adopted the latter strategy. 'Consciousness' designates a no-thing, 'an impersonal spontaneity' which 'determines its existence at each moment, without anything *before* it being conceivable . . . each moment of our conscious life reveals to us a creation *ex nihilo* . . . of which *we* are not the creators'. This 'lack' or 'nothingness' is presented as an ontological feature of human existence. Consciousness is pure relationality, a pre-linguistic 'directionality' towards Being-in-itself. The Cartesian hiatus between monologic reflection and communicative rationality is retained as an irreducible feature of this conception of subjectivity. Consciousness is a 'monstrous' spontaneity, an 'excessive' creativity, a 'vertiginous freedom' infinitely 'overflowing in its possibilities'. What previous philosophers have misconceived as the inner sphere of the Ego or substantial Self is in reality a construct developed from the infinite flow of conscious life. In this respect Hume's sceptical deconstruction was on the right track: the reality of consciousness appears as a selfless, Heraclitean process of transcendence, an interminable project of self-relationality. It is artificially focused through the gaze of the other. The reflective Ego is simply a holding action that stems this 'scandalous' haemorrhage of identity by projecting an attitude or performing a *role*:

perhaps the essential role of the ego is to mask from consciousness its very spontaneity . . . as if consciousness constituted the ego as a false

45

representation of itself, as if consciousness hypnotized itself with this ego it has constituted, absorbing itself in the ego, as if to make the ego its guardian and its law.

(Sartre, 1984: 230)

In Sartre's purple prose: the self is a fiction masking the nothingness of existence. Where the Cartesian view of the mind as a translucent substance has no account of mendacity other than as cognitive *error*, Sartre's view of the conflict between the Ego and pre-reflective consciousness provides a rationale for mendacity and, more specifically, for the reflexive psychology of 'self-deception', self-imposed illusions, and bad faith. Lying to oneself – the projection of an illusory, substantive Ego – is treated as a structure of necessary dissimulation by which the self avoids the vertiginous freedom of pure consciousness. Only a pre-reflective *cogito* or 'horizonal' conception of consciousness can account for such mundane phenomena as self-deception and narcissism. What is designated by the term 'consciousness' is simply *transcendence*, the interminable flight from *presence*, the infinite negation of positionality ('nihilation', *néantir* or, as it is usually, expressed *nothingness*). Consciousness is the struggle to annihilate the inertial facticity of existence (the condition of being bodily incarnate, historically located, and 'situated' in Being itself). It indexes an active *nihilation* or *lack* (a 'lack of Being'). In more functional terms, consciousness is pre-reflective experience of the world, 'an existential lack . . . which is found at the very heart of consciousness' (Sartre, 1984: 230). Following Husserl's lead, Sartre claims that consciousness posits its objects as 'transcendent' to its own acts. However, by radicalizing Husserl's famous account of the intentional directedness of consciousness Sartre commends a *kenotic* model of consciousness: 'To be for-itself is to lack . . . to determine oneself as not being that of which the existence would be necessary and sufficient to give one a plenary existence . . . the for-itself lacks the *world* . . . the totality of what the for-itself lacks to become in-itself' (*ibid.*: 232). There is thus no 'self' or 'transcendental ego' lurking behind the process of transcendence. We can say nothing of the 'mental content' or 'life of consciousness' *per se* (in a related essay on the ontological status of *images* Sartre criticizes the commonsense view of the image-contents of consciousness as the 'illusion of immanence').

Before addressing this kenotic (from *kenosis*, 'self-emptying') conception of consciousness, we should first return to the Hegelian concept of intentional consciousness as an earlier attempt to avoid the aporetic consequences of Cartesian dualism. Hegel's treatment of the subject begins with the problem of the constitution of identity *within* the field of experience. Hegel would have accepted Hume's suggestion that the 'republican' field of radical consciousness antedates its various modes of reflective and self-reflective awareness. Reflexive consciousness as the reality named by the speculative judgement is the process which immanently tests and examines and, possibly, 'negates' its own earlier modes of experience and 'spiritual' objectifications. Subjectivity understood in

its Romantic sense of absolutely singular and incommunicable experience is, for Hegel, only one mode – and, in its extreme development, an abstract and pathological form – of concrete ethical consciousness. Reflection's pathology is to forget that consciousness is essentially a practical 'testing', 'judging', 'critical' process of world-experience grounded in social and historical categories. Hegel had (re)discovered the profoundly social and historical character of reflexive experience. From this standpoint mind and self-consciousness are reciprocally constituted in the social and political forms and institutions of civil society. Previous monadic conceptions of self and society had ignored the *dialectical* content of consciousness – forgetting the inherence of persons in the common-wealth of reciprocal moral relations and obligations. The Cartesian, Kantian, and Romantic concepts of consciousness elide consciousness's incarnate dynamics as part of an encompassing 'spiritual' process. More generally, theories of self and society which proceed from dualist premises actively distort the role of material embodiment (the 'system of needs'), culture (objective spirit), and history (the teleology of spirit) in human development. Moreover, in Hegel's system these 'hermeneutic mediations' are grasped as active articulations of the life of *Geist* at work in the development of human culture.

In the *Phenomenology*, Hegel depicts reflexivity as the developmental process of self-interpreting and self-negating experience beginning with the aporetic concept of 'sense-certainty' and terminating in Absolute knowledge. Being appears to consciousness in modal, reflexive forms:

> For consciousness is, on the one hand, consciousness of the object, on the other, consciousness of itself; consciousness of what to it is true, and consciousness of its knowledge of that truth. Since both are for the same consciousness, it is itself their comparison; it is the same consciousness that decides and knows whether its knowledge of the object corresponds with this object or not . . . because consciousness has, in general, knowledge of an object, there is already present the distinction that the inherent nature, what the object is in itself, is one thing to consciousness, while knowledge, or the being of the object *for* consciousness, is another moment . . . Should both, when thus compared, not correspond, consciousness seems bound to alter its knowledge, in order to make it fit the object. But in the alteration of the knowledge, the object itself also, in point of fact, is altered; for the knowledge which existed was essentially a knowledge of the object; with change in the knowledge, the object also becomes different, since it belonged essentially to this knowledge.
>
> (Hegel, 1977a: Introduction, 141–2)

Here the subject–object duality of perception and reflection (*Verstand*) is replaced by a subject–object dialectic of Reason (*Vernunft*) as the purposive activity of Spirit. Reflection and self-reflection are processes within an

objective dialectic whose form and content is explicated through philosophical interpretation:

> When the might of union vanishes from the life of men and the antitheses lose their living connection and reciprocity and gain independence, the need of philosophy arises. From this point of view the need is contingent. But with respect to the given dichotomy the need is the necessary attempt to suspend the rigidified opposition between subjectivity and objectivity; to comprehend the achieved existence of the intellectual and real world as a becoming. Its being as a product must be comprehended as a producing.
>
> (Hegel, 1977b: 91)

It is this insight into dialectical mediation and nihilation that links Hegel's theory of reflection with Sartre's non-egological concept of consciousness.

In one respect Sartre radicalized the Hegelian emphasis on 'negation' and 'temporalization'. Consciousness is an index for the 'nihilation' that posits experienceable objects, a 'for-itself' which interminably withdraws from its operative field, a process that can never be frozen into a determinate entity. As pure negativity consciousness is literally self-less, a *no-thing* which sweeps out towards things and through things to Being. 'Not-being', in Sartre's memorable phrase, 'lies coiled in the heart of being, like a worm.' Sartre assumes the absolute transcendence of Being, but unlike Hegel's faith in the objective development of truth, this transcendence has now become an image of the absolute emptiness and infinity of pure consciousness. Consciousness harbours nothing but the truth of nothingness: 'If the vast distances of the stars produce a stupor akin to Pascal's terror, that is because it comes from the transcendent infinity of the transcendental consciousness' (in de Beauvoir, 1992, letter dated 11 October 1939). It is the appearance of human activity that introduces nothingness into the Parmenidean Sphere of Being. Sartre makes the movement of consciousness equiprimordial with the absolute being of the in-itself (analogous to the *res-cogitans* faced with the impenetrable substance of the *res extensa*). We thus have no grounds for modelling consciousness in instrumental, representational, or substantialist terms. For Sartre, then, consciousness is not a secure source of identity (the *cogito* or transcendental Ego) or the medium of the Absolute but the irreducible, non-principle of difference. In denying the immanence of conscious life Sartre reveals the radical difference between the ego and consciousness:

> Let us take a single example. We may say, for instance, that perception of *that* tree is above all an existential phenomenon: to perceive the tree, for consciousness is to surpass the tree toward its own nothing-ness of tree. One must not, of course, see in the word 'surpassing' [*dépassement*] any indication of an *act*. It is merely a mode of existing.

Consciousness exists for-itself beyond that tree as what is *not* that tree; the nihilating connection between reflection and the reflected ensures that consciousness can be for itself only by reflecting itself as being, precisely, nothingness of the world *where* there is that tree. Which means that it is non-thetic consciousness of itself as thetic consciousness *of* that tree; the tree is the transcendent theme of its nihilation. Thus, for example, intuitive knowledge is irruption of the nothing into immanence, which transforms the immanence of the in-itself into the transcendence of the for-itself. Thus the pure event which ensures that Being in its own nothingness makes the world appear as totality of the in-itself transcended by self-nihilating being. Being in the world and being numbed by Nothingness are one and the same thing.

(Sartre, 1984: 179–80)

Even Husserl's quest for a rigorous description of consciousness as a 'science of the transcendental Ego' cannot avoid positivity and the 'illusion of immanence'. Consciousness so to speak has nothing 'in mind'. To believe the contrary is to capitulate to a transcendental form of objectivism. Something, however, is overlooked in this critique of phenomenology. Sartre's solution represents an undialectical inversion of the videological rhetoric which opposes subjective consciousness to the objective world: Consciousness (*l'être-pour-soi*) is the process of nihilation of the being-in-itself (*l'être-en-soi*). Yet this 'resolution' of Cartesian dualism is secured by resorting to a fixed polarity of being-for-itself and being-in-itself, a dualism which preserves the original terms of reflection (subjective consciousness confronting objective Being). By contrast, in Hegel's phenomenology of mind we follow the itinerary of nihilation as a reflexive historical process which dissolves the static antinomies of the epistemic Subject in relation to the pregiven Object (even if Hegel will eventually totalize this conception of consciousness in the terminus of absolute knowledge). Moreover, in the *Phenomenology* Hegel situates the 'nihilation' of the individual subject in the context of a series of different, defeasible forms of consciousness. Here there is at least a premonition of a dialogical conception of reflexivity: 'For consciousness is, on the one hand, consciousness of the object, on the other, consciousness of itself; consciousness of what to it is true, and consciousness of its knowledge of that truth' (1977a: 141).

There is an even more important aspect of reflexivity that Sartre's position neglects. Hegel had understood that radical consciousness presupposes the public infrastructures of communicative reflexivity as it places its own modes of reflection and their objects in question. Moreover, in the *Logic* there is a clear awareness of the linguistic nature of these modes of relatedness. The upshot is that the developmental history of consciousness has irreducible practical, linguistic, and historical dimensions (Hegel was thus particularly interested in historical periods where this kind of questioning self-awareness was directed towards the institutions of the larger society – the breakdown of the ancient

world, the rise of 'the unhappy consciousness' in medieval Christendom, the French Revolution and its aftermath in the modern period). The developmental 'process' of consciousness as a historical process arises from strategies of negation and their meaningful differentiation and recuperation in ever-larger *Gestalten*. What began as a philosophy of Identity – the Cartesian *cogito*, Fichte's self-positing Ego, Kantian autonomy, and Romantic irony – is respecified within a philosophy of interpersonal difference. Indeed the centrepiece of the *Phenomenology of Spirit* is the demonstration that the isolated Ego – the reflective monad – is an abstract construct posited by a particular phase of historical consciousness; and that a richer concept of self must incorporate a fully social or 'cultural' conception of mindfulness based on the mutuality of self-recognition achieved through 'practical–critical activity'. Consciousness can only sublate its own earlier forms through the dialectical conflict with others. Unlike Sartre's pure nihilating consciousness, Hegel's concept of experience incorporates intersubjectivity as its medium and telos: 'Self-consciousness has before it another self-consciousness; it has come outside itself' (1977a: 229); 'the other is also a self-consciousness' (1977a: 231). In general the emergence of self-consciousness appears in the process of intersubjective recognition and the struggle for recognition. Self-consciousness's aspiration to universality, in other words, is only possible in dialogical relations with others ('Each is the mediating term to the other, through which each mediates and unites itself with itself . . . They recognize themselves as mutually recognizing one another' (1977a: 231)). The work of dialogical reflexivity as the sociality of rational self-development functions to negate, appropriate and elevate the one-sided, cognitive paradigm of reflection.

Hegel theorizes reflexive experience as the site of polemical forms of mind in which emergent forms of consciousness and cultural objects appear in the field of cultural life. Unlike abstract reflection, dialogical reflexivity discloses the positive, communicative dynamic in lived experience (allegorized in the famous accounts of 'Self-consciousness' and the Master–Slave dialectic in the *Phenomenology of Spirit*). In fact in ethical and religious awareness, consciousness recognizes its status as 'being-toward-the-world' as already containing a necessary social reference to the dialogical structure of 'being-toward-the-Other'. 'Being-toward-the-world' presupposes a reflexive relation of sociality, a being-*with*-others in a historical situation as a condition for any kind of self-relatedness. Phenomenology is not an introspective science of 'mental contents' encased in a cabinet of immanence, but a dialectical explication of self-reflexive intentionalities. In other words, Hegel had seen that the roots of consciousness lie in embodied, social experience. Reflexive consciousness antedates, grounds and sustains differentiated forms of consciousness such as sensory awareness, the understanding of Law and Force, and noetic modes of self-consciousness embodied in ethical life, religion, and philosophy. The field of consciousness is not a 'nihilation' of Being, but the living medium of the agonistic odyssey of Spirit.

Conclusion: dialogue, difference and the other

I have suggested that one of the constitutive problems of modernity lies in the question of how the self can relate to itself and grasp its own 'being'. Or, in specular terms, how consciousness can turn upon itself as a mirror of certainty. In its most extreme formulation, pure consciousness believes that it can 'know itself' by means of a spiritual reflection unmediated by difference, sociality, or alterity. This is what I have described elsewhere as the videological current of modern European thought (Sandywell, 1996). The philosophy of reflection logically excludes a principled understanding of the place of intersubjectivity and ethical relations in human experience. Thus the *Cogito* has no place for others or the moral and political recognition of the Other. For Sartre, hell is other people. The Other is a malign presence that 'has stolen the world from me'. The gaze of the Other is a prelude to struggle and violence. Sartre had seen that what I designate as 'myself' or 'ego' is a construct derived from my being-in-the-world with Others. But 'the Other', in this conception, is predefined as an alterity which powers the futile project of personal identity. But alterity can also be understood as the living medium of dialogue and institutional life. Indeed reflection is only possible within a relational field of others. The matrix of communal existence precedes every abstract conception of self and world. Alterity, from this point of view, indexes an ethical–dialogical *process* that antedates the ocularcentric universe of traditional metaphysics. It is not merely that we could not know the self without the Other. We could not exist and relate to the world without the prior contexts of alterity. In other words, the 'presence to self' is ontologically indebted to the voices and activities of others. It follows that the possibilities of personal existence and freedom are not something won *from* others, but rather are gifts which emerge from exchange relationships rooted in my obligations towards others. Indeed the 'dialectic' of the self and the Other is even more profoundly ethical. The emergence of selfhood is founded upon the presence of the other *in the self*.

This is where the theme of reflexivity leads beyond the ocularcentric philosophy of subjectivity towards a dialogical conception of the world. The life-and-death struggle depicted by Hegel and Sartre is only one extreme possibility of human encounter, and need not be taken as a paradigm for my dialogical involvements with others. Instead we need to think of the emergence of situated freedoms, of the conditional liberties created and constrained by our relation to others in specific historical situations. I have suggested that the paradoxes of dualism are most vividly revealed in Sartre's non-egological conception of consciousness. Sartre was acutely aware of the need for a 'non-reflective cogito' in establishing the generative 'condition of the possibility' of the Cartesian subject: 'Consciousness is consciousness *of* something. This means that transcendence is the constitutive structure of consciousness; that is, that consciousness is born supported by a being which is not itself' (*Being and Nothingness:* lxxiii). Or expressed in the specular language of Fichte, Schelling and Hegel, every thetic-consciousness is a non-positional consciousness of itself.

The non-thetic consciousness is what makes reflection possible. This is the realm of the pre-reflective or non-reflexive *cogito*:

> In non-reflexive thought, I never encounter the ego, my ego; I encounter that of others. Non-reflexive consciousness is absolutely rid of the ego, which appears only in reflexive consciousness – or rather in reflected consciousness, because reflected consciousness is already a quasi-object for reflexive consciousness. Behind reflected consciousness, like a sort of identity shared by all the states that have come after reflected consciousness, lies an object that we call 'ego'.
>
> (Sartre, 1981: 11)

Yet despite his recognition of the incalcitrant nature of the problem, Sartre could not avoid the schema of Cartesian dualism and its implicit metaphysics of presence. Sartre's phenomenology remained captive to the specular grammar of modernity.[6]

By contrast, a thinker like Heidegger attempted a more radical strategy by 'deconstructing' the metaphysical categories of reflection. Yet Heidegger is also caught in the same ocularcentric grammar. In his 'destruction' of Western metaphysics the visual language-games of European videology proved to be equally resilient and seductive. Heidegger's thought both before and after the 'turn' (*Kehre*) remained inscribed in visual figures and metaphors. Both fundamental ontology and existential philosophy are responses to the same set of logological auspices. What makes reflection – and other practices grounded in reflective idioms – possible is not itself another order of *reflection*, a concrete *structure* or dialectic of the Other, but rather the spacing of dialogical structuration itself, the openness 'that grants a possible letting-appear', a clearing in Being in which entities, including the substance that thinks and theorizes, come to stand:

> Wherever a present being encounters another present being or even only lingers near it – but also where, as with Hegel, one being mirrors itself in another speculatively – there openness already rules, the free region is in play. Only this openness grants in the movement of speculative thinking the passage through what it thinks.
>
> (Heidegger, 1978: 383–4)

Object reference and subjective reflection are derivative ontic modalities of Dasein's ontological *being-in-the-world*, revealed by the concern and resoluteness adopted by Dasein in the face of being-toward-death. Consciousness – whether in its Cartesian, Husserlian, or Sartrean variants – is an index of a site of difference, what Heidegger called the 'ontological difference' between beings and Being:

> light never creates openness. Rather, light presupposes openness. However, the clearing, the open region, is not only free for brightness

and darkness but also for resonance and echo, for sound and the diminishing of sound. The clearing is the open region for everything that becomes present and absent.

(Heidegger, 1978: 384)

But this is also the region of non-being and nothingness that negates all ontic orientations and intentionalities. According to Heidegger this difference has remained unthought in the texts of philosophy from the time of Plato to Nietzsche. Said in another manner – the philosophy of reflection is one articulation of the history of Western metaphysics as a forgetting of the difference between beings and Being (Heidegger, 1982: 64).

To conclude. In explicating one part of the grammar of specular discourse we can see that the epistemic subject turns out to be the creature of a grammatical universe created by speech genres whose canonical prototype is the personal soliloquy. The term 'Cartesian' is shorthand for a complex of cultural attitudes, a unique form of life or, perhaps an *epochal* transformation of the human relation to Being. As an English translator of Descartes observed:

[Descartes] ruins the very notion of the ancient Cosmos. Henceforth, the only spectacle which presents itself to the inquiring eye of man is that of matter agitated by movement according to mathematical laws. God is no longer present in the world and neither is man in the sense that he no longer has an assigned place there.

(Sutcliffe, 1968: 21)

By uncovering the metaphysical presuppositions of this world-view we may delineate the terms of reference for a more radical deconstruction of specular grammar as it informs the project of modernity. This leads to a dialogical conception of existence where knowledge is itself a process of struggle and becoming, 'always-already' implicated in pregiven discursive forms of consciousness and modes of disclosure. Truth claims are thus elaborated from within the conflicting idioms of a dialogized consciousness. At this point we see that the secret history of epistemology lies in a struggle between deep-rooted metaphor systems and their figural, rhetorical, and ideological entailments. As thinkers as diverse as John Dewey, Mikhail Bakhtin, Maurice Merleau-Ponty and Emmanuel Lévinas have pointed out, the soliloquizing ego threatens to darken and occlude the concrete ethics of personal answerability.

Notes

1 Arthur Schopenhauer, *The World as Will and Representation*, Volume 1, p. 3. The claim is even more explicit in the first chapter of Volume II: '*Consciousness* alone is immediately given, hence the basis of philosophy is limited to the facts of consciousness; in other words, philosophy is essentially *idealistic*' (Volume II: 5). A more differentiated analysis of the figural development of reflection would need to distinguish important

variations and themes in the texts of modern philosophy. Why introspective models of reflection and the privatized 'inner soul' should have taken such a hold on seventeenth- and eighteenth-century epistemology and why the language of interiority/exteriority ('inner' and 'outer' experience) was thought to have resolved the problems of classical philosophy are themes for both sociological and logological investigations. In a much more extended treatment of the theme of epistemocracy I have traced the complex semantic field of modern representation ('representationalism') as a discourse in which conceptions of the 'objective world' as 'my representation' could be articulated (see Sandywell, 1996: Vol. 1).

2 The figure of the monadic self created during the transition from feudalism to early capitalism made possible the construction of diverse *forms* of individualism – and their associated codifications in moral, legal, civic, literary, religious, political and philosophical theorizing, the mathematization of physical science and modern technology, the revival of Stoic natural law doctrines, contractual images of the body politic, the emergence of secular vocabularies of 'civil society', 'human rights', and self-aggrandizement, the birth of the modern 'author' and 'rise of the novel', and even, perhaps, intimations of a coming culture of therapeutic subjectivity shaped by explicit 'technologies of the self'. In Anglophone philosophy the ontological problems of subjectivity and objectivity ('how can the mind or consciousness come to know the "outside" world of empirical reality?', 'what is the relationship between my subjective consciousness and the totality of objective being?', and so on) are typically divorced from socio-cultural and historical analysis and transformed into abstract problems in the philosophy of mind and, more especially, into questions of mind–body dualism, personal identity, and 'the egocentric predicament'.

3 Martin Heidegger writes that 'Descartes can be overcome only through the over-coming of that which he himself founded, only through the overcoming of modern, and that means at the same time Western, metaphysics. Overcoming means here, however, the primal asking of the question concerning the meaning, i.e., concerning the realm of the projection or delineation, and thus concerning the truth, of Being – which question simultaneously unveils itself as the question concerning the Being of truth' ('The Age of the World Picture', Appendix 4, in 1977, 140–1); the original thesis concerning the technological determination of Being as picture (*Bild*) – that is, as depicted things – in the modern period can be found in Heidegger's *Holzwege* in the essay 'Die Zeit des Weltbildes' (Frankfurt am Main: Klostermann, 1972); the essay has been translated as 'The Age of the World Picture', in *The Question Concerning Technology and Other Essays* (1977, 115–54); the notion of 'frame' (*Gestell*) and 'enframing' belong to the later writings of Heidegger beginning with 'The Question Concerning Technology' around 1949.

4 Theodor W. Adorno, 'Subject and Object' (1969), in A. Arato and E. Gebhardt, eds, *The Essential Frankfurt School Reader* (Oxford: Basil Blackwell, 1978), 509.

5 I explore this contrast between reflection and reflexivity at length in *Logological Investigations* (1996), Vol. 1.

6 It is well known that Sartre uncritically followed the French translator of Heidegger, Henry Corbin, in translating the term *Dasein* as *la réalité humaine*. The mistranslation '*human reality*' functions to inscribe Heidegger's *Daseinanalytik* into the tradition of Cartesian humanist rationalism. Heidegger comments on this translation in the *Heraclitus Seminar* (with Eugen Fink): 'In French, Dasein is translated by *être-là* [being-there], for example by Sartre. But with this, everything that was gained as a new position in *Being and Time* is lost. Are humans there like a chair is there?' (1993: 126). See R.D. Cumming, *Phenomenology and Deconstruction*, Vol. 1 (Chicago: University of Chicago Press, 1991), 62, 72, 113.

References

Bakhtin, M. (1981) *The Dialogic Imagination*. Austin, Texas: University of Texas Press.

Bakhtin, M. (1986) *Speech Genres and Other Late Essays*. Austin: University of Texas Press.

de Beauvoir, S. ed. (1992) *Witness to My Life. The Letters of Jean-Paul Sartre to Simone de Beauvoir 1926–1939*. London: Hamish Hamilton.

Berkeley, G. (1962) *The Principles of Human Knowledge and Three Dialogues between Hylas and Philonous*. London: Fontana Press.

Descartes, R. (1911) *The Philosophical Works of Descartes*, trans. E.S. Haldane and G.R.T. Ross. Cambridge: Cambridge University Press.

Descartes, R. (1968) *Discourse on Method and the Meditations*. Harmondsworth: Penguin.

Descartes, R. (1985) *The Philosophical Writings of Descartes*, ed. and trans. J. Cottingham, R. Stoothoff and D. Murdoch. Cambridge: Cambridge University Press.

Dewey, J. (1958) *Experience and Nature*. New York: Dover Publications.

Hegel, G.W.F. (1977a) *The Phenomenology of Spirit*. New York: Harper Torchbooks.

Hegel, G.W.F. (1977b) *The Difference Between Fichte's and Schelling's System of Philosophy*. Albany: State University of New York Press.

Heidegger, M. (1962) *Being and Time*. Oxford: Blackwell.

Heidegger, M. (1977) *The Question Concerning Technology and Other Essays*. New York: Harper and Row.

Heidegger, M. (1978) *Basic Writings*. London: Routledge and Kegan Paul.

Heidegger, M. (1982) *The Basic Problems of Phenomenology*. Bloomington, Ind.: Indiana University Press.

Heidegger, M. and E. Fink (1993) *Heraclitus Seminar*. Evanston, Ill.: Northwestern University Press.

Heller, T.C., Sosna, M. and Wellbery, D.E. eds (1986) *Reconstructing Individualism: Autonomy, Individuality, and the Self in Western Thought*. Stanford: Stanford University Press.

Husserl, E. (1931) *Ideas: General Introduction to Pure Phenomenology*, trans. W.R. Boyce. New York: Macmillan.

Husserl, E. (1960) *Cartesian Meditations*. The Hague: Martinus Nijhoff.

Husserl, E. (1970) *The Crisis of European Science and Transcendental Phenomenology: An Introduction to Phenomenological Philosophy*. Evanston, Ill.: Northwestern University Press.

Jay, M. (1992) 'Scopic Regimes of Modernity', in S. Lash, and J. Friedman eds, *Modernity and Identity*. Oxford: Basil Blackwell.

Leibniz, G.W. (1989) *G.W. Leibniz. Philosophical Essays*. Indianapolis and Cambridge: Hackett Publishing Company.

Locke, J. (1975) *Essay Concerning Human Understanding*. Oxford: Clarendon Press.

Martin, L., Gutman H. and Hutton, P. eds (1988) *Technologies of the Self: A Seminar with Michel Foucault*, Amherst: University of Massachusetts.

Marx, K. (1964) *Pre-Capitalist Economic Formations*. London: Lawrence and Wishart.

Merleau-Ponty, M. (1962) *The Phenomenology of Perception*. London: Routledge and Kegan Paul.

Nietzsche, F. (1974) *The Gay Science*. New York: Random House.

Rorty, R. (1979) *Philosophy and the Mirror of Nature*. Princeton, N.J.: Princeton University Press.

Ryle, G. (1949) *The Concept of Mind*. London: Hutchinson (reprinted Harmondsworth: Penguin, 1990).

Sandywell, B. (1996) *Logological Investigations*, 3 volumes. London: Routledge.

Sartre, J.-P. ([1936] 1957) *La Transcendance de l'égo*. Paris: Vrin (trans. *The Transcendence of the Ego*. New York: Noonday Press).

Sartre, J.-P. ([1939] 1962) *Esquisse d'une théorie des émotions*. Paris: Hermann (trans. *Sketch for a Theory of the Emotions*. London: Methuen).

Sartre, J.-P. ([1943] 1956) *L'Etre et le Néant*. Paris: Gallimard (*Being and Nothingness. An Essay on Phenomenological Ontology*, trans. Hazel E. Barnes. London: Methuen).

Sartre, J.-P. (1981) 'Interview with Jean-Paul Sartre', in P.A. Schilpp, ed., *The Philosophy of Jean-Paul Sartre*. La Salle, Ill.: Open Court.

Sartre, J.-P. (1984) *War Diaries*. London: Verso.

Schopenhauer, A. (1958) *The World as Will and Representation*, 2 volumes. New York: Dover Publications.

Schopenhauer, A. (1995) *The World as Will and Idea* (abridged in one volume). London: J.M. Dent/Everyman.

Sutcliffe, F.E. (1968) 'Introduction' to Descartes, *Discourse on Method and the Meditations*. Harmondsworth: Penguin.

3

BAKHTIN AND THE
METAPHORICS OF PERCEPTION

Michael Gardiner

The human gaze has the power of conferring value on things; but
it makes them cost more too.

Ludwig Wittgenstein, *Culture and Value*

Introduction

In a recent interview, Emmanuel Levinas suggests that 'there is a dominance in
the look, a technical dominance' (1991: 16). In so far as the organization of
visuality in the modern era is subordinated to a project of mastery, as defined by
the intentional, knowing subject, vision is inherently destructive of 'otherness'.
As such, it must be replaced by a relation of obligation and responsibility, one
that is rooted in the spoken word and touch rather than sight. Levinas's stance
here can be said to typify an increasingly influential position in twentieth-
century thought that has argued for a strong correlation between vision and
the reifying and domineering aspects of modernity, which is felt to denigrate
the bodily, affective, and intersubjective qualities of human life. Many leading
feminists have taken this line of inquiry one step further, asserting that 'the
logic of the visual is a male logic' (Keller and Grontkowski, 1983: 207). The
hierarchization of the senses in Western culture since the early modern period
and the increasing reliance on sight as the foundation of objectivity and certitude
has facilitated a detached 'will to knowledge' – in essence, vision is the most
'phallic' of the human senses.

Visualization, understood as the perceptual strategy and technique of
modernity *par excellence*, would therefore seem to involve an irreducible element
of domination, a diagnosis typically accompanied by a call to 'de-throne' sight
as a privileged sense. More recently, however, it has been argued that such
manifestations of 'ocularphobia' effectively negate what is valuable or enriching
about the human capacity for sight because they merely reverse the existing
hierarchy that favours vision over other senses. Jonathan Crary, for instance,
reminds us that while specific perceptual regimes in modernity have sought to
'insure the formation of a homogeneous, unified, and fully legible space', errant
and non-oppressive forms of visuality continue to persist at the margins (1988:

33). These haunt the dominant visual regime like a guilty conscience, and have undermined the consummation of a totally ordered and regulated time/ space, the 'Cosmopolis' envisaged by such seventeenth-century philosophers as Descartes and Leibniz (Toulmin, 1990). Hence, we can locate a number of incommensurate perceptual systems operating in Western societies, and Cartesian perspectivalism, which is frequently identified as the archetypal visual register of modernity, is only the most familiar scopic regime (see Jay, 1993b; Rose, 1986).

There have, in short, been some tentative efforts to go beyond the dogmatically anti-visualist position sketched above and to develop a more nuanced and holistic post-ocularcentric paradigm. Such an approach does not seek to remove sight from the picture, so to speak, but to integrate vision into a non-hierarchical and open-ended perceptual regime, involving not just our 'actual' bodily senses but our metaphorical extension of these into a diversity of human domains and endeavours. This chapter will explore the tropes of perception utilized by the Russian thinker Mikhail Bakhtin as a compelling example of just such a post-ocularcentric approach. Given Bakhtin's current popularity in academe, it is curious that his contribution to the existing debate over ocularcentrism has not received the attention it deserves. Perhaps this is in part because Bakhtin would appear to be an unambiguously anti-visualist thinker. In most commentaries on his work, the metaphorical resonance of Bakhtin's ideas has been identified strongly with such overtly auditory concepts as 'polyphony', the 'voice', or 'heteroglossia'. Yet a careful consideration of his entire oeuvre reveals that Bakhtin utilizes a shifting and nuanced system of perceptual metaphors over a range of texts, which subverts any attempt to construct a rigid valuational hierarchy of sensory experience. At the same time, Bakhtin does not reject the visual mode *tout court*. Indeed, he implies that sight can be understood as part of a mutually enriching encounter between self and other, or what Jay terms 'dialogic specularity' (1993a: 169).

It is equally apparent that Bakhtin himself does not directly articulate such a full-blown post-Cartesian paradigm. None the less, it is possible to scrutinize his writings for fragmentary insights into a different way of conceptualizing the perceptual basis of our ideas about ontology, epistemology and so forth. In this respect, I argue that we can ascertain three broad phases in Bakhtin's writings: (1) his earliest work, in which he adumbrates a phenomenology of vision; (2) Bakhtin's writings of the late 1920s and early 1930s, as well as his post-war texts on the human sciences, wherein verbal and linguistic metaphors are foregrounded; and (3) *Rabelais and His World*, written in the period 1938–41, which is mainly concerned with the 'carnivalesque' and the senses of touch, smell and taste. In what follows, I shall explicate the metaphorics of perception in each phase of Bakhtin's work. Despite the elliptical nature of Bakhtin's comments on this topic, I hope to demonstrate that his ideas can aid in the development of what Marcuse once called a 'new sensibility' (1969: 30).

58

Otherness and the 'excess of seeing'

During the years 1919–26, Bakhtin produced a number of labyrinthine and fragmentary texts that remained unpublished in the Soviet Union until the late 1970s. In this richly allusive and complex body of work, Bakhtin attempts to theorize the cognitive, ethical and aesthetic qualities of the relationship between self and other, an enquiry that ultimately utilizes an elaborate metaphorics of vision. A significant feature of Bakhtin's approach in these formative writings involves his reliance on a sophisticated philosophical anthropology, which bears more than a passing affinity with the existentialist phenomenology of Heidegger, Merleau-Ponty and Sartre (Gardiner, 1998). He suggests that a key feature of the human condition is that we are literally 'thrown' into an external world of brute facticity, consisting of objects and events that confront us and demand some sort of response. In reacting to this pure 'givenness', each of us is animated by a dynamic impulse to 'sculpt' or transform the discrete elements of this object-world into coherent and meaningful wholes, and we are forced to make certain choices and value-judgements with respect to our Being-in-the-world. We are compelled to produce meaning in a world lacking intrinsic value, to transform this proffered 'givenness' into meaningfulness. In essence, for Bakhtin our existential situation is not only temporal and spatial but ultimately *axiological* as well (Pechey, 1993). Hence, the 'world-as-event' does not simply consist of finished, static things; it exists *in potentia*, and not *in statu quo*. This highlights the key error of positivism, which relies on a rigid distinction between a world of inert matter on the one hand, and a disembodied human consciousness on the other, in which the former is passively reflected or registered in the latter. For Bakhtin, by contrast, the world confronts each of us as an ongoing project, as a 'task to be accomplished', in which 'the moments of what-is-given and what-is-to-be-achieved, of what-is and what-ought-to-be, of being and value, are inseparable' (1993: 32). The object-world therefore only acquires a wholeness, a 'determinateness', through our active and concrete relation to it. As such, we must understand ourselves as 'embodied' or incarnate beings that exist in a particular time and place, one that is experienced by no other individual in exactly the same way. If we treat this object-world only as pure givenness, then it appears as something alien and hostile, because it is external to the 'event of being'.

However, in engaging with the world as embodied beings, our ability to attribute meaning and significance solely through our thoughts, deeds and perceptions is subject to certain limitations, which is especially true with respect to the 'imagining' of our own selfhood. Bakhtin's argument here is that just as we are impelled to attribute meaning to the object-world around us, we feel a need to envisage *ourselves* as coherent and meaningful entities. However, from the vantage-point of our own inner life and incarnate existence, we are unable to develop a multi-faceted, holistic image of our embodied self. That is, from within our own purview and subjective outlook, or what he calls the 'I-for myself', we can only perceive and experience the world as a disjointed,

chaotic flow of episodic events and fragmentary sensations. We are prevented from transforming these experiences into a coherent image of the self because, in a very real and profound sense, we exist on the 'border' between our inner subjective life and the external world, as mediated by our perceptual apparatus. Our visual-sensory field is, for instance, tightly constrained by our biological inheritance as upright, bipedal hominids with a binocular, forward-projecting mode of sight. We are therefore incapable of envisioning our outward appearance, and of comprehending our location within what he calls the 'plastic-pictorial world' (the material environment of objects, events, and other selves). One result of this, Bakhtin speculates, is that our inner life and our outer existence lie on different *axiological planes*, and these cannot be brought into alignment purely through our own efforts or thoughts. We cannot adopt an 'emotional–volitional attitude' with respect to ourselves; rather, from a position of pure inwardness, we can only be concerned with self-preservation. To be able to conceptualize ourselves as cohesive meaningful wholes, which is integral to the process of individuation and self-understanding, we require an additional, external perspective in order to supplement our own blinkered and constricted standpoint. This is because the other exists in a relation of externality or 'exotopy' to us, in a manner that transcends our own existential horizon:

> In order to vivify my own outward image and make it a part of a concretely viewable whole, the entire architectonic of the world of my imagining must be radically restructured by introducing a totally new actor into it. This new actor that restructures the architectonic consists in my outward image being affirmed and founded in emotional and volitional terms *out* of the other and *for* the other human being.
>
> (Bakhtin, 1990: 30–1)

Therefore, to envision ourselves as a complete and meaningful entity, and to understand the mutually constitutive nature of our relationship with others and the world at large, one must 'look at oneself through the eyes of another' (1990: 15). On the other hand, a complete fusion with the other (what Bakhtin terms 'pure co-experiencing'), of the sort advocated by such *Verstehen* theorists as Dilthey or Winch, is undesirable, and, strictly speaking at any rate, impossible (Shields, 1996). In taking this position, Bakhtin is adamant that we cannot abandon arbitrarily our own socio-cultural position and engage in a Gadamerian 'fusion of horizons'; rather, we need to maintain a 'radical difference' between self and other, but in a manner that does not preclude a rich intersubjective life. Since each of us occupies a unique time/space, we can see and experience things others cannot, within our sphere of self-activity. But the reverse is equally true, in that the other can visualize and apprehend things that we are manifestly unable to. Hence, the other has a 'surplus of seeing' with regard to ourselves, and vice versa, thereby facilitating what Merleau-Ponty (1968) has called the 'reversibility of perspectives'.

the excess of my seeing must 'fill in' the horizon of the other human being who is being contemplated, must render his horizon complete, without at the same time forfeiting his distinctiveness. I must emphasize or project myself into this other human being, see his world axiologically from within him as *he* sees this world; I must put myself in his place and then, after returning to my own place, 'fill in' his horizon through that excess of seeing which opens out from this, my own, place outside him.
(Bakhtin, 1990: 25)

Using another visual metaphor, Bakhtin argues that like the moon, the self can only shine because of the 'borrowed axiological light of *otherness*' (1990: 134). The dialogical character of the self–other encounter, however, is not simply a matter of the exchange of interlocking, reciprocal gazes. For Bakhtin, we are jointly interwoven into a shared universe in an even more primordial sense, through the bonds of everyday sociality and our material connection to others and to the world at large. The intercorporeal encounter with the other forces us to abandon our inclination towards an egological narcissism, and thereby connects us to the material world and other selves – a process of 'intertwining' within what Merleau-Ponty describes as the 'universal flesh' of the world. In so doing, Bakhtin implies that it is possible to 'decenter' the rational, self-sufficient *cogito* of Western metaphysics, and to call into question the whole problematic of what has come to be known as 'subject-centred reason'. Using language that is strongly reminiscent of Levinas, but that may not endear him to certain strains of feminist thought, Bakhtin suggests that we need to cultivate a fundamental openness, a 'feminine passivity', with respect to the other, for only then can we fully expose ourselves to the nature of Being. Only the other human being is 'experienced by me as connatural with the outside world and thus can be woven into that world' (1990: 40).

To summarize, in so far as each of us occupies a unique position in time/space, the self–other relation is dialogically enriching, so long as the reciprocity of perspectives is successfully maintained. Hence, the mutual recognition of selves is, in a very real sense, 'built into' our corporeal being and the modes of visualization that we habitually utilize. Extrapolating from this insight, Bakhtin further asserts that 'unified truth' can only be expressed adequately through a plurality of overlapping, incarnated viewpoints, rather than through the monocular, unidimensional gaze of a disembodied observer. When 'one and the same object is contemplated from different points of a unique space by several different persons', he suggests, it 'occupies different places and is differently presented within the architectonic whole constituted by the field of vision of these different persons observing it' (1993: 63). For Bakhtin, in other words, this 'architectonic whole' is ideally constituted by a multiplicity of standpoints. By conceptualizing visuality as an expanded, multidimensional field that incorporates a diversity of unique subject-positions, Bakhtin disrupts the homogeneous scopic domain of Cartesian perspectivalism, and thereby effects

61

what Rose has called a 'radical othering of vision' (1988: 119). Indeed, Bakhtin directly warns us that if the 'event is transposed in all its constituents to the unitary plane of a single consciousness, and it is within this single consciousness that the event is to be understood and deduced in all its constituents', the result is impoverishment and domination rather than mutual enrichment (1990: 87). By reducing the concrete, living world to the perspective of a single viewpoint, the density of lived experience and the particularity of each individual's embodied perspective is transformed into a reified abstraction. What is lost in this objectifying transcription, so typical of scientific rationalism, is an adequate understanding of the primordial sociality that binds together self and other in the context of the everyday life-world. Therefore, the integrity of the 'living and in principle non-merging participants of the event' is subsumed under a formalized, metaphysical system projected by a monocular consciousness, which denigrates or expunges what it cannot totally assimilate. 'All of modern philosophy', Bakhtin asserts, 'sprang from rationalism and is thoroughly permeated by the prejudice of rationalism that only the logical is clear and rational, while, on the contrary, it is elemental and blind outside the bounds of an answerable consciousness' (1993: 29). This purely cognitive relation to the other is what Bakhtin terms the error of 'epistemologism', in which abstract, dispassionate contemplation from afar supplants active participation within a shared horizon of value, meaning and intercorporeality. Bakhtin is adamant that a properly ethical relation to the other requires a 'loving and value-positing consciousness', and not a disinterested, objectifying gaze projected from the omniscient vantage point of an isolated ego – what Donna Haraway has characterized as the 'standpoint of the master, the Man, the One God, whose Eye produces, appropriates and orders all difference' (1995: 184). What Bakhtin terms 'cognitive-discursive thought' is therefore nonethical and domineering, because it simply cannot tolerate 'another consciousness outside itself, cannot enter into relations with another consciousness, one that is autonomous and distinct from it. [This] unitary consciousness creates and forms any matter it deals with solely as an object' (1990: 88–9).

In adopting this stance, Bakhtin upholds the general notion that it is possible to have a 'healthy' visual ontology, one that has utopian and affirmative resonances, which can facilitate and encourage a relation of openness, reciprocity, and mutual enrichment between self and other, and between ourselves and the world. As such, he refuses the widespread tendency on the part of poststructuralists and postmodernists to equate vision as such with domination and the 'will to power'. Bakhtin demonstrates convincingly that vision is not locked inextricably into a subject–object ontology, and that specularity is not necessarily a source of suspicion and paranoia. At the same time, he draws our attention to the inherent dangers of a disembodied, monocular gaze, which surveys the world from a lofty 'God's-eye' position and reduces a multiplicity of incarnate perspectives to quantifiable elements within a formalized, metaphysical system, as encouraged by the 'cult of unified and exclusive reason'. The latter, Bakhtin argues, is

co-extensive with a 'culture of essential and inescapable solitude' that is peculiar to modernity. However, for reasons that are less than clear, in his subsequent writings of the late-1920s Bakhtin challenges the monadistic solipsism of Cartesianism by focusing primarily on the voice and other oral metaphors. Yet even when he privileges the role of visuality in the constitution of intersubjective relations, Bakhtin acknowledges the importance of other embodied senses, especially tactility, and is hence open to the possibility of different perceptual and metaphorical constellations.

Dialogism and metaphor

While there clearly exists a phenomenology of vision in his early texts, it is indisputable that the dominant metaphorical emphasis of Bakhtin's best-known work can be identified with overtly auditory phenomena. Bakhtin, after all, once wrote that 'I hear *voices* in everything and the dialogic relations among them' (1986: 169). This fact is often celebrated as an antidote to the ocularcentric bias of recent social and cultural thought. 'The Bakhtinian predilection for aural and musical metaphors', as Robert Stam has remarked, signals an 'overall shift in priority from the visually predominant logical space of modernity [to] a post-modern space of the vocal[,] all as ways of restoring voice to the silenced' (1991: 256). Stam perhaps overstates his case, since, as I have tried to demonstrate here, Bakhtin utilizes a welter of different perceptual constellations at particular junctures of his intellectual career. Yet it is evident that Bakhtin's writings after the mid-1920s, with the notable exception of *Rabelais and His World*, are marked by a transition from the phenomenological orientation of his formative efforts to a more manifestly hermeneutical and 'textualist' one (Gardiner, 1992: 99–140). Hermeneutics views nomothetic science with extreme scepticism, mainly because the latter identifies neutral, detached observation as the only possible guarantor of 'objective truth'. By contrast, the hermeneutical approach stresses the creative interpretation of words and texts and the active role played by the knower. The goal is not objective explanation or neutral description, but rather a sympathetic engagement with the author of a text, utterance or action and the wider socio-cultural context within which these phenomena occur, in which a 'discerning ear' (both 'real' and metaphorical) is essential. And, moreover, this active process of interpretation is metaphorically associated with speaking and listening, as befits a discipline with strong historical roots in the tradition of biblical exegesis and the Hebraic stress on the sanctity of the word (Jay, 1993b). It is worth noting that the etymological derivation of 'hermeneutics' can be traced to both the Oracle of Delphi, the utterer of prophecies, and the mythical figure of Hermes, the wing-footed creature whose task was to transmit messages between the gods of Olympus and human-kind. Reading, although seemingly a visual experience, is considered to be an extension of orality by most hermeneutical theorists (Palmer, 1969: 17). Orality and the spoken word are felt to have a primordial richness, evocative power and

directness that are all but lost in the historical transition to modernity, a culture that is clearly dominated by the visual. Whereas scientific rationalism relies on the objectifying gaze of detachment and control, and is hence characterized by what Bakhtin terms a 'grey, monolithic seriousness' operating at the behest of powerful social interests, hermeneutics places its faith in an ongoing process of intersubjective communication that is oriented towards mutual recognition and understanding in the proximate setting of everyday sociality. Indeed, at one point Bakhtin suggests that 'ears are antiofficial', because hearing is sensitive to even the most subtle qualities of what Barthes once termed the 'grain of the voice' (intonation, accent, and so forth), and is thereby attuned to the intimate, personalistic contexts of human interaction. By implication, vision, at least when it is subordinated to the logic of objective science, is a distancing, homogenizing, and reifying sensory mode, one that is largely indifferent to the particularity of the other and the nuances of context. In short, hearing is held by Bakhtin (at least in his dialogical phase) to be less obtrusive, penetrating and objectifying than sight, although some theorists have disputed this valuation (see Serres, 1989).

In nuce, the unabashedly 'phonocentric' approach of hermeneutics seeks to replace the rigid subject–object ontology of the nomothetical sciences with a 'subject–subject' one, the latter rooted in an exemplar of unrestricted dialogue between active and engaged interlocutors (Godzich, 1991). 'In the process of dialogic communication', as Bakhtin puts it, 'the object is transformed into the subject (the other's I)' (1986: 145). Within any genuinely hermeneutical encounter, we should not confront the other as a *thing*, as a raw material to be objectified and manipulated in accordance with an egocentric self-interest; rather, we relate to the other as a unique and singular being, in which a dialogical relation is reciprocal and mutually enriching. In Bakhtin's metaphorical universe, dialogue is integral to human life and culture, an essential component of our Being-in-the-world: 'the immense, boundless world of others' words constitute a primary fact of human consciousness and human life'. Dialogical exchange allows us to 'burst into the circle of life, to become one among other people' (1986: 147, 143).

Accordingly, it is not surprising that Bakhtin's best-known works are replete with metaphors associated with the human capacity for speaking and hearing, a fact that has not escaped the attention of his many readers. The archetypal document in Bakhtin's dialogical phase is *Problems of Dostoevsky's Poetics*, and this study will constitute the main point of reference in the ensuing discussion. I wish to concentrate on the following observation: that Bakhtin's promotion of a 'decentred' vision in his earlier writings is transcribed into the terminology of dialogism. More precisely, a concatenation of intersecting visual fields emanating from a series of incarnate selves is conceptualized instead as a polyphony of multiple, overlapping *voices*. Likewise, the objectifying gaze of the detached ego that Bakhtin critiques in his formative studies is rendered as the authorial word, which is capable only of monologue and not authentic dialogue. As is

well-known, Bakhtin opines that Dostoevsky was best able to capture this quality of polyphony within the novel form. Dostoevsky's novels contain a plurality of unmerged consciousnesses, a complex admixture of fully 'valid voices' which are never subordinated to an omniscient authorial voice. The word of each novelistic character in Dostoevsky's writings 'possesses extraordinary independence in the structure of the work; it sounds, as it were, *alongside* the author's word and with the full and equally valid voices of other characters' (Bakhtin, 1984a: 7). The result is an endless clash of 'unmerged souls', or what Bakhtin refers to as the 'great dialogue'.

In constructing such a genuine polyphony, argues Bakhtin, the author's affirmation of a character's absolute and inviolable right to be treated as a subject and not as an object must comprise the guiding aesthetic principle. But it equally constitutes the foundation of a distinct ethical position and a fully fledged dialogical world-view (Gardiner, 1996). For Bakhtin, Dostoevsky's utilization of polyphony as a pivotal artistic device is the centrepiece of a dialogical principle that manages to subvert the abstract, subject-centred Reason that dominates modern society and culture. The latter phenomenon Bakhtin gives the name 'monologism', which characterizes a situation wherein the matrix of values, signifying practices, and creative impulses that constitute the living reality of language and socio-cultural life are subordinated to the dictates of a single, unified consciousness or perspective. Whatever cannot be subsumed under this transcendental, metaphysical consciousness is regarded as extraneous or super-fluous. In other words, monologism denies the 'equal rights of consciousnesses *vis-à-vis* truth' (1984a: 285), thereby reducing otherness to sameness. Significantly, Bakhtin argues that this monologic principle, which permeates all spheres within society in the modern era, was promulgated by the scientific rationalism that has held sway in Western societies since the Enlightenment. Monologism, writes Bakhtin, 'denies the existence outside itself of another consciousness with equal rights and equal responsibilities, another *I* with equal rights (*thou*)' (1984a: 292).

By so undermining the dialogical principle, Bakhtin claims that monologism subordinates unrestricted dialogue to the dictates of a monolithic world-view that is ultimately controlled by a unitary, transcendental consciousness. Not surprisingly, he has scant regard for the monological position. Aesthetically, he feels that monologism fails to represent adequately the heterodox discursive practices that exist in the social world, as well as the intrinsically responsive character of all human language. Ethically, of course, monologism objectifies and quantifies the human being, and it denies the dialogical well-spring of our selfhood. On this latter point, we can also identify a strong parallel between Bakhtin's earlier and later work, in that he takes the insights developed in his initial phenomenological phase (which rely on such concepts of carnality and visuality) and invests them with the metaphors of dialogism. His essential point is that a self-sufficient, Cartesian *cogito* cannot possibly exist, except as a mythical construct projected by egological, idealist philosophies. This is because the very

process of acquiring self-consciousness and a sense of distinctiveness *vis-à-vis* others is something that is utterly dependent upon our verbal interaction with another 'I'. A total separation from the other and the aspiration to pure self-sufficiency does not lead to mastery or ennoblement à la Robinson Crusoe, but can only result in the loss of self, a figurative death: '*To be means to communicate. Absolute death (non-being) is the state of being unheard, unrecognized*' (Bakhtin, 1984a: 287). The presence of the other in myself must be recognized and respected; only then can we gain an awareness of a self that is not egocentric but profoundly social and intersubjective. Even the most rigidly monologic voice is premissed ultimately upon a 'firm social support, presupposes a *we*' (1984a: 280–1). The solitary voice, which does not anticipate or even attempt to solicit an answer, is for Bakhtin merely a dogmatic postulate, an arrogant conceit. 'No Nirvana is possible for a *single* consciousness', asserts Bakhtin. 'Consciousness is in essence multiple' (1984a: 288). In order to free ourselves from 'the burden of being the only *I* (*I-for-myself*) in the world' (1986: 147), we must realize that every aspect of consciousness and every practice a subject engages in is constituted dialogically, through the ebb and flow of a multitude of continuous and inherently responsive communicative acts. Hence, it is important to realize that, for Bakhtin, the metaphorical resonance of dialogue is not only textual: it reaches out to embrace the social and natural worlds as a whole, and it also implies a distinct ethical stance, as the following passage indicates:

> Life by its very nature is dialogic. To live means to participate in dialogue: to ask questions, to heed, to respond, to agree, and so forth. In this dialogue a person participates wholly and throughout his whole life: with his eyes, lips, hands, soul, spirit, with his whole body and deeds. He invests his entire self in discourse, and this discourse enters into the dialogic fabric of human life, into the world symposium. Reified (materializing, objectified) images are profoundly inadequate for life and for discourse.
>
> (Bakhtin, 1984a: 293)

The preceding quotation, however, draws our attention to the fact that even in his most 'dialogical' writings Bakhtin does not wholly abandon his earlier emphasis on corporeality. Dialogue does not imply an exchange of abstract symbols between disembodied speakers in a void. On the contrary: speech is embodied in gestures, the nuances of the voice, and the disposition of the body (Holquist, 1989). 'In everything a person uses to express himself on the outside (and consequently, for *another*) – from the body to the word – an intense inter-action takes place between *I* and *other*', writes Bakhtin (1984a: 295). Dialogue must be understood as a 'primordial' form of interaction that involves the total human being. Again, even when appearing to wholeheartedly embrace a given perceptual/metaphorical system, in this case the aural, a trace of a different sensory regime can always be glimpsed in Bakhtin's texts.

Carnality and the carnivalesque

This metaphorical 'slippage' is evidence of Bakhtin's refusal to essentialize any of the senses, a stance that is realized most fully in *Rabelais and His World*. Here, Bakhtin turns his attention towards the boisterous, disruptive and libidinous qualities of popular cultural forms and the body, within an historical period marked by the collapse of medievalism and the emergence of a more open and humanistic Renaissance culture. He celebrates the sixteenth-century writer François Rabelais primarily because he managed to incorporate into his novel *Gargantua and Pantagruel* the lived culture of the 'common folk'. According to Bakhtin, the earthy, sensuous, even scatological qualities of popular everyday life had a tremendous symbolic power to combat the 'monolithic seriousness' of officialdom. The characteristic images and tropes of a 'thousand year-old popular culture' (symbolic inversions, ritualized parodies, and so forth) were, in his opinion, capable of deflating the pompous idealism of the 'agelasts' (the self-appointed guardians of order, propriety, and respectability), thereby under-mining the ideological foundations of a gloomy and moribund medieval system. In repudiating the asceticism and other-worldly spirituality of medievalism, this folk-festive culture laid primary emphasis on the sensual, bodily and tactile aspects of human life within the context of everyday sociality. These 'utopian tones', writes Bakhtin, 'were immersed in the depths of concrete, practical life, a life that could be touched, that was filled with aroma and sound' (1984b: 185).

For our purposes, what is important to emphasize is that *Rabelais and His World* constitutes Bakhtin's most radical and politically charged attempt to demolish the sovereign, anthropomorphic subject and its ontological basis in a rigid dualism between subject and object, mind and body, and to replace it with an alternative sensory regime. In particular, he 'fleshes out', so to speak, the latent theme of intercorporeality developed in his early writings, by giving this phenomenon a markedly higher degree of socio-historical specificity and concreteness. In *Rabelais and His World*, we witness a pronounced devaluation of sight, and a relative diminution of hearing. Admittedly, Bakhtin does refer in passing to the qualities of popular speech and language in his writings on carnival, but he is less concerned with their 'dialogic' qualities than with their capacity for symbolic degradation, satire, and so forth. Hence, there is a notice-able shift towards the more sensuous, direct, and 'carnal' senses of touch, taste, and, to a lesser extent, smell. 'Alterity' in the context of the carnivalesque becomes less a matter of the intersection of different visual fields or verbal exchanges than with the bodily intertwining of self and other (including the 'other' of nature) within the overarching 'flesh of the world'.

Bakhtin's use of perceptual tropes in *Rabelais and His World* is best evinced in his discussion of the 'grotesque body', and his analysis of a succession of different body canons that he claims has occurred in European history since the Middle Ages. Officialdom, he suggests, relies heavily on ideologies and images that stress

the eternal, fixed and monolithic qualities of social organization and the cosmos as a whole. By contrast, when infused with 'grotesque' or folk-festive imagery, objects transcend their established boundaries and become fused or linked with other things. From this is derived their pregnant and two-sided nature, the quality of 'unfinished becoming' and radical ambivalence that is anathema to the status quo. Not surprisingly, Bakhtin asserts that this hyperbole and anamorphosis is positive and affirmative. The primary guiding image in folk-festive or carnival culture is one of abundance, growth and fertility, which supplants the drabness and routinization of everyday life with a celebration of gaiety and festivity. Repudiating the asceticism and other-worldly spirituality of medievalism, the grotesque stresses the sensual, bodily aspects of human existence. All that is abstract and idealized is degraded and 'lowered' by the transferral of these images and symbols to the material, profane level, which represents the 'indissoluble unity' of earth and body. Grotesque realism acts to 'degrade, bring down to earth, turn their subject into flesh' (1984b: 20). Bakhtin's scatological materialism is designed to challenge resolutely the arid abstractions of idealist philosophy; the grotesque image, in his words, 'materializes truth and does not permit it to be torn away from the earth, at the same time preserving the earth's universal and cosmic nature' (1984b: 285). Accordingly, acts of defecation and bodily expulsion, sex, birth, eating, drinking, and conception perform a major symbolic role in folkloric texts and practices, and these activities involve primarily the sensory apparatuses of touch, taste and smell. For instance, Bakhtin asserts that eating and drinking are crucial to the system of popular-festive images found in *Gargantua and Pantagruel*. The act of consuming food and drink reveals the body as open, unfinished; its connection with the universe is most fully revealed because this body transgresses its own limits by assimilating the material world and by merging with the other beings, objects and animals that populate it:

> The encounter of man with the world, which takes place inside the open, biting, rending, chewing mouth, is one of the most ancient, and most important objects of human thought and imagery. Here man tastes the world, introduces it into his body, makes it a part of himself.
>
> (Bakhtin, 1984b: 281)

Tactility in *Rabelais and His World* is expressed through a rampant and untrammelled sexuality, a continual commingling of bodies, but also in the metaphorical sense that Bakhtin promotes the idea of a sensuous, direct and familiar contact with everything, rather than through the rarefied abstractions of rationalism or obscure theological systems. Smell, although singled out less by Bakhtin, is located in the multifarious aromas of the marketplace and the cooking smells associated with festive food preparation, not to mention the less pleasant odours that tend to emanate from human bodies not duly concerned with the contemporary penchant for obsessive hygiene. The main point to

underscore is that the body as depicted in grotesque realism is not an autonomous, self-sufficient object, and is therefore irrevocably opposed to the 'completed atomized being' of bourgeois culture. The crux of the grotesque aesthetic lies in its portrayal of transformation and temporal change, of the contradictory yet interconnected processes of death and birth, ending and becoming. Grotesque symbolism explicitly denies the possibility of completion, of ending, of finality. For instance, carnival images often involve the playful combination of animal, vegetable and human forms, or the metamorphosis of one into another, so that 'the borderlines that divide the kingdoms of nature in the usual picture of the world were boldly infringed' (1984b: 32). Commenting on the interconnection between carnival and nature in grotesque imagery, Bakhtin asserts that the 'carnival awareness of the people's immortality is intimately related to the immortality of the becoming of being and is merged with it. In his body and his life man is deeply aware of the earth and of the other elements, of the sun and star-filled sky' (1984b: 256–7). In other words, the carnivalesque functioned to reverse the estrangement of humanity from nature fostered by the hierarchical medieval order, to re-familiarize human beings with the natural world (including human nature) and thereby bring it 'closer to man'. Folk-festive culture, in short, promised a better and happier future, one characterized by material abundance, equality and freedom. For whereas the dominant feudal ideology inculcated a 'cosmic fear' of the natural world, emphasizing nature's boundless capacity for apocalyptic retribution and 'stinginess', folk-comic culture had evolved specifically to combat this dread. Carnival bolstered a 'true human fearlessness' via a celebration of the immortal, collective human body, and the system of images it expressed portrayed nature as familiar and benign.

Hence, Bakhtin's demolition of Cartesian dualism and the atomized, anthropocentric subject is underscored by the radical alterity expressed in the grotesque body, which can never be isolated from its socio-historical or ecosystemic context. And, in so far as it fully partakes of the continuous, cyclical flow of matter and energy that characterizes the organic and inorganic world as a whole, the grotesque conception of the body 'materializes truth and does not permit it to be torn away from the earth, at the same time preserving the earth's universal and cosmic nature' (1984b: 285). Accordingly, the sensory emphasis of the grotesque body shifts from sight to the other, more carnal senses of touch, taste, smell, and hearing, and to those bodily organs associated with these senses. In his own study of Rabelais, Lucien Febvre reminds us that the non-visual human senses were much more acute in early modern and medieval times, and that sight only later became the sense of modernity and objective science *par excellence* (1982: 432). Not unlike Lévi-Strauss's myths, therefore, carnival can be interpreted as a shifting 'liminal zone' which calls into question the boundary between nature and culture, a division that 'official' Western society has desperately striven to maintain for the last two or three hundred years. By so blurring the distinction between mind and body, self and other, and between

humanity and nature, carnival presents a profound challenge to the traditional bourgeois ideals of predictability, stability and closure (Ferguson, 1989). If we become more conscious of the fact that our bodies are enmeshed with the natural world, then there is some potential for fostering a new intercorporeal, post-ocularcentric paradigm that encourages a utopian reconciliation of humanity and nature (Bell, 1994; Gardiner, 1993).

Bakhtin's decision to focus on Rabelais and the folk-festive culture of the early Renaissance period is, therefore, not an arbitrary one. Rather, he consciously sets out to identify a historical conjuncture of great significance, a relatively brief interregnum marked by the breakdown of feudalism (with its denial and mortification of the flesh), but before the consolidation of Cartesian dualism and the valorization of an abstract visuality, and the construal of the social self as a unified and autonomous ego (Synnott, 1993: 11–27). As Toulmin asserts in his book *Cosmopolis*, the brief flourishing and great promise of Renaissance humanism, exemplified in the writings of Rabelais, Montaigne, and Erasmus, was effectively squandered when seventeenth-century thinkers like Descartes and Leibniz came to dominate European intellectual life. Whereas the former emphasized the sensual, local, oral and particularistic aspects of human life and language, the latter transferred cosmology and philosophy to a 'higher, stratospheric plane, on which nature and ethics had to conform to abstract, timeless, general and universal theories' (1990: 35). The Enlightenment, Toulmin asserts, consolidated this intellectually imperious and reifying trend, with deleterious results that are still being felt today. Bakhtin would have undoubtedly concurred with Toulmin's assessment of this transformation. In successfully combating pre-modern mythological and metaphysical forms of thought, Bakhtin argues in *Rabelais and His World* that the modernity's preference for formalized reason encouraged a condensation and purification of reality. By adhering dogmatically to 'abstractly moral or abstractly rational criteria', the metaphysical systems developed under modernity have prevented humankind from understanding properly and participating in the immanent dynamism and open-endedness of the world. For Bakhtin, the Enlighteners' mechanistic view of matter and penchant for abstract typification has served to impoverish the world, and has precluded a proper appreciation of the 'culture of ambivalence' that he so clearly favours. 'In the age of the Enlightenment', he writes, 'cognitive reason became the yardstick of all that existed', which 'prevented the Encyclopaedists from grasping theoretically the nature of ambivalent festive laughter' (1984b: 118).

Conclusion

In his pioneering study *History of Bourgeois Perception*, Donald Lowe reminds us that specific perceptual fields are always-already intertwined with particular forms of socio-cultural organization and regimes of power/knowledge. Given that different perceptual registers are subject to a process of hierarchization

and valuation, perception is marked by an internal, constitutive relation to wider struggles over power, legitimacy and authority. Our experience of modernity is not exempt from this general postulate. 'By emphasizing the visual, the nonreflexive, [objective] reason enabled the bourgeoisie to triumph over the "irrational" value orientation of the other classes', writes Lowe. 'In that space, knowledge of both the world and the human being became more objective and specialized. However, this objective reason would reduce the intersubjectivity of the world, as well as the reflexivity of embodied life' (1982: 55). Yet there always remains the possibility of disengaging this historical connection between discrete perceptual fields and systems of power and domination, of exploring alternatives to the ocularcentric bias of contemporary Western culture. I have attempted to demonstrate here that the heterodox and iconoclastic writings of Mikhail Bakhtin offer us a glimpse of what such a post-ocularcentric paradigm might look like. In challenging the abstract, egological and disengaged 'seeing' of Cartesian perspectivalism, he holds out the possibility of an entirely different metaphorics of perception, one that embraces a 'plural metaphoricity that resists reduction to a univocal master trope' (Jay, 1993a: 511). Bakhtin's work gives us an image of an embodied, intersubjective form of reason that engages all of the human senses, but without denigrating the visual register, in a manner that privileges an open, mutually enriching and ethically responsible relationship between self, other and nature. In so doing, he realizes successfully Jay's injunction that 'rather than essentialize sight, hearing, or any other sense, it is far more fruitful to tease out their multiple, even contradictory potentials' (1993a: 104).

References

Bakhtin, Mikhail (1981) *The Dialogic Imagination: Four Essays by M.M. Bakhtin*. Austin: University of Texas Press.

Bakhtin, Mikhail (1984a) *Problems of Dostoevsky's Poetics*. Manchester: Manchester University Press.

Bakhtin, Mikhail (1984b) *Rabelais and his World*. Bloomington: Indiana University Press.

Bakhtin, Mikhail (1986) *Speech Genres and Other Late Essays*. Austin: University of Texas Press.

Bakhtin, Mikhail (1990) *Art and Answerability: Early Philosophical Essays*. Austin: University of Texas Press.

Bakhtin, Mikhail (1993) *Toward a Philosophy of the Act*. Austin: University of Texas Press.

Bell, Michael (1994) 'Deep Fecology: Mikhail Bakhtin and the Call of Nature', *Capitalism, Nature, Socialism* 5 (4): 65–84.

Crary, Jonathan (1988) 'Modernizing Vision', in Hal Foster (ed.), *Vision and Visuality*. Seattle: Bay View Press.

Febvre, Lucian (1982) *The Problem of Unbelief in the Sixteenth Century: The Religion of Rabelais*. Cambridge, Mass. Harvard University Press.

Ferguson, Harvie (1989) *The Science of Pleasure: Cosmos and Psyche in the Bourgeois World View*. London: Routledge.

Gardiner, Michael (1992) *The Dialogics of Critique: M.M. Bakhtin and the Theory of Ideology*. New York and London: Routledge.

Gardiner, Michael (1993) 'Ecology and Carnival: Traces of a "Green" Social Theory in the Writings of M.M. Bakhtin', *Theory and Society* 22 (6): 765–812.

Gardiner, Michael (1996) 'Alterity and Ethics: A Dialogical Perspective', *Theory, Culture and Society* 13 (2): 121–43.

Gardiner, Michael (1998) '"The Incomparable Monster of Solipsism": Bakhtin and Merleau-Ponty', in Michael Bell and Michael Gardiner (eds), *Bakhtin and the Human Sciences: No Last Words*. London: Sage.

Godzich, Wald (1991) 'Correcting Kant: Bakhtin and Intercultural Interactions', *Boundary 2* 18 (2): 5–17.

Haraway, Donna (1995) 'Situated Knowledges: The Science Question in Feminism and the Privilege of Partial Perspective', in Andrew Feenberg and Alastair Hannay (eds), *Technology and the Politics of Knowledge*. Bloomington: Indiana University Press.

Holquist, Michel (1989) 'Bakhtin and the Body', *Critical Studies* 1 (2): 19–42.

Jay, Martin (1993a) *Downcast Eyes: The Denigration of Vision in Twentieth-Century French Thought*. Berkeley: University of California Press.

Jay, Martin (1993b) *Force Fields: Between Intellectual History and Cultural Critique*. New York and London: Routledge.

Keller, Evelyn Fox and Grontkowski, Christine R. (1983) 'The Mind's Eye', in Sandra Harding and Merrill B. Hintikka (eds), *Discovering Reality: Feminist Perspectives on Epistemology, Metaphysics, Methodology, and Philosophy of Science*. Dordrecht: D. Reidel Publishing Company.

Levinas, Emmanuel (1991) 'Interview', in Raoul Mortley (ed.), *French Philosophers in Conversation*. New York and London: Routledge.

Lowe, Donald M. (1982) *History of Bourgeois Perception*. Chicago: University of Chicago Press.

Marcuse, Herbert (1969) *An Essay on Liberation*. Boston, Mass.: Beacon Press.

Merleau-Ponty, Maurice (1964) *The Primacy of Perception and Other Essays*. Evanston, Ill.: Northwestern University Press.

Merleau-Ponty, Maurice (1968) *The Visible and the Invisible*. Evanston, Ill.: Northwestern University Press.

Palmer, Richard (1969) *Hermeneutics*. Evanston, Ill.: Northwestern University Press.

Pechey, Graham (1993) 'Eternity and Modernity: Bakhtin and the Epistemological Sublime', *Theoria* 81 (82): 61–85.

Rose, Jacqueline (1986) *Sexuality in the Field of Vision*. London: Verso.

Rose, Jacqueline (1988) 'Sexuality and Vision: Some Questions', in Hal Foster (ed.), *Vision and Visuality*. Seattle: Bay View Press.

Serres, Michel (1989) 'Panoptic Theory', in Thomas M. Kavanagh (ed.), *The Limits of Theory*. Stanford, Calif.: Stanford University Press.

Shields, Rob (1996) 'Meeting or Mis-meeting? The Dialogical Challenge to Verstehen', *British Journal of Sociology* 47 (2): 275–94.

Stam, Robert (1991) 'Bakhtin, Polyphony and Ethnic/Racial Representation', in Lester D. Freidman (ed.), *Unspeakable Images: Ethnicity and the American Cinema*. Urbana and Chicago: University of Illinois Press.

Synnott, Anthony (1993) *The Body Social: Symbolism, Self and Society.* New York and London: Routledge.

Toulmin, Stephen (1990) *Cosmopolis: The Hidden Agenda of Modernity.* Chicago: Chicago University Press.

Wittgenstein, Ludwig (1980) *Culture and Value.* Chicago: Chicago University Press.

4

DURKHEIM'S DOUBLE VISION

Chris Jenks

> [M]ost sociological research involves the visual domain, because
> in large part we theorise what we see: social contexts, spatial
> arrangements, people's appearances and their actions; although
> the huge visual dimension of the social world and the fact that
> we transpose this into words are not so much remarked upon.
>
> Chaplin, *Sociology and Visual Representation*

At around the turn of the nineteenth century Durkheim opened up a new
landscape for our attention. Philosophical, political and economic paradigms
extending back to the pre-Socratics had cast their gaze upon the ordered relations
between people but Durkheim originally maps, through his science of ethics, the
social 'world'. This is an ontological space, a source of causality, and the primary
context for the functioning of all previously considered theories of human
conduct. What Durkheim achieved at a more analytical level than merely
founding a discipline (though this is achievement enough) was an awakening of
vision and a cognitive commitment to a new perceptual territory. Many previous
nineteenth-century explorers revealed whimsical sights fit for the new tourist,
be it traveller or taxonomer, but Durkheim's 'social' was hard, factual, contested
and burgeoning with the propensities to both change and explode. This was
no space for the tourist, but rather a battleground for the social scientist *qua*
moral scientist. So compelling were the images in interlocking constellations
he laid before us that their existence, though not their interpretation, has gone
without challenge until the end of the twentieth century. This latter-day assault
on the social world has emerged as part of a Western manifestation of egoism
in the form of retro eighteenth-century economic theory, and also as a dimension
of de-traditionalisation in Baudrillard's conception of the postmodern. Both of
these challenges were, incidently, anticipated in Durkheim's corpus of work
through his concepts of 'forced' and 'anomic' divisions of labour.

> the potential to reopen modernist closure is not found in the lax
> pluralities of many 'posterities' but in the rather more awkward
> constraints of Durkheim's notions of solidarity and the normative. The
> impulses of much postmodern theory are too ironic, too ready, like

Baudrillard to keep 'simulacra' within the index of negativity and alienation, too ready like Lyotard to define the sublime in terms of an act of continued negation.

(Smith, 1995: 253)

Durkheim's vision was both complex and truly 'visionary'. His irony is, however, that his thought has become ideologically *passé*. Crude appropriations of Durkheim manage his ideas as simply positivist, functionalist and essentially conservative. Rather more sophisticated, yet still conventional, views of Durkheim treat his work diachronically and at three different levels. First, *substantively* his concerns are understood as demonstrating a shift from institutions to beliefs. Second, his work is gathered *theoretically* within an evolutionary thesis; that is, his manifest preoccupation with the transition from simple societies into the form of complex societies. It is suggested through constructing a rigid framework of morphologies that he attempted to establish the functional conditions for the moral bond along a historical continuum. Finally, his *methodological* commitment is witnessed as a development from an early positivism, and indeed empiricism, through a series of analytic encounters which lead ultimately to the inappropriate character of this method and the emergence of a new, yet not entirely articulated, style of address. This chronology is well expressed by Parsons (1968) as Durkheim's movement from 'positivism' to 'idealism' – so we are presented with a version of an 'epistemological break'; a fractured vision.

My argument here attempts to restore the remarkable and visionary character of the Durkheimian view. I will assert that all of Durkheim's work is coherent and principled. It does not simply demonstrate a change in substantive interests, it is not simply developmental in its theorising of societal forms and it does not reveal an overthrow or defeat of an increasingly inappropriate sociological method. At a deep structural level Durkheim's whole project is unified and essential in its variety – its differences are homologous.

I suggest that Durkheim's methodological programme may be viewed as occasioned by real social change – the experience of modernity and the threatening spectre of postmodernity – and perhaps, at one level, as attending concretely to that experience of change.

Over and over again, Durkheim comments on the uneasiness, anxiety, malaise, disenchantment, pessimism, and other negative characteristics of his age. His comments on the leading proponents of the *fin de siècle* spirit – among them, Bergson, James, Nietzsche, and Guyau – are mixed with sympathy as well as outrage. But his remarks on the Enlightenment philosophers, Hobbes, Montesquieu, Rousseau, Comte, Kant, Saint-Simon, and others, are unequivocally critical with regard to their *naïveté*, optimism, and simplicity.

(Mestrovic, 1991: 75)

However, at an analytic level, Durkheim's corpus generates different and predicted methods for different sets of problems which are, in turn, echoes of the two different manners through which people might realise their world; that is, a double vision. In this way Durkheim's insights are not linked specifically to the moment of their occurrence but have applicability to the rapidly transforming conditions of modernity into late modernity.

The methodological programme is provided with its models through Durkheim's thesis in *The Division of Labour* (DOL). This work will be regarded as grounding all of Durkheim's theorising. I will argue that the two forms of solidarity revealed in Durkheim's text, the Mechanical and the Organic, may be treated as metaphors for different ways of being in the world, different ways of seeing and understanding the world, and thus for different sociological approaches to the world – the two sites for sight. Indeed, they are paradigmatic.

These two possibilities I shall refer to as the 'mechanical' and 'organic' epistemologies of the two sociologies. The former, the mechanical, is a mode of both cognition and accounting that is preoccupied with description. This betrays an habitual realism with no distinction at work between objects-in-reality and objects-in-thought. It renders all understanding obedient to the criteria of literalism. This way of being is clearly primary to and celebrated through the twin traditions of positivism and empiricism that have engaged and stalked sociological reasoning, and subsequently mediated its relation to the wider culture, from its inception at the close of the nineteenth century up until its threatened fragmentation in the present day. Also instilled within the lexicon of the sociological analyst is the central metaphor of 'observation', deriving from the relations of mechanicism, and this exceeds in recurrence even the 'ubiquity of visual metaphors' that Jay (1993) refers to as current within everyday speech. Beyond these meta-theoretical considerations, the mechanical epistemology bestows a particular, practical status upon the theorist, a status that enables such continuous literal description by and through the privileged difference of the sociologist. The sociologist is thus realised through expertise, the sociologist is as a high priest. This, in a nutshell, is Durkheim's first vision; what I have referred to elsewhere (following Nietzsche) the 'doctrine of immaculate perception' (Jenks, 1995).

In the latter mode, the second yet simultaneous vision, that of the organic epistemology, we are offered understanding not through description but through espousal. Within organicism difference becomes accepted, it becomes conventional. The taken-for-grantedness of difference emerges as the grounds on which we begin to understand the other, thus difference itself must be regarded as a form of equivalence. In this context, the understanding of difference requires not the privileged description of that which is sundered from self, but an espousal in the dual sense of an analytic wedding to or sameness with the other and an adoption or indeed advocacy of that other's position. The theorist now experiences a dramatic change in status; the reification of expert

and high priest as describer of the mundane becomes itself secularised and a part of that realm of the mundane. The theorist becomes like Garfinkel, an espouser of and equivalent to the lay member. Similarly, the lay member is enjoined in the ethno-methodology of the sociologist to both artfully see, on a shared plane, and apprehend.

Let us then work with the view that the two forms of solidarity, rather than being concrete descriptions of historical conditions, are metaphors for different forms of life; that is, different ontological orders, or 'scopic regimes' (Jay 1992) each giving rise to attendant and complementary epistemological rules of apprehension. Clearly, the forms of solidarity, treated as analytics, signified particular empirical referents, such as clans or states or whatever, and thus enabled Durkheim to account for real social change along a historical continuum; the inspiration for this change being the degree of moral density, and the key to decoding its form being the manner of aggregation. However, the point of my current reading is to elucidate the constitution of the two phenomenal models of social life which lead to two positions on method, two perspectives.

I assemble here, for the sake of brevity, a set of binary oppositions instanced as the forms of solidarity but in turn instancing two different ways of seeing and ways of being in the world – what Wittgenstein might refer to as two 'forms of life' (Table 4.1)

I shall now demonstrate the transformation of these two 'visions', or forms of life, into methodological paradigms and subsequently highlight the distinct features of these two paradigms at work in the 'early' and 'late' phases of Durkheim's work (albeit in truncated form as the full exegesis is part of a much larger thesis). Both paradigms will contain ontological and epistemological commitments; that is, assumptions concerning the nature of the phenomena of interest and also assumptions concerning the best ways of relating to such phenomena. This resonates with Kuhn's (1970) notion of 'paradigmatic knowledge' in that they map out the parameters of knowing by providing rules for what is visual and what is not.

Within mechanical solidarity, our first model, we have a primary ontological commitment to the inherent order in the social world. This order is an essential metaphysic which is mobilised, in human terms, through the pre-social yet gregarious urges of the 'primitive horde'. Humankind is disposed to sociality by virtue of its species being, and a person's experience of him/herself and of others within that sociality is through and by virtue of the social bond. The social bond, which is based on resemblance (a pragmatic ordering principle), is maintained by a strong collective consciousness. The collective consciousness is, in turn, transcendent – it is projected out as God (an unquestioning ordering principle). The a priori status of the deity is not contentious in mechanical solidarity, people and their understandings are held in check by faith – the world is experienced as inherently ordered; humankind itself is contingent upon that order. Such conservation of order also legislates for the finite. The world is comprised of a fixed and limited number of segments and their possible relation

Table 4.1 Binary oppositions

Mechanical solidarity	*Organic solidarity*
Predominant in more simple societies	Predominant in more advanced societies
Characterised by homogeneity, likeness; social bond based on resemblance	Characterised by heterogeneity, difference; social bond based on interdependence
Segmented structure – clans, tribes	Organised aggregate structure – cities and states
Belief system religious, transcendental Gods	Scientific knowledge, secular ideologies
Strong collective consciousness; singular and absolute authority	Collective consciousness dispersed through the division of labour; authority functional and moderating
Concrete cognitive structure, meanings particularistic	Abstract cognitive structure, meanings universalistic and general
Primary orientation for social action – altruistic	Primary orientation for social action – egoistic
Pervasive doctrines conservative	Pervasive doctrines innovative
Normative legal structure repressive sanction	Normative legal structure restitutive sanction
Form of control – positional status centred	Form of control – personal, person centred
Experience of control – shame	Experience of control – guilt
Assigned social roles and status; roles communalised	Achieved social roles and status; roles individualised
Weak boundary maintenance, low discretion (public)	Strong boundary maintenance, high level of discretion (private)
Individual experience of collective life through consensus	Individual experience of collective life through divergence
Symbolic system – condensed correspondential symbols	Symbolic system – diffused, interpretive symbols
High communicative predictability	Low communicative predictability
Low expression of unique intent	High expression of unique intent
Speech mode – restricted	Speech mode – elaborated
FACT	**VALUE**

– the model is, in Durkheim's own formulation, 'mechanical'. Society then, is intrinsically ordered, transcendently regulated and mechanistically maintained.

> The 'politics of the eye' presented here are concerned with the corporeal discipline which represses the eye as an organ. The question of the body . . . would thus provide the link between power and art productions. Since Plato, mind governs the eye and the body. The thematics of representation partly perpetuates the conception of visibility as a subjugated instrument.
>
> (Lucbert, 1995: 253)

Such ruthless and unerring finitude has two epistemological consequences. First, the reduction of social phenomena to things, at hand, but not wilful or

independent. Such 'thing-like' status as derives from this shared, condensed symbolic order itself leads to the experience of phenomena in the constant, particularistic here-and-now of an unchanging cosmos. The convenient methodological tools of such experience are the senses, sight and touch and sound; they are concrete. The second consequence is the reduction of the person as a potential theorist. People within this form of life operate only on the surface; they are essentially irrelevant except as messengers. Indeed, they too are relegated to the status of being one more 'thing' located mechanically within the true order of things; they have no 'intentional' relation with phenomena other than themselves.

The singular and absolute authority of the God that symbolises mechanical solidarity ensures a unitary and necessarily shared epistemology. The strict rule system is worked out by taboo relating to the infringement of good conduct. The firm correspondence deriving from a restricted and condensed symbolic repertoire ensures only limited room for dissent – the same correspondential unequivocal symbols make for solidaristic and consensual group membership. The individual member, if indeed he is distinguishable as such, has only a positional responsibility to the rules of community, this emphasises the reliance on one methodological way and further contributes to the weak sense of self – 'self as anyman' as McHugh (1971) puts it. In fact, such is the antipathy towards egoism within such a community that in methodological terms 'self' becomes the source of all bias and corruption; as the *Rules of Sociological Method* (Rules) instructs us, we must 'eliminate all preconceptions'.

We can now view these methodological assertions in terms of Durkheim's early work, particularly the *Rules*. In the *Rules* the tone is prescriptive; it is as if Durkheim were legislating for the conduct of a scientific community. To suggest that such legislation were accompanied by repressive sanction would be to press the metaphor through analogy into simile; but the work is clearly 'laying down the laws' for the recognition (ontology) and recovery (epistemology) of sociological phenomena, and the rules are hardly stated in an equivocal or flexible fashion.

The Preface begins with the tantalising statement that:

> We are so little accustomed to treat social phenomena scientifically that certain of the propositions contained in this book may well surprise the reader. However, if there is to be a social science, we shall expect it not merely to paraphrase the traditional prejudices of the common man but to give us a new and different view of them; for the aim of all science is to make discoveries, and every discovery more of less disturbs accepted ideas.

So, we are promised a science of discoveries, and of surprises, and one capable of transcending common sense – and the *Rules* will enable us to achieve this end. The *Rules* has been variously described as a manifesto (Lukes 1985; Thompson

1982) in as much as it seeks to establish the rule system for a social science, but also in as much as it seeks to describe the nature of sociological phenomena. Hirst (1975) captures this element well with his sense of Durkheim as pioneer, staking out the vacant territory for sociology and thus ring-fencing the particular facticity of sociology from all other facticities. Of course the character of this facticity is crucial. In what sense is it present for Durkheim as a sign of different forms of relation both in-reality and in-thought? This, in turn, releases social phenomena from the epistemological imperialism of psychology, biology, individualist metaphysics and, indeed, common sense. So in this way, sociology's object is located, provided with a special identity and offered up for observation and understanding through a finite set of explicit transformational rules.

The primary entities that comprise a social world are social facts; they are the 'absolute simples', the irreducible elements that, in unique combinations, constitute different societal forms. Social facts are also the primary units of analysis. Durkheim seems at this stage to draw no distinction between objects of reality and objects of science, yet it is social science which releases such facts from their obscurity. The language of sociology brings this form of facticity into focus. The social facts are:

> every way of acting, fixed or not, capable of exercising on the individual an external constraint or again, every way of acting which is general throughout while at the same time existing in its own right independent of its individual manifestation.
>
> (*Rules*: 13)

and we are further instructed to 'consider social facts as things' (*ibid.*: 14).

The social facts, then, are typified through three major characteristics: externality, constraint and generality. They are *external* in the sense that they have an existence independent of our thought about them, they are not simply realised or materialised by the individual member and further they predate that member, and as such constitute any world that he enters. They *constrain* in as much as they are coercive when infringed; normal social conduct falls within their conventions and manifests their reality; attempts to act otherwise than normatively transgress the implicit and explicit rule structure and invoke constraint. Their *generality* derives from their being typical, normal, average, sustaining and not transitory, and morally good in the sense that they maintain the collective life – they are the very fabric of social 'nature', their generality enables them to speak for themselves, but through the auspices of sociological patronage; that is, they have a sociological facticity.

This last characteristic is further mobilised in Durkheim's method through the invocation that 'The voluntary character of a practice or an institution should never be assumed beforehand' (*ibid.*: 28), which provides for the possibility that even the most arbitrary, isolated or seemingly random occurrence of a social phenomenon may, on further observation, be revealed to be yet a further

necessary component within a systematic and stable social structure – indeed, the inherent order of things predicted in the 'mechanical' paradigm.

Throughout this section of the text, where Durkheim is providing the rules for the observation of social facts, we could say that he is actually siting or locating the observer in such a manner that his perspective on reality cannot be other than that of a sociologist. Part of this siting involves instruction as to the extent of our observations, but part also involves our insulation from all other view-points. Hence we are told, 'All preconceptions must be eradicated' (*ibid.*: 51); we must eschew the legitimacy of common sense as a starting point for social investigation. The obverse of this instruction is an implicit theory of the inadequacy or distorted character of presociological speech, one which Durkheim makes clear with critical reference to biology, psychological reductions and to the categories of common sense itself. This points also to the mechanical sense of 'priest' or expert. Hirst (1975) has picked up this attack on layman's knowledge and produced it in terms of a Durkheimian theory of ideology. For our purposes it would seem that Durkheim treats common sense as historically partial and thus prone to misrepresent the real, and so sociology, using the same sense agencies but different categories to common sense, must serve to overcome this imaginary world. So here Durkheim is recommending a break away from the illusions of the subject and a systematic, 'disciplined' movement towards the real object. The production of common sense as distorted in this manner distances the social member from a lived, sensuous appreciation of the 'real' social world. There is a strong sense in which the member inevitably becomes relativised in the face of the preponderating finitude of the social – which is, as established, the primary reality. We must explain the social in terms of the social. The member, though integrated into the social and active in its reproduction through his day-to-day conduct, is unaware, analytically, of its true structure unless informed by the correct and singular rules of methodology. To adopt this method is, then, to attain a grasp of the real, and thus it is the method and not the member that holds a constant and unerring relationship with the social for the method to vary or to be person-based would give rise to a proliferation of realities, a seculari-sation of Gods – an act of profanity. It is in this context, within the mechanical epistemology, that the individual, as theorist, is sensible beyond the surface only if he sublimates his difference to a corporate method and a singular reality. It is in this way that the 'good' methodologist becomes a messenger.

Durkheim continues to inform us that social things are 'givens' and that they are subject to the practice of observation; this then becomes a central analytic problem – namely, to discover the rules that govern the visual existence of social things. We are given rules of recognition and assembly and we are to combine these rules with the social fact's proportions of thing-like-ness that we have already considered. So social facts are resistant to our individual will, our attempts to alter or amend them; they are objectively available (that is, free of possible interpretation or value judgement), and they are irreducible to other phenomena. They are, in terms of the social world, all that is the case. More than this, all

manifestations of a social fact are linked by causality – the mechanical whole seems complete.

Recognition of the social facts remains, however, a problem. Although their existence is *sui* generic they do not have form. Their reality does not consist in a material or physical presence; they are more experienced than tangible. Their manifestation is as constraint; they are invisible prison walls. Clearly they can be witnessed but only in as much as they inhabit or are realities – so Durkheim instances the legal system, the use of French currency, and the French language, all extant structural features embodying social facts. Ultimately then, they are representations which arise from and are indicators of the collective consciousness – the methodological rules of the scientific community. It is interesting that within the mechanical paradigm the social facts constrain the individual and yet the social member remains largely untheorised as an alternative causality.

The *Rules*, which mark out the character of the mechanical paradigm, produces science as a form of perception which has sensation as its basis. The human perceiver (or theorist) thus received 'the message' from the pre-established order of the cosmos via the scientific method. As, within this model, reality is viewed as an organised system with stable relations holding between the part and the whole, then also the relation between cause and effect is seen as logical rather than temporal – it is a fixed mechanical system, and as such the model lent itself to a functionalist approach. From such a position the sociologist is concerned to observe the logical equilibrium of social systems, and comparisons are drawn through correspondences or homologies from one system to the next. Laws are established through the constant correspondence between variables within systems.

An important methodological distinction in the *Rules* is that made by Durkheim between the concepts of the *normal* and the *pathological*. He says that 'for societies as for individuals, health is good and desirable; disease, on the contrary, is bad and to be avoided' (*Rules*: 49), and also in more general terms that:

> One cannot, without contradiction, even conceive of a species which would be incurably diseased in itself and by virtue of its fundamental constitution. The healthy constitutes the norm par excellence and can consequently be in no way abnormal.
>
> (*ibid.*: 58)

This crucial distinction then, refers to social facts that are typical and general (the normal) as opposed to those that are irregular, particular or transitory. It is a useful distinction to exercise but also we need to ask why the concepts should have been employed, for they would seem to operate at two levels. First and most obviously, at the concrete level of actual social members, the *normal* facts are those which constitute solidarity and continuity and the *pathological* are those which manifest individualisation, fragmentation and interruption. In their

different ways the two orders of social fact are markers of good and concerted conduct within the collective life. Second, at the analytic level, and this is their main thrust, it might be suggested that the normal/pathological distinction is a moral distinction or election mode by the theorist in advance of his commitment to a programme of methodology. It is the theorist's projection of notions of choice and arbitration into the particular form of social structure that emanates from a mechanical form of life. The binary opposition contained within the normal/pathological distinction resembles the binary cognitive code necessary for the articulation of the individual and collective interests within a mechanical solidarity. Issues have to be resolved in absolutes of Yes and No, Collective and Individual; the lack of a developed division of labour disenables the proliferation of views of justifiable positions. Thus as the dialectic between normal and pathological facts can be seen to have a remedial and beneficial function at the concrete level of the social member, so also it has a function in the method-ological social engineering of the theorist who seems to construct these facts as mechanically coherent.

Durkheim defines the normal in terms of the average, a definition which must continue to reaffirm itself – a sure feature of mechanical reproduction. The pathological are structurally transitory and thus inappropriate for our study; thus instead of using the concept 'pathological' to refer to inherent threats within a social structure Durkheim uses it to establish the a-social character of individual manifestations and through this to sanctify the altar of collective purity. Pathological behaviour serves as a negative reinforcement for the collective sentiments; crime creates outrage, punishment gives rise to expiation, the normal has its boundaries once more confirmed.

The average equates with the healthy which in turn equates with the good. Durkheim's method is clearly monotheistic in this particular model, which is wholly appropriate for the structure of institutions and consciousness that it is, at one level, seeking to illuminate – namely, primitive, simple, religiously based, coherent societies.

The next stage in Durkheim's methodology within the mechanical model involves the practice of classification. This activity aims at the construction of a social morphology – a scheme which distinguishes between yet logically relates what Durkheim refers to as social forms or social types. By adopting this middle range unit of analysis Durkheim hopes to avoid speaking in particularistic relativisms on the one hand or in gross a priori generalisations like 'humanity' or 'human nature' on the other. The social type, then, makes reference to a particular structuring of social relations; the simplest being the 'primitive horde', from which origins the forms progress in complexity through clans and tribes up until cities and states. As previously discussed, with relation to *DOL* all forms consist of the basic irreducible elements of social life that the 'horde' embodies, but they are distinguishable through their particular mode of aggregation of these elements. A classificatory scheme is thus to be achieved in terms of a series of definitions of modes of combination. The 'types' or 'species' are not seen as

83

temporal stages, their systematic ordering is not evolutionary – they are logically synchronic not materially diachronic.

If we now regard the practice of classification as a metaphoric instance of the mechanical form of life we find it wholly compatible with that model. The urge towards a strong system of classification is a desire to perpetuate order and firm control. To generate strong classification requires the election and maintenance of strong boundaries, each marking off inflexible contents. In terms of social roles strong boundaries enable static and secure identities to be exercised with a high degree of discretion. Within such a set of social relations there is little interdependency, as each identity is self-sufficient and interactionally incapable of expressing need through difference. Strong classification instances the form of social relationships that precede the division of labour. Once again, the analytic of Durkheim's method is seen to reflect the concrete features of his simplest mode of solidarity.

The concluding stages of Durkheim's methodology in the mechanical model contained in the *Rules* proceed through explaining the newly classified social fact through seeking out 'separately the efficient cause which produces it and the function it fulfils' (*Rules*: 95). The two important instances here with relation to the social fact are '*cause*' and '*function*'. Within the mechanical model we might suggest that the former, *cause*, which is constant and determinate, emanates from the intrinsic order of such a social world; it is like the word of God. The latter, *function*, is the word made man – it is man's practical, but nevertheless various and different, way of enacting such a cosmic directive. Again this process is metaphoric of the God-head in mechanical solidarity.

Finally, having moved from observation to theory, Durkheim's method within this model concludes with the production of a general law; that is, a theory that will enable us to make predictive statements concerning the occurrence of the studied phenomenon in other social circumstances, the ultimate act of control through reproduction.

We may now briefly investigate *Suicide*, Durkheim's other major 'early' methodological work, and attempt to demonstrate that too as an instance of the mechanical form of life. *Suicide* has been hailed as a remarkable exercise in Durkheim's sociological method; as Thompson (1982) puts it:

> If the *Rules* was a revolutionary manifesto for establishing scientific sociological explanation, it was given its most forceful demonstration in the famous work that followed *Suicide*.
>
> (Thompson, 1982: 109)

Indeed Durkheim himself claims this working association in his Preface;

> In the course of this work [Suicide], but in a concrete and specific form, will appear the chief methodological problems elsewhere stated and examined by us in greater detail.
>
> (Footnote to *Rules*: 37)

Thus the claims for a close relationship between these two texts seem traditional and established; although this does not necessarily attest to the stability of their coupling.

If we recall Durkheim's driving methodological intention; his concerted aspirations to generate a clearly identifiable scientific community of theorists who explained purely sociological phenomena exclusively in terms of the social, then we can appreciate some of the reasons why suicide should have become Durkheim's substantive topic.

In commonsense terms, suicide is manifestly among the most individually motivated of all acts. Suicide is the moment when the individual, seemingly most alone with his soul or psyche, wilfully decides to cancel his continued commitment to collective life. It is an act viewed as wholly existential, and it is a form of change that is rapid and irrevocable. Now if, through the application of Durkheim's method, such conduct can be shown to be part of a social fact, caused through externality and constraint, then an intellectual victory will have been achieved. To explain suicide as a social fact like other social facts is to demonstrate beyond question the viability and autonomy of sociology. Sociology will be revealed as a selective and unique scientific practice with its own realm of phenomena and its own distinctive perspectives, all free of psychology, biology and common sense. Such a victory would claim the individual motivation back into the arena of collective response.

Durkheim's work can be situated with a contemporary set of theoretical and practical concerns with self-destruction. Many writers were addressing the issue, and operating largely with statistical-demographic techniques. Such 'theorists' were constructing an image of suicide as an evolving evil, one which necessarily stemmed from the growth of psychic malaise inherent in industrial society. This group of 'moral statisticians' accrued considerable quantitative data to support their overall thesis that the growth in suicide in Europe, as also the growth in divorce, could be treated as an index of the decline of moral control within society as a whole. Durkheim certainly mobilised their statistical studies, though he wished it to be clearly understood that sociology was far more than their descriptive fact-gathering. At another level, however, he was, nevertheless, working through his own moral response to the dominant emphasis on individualism in the late nineteenth century. This early work can be seen as a 'mechanical' reaction or retrenchment in the face of the worst excesses of unregulated 'organicism', through the division of labour.

Durkheim's *Suicide* served to claim the individual back into the social, while still leaving modern man intact within the division of labour. His thesis postulates a kind of secular predestination; namely, that through the act of suicide the individual becomes at one with his society. If social life is comprised through constraint, then to commit suicide because of social constraint is to serve out one's social obligation. In this way Durkheim neatly inverts the notion of 'escape' or 'release' that is inherent in the commonsense view of suicide. He produces suicide as an inevitable complement to the social moment. The death

of the individual serves to destroy that which threatens the life of the social. Thus, individual suicide, in all its forms, can be regarded as a kind of symbolic sacrifice necessary in the worship of the collective moral good.

The fact that the exercise of method in *Suicide* by Durkheim seems to fall short of his own rigorous demands as specified in the *Rules*, in no way affects my assertion that both texts share a methodological paradigm or form of life. The world-view stated and traded upon in each text rests upon a firm sense of the inherent order within the social world as being an absolute state of affairs. The view of social science is that of one operating with the 'appropriate', and thus a unitary, method – the method which will inevitably deliver the reality structure of the inherent order. The phenomena that are thus taken to constitute the social world are regarded as finite, and man's place as a potentially creative world-builder is relegated to that of the low-status receiver of messages. And finally, the primary metaphor that relates the theorist to his object is that of 'observation', which points to the empiricist character of this form of positivism.

That the 'suicidogenic currents' do not fit comfortably into this scheme of perception and retrieval, and yet the study is convincing, points to the limits of the mechanical model in the face of organicism. But it also points to the relative success of positivism in its appropriation and compilation of the notions of science, truth, certainty and knowledge.

Let us now proceed from the mechanical model to the organic model of method following the structure in Figure 4.1.

Durkheim, with Mauss, introduces the problem of *Primitive Classification* (PC) with the statement that

> The discoveries of contemporary psychology have thrown into prominence the frequent illusion that we regard certain mental operations as simple and elementary when they are really very complex.
>
> (*PC*: 3)

Thus we are aware of the ways that people relate to objects and states of affairs in the concrete world but we are little accustomed to treating our logical representations in discourse and consciousness as of the same nature. These, Durkheim states, we tend to treat as immanent in consciousness and refined through the history of experience and practice. So the conventional belief is that the capacity to classify and order the world is reducible to individual psychology – a belief that is coherent with the model of the typical actor contained within the society of the *Rules* – a naturalised unit responding to *sui* generic constraint. Durkheim notes, however, that within simple societies the capacity to differentiate between self and object or indeed between self and other appears to be absent, people may believe themselves to be as the crocodile for example, and personality fuses into one continuous form. Thus he suggests, in its origins humanity 'lacks the most indispensable conditions for the classificatory function'. In a primal state

The Division of Labour (1893)
(Primary work – sets the thesis)

'Mechanical' model	'Organic' model
Rules of Sociological Method (1893)	*Primitive Classification* (1903)
Suicide (1897)	*Elementary Forms of the Religious life (1912)*
(Early works – positivistic)	**(Later works – hermeneutic)**

Figure 4.1 Durkheim's double vision

humankind is unequipped to gather like from unlike and certainly unable to organise a ranking of things in hierarchical terms; the world as it presents itself to our observation does not display hierarchy – it is constructed as such.

Here we arrive at the central issue: if human cognition is not naturally endowed with the capabilities of constructing classifications on what basis did such a systematic and regular occurring function develop? Durkheim seeks to reveal this basis in the elementary social structures themselves.

Durkheim and Mauss go on to demonstrate how systems of classification were generated and aim to specify the social forces that induce men to divide between classes. They employ second-order material; that is, speculative ethnographies concerning Australian Aborigines, North American Indians or Ancient Chinese communities. They point out that all such elementary societies appear to be sectioned into kinship groups which are intelligible as distinct in terms of the different expressions, forms and degrees of affective intensity contained within those various social relations. Of these social divisions the largest and the oldest are termed 'moieties'; these are the fundamental expressions of social affinity. Each moiety is further subdivided into 'clans' which proliferate into smaller marriage groups. These divisions, these expressions of belonging and related-ness, are not capricious nor random, but relate directly to the style of relation encapsulated within them. In the explanation provided of how people in these structures perceive their world it is argued that all phenomena of the natural world, animate and inanimate, are seen to be treated as symbolically attributed to or belonging to particular specific groups, usually as totems. Initially this 'possession' is structured primarily in terms of the larger older groups (the moieties) and then subdivided more specifically into clans and smaller kinship associations. Durkheim. and Mauss then liken this claiming of 'related' segments of the cosmos to our contemporary branching classificatory scheme. They suggest that, in concrete terms, through the mediating symbols of the totems, moieties provide for the original 'species' and the clans for the original 'genera'.

Durkheim and Mauss further argue that although modern scientific morph-ologies might appear to have become somewhat removed from their 'social

origins', the very manner in which we still gather phenomena as 'belonging to the same family' reveals these social origins. Despite what they refer to as the acknowledged remove from primitive classifications up to the present day, Durkheim and Mauss wish to argue that primitive classifications are certainly not exceptional or singular. Rather, they assert, they are on a continuum, connected without a break in continuity up to the first scientific classifications. Indeed, 'primitive classifications' in themselves display the essential characteristics of all scientific classificatory systems, being that (1) they are arranged hierarchically, such that all phenomena of the natural world are perceived to be in a fixed relation with one another, and (2) that they are speculative, in the sense that they are used for understanding or coming to terms with what is other than oneself.

Throughout his writings, Durkheim was concerned with the analytic problems of the successful establishment and appropriate interpretation of manifestations of the social bond. He worked at the production of a continuous morphology of possible rule systems by and through which people are oriented in their conduct, within, and as part of, the various orders that constitute society. He endeavoured, then, to construct the analytically conceived conditions for people living together; these would stand as the external organising principles of society; and from this framework it was stated that their actions could be made intelligible in terms of that very living together. He was, at each level, concerned to explain the social in terms of the social. Thus the later Durkheim sensitises us to the centrality of symbolism in social life and now asserts that symbols themselves are fundamental in the structuring and interpretation of social experience.

Whereas the earlier works of the *Rules* and *Suicide* revealed a mechanically explicit concern with the specification of the natural unequivocal moral order of society in terms of generalities, their constraining influence and thus their causal significance – the '*sui* generic' mechanistic reality – the later work of *PC* and *Elementary Forms of Religious Life* (EFRL) now shifts from the stance of a phenomenalistic positivism and directs itself to explain the non-observable, the non-material, the realms of mind, knowledge and symbolic representations; what Alexander (1988) has seen as the appropriate grounds for an analysis of culture. Substantively we move from institutions to beliefs, from laws and contracts to epistemologies and cosmologies – Durkheim now uses the latter as the occasion for his work, but he is also occasioned by them; they are part of his methodological purpose. When Durkheim begins to write his implicit epistemology, as a method, it reveals how a natural moral order is equivocally intelligible from within a complex interpretive network of diffuse symbols. The concerted or disciplined unification of understandings within this context points to the necessity and purpose of an organic method, a method that unites differences which are no longer identical, continuous or stable in their relations.

Durkheim is quite clear in his Introduction to *EFRL* that he is involved in an analysis of totemism, in the first instance, as a critical illumination of his general theory of religion; this, however, is in turn only one facet of his wider theory of

knowledge, the culmination of all his studies. It is then, the epistemology that is his principal, underlying concern throughout the study, and religion may be conceptualised relating to the symbolic system through which man addresses his world and through which his world and his consciousness are constructed. The importance of religious theory goes far beyond an examination of the social character of ceremony or ritual – it indicates the very nature of human knowledge. So for Durkheim, religion sheds light not only on what people believe but more fundamentally in what and on how they think.

The substantive truth value of elements comprising a mechanical order is attested to by Durkheim in the Introduction to the *EFRL* when he states that there exist in society no institutions that are based upon a lie. Within a positivist world all phenomena are present to us and coherent by virtue of their ultimate reality; the symbol and its referent are as one. Thus all religious practice, whatever form it takes, translates some human need. Religions embody a specific social function which is their recognisable constraint.

Durkheim's concern with the origins of symbolism is made paramount in his discussion of the 'categories of understanding' – that is, the ultimate principles which underlie all our knowledge and which give order and arrangement to our perceptions and sensations, thus enabling us 'to know' at all. He wishes to establish the social derivation of these basic categories like, for example, concepts of space, time, class, substance, force, efficacy, causality, etc. – all concepts which were taken to be universally valid fundamentals of all human thought.

> Instead of Durkheim's saying 'the unconscious is history', one could write 'the a priori is history'. Only if one were to mobilize all the resources of the social sciences would one be able to accomplish this kind of historicist actualization of the transcendental project which consists of reappropriating, through historical anamnesis, the product of the entire historical operation of which consciousness too is (at every moment) the product. In the individual case this would include reappropriating the dispositions and classificatory schemes which are a necessary part of the aesthetic experience as it is described, naively, by the analysis of essence.
>
> (Bourdieu, 1993: 256)

Reviewing the dominant epistemological explanations Durkheim dismisses the types of idealism which depict the ultimate reality behind the world as being spiritual, informed by an Absolute; or those which account for the categories as being inherent in the nature of human consciousness. Such 'a priorist' position, he says, is refuted by the incessant variability of the categories of human thought from society to society; and further it lacks experimental control, it is not empirically verifiable. Indeed, such a position 'does not satisfy the conditions demanded of a scientific hypothesis'. In this section he can be read as addressing the Kantian edifice which has a theory of mind as that being informed by divine

reason. For Kant the categories exist somehow beyond the individual consciousness as prior conditions of experience and without which experience would be meaningless and chaotic – the divine reason is thus made manifest through individual consciousness.

Durkheim also criticises the varieties of subjectivism, in particular the theory stating that individuals construct the categories from the raw materials of their own particular empirical experience or perception; that is, we each infer and create our own unique set of categories from the peculiar orderings of our own sensations. This is the extreme logical position of the tradition of empiricism, and in this context Durkheim is addressing the anthropology of Tylor and Frazer. Durkheim suggests that although the categories of thought vary from society to society, within any one society they are characterised by universality and necessity. Thus for the subjectivists, since all sensations are private, individual and different, it is difficult in terms of their theory to account for how people generally come to possess and operate with the same categories within particular societies.

Durkheim also, at this stage of his work, dissociates himself from any materialist standpoint. In order to avoid deriving mind from matter, or invoking any supra-experiential reality, Durkheim says that it 'is no longer necessary to go beyond experience' – and the specific experience to which he is referring is the 'super-individual reality that we experience in society'. He considers that men do not make the world in their own conscious image any more than that the world has imposed itself upon them, indeed 'they have done both at the same time'. Although within the *EFRL* he makes occasional reference to 'objectivities' and to 'the nature of things' he continues to speak throughout to a 'super-individual reality' which is not the material world – it is society as a symbolic universe.

For Durkheim, society is the fundamental and primary reality; without it there is no Man – but this is a reciprocal dependency. Society can only become realised, can only become conscious of itself and thus make its influence felt, through the collective behaviour of its members – that is, through their capacity to communicate symbolically. Out of this concerted conduct springs the collective representations and sentiments of society, and, further, the fundamental categories of thought for they too are collective representations. So humankind finds expression only in and through the social bond; and, of course, this bond is itself an expression of sociology's epistemology.

Anthropology and in particular Durkheim in the *Annee Sociologique* group developed a tradition that is continued in the structuralism of Levi-Strauss. And while Bourdieu takes issue with the Durkheimian model, the social determinism that works via the formation of individual habitus indicates a continued fascination with what might be called Kantian subjectivity, and with the social bases of cultural classification. Certainly, the generation of schemes of classification and of social

distinction in the practice of social relations is an essential ingredient in
the formation of social and individual identity.

(Lash and Friedman, 1992: 4)

The movement from the early to the late Durkheim depicts a move from
form to content. The *Rules* instances a firm positing of society as a concrete
reality and implies an abstract and implicit concept of the person within this
model; man as consciousness emerges as an epiphenomenon of society. In the
place of a member's consciousness the *Rules* substitutes collective responses
to constraint. Such positivism sets a strict limit to human understanding and
creativity – the limit being not merely the isolated individual's sense impression,
but the sense impressions of the individual as a compelled member of a unified
collective consciousness.; The collective consciousness is thus the teleological
representation, the ultimate and finite reality structure.

In the later Durkheim, symbolism is produced as fundamental to cultural
formation; it can give rise to the self as potentially analogous to society but also
as potentially different from that society. Thus symbolism is consciously creative,
its occurrence and its interpretation – both by lay members of particular forms
of society and by Durkheim as the methodological architect of these different
forms of understanding – distancing the sign from the signified. The capacity to
symbolise opens up the distinction between objects-in-thought and objects-
in-reality which were conflated in Durkheim's early realist epistemology. The
content of the person is now imbued with potential and choice. Durkheim
articulates this sense of diffusion between the collective and the individual
representations through his concepts of the 'sacred' and 'profane'. Initially, the
presence of sacred things provides a substantive criterion for the existence of
religion. Sacredness, then, denotes religiosity.

At another level, this common characteristic of all religious belief – namely,
the recognition of the sacred and the profane – presupposes a classification of all
things, actual and imaginary, into two opposing domains. The two realms are
not alternatives, they are profoundly distinct, ranked in terms of power and
dignity, and insulated by antagonism and hostility.

> The sacred is par excellence that which the profane should not touch,
> and cannot touch with impunity.
>
> (*EFRL*: 40)

The two orders jealously patrol their own boundaries to prevent the con-
tamination of one by the other and thus the perpetually revivified structure
of interdictions or taboos serves to keep things apart. Transition from one
realm to the other is not wholly precluded, but it requires not movement but
metamorphosis.

At yet a further level Durkheim's notions of the sacred and the profane reflect
the experiential tension between the social interest and the personal interest. The

sacred may be seen to represent public knowledge and social institutions, and the profane represents the potential of individual consciousness – it is that which is always threatening to bring down the sacred; it is that which, in Douglas's (1966) terms, promises 'danger'. The bifurcation of human interests provided for by these deep structural binaries reveals the grounds of the epistemological differences between the mechanical positivism of the early Durkheim and the organic hermeneutic of the late Durkheim, and these grounds are moral.

> Douglas selected for inclusion a part of Herz's book on the hand . . . in which he argues that the distinction between right- and left-hand-edness concerns the sacred and the profane. He saw this as a widespread distinction that could not be explained in terms of 'nature'. He did not deny that there were physical differences between the two sides of the body, he only denied that such differences explained the consistency with which diverse cultures affirm the priority of the right hand. Herz's interest in the hand derived from the fact that it stood for an abstract principle – the sacred and the profane must be kept separate and their relationship strictly controlled for the sake of (a sense of) order.
>
> (Jordanova, 1994: 253)

The early work proceeds from compact, continuous symbols. Such symbols occur as social facts which are contingent upon mechanical perception; we feel their constraint, we observe their presence. Their sacredness derives from their reification (or substantively their deification) into constant components of a consensus world-view. This characterises the method; it emanates from close, shared, uncritical communities of thinkers – its moral imperative is a demand for obligation, a membership of unquestioning allegiance.

The later Durkheim takes up a concern with the potency of diffused, fragmented symbols. This is a symbolic universe potentially populated by varieties of egoism. Within such a model all shifts towards the ascendance of the individual over the collective threaten to produce a crisis in our classificatory systems – a deregulation, a condition already predicted in *DOL* as 'anomie'. With reference to primitive religion Durkheim shows us in the *EFRL* that the 'totem' is in itself symbolic of the social group that produced it as a totem. Thus proliferating groups within any social structure 'objectify themselves' in material objects as totems; the totem then acts as an emblem which the member identifies with and thus, through identification, remains part of his group. Elementary methodic practices, like ritual, can now be seen to involve the periodic celebration and renewal of collective sentiments by way of the symbolic totem.

The impact of the study of totemic religion on Durkheim's later epistemology, then, is that totems seem to demonstrate the beginnings of understanding. Totems are not the things themselves; they stand for or in the place of things and forms of relationship – in this sense they are metaphoric. Thus they instance a break from the continuity provided by compact symbols between material reality

and consciousness; they act as a mediating order whose status derives from the work of interpretation. Totems, then, belong to difference in that they require the individual to relate to them as something other than they manifestly are; totems also are derived from difference in that they are brought into being through an elementary affective division of labour. In both these ways totems are potentially profane; that is, they most forcefully give rise to the tension between consensus understanding and belief, and individual interpretation. To live in a world of diffused symbols but to share that world requires self-conscious discipline and commitment, not a sense of obligation of allegiance. Pressing this point into a technical metaphor we might draw on Virilio (1994) who states that:

> Seeing and non-seeing have always enjoyed a relationship of reciprocity, light and dark combining in the passive optics of the camera lens. But with the active optics of the video computer, notions like toning light down or bringing it up change completely, privileging a more or less marked intensification of light.
>
> (Virilio, 1994: 73)

The organic epistemology rests on the distinction between the sign and the referent; things are not as they appear. Their appearance is contingent upon intentionality, which is saved from animilism through a theoretical commitment to a principled way of formulating the world. This is the community experience of the shared totem of an elected tradition. The constraint inherent in the positivistic mechanical model, comprised of '*sui* generic' and the spatialised consciousness, now requires individual representation. The organic form of life is ordered, as it is social, but its order derives not from determinism but from interpretation and reflexivity. It presents itself reflexively as a formulation which is open to and available for reflexive formulations. The disciplined character of this new way of realising the world depends not on obedience to external methodological rules but on a thoughtful explication of grounds – its availability. This subtle normative order may be likened to the experiential constraint of taboo, but the sacred writ is no longer clear to us, as Durkheim has told us:

> the old gods are growing old or already dead, and others are not yet born . . . it is life itself, and not a dead past which can produce a living cult.
>
> (*EFRL*: 427)

The rules are no longer clear and we are freer because of this. Our responsibility, however, is to constitute the social world and to believe in those constitutions for, as Durkheim says, we can no longer receive the world with a fixed stare; that is, from closed systems of knowledge:

for faith is before all else an impetus to action, while science, no matter how far it may be pushed, always remains at a distance from this. Science is fragmentary and incomplete; it advances but slowly and is never finished; but life cannot wait.

(*EFRL*: 431)

Seeing is no longer believing, we must believe and we are thus enabled, reflexively, to see. That 'life cannot wait' is sufficient as grounds and manifesto for the emergent and proactive visionary. Durkheim's double vision was no absolutist triumph over the will; his dual ways of being/seeing provided inspiration and fortitude in the face of modern and late modern tendencies to blur and distort both the boundary and the category contained. Though images became unclear and indecisive with the progress of the century some certainty, through moral and altruistic purpose, was provided by Durkheim's view. His purpose must remain, however, for the active theorist *qua* social member to peer onwards and yet beyond. The postmodern visionary is no longer bound to concerns with the dimension of 'heaven to earth' in ensuring pure sight, but rather with a concentration on horizons for the combined human and political purposes of providing fixity in the face of nausea and future in the face of time's end.

References

Alexander, J. *Durkheimian Sociology: Cultural Studies*, Cambridge: Cambridge University Press, 1988.

Bourdieu, P., *The Field of Cultural Production*, Oxford: Polity Press, 1993.

Chaplin, E., *Sociology and Visual Representation*, London: Routledge, 1994.

Douglas, M., *Purity and Danger*, London: Routledge, 1966.

Hirst, P., *Durkheim, Bernard and Epistemology*, London: Routledge, 1975.

Jay, M., 'Scopic Regimes of Modernity', in S. Lash and J. Friedman (eds) *Modernity and Identity*, Oxford: Blackwell, 1992.

Jay, M., *Downcast Eyes*, Berkeley: California University Press, 1993.

Jenks, C., 'The Centrality of the Eye in Western Culture', in C. Jenks (ed.) *Visual Culture*, London: Routledge, 1995.

Jordanova, L. 'The Hand', in L. Taylor (ed.) *Visualizing Theory*, London: Routledge, 1994.

Kuhn, T., *The Structure of Scientific Revolutions*, Chicago: Chicago University Press, 1970.

Lash, S. and Friedman, J. (eds) 'Subjectivity and Modernity's Other', in *Modernity and Identity*, Oxford: Blackwell, 1992.

Lucbert, F., 'The Pen and the Eye: The Politics of the Gazing Body', in S. Melville and B. Readings (eds) *Vision and Textuality*, London: Macmillan, 1995.

Lukes, S., *Emile Durkheim: His Life and Work*, Stanford Calif.: Stanford University Press, 1985.

McHugh, P., 'On the Failure of Positivism', in J. Douglas (ed.) *Understanding Everyday Life*, London: Routledge, 1971.

Mestrovic, S., *The Coming Fin de Sècle*, London: Routledge, 1991.

Parsons, T., *The Structure of Social Action*, New York: Free Press, 1968.

Smith, J. 'Three Images of the Visual: Empirical, Formal and Normative', in C. Jenks (ed.) *Visual Culture*, London: Routledge, 1995.

Thompson, K., *Emile Durkheim*, London: Tavistock, 1982.

Virilio, P., *The Vision Machine*, London: BFI Press, 1994.

Part II

RETHINKING THE VISUAL IN ART

The challenge to contemporary theorizing

5

READERS OF THE LOST ART

Visuality and particularity in art criticism

Nigel Whiteley

The motivation to write this chapter arises from an unease – even a dissatisfaction – with much contemporary art criticism. The dissatisfaction is at its greatest when I compare much criticism with my own *experience* of art, whether that art is 'high quality' 'old master' paintings, or 'interesting' contemporary experimental work. The encounter with an artwork can be engaging, absorbing, fascinating, deeply satisfying, moving, life-enhancing, stimulating, humbling, frustrating, or even infuriating, and it cannot simply be put into words. These seem to be responses shared, at one time or another, by many people. Yet contemporary criticism, largely because of its intellectual(ist) preoccupations for reading artworks as texts so as to deconstruct their meanings, tends to ignore or dismiss a response which takes into account the qualitative and/or particular experience of art. The reader loses out twice: the attention to art is lost amidst intellectual interpretations and, with it, there is lost an art of critical looking.

What I want to focus on in this chapter is what I argue is a major limitation of contemporary art criticism, one might even suggest its blindness: its reluctance or inability adequately to deal with the visual particularities of individual artworks. Such a limitation reveals nothing less than a significant partiality in the hermeneutics of the visual, and a major weakness in dealing with or doing justice to visual experience. My critical response is not reactionary, because it is based on an acceptance of the expanded field that contemporary criticism has brought about in relation to art and our understanding of its more hidden or assumed values. However, it is revisionist in that, while accepting the broad scope of contemporary criticism, it seeks to redress an imbalance in what has become an 'ocularphobic' orthodoxy with its 'denigration of the visual'.

The chapter begins by assessing some of the salient characteristics of both 'old' and 'new' criticism in order to gauge changing attitudes to, and values of, the visual. It then goes on to look at the significance of the formal analyses of particular works and the ends which those analyses serve. This leads on to a discussion of the role of judgement and quality in criticism, including the move by some 'new' critics to reject the visual and prioritise the textuality of

the artwork and its interpretations. Finally, I argue against the shortcomings and 'blindness' of intellectualism, and argue for 'critical looking' and a re-evaluation of sensibility in criticism.

'Old' art criticism

The historical and conceptual necessity of the expanded field that contemporary art criticism has brought us can be underlined if we revisit 'old' art criticism. *Painting in the Twentieth Century* was a widely read book, stocked by most institutional libraries after it was published in German (1964) and English (1965). It was written by Professor Werner Haftmann, a well-respected academic who was one of the organisers of the Documenta exhibitions in Kassel, and who served on the Jury of Award for the Guggenheim International Award in 1964. Haftmann had an awareness of art that was not, in other words, either merely historical or provincial, yet his critical writing in *Painting in the Twentieth Century* verges on the trite and hagiographic, and represents traditional criticism at its worst.

A lengthy extract will suffice to show the worst characteristics of this 'old' art history and criticism. When writing of the work of Henri Matisse, for example, Haftmann gushed:

> Matisse is the Frenchman *par excellence*: . . . His sensibility is bent upon extracting the simplest formula of beauty from all his emotional responses . . . His arabesque is extremely economical, but in the clear curve of pure line the artist reveals his heart to the viewer, as though taking a deep breath of joy. It is the secret of Matisse and his French genius that the vigorous, autonomous life of his ornament of colour, line, and light is never divorced from the object, but stresses its reality as a springboard for the sensation that touches off the formal play and raises it to the plane of a higher artistic reality. 'I have always seen everything just as I have painted it,' says Matisse, 'even the things that critics have set down as clever, arbitrary ornament. I have invented no form.' And yet he did invent something: with the help of combinations of line and colour he distilled from the visible an aesthetic formula, and so perfected this formula by sensitive and intelligent work that it became a reality in its own right, a statement of man's creative mind, which transcends nature. It is a formula which implies acceptance of the created world – the joy of existence – but also asserts the lofty freedom of the human mind.[1]

This sort of adoring, breathless prose is hardly critical. Nor does it raise any sort of issues which the reader can think about further. Instead, the reader is presented with a series of evaluations which are neither discussed nor explained (the preceding paragraphs in the book do not lead up to these judgements in

any explanatory way). Authorship is paramount to this type of criticism. First, the critic himself (in Haftmann's case) is the central authorial voice, providing evaluations that are authoritatively given and apparently without need of explanation; and, second, the artist, the subject of the criticism, is the 'genius' creator who, in and through his secret, mysterious and God-given gifts, 'reveals his heart to the viewer'. The artist is allowed a voice to explain his intention, but it is never challenged or queried – what the artist says is what the art is about. Together, the critic and artist reinforce one another's credibility, status and authority. The genius artist is the missing link between the mortals and the immortals: his work is nothing less than a 'statement of man's creative mind, which transcends nature' and a manifestation of 'the lofty freedom of the human mind'. The critic, in this scheme of things, is the artist's earthly representative: the priest who officiates the mass worship and who, in so doing, is conferred something of the artist's genius. Another, even more sceptical interpretation, casts the critic as the artist's marketing agent who hypes up reputation and status.

When one reads Matisse described as 'the brush-wielder and paint manipulator *par excellence*, the quiet, deliberate, self-assured master who can no more help painting well than breathing',[2] readers might assume they are still in the company of Werner Haftmann. In fact, this quotation is taken from Clement Greenberg's 1949 review of a Matisse exhibition. For postmodernists of various persuasions, Greenberg is the nadir of criticism: authorial, autocratic, and immodestly confident in his own judgement. Art and its criticism, as far as Greenberg is concerned, are uncomplicated matters which do not have to take into account gendered or social audiences and reception. The quality of the artist's work was all, and so,

> In my opinion the highest praise an artist can be given is to say that, even when many of his individual works are not completely achieved in their own terms, their general, 'floating' quality is so strong and ample that it serves to move the spectator as effectively as only the master-pieces of other artists can do.[3]

Greenberg's talk of masterpieces, allied to his praise for 'self-assured' masters *par excellence*, seems to put him on a par with Haftmann, but Greenberg is a more critical spectator and writer who avoids the hagiographic and offers a rather more balanced judgement. In the same review, for example, Matisse is chided for, at times, executing 'superficial work, [and] he may do so for years'. In his later work, Greenberg continues, Matisse's talent had begun to 'thin out and that the emotion which had moved us in his masterpieces of the years before 1920 was being replaced by virtuosity'.[4]

Greenberg may be more rounded than Haftmann in his criticism, but is this merely a question of degree with the same critical agenda? Can one attach significance to the glimpses one has in his writing of the thinking behind Greenberg's

judgements? For example, Greenberg adjudges Matisse's *Large Interior in Red* of 1948 'the best picture on hand, and the only one felt through as completely in design as in colour . . . a masterpiece'.[5] A brief description of some of the salient points of the picture are presented by way of indirect explanation:

> he puts his picture together in accordance with the implicit rule of easel painting and arrives at a massive simplicity that pertains more to the Italian Renaissance and classical antiquity than to the Orient. In the *Large Interior in Red* a few rather simple rectangular forms are played against a few somewhat more complicated ovals, all these embedded in an intensely red background that swallows both floor and wall in the same abstract space.[6]

At least Greenberg is paying some attention to particular works so that the reader can relate description and evaluation to one another. This is, I would argue, an improvement on Haftmann's disembedded judgements with which the reader or spectator cannot even begin to engage because they are not tied to particularities. But the dominant values and assumptions of Greenberg's discourse, with its conventional, authorial, artist-centred terms of reference, become crystal clear when one compares his criticism to that of a 'new' art history and criticism writer.

'New' art criticism

In an essay which first appeared in 1973, Carol Duncan analyses Matisse's paintings from the point of view of gender relations and power – focusing on the artist and his model. Duncan compares the assertive, suggestively promiscuous depictions of female nudity by artists such as Ludwig Kirchner and Erich Heckel, and concludes of Matisse: 'Rarely does he indulge in the open, sexual boasting of these other artists. Matisse is more *galant*, more bourgeois. A look, an expression, a hint of personality often mitigate the insistent fact of passive available flesh.'[7] This seems like the sort of damning praise which tars Matisse with the same brush, albeit applied with a lighter touch.

Duncan does deal with particular works to give weight to her assertions. Of *Carmelina* (1903), a painting of a seated nude behind whom there is a mirror reflecting part of the model and artist, she writes how the model is not overtly sexual, and this may lead us to think that Matisse is less guilty of objectifying women than some of his contemporaries,

> but the artful Matisse has more subtle weapons. From his corner of the mirror, he blazes forth in brilliant red – the only red in this sombre composition – fully alert and at the controls. The artist, if not the man, masters the situation – and also Carmelina, whose dominant role as a *femme fatale* is reversed by the mirror image.[8]

The general point that Duncan is making is that, in the late nineteenth and early twentieth centuries,

> the celebration of male sexual drives was more forcefully expressed in images of women. More than any other theme, the nude could demonstrate that art originates in and is sustained by male erotic energy. This is why so many 'seminal' works of the period are nudes. When an artist had some new or major artistic statement to make, when he wanted to authenticate to himself or others his identity as an artist, or when he wanted to get back to 'basics', he turned to the nude. The presence of small nude figures in so many landscapes and studio interiors – settings that might seem sufficient in themselves for a painting – also attests to the primal erotic motive of the artist's creative urge.[9]

Even in paintings which do not contain the direct presence of the model, gender is represented. Referring to *The Red Studio* of 1911, Duncan points out how eight of the eleven recognisable art objects

> represent female nudes. These literally surround another canvas, *The Young Sailor* (1906), as tough and 'male' a character as Matisse ever painted. Next to the *Sailor* and forming the vertical axis of the painting is a tall, phallic grandfather clock.[10]

The priorities of this kind of criticism could not be more different from those of Haftmann, Greenberg and other 'old' critics. The authorial intention and the focus on aesthetic quality is rejected in favour of the artwork as a text to be deciphered by the critic who deconstructs meaning in order to expose values and analyse social relations. Matisse is quoted by Duncan, but only to the extent of eight words, and these are used ironically by the critic to imply an economy with the truth by Matisse about his real intentions. Just as intention is of little interest or relevance to this critical project so, too, is the quality of the artwork. Whether *Carmelina* or *The Red Studio* are 'good' paintings is of no concern to Duncan, whose criterion of selection is the degree to which the painting reveals meaning. Visual characteristics may be commented on – as in the case of Matisse's red in the 'sombre' *Carmelina* composition – but only in so far as they signify meaning. Comments about visual quality are not made at all. The role of the critic as arbiter of taste and aesthetic judge is replaced by the critic as deconstructor and interpreter. Judgements are still being made but they are different in kind from those made by 'old' critics: with Duncan and 'new' critics we have judgements about the artist's attitude, assumptions and values regarding such matters as gender.

Duncan's essay is approximately twenty-five years old, and was written at a time when the 'new' criticism was trying to break the stranglehold of

traditionalism and establish a new agenda. The sometimes over-assertive tone, although historically understandable, has given way to a more measured approach that, in the words of Gill Perry, 'does not involve a "conscious" conspiracy on the part of Western artists such as Matisse or Picasso to distort or misappropriate'.[11] Perry points out how artists' values are absorbed, often unconsciously, from the society in which they operate and so, inevitably, an artwork will contain non-intentional meanings and dominant representations of contemporary values about such things as colonialism. For example, discussing Matisse's *Blue Nude* (1907), Perry, through careful documentation, exposes how Matisse chose 'an explicitly colonial subject. Since the conquest of Algiers in 1830 the country had been actively colonised by the French, and the primitivism of the work is tied to the contemporary rhetoric of colonialism.' Matisse saw North Africa as 'a lush peaceful paradise, with its connotations of "replenishment" for the civilised traveller', and Perry suggests the 'reclining sensual woman . . . functions as another symbol of this "primitive" oasis'.[12]

Perry's criticism shares much with Duncan's in its conclusion that 'this is still a voluptuous female nude luxuriating in fertile nature. The "primitive" – or colonial – subject is still implicitly gendered.'[13] However, Perry pays closer attention to the visual particularities of the painting and shows how

> the various technical devices employed by Matisse upset some of the conventional expectations (both artistic and ideological) aroused by the subject of an oriental nude. The technique appears both crude and artful. Space is ambiguous, combining a mixture of modelling – or facetting – with flatter areas of colour. This spatial ambiguity is further emphasised by the odd distortions in the woman's body, which frustrate some of the associations of the odalisque pose. These distortions are indirectly related to the forms of 'tribal objects', and some details, such as the bulbous breasts and exaggerated shape of the buttocks, are common features of African statuettes. The nude woman also assumes an impossible pose, a dramatic form of contrapposto, which further confuses the conventional sexual connotations of the theme.[14]

This is astute looking by Perry, typical of her criticism as a whole, and goes beyond the somewhat simplistic visual analyses of Duncan's. Duncan 'reads' the work unidimensionally, seeming to assume that a visual form has a single meaning: the work as a whole is just the aggregate sum of its parts. Perry's more visually attentive reading leads her to conclude that

> Matisse's image cannot be read *simply* as an exotic luxury item for male consumption. In this painting the means of representation are to the fore, and they serve to confuse or frustrate an easy reading of the woman as a passive (and primitive) sexual object. The distortions, the artfulness, help to produce an image which is less obviously erotic, and

less clearly 'feminine', in which the sexual relations are less explicitly conveyed than in the manner of [for example] Ingres' *Bain Turc . . .*[15]

Perry is looking at the means of representation as well as the end to which they are put, and exploring meaning as the relationship between the two. This greater complexity avoids the reductivism of the unidimensional critical approach evident in Duncan's criticism, and upholds the 'artfulness' of the work as a painting. It is significant that Perry concludes her discussion of *Blue Nude* by quoting Matisse 's remark that 'If I met such a woman in the street, I should run away in terror. Above all I do not create a woman, *I make a picture.*'[16] The inclusion of such a quote not only accords some status to the intention of the artist – the quote is not being used ironically or to reveal a contradiction – but highlights the constructive relationship between the means and the end of representation, and that they cannot be collapsed into simple signifier.

' . . . not optics but graphics'

As I declared at the beginning of this chapter, my views about contemporary criticism are not based on a lack of sympathy with the 'new' critical project, but are an attack on this criticism when it denigrates the visual and reduces art to mere signifier of meaning. The ambivalence I have towards 'new' criticism came to a head with the publication of an essay by Griselda Pollock in 1993 entitled 'Trouble in the Archives'. The essay expertly summarises the development of the 'new' art history and criticism, and reminds the reader that feminist art history and criticism, as a central ingredient of the wider critical changes,

> had to challenge one of the fixed ideas which still dominated both contemporary art and art history – namely that art is purely a *visual* experience, that it is not shaped in any way by language, and that it is independent of all social factors. Whether as formalism or aestheticism, these ideas made it impossible to raise the repressed question of gender.[17]

Pollock does not exaggerate the dominance of Greenbergian Formalism in the later 1960s and early 1970s, which not only prioritised sight but also dismissed interpretation and content. Such an exclusive notion of art did a disservice to the variety and range of art practices, let alone come to terms with art as visual representation. To challenge the disreputable assumption that vision was neutral and 'innocent' was necessary and urgent, and the contribution of critics such as Duncan and Pollock herself cannot be underestimated.

The shift away from the visual led to an engagement with a wide and inclusive range of relevant concerns including 'issues of training, patronage, access to exhibiting facilities, languages of art criticism, mechanisms of the market, the nature and effects of materials and specific making processes, as well as with the

semiotic and ideological productivity of the "image" itself'.[18] One of the major outcomes, as we now know, was a contestation of the very idea of the canon, because

> the canon inscribes a masculine fantasy in the archives of art's histories. These masculine inscriptions tell a tale of narcissistic fantasy of masculine omnipotence, freed from the real social and parental constraints to which men have to submit as the price of their privileged status in patriarchy. When feminism questions that canon and contests that fantasy it makes 'trouble' in the archives.[19]

The constructive 'trouble' that the 'new' criticism caused should be seen in its proper perspective which, in Pollock's opinion, involves nothing less than

> a major shift from traditional art theory. The art work, especially in the form of painting, is not treated as 'the window on the world' or the 'mirror of the soul' where vision is pure and the artist a kind of visionary. Instead, art is perceived as something made, produced, by a social mind and a psychically-shaped body which 'writes' upon its materials to produce a series of signs which have to be read like hieroglyphs or deciphered like complex codes. The real realm is not that of optics but graphics.[20]

The significance of the 'real realm' being 'not optics but graphics' is a point to which I shall return. At this juncture, the comment which needs to be made is that the shift as described by Pollock has some of the hallmarks of the fundamentalist's passion or the puritan's public disavowal of visual pleasure. As we have seen in Duncan's criticism of Matisse, 'old' values and methods were not just comprehensively revised, but wholly rejected. This may have been understandable in 1973, but Pollock is writing 20 years later when an acceptance of the visual in a modified way is apparent in the writings of 'new' critics and historians such as Perry.

Particularity and formal analysis

Pollock herself has made the important point that there is a 'delicate balance to be held in feminist art practice between its commitment to feminism and its specificity as an art practice'.[21] That balance, she would presumably agree, needs also be to reflected in criticism. Nor is that balance restricted to feminist art practice and criticism – tendencies in feminism are largely symptomatic of wider tendencies – and so Pollock's point is equally applicable to the broader contemporary critical situation.

The specificity of art practices as well as the particularities of individual works were accorded close and sensitive attention in the best of 'old' criticism. As an

example of 'old' history and criticism, Norbert Lynton's *The Story of Modern Art* (1980) has all the weaknesses and faults one would expect of traditionalist writing: it operates *within* art; it takes for granted the validity of the values subscribed to by the artist in particular and by Modernism in general; it does not debate the meanings of the subject matter, nor conjecture on the implications of the work in terms of social, cultural or political values. But its strength – within, I repeat, the limitations of its approach – lies in its examination of particular paintings. A lengthy quotation of Lynton's analysis of *Madame Matisse: the Green Line* (1905) makes the point. In the painting,

> the colours, however surprising in themselves, firmly support the forms and so do the brushstrokes: where they are vehement they serve to clarify and confirm. The hair is blue with glimpses of bright red; the background consists of areas of orange, purple, and blue-green; the face is pink one side, yellow and green the other, and a pronounced band of lime-green goes down the middle of it from forehead to chin and on to the neck. This sounds arbitrary yet the effect is convincing: a bold account of the features of a handsome woman. Another painter might have modelled the head with forceful shadows to give it sculptural presence: Matisse achieves it through colour contrasts that produce an optical tension similar to that given by lit areas and shadows. He does not have to lose part of the face in shadow or tone down the vividness of any part of his picture.[22]

The strength of this criticism is that Lynton is visually *scrutinising* the painting: studying it closely so that the reader/viewer no longer just notes or glances at the painting, but *sees* what is there and how it is put together. Unlike Formalism, which rejects or ignores everything in an artwork but the qualitative relationship of the formal elements, the formal analysis of a work can be conjoined to other types of analysis so that the visual scrutiny of what can literally be seen can be studied in relationship to reception, meaning and content.

Formalism is an exclusive system of value, and it tends to the autocratic. Bell committed himself absolutely to his 'aesthetic judgements in the rightness of which I have the arrogance to feel considerable confidence',[23] and Greenberg, certainly, is guilty of that arrogance which enabled him to feel he can give judgement without explanation. Formal analysis, on the other hand, is a methodology which can serve a range of values depending on the extent to which the analysis is carried *outwards* into wider social and cultural matters. Perry's formal analysis set up a dialogue with colonial values; Lynton, as an 'old' critic, is content to dwell on the formal. What he does usefully do is offer the reader a possible explanation of the source of Matisse's manner of representation:

> many African masks propose that a face is to be understood as two broad planes either side of a central ridge. It is possible that Matisse's

representation of his wife's face came directly from what he saw – from two sorts of light, perhaps: daylight on her left cheek and reflected light, tinted by whatever surface reflected it, on her right. Knowledge of African masks may have guided his reading of the face.[24]

This provides the viewer/reader with both the experience of scrutinising a work, and the reason for the form of representation.

It is worth noting that Lynton refers to Matisse's 'reading of the face', a comment which bears a similarity to Pollock's claim that 'the real realm [of art] is not that of optics but graphics'. However, the similarity is superficial and the difference significant. Lynton's use is a general one which, in this instance, refers to Matisse's treatment of the face or way of working – the types of visual marks that he employed, and their sources. The 'reading' is part of a *visual* language of forms. Pollock's use of words associated with reading is not analogical but literal in the sense that the artwork is a 'text' 'written' by an artist and 'read' by the viewer. Any specificities of the medium or the practice, any distinctive features relating to the class of the object, are ignored as the artwork is de-differentiated to become merely a sign which connotes meaning. A painting is just a visual signifier in the way that a cartoon or a poster or a film still are visual signifiers – all are levelled out as vehicles of meaning, texts which are to be read and interpreted rather than (also) aesthetically or visually experienced or responded to.

Pollock's position is one that challenges the once-held belief that 'art is a purely *visual* experience, that it is not shaped in any way by language, and that it is independent of all social factors'. It is a position that assumes that no radical or thorough-going analysis of the visual arts 'could be developed which did not deal with questions of the visual – namely, who is looking and who is looked at, why, and how and with what effects'.[25] These positions were timely in the post-Greenbergian climate when the innocence and autonomy of the visual needed to be challenged and comprehensively renegotiated. However, Pollock seems not to take into account the later developments in 'new' criticism which, while upholding the fundamental positions that are rightly dear to her (and many of us), also re-differentiates media and practices in order to gain a richer, less ideologically unidimensional understanding. Perry's engagement with the specificities of a particular work – its distinctive visual features and the way they relate to meaning – is a model that Pollock seems unwilling to follow, with the result that her assertion that 'the *real realm* is not that of optics but graphics' has about it the same intolerance and absolutism as Bell's or Greenberg's claims that nothing mattered other than the visual. A 'denigration of the visual' is maintained, leaving one with the conclusion that Pollock is unaware of the implications of her statement that a 'delicate balance' needs to be held between the artist's political commitment and the specificity of the art practice. Surely this is what Perry is achieving in her discussion of Matisse's *Blue Nude*.

Perry and Lynton both engage with the visualness of artworks but, as one would expect given their critical orientation, each uses the engagement differently. Perry is largely descriptive about the painting, analysing the 'means of representation'. Lynton is also descriptive but mentions how the colour effect is 'convincing'; later he comments on the painting's success and how Matisse's paintings of the period are 'dynamic and searching'.[26] Both critics analyse what we might call the 'visual characteristics' of the paintings, but Lynton also addresses 'visual qualities'. The distinction is the difference between a close scrutiny which is not explicitly judgemental, and a close scrutiny which includes evaluations of worth.

Judgement and judgementalism

The issue of judgement on aesthetic quality is one which sharply divides 'old' and 'new' criticism. Clive Bell's belief that 'great art remains stable and unobscure because the feelings that it awakes are independent of time and place'[27] meant that the critic's role was one of giving judgement on quality. Whether the work was 'interesting', 'influential', 'significant' or full of meaning mattered not a jot – this was the sort of assessment left to the art historian, that 'science-besotted fool'.[28] What *did* matter was whether it exhibited 'significant form' – the 'one quality common to all works of art'.[29] In the 1960s Clement Greenberg announced that 'in the long run there are only two kinds of art: the good and the bad. This difference cuts across all other differences in art.'[30] Even in the period of 'new' criticism, Greenberg was still pronouncing that 'value judgements constitute the substance of aesthetic experience. I don't want to argue this assertion. I point to it as a fact . . . '[31] He qualified this statement by admitting that

> Of course, there's more, and should be more, to art criticism than the expressing of value judgements. Description, analysis, and interpretation, even interpretation, have their place. But without value judgement these can become arid, or rather they stop being criticism. (A bad work of art can offer as much for description, analysis, and interpretation – yes, interpretation – as a good work of art . . .)[32]

To someone like Pollock, the value of an artwork lies in the extent to which it illuminates cultural and political conditions and so, indeed, its quality as a work of art is immaterial.

This 'new' position has been most clearly stated by the New York-based critic Thomas McEvilley. Discussing directly the role of the critic in postmodern culture, McEvilley opines:

> The living critic comes to realise that the least interesting thing he or she has to offer is a value judgement – such dicta are finally about as

relevant to the rest of the world as what flavour of ice cream the critic prefers.

The critic will come to see art as culture and culture as anthropology. Anthropology in turn will increasingly become a means of critiquing one's own inherited cultural stances rather than of firing value judgements in all directions. The critic will see that he or she may investigate, analyse, interpret, compare, gather together and sever apart – but not attempt to enforce his or her value judgements on others; of all things, that will be the most direct betrayal of the reconsidered critical project. The purpose of criticism will no longer be to make value judgements for others, but to sharpen the critical faculty and its practice through all of culture. Ultimately the art historian will come to view value judgement systems as objects of anthropological and sociological interest, not as carriers of truth value.[33]

In determining the 'reconsidered critical project' to be a deconstruction of signs and signifying systems in order to critique 'one's own inherited cultural stances', McEvilley is in sympathy with Pollock. The status of value judgements is the benchmark: Bell and Greenberg claimed an exclusive criterion of judgement and its inclusive application; McEvilley seems to be rejecting any notion of judgement, however inclusive. Value judgements are dismissively relegated to the realm of personal and arbitrary likes and dislikes – they are, for him, entirely relativistic and subjectivist. Furthermore, that McEvilley uses the phrases 'enforce . . . on others', and 'make value judgements for others' is revealing. In politically correct times, being 'judgemental' is socially unacceptable. Quite right that it should be if it exposes intolerance of alternative points of view and a moralising attitude, but to confuse 'being judgemental' with value judgements shows not just a collapse of terms, but a collapse of critical thinking and responsibility. It is also an easy way out.

Critics have used value judgements well and badly. Greenberg was often guilty of delivering a value judgement as if a papal edict: authority was absolute and unchallengeable, and the rationale, like the Holy Ghost, invisible if not mysterious. Lynton, on the other hand, makes 'soft' value judgements that are not proclaimed loudly, but which grow, almost imperceptibly, from the descriptive and analytical analysis. They highlight rather than blind or overshadow. That McEvilley uses the phrases 'for others' and 'on others' also reveals his assumption that judgements are inevitably imposed in an unwelcome, authoritarian way and that they disempower the supposedly passive viewer/reader. I believe the reverse is true. A critic employing value judgements in conjunction with analysis and explanation *empowers* the viewer/reader, not only by helping the recipient pay close attention to the work, rather than just notice it without studying it, but also because value judgements accompanied by analysis and explanation facilitate the viewer/reader form her or his own informed judgements over time, which may include rejecting those of the initial

criticism. Value judgements can be part of an intolerant regime; equally they can be part of an ongoing, informed, critical and tolerant debate about quality.

In what can only appear as a contradictory statement following on from the last quotation, McEvilley states that 'considerations of quality in formal terms will not lose their place in the art discourse, but they will be revitalised for different cultural settings'.[34] It could be said that this is exactly what critics like Perry are doing – shifting from Formalism to formal analysis in relation to subject matter, content and meaning. This does, indeed, enable the critic to 'investigate, analyse, interpret, compare', etc. and 'sharpen the critical faculty and its practice through all of culture' but, in so doing, it does not preclude value judgements, even if most critics prefer not to make them overtly.

Quality and 'ideological impositions'

McEvilley feels aesthetic value judgements are possible but not desirable or politically correct; Francis Frascina, an academic and critic, would seem to believe they are neither possible nor credible. In a book of 1993, Frascina, almost as an aside, states how he wants to

> distance . . . [himself] from those who argue for a distinction between Ingres and Bouguereau on grounds of 'quality', between Ingres as an inheritor of the elevated ideals of 'high art' and Bouguereau, a *pompier* artist . . . We have to be wary of such distinctions, which may be ideological impositions of retrospective evaluations.[35]

Frascina's criticism deals directly with 'ideological impositions'. When reviewing the 'American Art in the Twentieth Century: Painting and Sculpture, 1913–1970s' exhibition held at the Royal Academy and Saatchi Gallery in 1993, Frascina refused to engage in any discussion about artworks and quality and, instead, attacked the ideology underlying the exhibition which he described as a 'deeply reactionary manifestation of a myth about the positive images of a proper society'. In 'American Art',

> The USA is presented in a post-Cold War, post-Gulf War ideological construction which erases the history of the relationship between art practice, domestic repression and US global policy to make the world safe for exploitation by its own corporate interests – a policy which has and still requires the installation and maintenance of brutal military or police dictatorships throughout the Third World.[36]

Such an exhibition made the host galleries politically tainted

> outposts of official White House history. The unsuspecting viewer is exposed to an undialectical imaginative excess of the USA as the

creative force for white, male individualism and unfettered expression. And the narrative basis of this exhibition is a Modernist myth, long since discredited, which is sustained by a fear of what its adherents regard as the dark secrets of lived experience.[37]

The review continues in this way, concluding with the sentiment that this is 'another mega-financed instance of the hermetically sealed bourgeois universe'.[38] Here we have criticism as ideological deconstruction – 'new' criticism at its most hard-line and uncompromising in its unwillingness to entertain conventional notions of art and authorial intention, or be sidetracked into judgements of visual quality.

Strongly ideological criticism such as Frascina's is perfectly legitimate for an exhibition such as 'American Art'. Any general or thematic exhibition of this kind is bound to invite discussion of issues of selection criteria, relevancy, historical representativeness and value. Frascina's comments on the absence of politically engaged art involving work by African-Americans, Hispanics, Latinos and Native Americans are well-made. There is no attention to particular works, but any such attention would positively – in this instance – distract from the important issues Frascina is raising.

However, in some of his other reviews, the absence of attention to visual particularities is a major critical limitation. Frascina's review of the 1994 Franz Kline exhibition is the occasion for another attack on 'ideological imposition', this time 'the secular legacy of "the religion of art" . . . in a pristine white chapel':

> White walls and the fetishisation of the materialism of the paint surface preclude the visualisation of the effects of Nixon and McCarthy: anti-communism and existentialism; the Hipsters and the Beats; T-shirts and suits; art market money and critical ambition; husbands painting in studios whilst wives paint in the small spare bedrooms . . . Information is not merely socio-historical *context*, it is the means to enable viewers to locate the codes and conventions within which works and meanings were and are produced.[39]

Again, this critical position is perfectly reasonable, exposing as it does the historical decontextualisation that occurs when historical work is severed from the context in which it was produced. Frascina's criticism is seeking to recover something of the meaning that Kline's work had at the time, but the weakness of this type of criticism is exposed when it comes to discussing the actual artworks. According to Frascina,

> One of the aims of these artists' work was to offend the middle-brow tastes of tyro collectors whilst maintaining an uneasy balance between so called 'pictorial form' and the inevitable associations, most notably

in Kline's work, with landscape and silhouettes of industrial and dock sites. Works such as these are thus on the verge of conventional meaninglessness or pretentiousness, carrying negative connotations of the limits of modernist abstraction; or they are positive tracks of the body as maker of shape, texture and form where 'meaning' is developed through the construction of a painting series.[40]

Frascina argues that visual representations 'can only be understood as *non-mythologised* forms of knowledge and experience when access to information is guaranteed'. But, just as it is necessary to provide the materialist history which Frascina cites, so too it is necessary for the critic to deal with the actual artworks in some depth to point out the two-way trade of forms, readings and meanings. Without a reasonably detailed discussion of the visual characteristics of particular works and the way in which they materially signify meaning, how can we be convinced of the way they reveal the 'limits of modernist abstraction' or function as 'positive tracks of the body'?

Without paying attention to particular works, the critic is in danger of being marooned in a sea of generalities which could be applied to any artist working in this milieu. The reader has a right to an analysis of Kline's work in relation to the wider political issues, otherwise the critic, in making the same broader points as in other reviews, becomes repetitive and predictable. The critic could work in such generalities that s/he does not even need to have visited the exhibition, merely ascertain whether it is a conventional 'white cube' format. The review could be generated wholly from the armchair and lap-top when the actual encounter and engagement with particular works is not seen as relevant. Surely the critic owes it to herself or himself, let alone the readers, to respond directly to the assembled artworks of a particular artist, even if the experience turns out not to dent her or his preconceptions. At its worst, non-particular criticism like this seems like it can be bought off-the-peg and *in absentia*, rather than made-to-measure from a personal fitting. In its anti-visualness, it can be puritanical, arid, and bluntly unidimensional.

Given his distrust of evaluations of quality, it is surprising to find Frascina pronouncing that 'it is crass and reactionary to denounce work such as Kline's or de Kooning's or Rothko's as the daubings of the untalented or unskilled . . .'[41] If skill and talent are factors in their work, should not the critic take the level of talent into account and its relation to the expression of meaning? Surely an artist with talent and skill is likely to produce qualitatively superior work, not, of course, necessarily in any Formalist way, but in the way that formal expression informs and communicates content and meaning.

This possible contradiction aside, Frascina would evidently agree with Thomas McEvilley that 'the art historian will come to view value judgement systems as objects of anthropological and sociological interest, not as carriers of truth value' – the model of the historian/critic as social anthropologist. Inevitably, as they are historically located, value judgement systems are not simple truth carriers,

but reveal much about the society and cultural conditions in which they are forged. They are, indeed, worthy of anthropological and sociological interest as are all cultural values and manifestations. But distinctions on the grounds of quality cannot just be wholly reduced into irrelevancy, relativism or power struggles, in the ways that Frascina seems to wish. Frascina's position is certainly not always shared by those who might sympathise with the general thrust of his argument. The sociologist Janet Wolff is prepared to admit that 'I do not know the answers to the problem of "beauty", or of "artistic merit", and will only state that I do not believe this is reducible to political and social factors.'[42] And Frascina's erstwhile colleague and academic collaborator, Charles Harrison, has gone so far as to admit that 'it remains true that the most interesting and difficult thing about the best works of art is that they *are* so good, and that we don't know why or how (though we may know much else about them)'. Harrison went on to write that, 'unless we can somehow acknowledge the great importance of this limit on our explanatory system, we might as well give up. What would giving up be like? I suspect that it would be like becoming a social anthropologist.'[43]

Anti-visualness and intellectualism

As I have argued above, art criticism as a form of social anthropology is an important form of new criticism, not a failure or a giving up. However, it has its limitations, the most serious of which is when it needs to pay close attention to artworks but fails so to do. It might be argued that much actual art now is purposefully anti-visual, and that paying close attention is neither relevant nor rewarding. One response to the apparent dilemma is that to fail to study work closely because its particular visual characteristics are not deemed relevant would seem to be falling back into overemphasising intentionality and giving it too high a status. A recent example of anti-visual art/art criticism neatly highlights this issue.

Reviewing the '1965–1975: Reconsidering the Object of Art', held at the Museum of Contemporary Art in Los Angeles at the end of 1995, the London-based critic Michael Archer reassessed the nature and legacy of Conceptual art. Archer was in agreement with the exhibition organisers and saw Conceptualism as essentially opening up political and social discourses. A work such as On Kawara's *Title* painting, three magenta-coloured canvases with white texts that read, respectively, 'one thing', '1965' and 'Viet-nam' 'explicitly proclaims itself,' Archer argued, 'not only as an intercalation of object, representation and category, but also as an object that is historically specific and which is meaningful in a socio-political context'.[44] Archer deals in a perfunctory way with a number of representative conceptual works but, as an aside in brackets, remarks: '(incidentally, the striking thing about this exhibition as a whole is the degree to which it demands that the viewer look)'.[45] One would think that such a remark has a significance that merits explanation and discussion – many

114

issues are raised by this remark, not the least of which is the presence of visual particularity and its relationship to meaning. Perhaps this is what Archer is hinting at, but it remains unexplored and unresolved. Not following through his remark cannot be good criticism, but it may not be untypical.

Avoiding visual particularities, whatever the anti-visualness intended by the artist, frequently leads to either pretentious, over-generalised or sloppy criticism which, ironically, emphasises the authorial voice and turns the critic into a virtuoso performer. One of the extremes of bad criticism in recent years was the catalogue which accompanied the Hayward Gallery's 'Doubletake' exhibition of 1992. The exhibition was largely berated; the catalogue merits similar disacclaim. For example, we are informed in the main essay by Lynne Cooke that, in his apparent copying of Bridget Riley's work, Philip Taaffe 'manoeuvres an almost lethargic semi-automatic response through several registers without at the same time pretending to radical revitalisation. This etiolated savouring of one's memories of one's former responses requires a kind of distance that Taaffe's paintings deliberately refuse to sustain.'[46] The 'notes on the artists' in the catalogue explain that Taaffe's paintings

> are collages in fact and spirit, fusions of historical moments embodied in decorative styles that still live on around him. Much more than functionless, the designs he uses carry emotion both in their original forms and in the accretions to which they have been subjected over time. As an artist, rather than a historian or a sentimentalist, Taaffe neither invokes nor ignores these forms' specific sources. Instead, he pays homage to the intellectual continuum from which they come, the impulse to geometric interpretation of human thoughts and aspirations.[47]

It is claimed that 'the atmospheric range of his work' persuades 'us of the value of complexity'. The author here seems to be confusing complexity with pretentiousness.

In the case of Mike Kelley's installations of teddy bears, some arranged having picnics, Cooke's essay quotes the artist who tells us that,

> 'Because dolls represent such an idealised notion of the child, when you see a dirty one you think of a fouled child. And so you think of a dysfunctional family. In actuality', [Kelley] continues, 'that's a misreading, because the doll itself is a dysfunctional picture of a child. It's . . . an impossible ideal produced by a corporate notion of the family.' The Freudian tenet [comments Cooke] that culture is built on repression is dear to Kelley, whose focus on toys serves to underline the hypocrisy in the notion of the innocence of childhood, and the sublimation of sexual passion. In confronting the adult's halcyon collective notion of childhood, and his or her reconditioned memories

of the infant's first manifestations of affection and regard, with the soiled and worn residual evidence Kelley stirs actual memories, many of which are buried almost beyond recall, and therefore acknowledgement. The sullied toy becomes metaphorically the site of a conflict between the wish for mint condition dreams and the stained memories of actuality.[48]

As a viewer/reader, one is struck by the gap between the banality of the visual experience and the 'meaningful' interpretations supplied both by Kelley and Cooke. In passing, it is worth mentioning that the relationship between Cooke and Kelley is very similar to the relationship between Lynton and Matisse – the critic is wholly in sympathy with the artist and does not distance herself or himself from the artist's pronouncements and claims. Both are interpretative rather than critical, albeit drawing on entirely different forms of interpretation – where Lynton examines the particular visual appearance with insight, Cooke does not mention any particulars, and keeps her criticism at the level of abstractions and speculation.

In Cooke's criticism, symptomatic, for me, of the worst kind of 'new' criticism, the banality and impoverishment of the particular visual object seems hardly to matter. The artwork seems like a pre-text which plays the same role as a preface in a book – sometimes no more than a kind of necessary acknowledgement to play the game, but something to be moved on from summarily to the real substance of the main text. The artwork is reduced to an *illustration* of the text in Cooke's criticism (and Kelley's art), the logical but absurd conclusion to Griselda Pollock's dictum that 'the real realm' is 'not that of optics, but graphics'. One is reminded of Yve-Alain Bois's attack on 'arrogant, ignorant, predatory texts that consider painting a collection of images to be tracked down, illustrations to be captioned'.[49]

There is, then, a tendency in 'new' criticism, whatever its undoubted benefits, to denigrate the visual and downgrade visual scrutiny. As I have stated previously, my argument is not one of opposing the artwork being interpreted as text, but that this should be done by engaging with the visual particularities of the artwork. Not to do this *reduces* the artwork to mere text – it de-differentiates practices and is tantamount to the colonisation of the visual by the literary. Even an artist such as Terry Atkinson, who declares his aim as that of 'circumnavigating the limits of "the visual"',[50] still creates particularised visual objects which can formally be analysed to show by means of which strategies, techniques and representations they achieve their aim. Without this, we have intentions, claims and interpretations, but not convincing demonstrations.

The reference to Atkinson's work underlines the fact that my argument does not assume a model of art as visual quality. Equally important are visual characteristics and their relationship to meaning: it potentially accommodates diverse artistic practices and values. What it demands of the critic is visual scrutiny – careful looking – to whatever end. Not to deal with visual particularities is

almost certain to lead merely to speculative criticism, which foregrounds the critic as author and star, or to cleverness, pretentiousness, simplistic ideology, or intellectualism, the danger of which was expressed by the philosopher Daniel Herwitz when reviewing 'A Forest of Signs' (1989), the Los Angeles Museum of Contemporary Art's precursor to 'Reconsidering the Object'. Artists in the exhibition included Jenny Holtzer, Cindy Sherman, Richard Prina and the aforementioned Mike Kelley. According to Herwitz, too many artists in the exhibition relied on 'either slogan or image to instantly engender thought, or on heavy doses of theory (especially Baudrillard) to do the work for them in which case one had better dispense with the exhibition entirely and read the books)'.[51] Of Prina's *Upon the Occasion of Receivership*, a set of 61 works on paper which contain translations of a sentence about translation into various groups of languages, Herwitz finds its meaning opaque 'until one reads in the catalogue that Prina is influenced by post-structuralism, and even then how that myriad of theories relates to this object still remains opaque. The work lacks the focus required by visual art to direct thought.'[52] Herwitz contends that, 'in reducing the materials of critique to a set of images these artists are . . . monosyllabically reducing the powers of critique, whether the big guns of theory that drive their images . . . inflate them with the very hype and self-exhibition of self-importance that is the problem they intend to address'.[53] Herwitz rightly concludes that 'you cannot simply place a found image before the viewer with a tag of theory on it and expect that something serious will happen in the encounter with the object or gesture'.[54]

Critical looking and sensibility

For many critics, it would appear that there is a directly inverse ratio between the artwork and the interpretation – the less visually demanding the artwork (teddy bears picnics or appropriated canvases), the more intellectually demanding the theory and interpretation of the artwork. Robert Hughes makes the point that visual experience cannot be reduced to text without significant loss, that a concern with meaning and theory does not

> exhaust the content of the art as art, or ultimately determine its value . . . It revives the illusion that works of art carry social meaning the way trucks carry coal. It . . . relieves the student of the burden of imaginative empathy, the difficulties of aesthetic discrimination.[55]

To practise 'imaginative empathy' and apply 'aesthetic discrimination' – to whatever ends – requires sensitively developed skills and abilities: it cannot be achieved readily by a 'tourist' from another word-based discipline. The experiencing of a work of art is not the same as the reading of a text – the linearity of the latter is unlike the experiential nature of visually scrutinising. The critic needs to practise *critical looking* which combines formal analysis

(whether of characteristics or values) and interpretation. Those from a whole range of non-visual disciplines bring major insights and ideas into the interpretative aspect of the venture; but the 'looking' aspect requires experience and nurturing before truly *critical looking* – with both words fully served – comes into being where 'critical' and 'looking' are fused together and continually interrelate and inform.

Critical looking demands an intelligent and sensitive engagement which makes one *see* the artwork, rather than just glancing at it in the way most visitors to a gallery look at works. It may involve standing in front of the artwork for some considerable time, and it underlines the difference between seeing the work 'in the flesh', so to speak, and seeing it merely reproduced as an illustration in the catalogue. Working from the illustration, rather than the actuality, skews the critic's response and shifts it towards general meaning, unmediated by the experience of the individual artwork which, as we all know, can confound us and overturn the way we thought we would respond to it. A concern with direct looking does not contradict the intellectual and intelligent discussion of the work in terms of its meaning – it is complementary. It allows us to move almost simultaneously in two directions: from the general to the particular and vice versa.

Critical looking requires sensibility, a word which needs to be rescued from the foppish connotations of the aesthete eulogising about beauty. For, unless one thinks that visual art can be reduced to words, sensibility – which combines visual intelligence and sensitivity – is necessary to guide us through the visual experience. In 1939, the fibre artist Anni Albers made a plea for the value of visual experience over interpretation:

> Layer after layer of civilised life seems to have veiled our directness of seeing. We often look for an underlying meaning of things while the thing itself is the meaning. Intellectual interpretation may hinder our intuitive insight. Here education should undo the damage and bring us back to receptive simplicity. It is obvious that a solely intellectual approach to art is insufficient and that we may have to try to redevelop those sensibilities which can lead to immediate perception. Only thus can we regain the faculty of directly experiencing art.[56]

Alber's remark still has great substance – indeed, I would argue that it has increasing substance as criticism deals less and less with the direct experience of art, and both art and criticism become reductively intellectualised.

In the light of the downgrading of sensibility in much contemporary criticism, it is timely to revisit Susan Sontag's 'Against Interpretation' essay of 1964, because many of its warnings are again relevant. Sontag saw in contemporary criticism 'an overt contempt for appearances', arguing that 'the effusion of interpretations of art today poisons our *sensibilities* [my italics]. In a culture whose already classical dilemma is the hypertrophy of the intellect at the expense

of energy and sensual capability, interpretation is the revenge of the intellect upon art.'[57] The characteristics of our culture are described as 'excess . . . [and] overproduction; the result is a steady loss of sharpness in our sensory experience. All the conditions of modern life – its material plenitude, its sheer crowdedness – conjoin to dull our sensory faculties . . . What is important now is to recover our senses. We must learn to *see* more, to *hear* more, to *feel* more.'[58]

Sontag also warns against a reductivism in criticism: 'By reducing the work of art to its content and then interpreting *that*, one tames the work of art. Interpretation makes art manageable, comfortable.'[59] Sontag cannot be described as a Formalist who, by her very position, is unsympathetic to interpretation, nor is she likely to underestimate the contribution of the 'new' criticism; but the misgivings about the impoverishment of the experience of the artwork have lasting relevance. Her response to the question of how criticism should be written is similar to the argument I have offered in this essay:

> What is needed, first, is more attention to form in art. If excessive stress on *content* provokes the arrogance of interpretation, more extended and more thorough descriptions of *form* would silence. What is needed is a vocabulary . . . for forms. The best criticism, and it is uncommon, is of this sort that dissolves considerations of content into those of form . . .
>
> Equally valuable would be acts of criticism which would supply a really accurate, sharp, loving description of the appearance of a work of art. This seems harder to do than formal analysis.[60]

If one substitutes the word 'caring' (which could mean 'loving' or just 'with care'), one would encompass criticism which deals with visual characteristics as well as quality. Sontag argues that 'the function of criticism should be to show *how it is what it is*, even *that it is what it is*, rather than to show *what it means*'. This is a view with which I can sympathise, so long as the word 'only' is inserted after 'show'. She famously concluded, 'in place of a hermeneutics we need an erotics of art'.[61]

An 'erotics' of art criticism may now, indeed, be what is needed to redress the imbalance which has resulted from an overemphasis in 'new' criticism on hermeneutics. As I have stated several times in this chapter, the 'new' art history and criticism has brought about major gains in our understanding of art and the institutions that provide its context but, after a quarter century of 'new' criticism, we are in a good position to take stock of gains – and losses. Although it is not symptomatic of all 'new' criticism, there is a clear – if not dominant – anti-visual tendency which is apparent in writers such as Griselda Pollock and Francis Frascina. With its references to art as 'something made [and] produced, by a social mind and psychically-shaped body' (Pollock), a reaction to any art which shows the 'undialectical imaginative excess of the USA' (Frascina), and any judgmental criticism which marks the 'betrayal of the reconsidered critical project' (McEvilley), we are witnessing with this tendency one of the hallmarks

119

of the legacy of the hard-line wing of Marxism which believes the aesthetic 'is reducible to political and social factors'. Any talk of visual quality is 'false consciousness' or 'bourgeois aesthetics' – Frascina dismisses this non-Marxist, Romantic legacy as 'expressionist theory masquerading as objectivity'.[62]

Frascina himself prefers visual representations which 'begin to threaten the orthodox certainties', such as Jenny Holzer's neon installations which provide 'many phrases which should make the exhibition organisers and catalogue authors [of 'American Art'] blush, if only they were capable of realising the meaning of these same phrases, which they use in their unreconstructed rhetoric'.[63] It does not seem to matter to Frascina if the artworks which threaten the reactionaries and make them blush are as visually arid, banal and unidimensional as the criticism which sometimes accompanies them, so long as they can be read as politically correct. But good ideology does not guarantee visually rich, stimulating or even interesting artworks however much we might wish that it were so. And to concentrate on ideology and meaning *at the expense* of the artwork is to sell art short, whether we study the visual qualities of a work, or its visual characteristics in relation to meaning. Criticism needs the sort of close attention to and careful scrutiny of the artwork, provided, at times, by writers as diverse in their projects as are Meyer Schapiro and Yve-Alain Bois.[64]

In reaction to 'old' criticism's fixation with the artwork as form as an end in itself, some 'new' criticism pays virtually no attention to the artwork. I am proposing moving beyond this understandable and necessary historical stage to a reorientation to the scrutiny of the visual. This does indeed represent a return in criticism to the artwork as a material and experiential presence, but, for the most part, this scrutiny will be part of a dialogue between form and meaning. To deny either the experience of art's particularity or, as previously happened, to inflate that particularity to an absolute end in itself, would be to maintain the unfortunate and destructive dualism of puritanical 'new' and complacent 'old'. A synthesis of the best of the two approaches is not only possible, but – as we have seen – available . . . it is *critical looking*.

Notes

1 Werner Haftmann, *Painting in the Twentieth Century: an Analysis of the Artists and their Work* (New York: Holt Rinehart Winston, 1965), p.76.
2 Clement Greenberg, 'Review of an exhibition of Henri Matisse' (1949), in John O'Brian (ed.), *Clement Greenberg: the Collected Essays and Criticism*, volume 2 (Chicago: University of Chicago Press, 1986), p.292.
3 Ibid., p.293.
4 Ibid., p.292.
5 Ibid., p.293.
6 Ibid., p.294.
7 Carol Duncan, 'Virility and Domination in Early Twentieth-Century Vanguard Painting' (1973), reprinted in Norma Broude and Mary Garrard (eds), *Feminism and Art History* (New Haven: Yale University Press, 1982), p.300.
8 Ibid.

9 Ibid., p.306.
10 Ibid., p.307.
11 Gill Perry, 'The decorative and the "culte de la vie": Matisse and Fauvism', in Charles Harrison, Francis Frascina and Gill Perry, *Primitivism, Cubism, Abstraction: the Early Twentieth Century* (New York: Harper and Row, 1993), p.56.
12 Ibid., p.58.
13 Ibid., p.59.
14 Ibid.
15 Ibid.
16 Ibid., p.61.
17 Griselda Pollock, 'Trouble in the Archives', *Women's Art Magazine* no.54, September/October 1993, p.11.
18 Ibid.
19 Ibid.
20 Ibid. p.12.
21 Griselda Pollock and Rozsika Parker (eds), *Framing Feminism* (London: Pandora, 1987), p.54.
22 Norbert Lynton, *The Story of Modern Art* (Oxford: Phaidon, 1980), p.30.
23 Clive Bell, *Art* (London: Chatto and Windus, 1928), p.101.
24 Lynton, op. cit., p.30.
25 Pollock, 'Trouble in the Archives', op. cit., p.11.
26 Lynton, op. cit., p.30.
27 Bell, op. cit., p.37.
28 Ibid., p.102.
29 Ibid., p.8.
30 Clement Greenberg, 'The Identity of Art' (1961), in John O'Brian (ed.), *Clement Greenberg: the Collected Essays and Criticism*, volume 4 (Chicago: University of Chicago Press, 1986), p.117.
31 Clement Greenberg, 'The State of Art Criticism' (1981), in James Thompson (ed.), *20th Century Theories of Art* (Ottawa: Carleton University Press, 1990), p.102.
32 Ibid., p.104.
33 Thomas McEvilley, 'Father the Void' (1990), in *Art and Discontent: Theory at the Millennium* (New York: Documentext, 1991), p.177.
34 Ibid.
35 Francis Frascina, *Primitivism, Cubism, Abstraction* (New Haven, Yale University Press, 1993), p.120.
36 Francis Frascina, 'American Art?', *Art Monthly*, November 1993, p.19.
37 Ibid.
38 Ibid., p.21.
39 Francis Frascina, 'Franz Kline', *Art Monthly*, September 1994, p.30.
40 Ibid., p.31.
41 Ibid.
42 Janet Wolff, *The Social Production of Art* (London: George Allen and Unwin, 1981), p.7.
43 Charles Harrison, 'Taste and Tendency', in A.L. Rees and Frances Borzello (eds), *The New Art History* (London: Camden Press, 1986), p.81.
44 Michael Archer, 'Reconsidering Conceptual Art', *Art Monthly*, February 1996, pp.13–14.
45 Ibid., p.15.
46 Lynne Cooke, 'The Site of Memory', in Hayward Gallery, *Doubletake: Collective Memory and Current Art*, exhibition catalogue (London: The South Bank Centre, 1992), p.34.

47 'Notes on the Artists', in ibid., pp.237–8.
48 Cooke, op. cit., p.27.
49 Yve-Alain Bois, *Painting as Model* (Cambridge, Mass.: MIT, 1990), p.246.
50 See Terry Atkinson, 'The Siren Song of Dualism', *Art Monthly*, November 1996, p.7.
51 Daniel Herwitz, 'A Forest of Signs', *Modern Painters*, vol.2, no.2, Summer 1989, p.84.
52 Ibid.
53 Ibid.
54 Ibid. p.85.
55 Robert Hughes, *Culture of Complaint* (Oxford: Oxford University Press, 1993), p.114.
56 Anni Albers, 'Art – a Constant' (1939), in *On Designing* (Middletown, Conn.: Wesleyan University Press, 1962), pp.45–6.
57 Susan Sontag, 'Against Interpretation' (1964), in *A Susan Sontag Reader* (London: Penguin, 1982), p.98.
58 Ibid., p.104.
59 Ibid. p.99.
60 Ibid., pp.102–3.
61 Ibid., p.104.
62 Frascina, 'American Art?', op. cit., p.20.
63 Ibid., p.21.
64 For examples of criticism which deal admirably with particular paintings in depth – in this case works by Mondrian – see Bois, 'Piet Mondrian, *New York City*' (1988), in *Painting as Model*, op. cit., pp.157–83; and Meyer Schapiro, 'Mondrian: Order and Randomness in Abstract Painting' (1978), in *Mondrian: On the Humanity of Abstract Painting* (New York: George Braziller, 1995), pp.28–34.

6

SEEING BECOMING DRAWING

The interplay of eyes, hands and surfaces in the drawings of Pierre Bonnard

Michael Phillipson and Chris Fisher

Pembs, May 1996

I have fixed the xeroxed copies of the Bonnard drawings (several of which I am already familiar with and close to from catalogue reproductions) to the wall around my desk; they constitute an intimate exhibition within which I can move and be moved without moving. In spite of the losses and the accentuations of the copying process, they retain their ability to amaze, seduce, and undo. I am sure that through this little collection we can explore together the differing and converging qualities of our relations to them, of how we are rivetted by and to them . . .

Notts, June 1996

I'm glad the copies of the drawings arrived safely. At this time of year, it is just before harvest and the air is full of tiny insects. Clouds of them come out as the corn is about to be cut and hang around in the air. They have the irritating habit of crawling behind the glass of any surface they can find, and dying. I look at the drawings on my way down stairs, and discover that they are pockmarked with tiny bodies from the night before. Black dots appear overnight on drawings whose surface is already a haze of marks. It is maddening. The drawings are put away from all this now. I have always liked the idea the Japanese have

of removing special things from sight at certain times of the year; then setting up selected objects in particular places where they can be viewed without visual interruption.[1] I have taken the Bonnard drawings down now, and pinned up a number of xerox copies in the studio. I think that I prefer these poor reproductions to facsimiles that strain so hard to be something they can never be. I find too that there is more room in the fog of the Xerox for the memory of the originals and I can let my imagination make up for what I no longer have in front of me. I do miss the drawings however now that they are not around. I get used to seeing them everyday, even if I just scan them as I walk by. Bonnard would not have been surprised about the way his drawings are now so cherished. He clearly valued them as much as his pictures, and, from what I can discover, he kept them by him all his working life.[2] When I think of the drawings now, I am confused by the fact that although I have lived with them for so many years, they are still images of 'nothing' to me. Nothing occurs in them. Many of them have no subject centre at all, as everything is expanding in a temporal field that stretches across the paper-space and out beyond its edges. Nothing stands long enough in the front of this white screen of the paper to secure the title of subject, and all the relationships are constantly being re-absorbed into a mush of the here and now. They are 'evidence' of non-events that I would not notice had they not been noticed for me. I could not make these drawings because I could not notice these particular moments of 'nothing' before they were turned into art for me by Bonnard . . .

Withdrawn from a familiar but ungraspable corpus ('Bonnard'), the drawings ensnare both of us, but necessarily differently. Starting in the midst of our different relations to Bonnard's work we are constituted as two libidinal involvements which provoke several 'voices' as our response. It will not be possible to either unite on a single analytic site or finally separate these intertwined overlapping but different 'voices'. They speak to the drawings' demand of us, to the ways they draw us out of ourselves, out of the 'I's' that know. Representing nothing but themselves-as-art's-work the drawings withdraw from knowledge's grasp, a withdrawal within which we are caught up and scattered: two 'I's' becoming multiple. Perhaps art is the other of analysis. Perhaps the unifying tendencies of analysis, of theorising, cannot be reconciled with the personal, the situated, the sensuous, the indexical qualities of the relation to works of art of human 'subjects', a relation which is a becoming-plural (the subject's undoing).

For us it is this plurality of response, the articulation of feeling-valuing-undoing through multiple voices, that constitutes how, if at all, art 'takes place'

in our culture. Indeed we suggest that 'place' itself is suspended in Bonnard's drawing. Something of this play of differences necessarily constitutes this writing. There are several 'I's' in play here (some already familiar to us and some not) and some voices for which there is no locatable 'I'. This is something we neither seek to nor could remedy through gathering them under a supposedly singular authorial 'I' or 'We' that would want to write from a place grounding analytical authority. Any 'we' in this text is a strictly temporary alliance. Yet the different trajectories of these voices do intertwine, overlap, cross, re-cross and mark each other. Perhaps it is art's virtue, experienced here in and as the particulars of Bonnard's drawings, to provoke both this awareness of plurality, of the undoing of the one, and to offer the possibility, however tenuous, of sharing, of merging, of becoming one again (but this time differently).

What constitutes the undiminishable provocative excitement of the drawings is precisely the way they require us to go our separate ways and, recognising this, to bring these differences 'together' without the need for a unifying analytical frame. We are thus concerned not with Bonnard, as if this named a life partially independent of the drawings, but with 'Bonnard's drawings'. Nor are we concerned to 'use' Bonnard's drawings as an occasion (an example of something outside themselves – drawing in general, drawing as Idea) or to construct a 'theory of drawing'. Rather it is the specificity of each of his drawings and the very particular variations that traverse them that enable us to group them as, precisely, 'Bonnard's drawings'. Each is a member of a singular corpus that is only multiple (a singular whole only in the sense of a now complete series), a corpus that can never settle into an identity but which is characterised by the way its concrete constituents (each drawing) come together as a swarming – a becoming-swarm.

We are thus taken out of ourselves by Bonnard-who-drew-and-painted, but here want to focus primarily on the Bonnard-who-drew. And if there are terms that seem to be given more weight or value beyond the boundaries of the Bonnard-who-drew, then we must emphasis that their use in this text is indebted to our relations to specific drawings. It is the difference of the concrete particular that draws us into Bonnard, the difference that each work (drawing) makes, and not an interest in some overarching thesis.

Given the circumstances in which the drawings were made, it is a small miracle that they have survived at all. They are so diminutive, so unassuming, that it is certainly not their size that has kept them from ending up in the bin. He has scribbled them down on odd bits of paper, scrawled them across the unused pages of his diary, or simply made them alongside a shopping list for tomorrow's lunch. He made them every day, of the everyday, thousands of days, thousands of drawings. It is bewildering. What is the 'everyday'? What are these drawings all about? How do they, as the re-marking of the taken-for-granted, reconstitute the 'everyday' itself? How do they, as constituents of Bonnard's own everyday life as a drawer (which was precisely to mark the overlooked, the unnoticed, the

Plate 6.1 Pierre Bonnard: *La Seine, près de Vernon, c.* 1920, pencil (11.4 × 14.9 cm)
Source: Print supplied by Chris Fisher; copyright ADAGP, Paris and DACS, London 1998

in-between, hence taking away its everydayness) participate in our everyday life? These are drawings both absolutely immersed in and to one side of the everyday. By probing at what's 'in' a glance (across a sun-filled garden, towards a river caught by the wind, at a nude in the bath) they open up not the 'meaning' of the glance, but the question of how the glance, how his glancing, is caught up with 'place', with how glancing 'takes place' or loses itself to 'place'. The everyday relies on 'place'; it 'takes place' by holding its placing work in reserve thus making 'place' unremarkable – a seen but unnoticed condition of its own taken-for-grantedness. In the intensity of Bonnard's remark of the unremarkable, glancing is both overwhelmed and preserved.

In his *Critique of Everyday Life* Lefebvre quotes Hegel: 'The familiar is not necessarily the known.' He is clearly fascinated by this remark and goes on to say:

> Let us go farther and say that it is in the most familiar things that the unknown – not the mysterious – is at its richest, and that this rich content of life is still beyond our empty, darkling consciousness, inhabited as it is by impostors, gorged with the forms of Pure Reason, with myths and their illusionary poetry.[3]

Bonnard seems to love the immeasurable illusion of the everyday passing in Time. The constant rubbing of the surface as he works, is his way of invoking

126

the phantom of Time as an image until it appears to claim its own presence without a fixed name and place. Each line, each dot traces the motions of the superficial, and the endless exchange between the material and immaterial, between the meaningful and the meaningless. He particularised this flow back and forth through the disintegration of bodies in light and the placed marks registering a flash of his own being.

Notts, 16 June '96

I think you can tell that Bonnard is infatuated with temporal and profane time in our private existence. He sees the rich muddle of our domestic life and reflects it back to us in all its glowing clutter through the representations of corporeality in his images. Even the casual passing of the weather is caught on the run as it happens, around him, to him, on the house, within the day. Mornings, evenings, impending rain and blankets of snow, become screens of layered, absorbing immediacy. People, children, animals, everything in fact, is laced together through the transfiguration of light. In Bonnard's paintings all these events are suspended in coloured matter that looks like it is made of expanded pollen. Everything is noted and stirred into a coloured cloud of atomised marks. Bonnard used colour in his work to affirm the sensuality of the world. It becomes a celebration of daily instances, sorted and sifted into a blazing field of particulars. In the late pictures there is no figure, no ground, just surface; everything is blocked out and filled in with colour. The air is thick with a tinted dust, made from countless dabs of paint that prod and poke the surface into a sensuous and wrinkled skin of moments. I can hardly look at them because their atmosphere is quite suffocating . . .

In his black and white drawings this is never the case. Each image is organised as a tiny micro-dot framed around a non-event, a happening so uneventful, so breathless with its own immediacy, that it took something as radical as his art to bring it to our attention. Each drawing homes in on an ensemble of distant sounds, tuning up, yet playing so quietly that they become almost inseparable from the background hum of our domestic noise. Each one has a surface that is made up from sets of provisional marks that catch a vanishing moment and spread it across a shimmering skin of the 'now'. They are precariously balanced, suspended somewhere between finite descriptions of a slurred domestic action and the rush of the immediate on its way to becoming forgotten.

In attracting so little attention for themselves the drawings take enormous risks. By ignoring the separation between the exceptional and the mundane, they open up for us a place of danger and confusion. Where no clear area is secured and demarcated for the re-enactment of significant meaning, the lines of social force that delineate sense from non-sense are confused, and the categories that keep apart the divine and the secular become blurred. At this moment we are in risk of tangling up the cultural values that separate the spiritual from the worldly and, through this collision, of infecting the purity of one with the impurity of the other. Our deeply felt social need for rituals of distinction is undermined and we slide uneasily between the two. The drawings designate a new site of signification hidden in our lives that is usually lived out unnoticed through the drone-like duties of our mundanity. They are asking us to question the boundaries of the significant, as they destabilise the metaphoric divisions between legitimate subjects for our art practice and private time.[4]

This new site of significance is the 'ordinary'. Each mark parallels an escaping moment lost in a banal event. He makes drawings that query our common fictions about being invisible when we are hanging out the washing or talking to the cat. In doing this Bonnard instantiates 'nothing' itself as a special 'event'. Instead of asking us to applaud these candid representations as something revolutionary, the drawings shyly introduce the more difficult task of picturing the inconsequential in a memorable way, a way that undoes what we take for granted in our work of representing anything. They register a haze of purpose which is woven into the texture of our lives and usually lost to us through the banality of our domesticity.

Everydayness is suffused by this 'inconsequential', for the latter is that from which nothing follows: the little nothings that do not (seem) to matter. These little nothings are the places where what matters loses and erases itself. Yet it was precisely 'that which did not matter' that Bonnard transformed into matter, for the drawings materialise, convert into matter, the immateriality, the absence, of that which is to one side of' the flow of consequences – the unplaceable condition of all our lives.

Each drawing records a peripheral event and the churning of our daily pastimes. What can be so interesting about this everydayness? Do the drawings take another (the first?) look at all that has been ignored the first time around? Do they allow a second chance to see those minor experiences that are about to pass into the mulch of the forgotten? How are they so articulate about events that are so small, that have no dominant voice, just the hum of their own continuum?[5] And why Bonnard-who-drew today? Aren't these drawings 'out of their time', past their sell-by date? Wouldn't an engagement of a contemporary drawer draw us more directly into the 'relevance' of drawing today, of drawing to art and life now, of drawing to today?

We want to suggest that the drawings' attraction for us lies precisely in their effect upon 'today', upon what we take for granted in the way 'today' passes (our passing through 'today' as a passing by), upon the dailyness that inheres in

what all of us 'know' as everyday life. They press upon us more vitally than ever when 'dailyness' is suffocated by an excess of representation, a superfluity of images which pose no question about themselves or their emergence, or about what it is to emerge into the light, to make a region, a neighbourhood. The everyday is pure obscurity; we have to obscure it to get by. It is the always hazy indeterminacy of that which surrounds the givens of representation. And, as this indeterminacy (the unclear, the unlit), obscurity poses a threat to anything that seeks to affirm the clarity, the unquestionable status of all the representing work that sets up the parameters of our daily lives. The obscure 'threatens in its non-recognition the sovereignty of an integral light'.[6] This 'integral light' (ideology?) is what we are immersed in in everyday life; it is our element, 'that which causes us to breathe and, at the limit asphyxiates us'.[7]

For ideology (the State) the obscure is always a threat, suspect, precisely in its indeterminacy (it will not, cannot, be placed). Blanchot calls this indeterminate manner of being 'everyday indifference'. It is what Bonnard draws without ever seeking to turn it into something else (information). While preserving obscurity, his drawings open onto the oblique that always escapes 'the clear decision of the law' with its integrating light.[8] The work of drawing here disintegrates what we take the 'integrating light' to be. If everyday indifference (a certain mood, a certain neutrality, an obliquity) is the subject matter of Bonnard's drawings and paintings, it is what he makes appear in its uncertainty, without ever resolving it in favour of (a) determination. The drawings make different, draw out, the unspeakable indifferent. They give us, show us, the giving in what is given; they offer us the grant, the granting, in what ideology insists that we take for granted and learn to forget. They render visible an unsettling zone, surrounding every-thing which is settled by ideology, by technoscience, by the empiricism of daily life. In this surrounding zone nothing is settled and this nothing is what Bonnard draws.

Bonnard seemed to see the way things jostle for our attention and then drop into memory. He seemed to see the vapour trails they leave in their fall from the level of anxious necessity, downwards to that of the forgotten and unremarkable. He noted those activities that are not substantial enough to carry grace and pass unremarked on from one act of unreflection to the next. Bonnard's still-lifes are images of grace adrift and going sour. Their wrinkled skins of colour and clouds of jumbled tones suggest a complete change in our ontological state, where eternity has begun to decompose and the humus of life is pungent, fleshy and fallible.[9]

Bonnard's 'drawing machine' gave up on both 'will' (and its obverse, 'deep subjectivity'), by making small works at great speed; his machine, to one side of illusion, had nothing to do with representation, with offering us an image of the relation between an original (model) and a copy. It was only about drawing out a relation, art's relation, to indifferent everydayness. The speed of the manic machine enabled the leap out of everydayness, making the unremarkable remarkable.

[Postcard] Notts, 5 July 1996

I think a better understanding of his place in contemporary painting only comes about if we understand that he paints something that has always been there in a unique way . . .

Plate 6.2 Pierre Bonnard: *Paysage valloné, c.* 1925, pencil (11.7 × 15.6 cm)
Source: Print supplied by Chris Fisher; copyright ADAGP, Paris and DACS, London 1998

When he draws the landscape he makes marks that start at the very end of his nose. Nothing has concrete measure; everything has a relative size and hesitant form. A field boils in full sun, the rain on distant hills soaks the tree line and smudges together the earth and sky. All these are constituted in lines and dashes that make a complicated, responsive, shorthand that spreads across the paper like a spore and creates a freshly mixed materiality. Each mark re-enacts the physical, as it holds the phenomenal moment down and flicks the result across the whiteness of the paper. In the struggle of the here and now with the going and the gone, these partial signs run breathlessly alongside the transient moment and refuse to become a pictorial dogma. Although 'fixed' by Bonnard's touches they refuse fixity.

Bonnard's touching practices take us across the threshold of language to its other side, bursting through its outer skin, towards a zone where the 'written' mark, the letter, the word, the figure, the line, the smudge, the dot, caress language into oblivion. Perhaps these little touches open onto what Bonnard's marking 'does': how his drawings withdraw us from language – the difference between the outer surface of language as thought from within (meaning) and Deleuze's parallel 'logic of sensation'. For us it is not the eye–mind relation that Bonnard draws out but how in the haptic (how Bonnard touches the paper's surface), the optical, the manual, and the erotic coalesce in drawing's becoming. Drawing multiplies sight, gives it a new dimension, taking it out of itself. This is how Deleuze characterises the haptic: 'when sight discovers in itself a function of touching that belongs to it and to it alone and which is independent of its optical function'.[10] Bonnard draws us into the way this functionality works, how the hand becomes something other than just a prosthetic of the eyes, how it 'functions' to render the eyes' work and yet has a life of its own – absolute independence.

Pembs, July 1996

It seems to me that in much analytical-critical writing, 'eye' is a gloss for the work of two eyes, two eyes made one, the production of a singular screen, a working and becoming together – perfect-coordination. In the intensity of his touching Bonnard becomes a drawing machine whose hands draw out of him (and in so doing withdraw, outdraw, the ego of the phenomenological subject) something that the eyes had not seen in advance – the drawn marks that expressed nothing, nothing that was already there within (on vision's screen), but something that the hand alone offered to the eyes for the first time. This something is the hands' essential gift to the eyes. That relation, that interdependence (of eyes, hands, and touch), is the absolute concentration of energies into a seemingly singular combination of differences without totality, boundary, unification. Different singularities come together: eyes as one eye, hand(s) as singular (not four fingers, a thumb and a palm) and thus a pure grasping hold that moves across a surface – a traversing by touchings, a multi-directional movement producing a 'chaosmos' of marks. Bonnard offers us, then, drawing as a holding operation. It is as if Bonnard's hand(s) is a scout for his eyes, in advance of his eyes, leading them out of themselves into the 'new'.

131

Identities crumble and reform as Bonnard draws. He makes work that shows the wonder of the light from a window, the meeting of steam and flesh in water, and the melting of the day into the night. Everything glows, everything becomes its own burning bush.[11] In his garden, categories separating plant, object and subject dissolve. The owned and the disowned blur into one state. His garden is inclusive; it gathers its own outside. When he looks across his gardens, he sees through them in the sense that each becomes his medium, the trembling suffusing substance that allows him to embrace the beyond. The gardens that, seeing through, he offers us, are not separations, enclosures, formalisings, controllings, subduings of 'nature'; they are rather ways of allowing the familiarity of the domestic environment, the feeling of being in 'one's own place', to flow out into the open. His drawing activates this mutual embrace. The drawn gardens hint at a kind of edenic gardening – a garEdening – in which landscape and garden become each other, suit each other down to the ground. And if we are always beyond the beyond-the-garden that the drawings put into play, they suggest nevertheless, in the ways that they draw us in, that 'his place' and 'our places' could become 'one'.

Each drawing guards an essential paradox. A tactile screen juxtaposes the facticity of the work with a reluctance to fix anything down. This precarious state keeps the whole surface turning over. Nothing has a rigid place as this flow of uncertainties disrupts the compulsion to 'know' and 'fix'. It uncouples the 'what' from the 'how' and, by taking away the dominance of the first, allows you to linger with the second. Through doing this the work liberates the viewer from a dependency on the identifiable, from the preconceived, and reminds us of the aleatory nature of the drawings. To fully appreciate what has happened in the work, viewers must remake the drawings for themselves and rediscover the difference between fantasy and invention. Lines cluster in shapes and creep towards differentiation without finally becoming separate identities. They coerce and push towards a particularity without settling into a mask of likeness that ends only in mimicry. It is very unnerving to be so convinced by a series of disabling signs that undo categories of knowledge and leave an uncertainty in their place which then becomes even more convincing. It is not that they do not account for the world in any substantial way, but rather that their means of becoming seem to ignore the anxiety to fix and to classify. Images break up and their unstable relations are interwoven with the current of passing time. Materials become phenomena and these, in turn, become sheer pulse. Our concern here is with how this pulse beats across from the drawings to drive our response and our relation to them, how the libidinal attraction of a body of work by one artist might 'work', why it is that (having seen one of his drawings) we are drawn endlessly to search out and endlessly (so far) to return to as many others as we can: to enquire into the hold that they have over us.

I think that the underlying structure of each drawing seems to be a combination of a lived experience, the flux of the world and the turn of a card. Bonnard's intuition of the Real is not based on rigid a priori formal structures. Everything is so ontologically frail that space itself becomes an unstable sea in which he swims like a very shy fish . . .

Of course, all artists have their own way of doing something – a visual code which seems to come both 'already in place' yet is only 'self-evident' afterwards. This code contains a human history, a personal past that cuts out an internal and lived particular from the general universal, and from this an unseen combination of touchings emerges. But this singularity can be so intense that it can obscure the sheer range of choices and risks involved in the process of creating a work. The 'already in place' is made up of the limitless number of possible options available, and the drawing is the result of reducing the endless choices to the inevitable which makes up the work and where it finally becomes 'self-evident'.

Each drawing contradicts a single view of its own beginning and shows a pure antagonism towards the simple dialectic of cause and effect. Each becomes an actualisation of duration itself and, in its own complex way, attempts to share domestic chaos with the mimesis of art. Without becoming potentially lost in endless, unremarkable events, it cannot open itself out to enough possibilities. It must risk being ordinary and being consumed by our life's insatiable hunger for dross. So unless the work runs the risk of not encountering and recognising its own being, it cannot become a work. It must confirm its own genesis at the same time as risking failure and non-appearance. Through the friction between Will, Desire, Fortune and Luck, the act of making acknowledges both hope and disillusion at the same moment. Little wonder that the ancient Greeks loathed and feared these forces which forever follow us through our lives.[12] This risk and this acknowledgment generate Bonnard's ways of marking that draw us out of ourselves and into a zone of indeterminacy where representation is suspended on behalf of other possibilities.

Bonnard's marks, drawn out, set down, onto, into, a surface, are in a certain register (a 'key' perhaps): they register a certain whirling suspension, the work of trying to remain suspended, to hold onto position itself, within that medium which is without resistance, which has no substance, which allows free-fall, and yet where a certain upholding happens. The marking holds (us) up within the zone of no resistance – the marks register, enact, the suspension. Their hope is to leave us, the receivers, in permanent suspense because we cannot get past them to a zone that is free of them (even though this is what they seem to open

Plate 6.3 Pierre Bonnard: *Paysage Provençal*, *c*. 1940, pencil and black pencil which is
not quite graphite (16.5 × 24.8 cm)
Source: Print supplied by Chris Fisher; copyright ADAGP, Paris and DACS, London 1998

us to – a zone before their arrival). Nor do they take us to some place this
side of the zone because they do not represent anything; they come before
resemblance: they are the coming and going of resemblance.

Pembs, August 1996

Under the sway of Bonnard's 'Paysage Provençal' drawing of 1940 I am
no longer sure of hanging onto an 'I'. It is an absorbing atmosphere. I
could describe my journeys through it, writing out how I entered the
drawing through the unusually large area of paper left untouched or,
perhaps, suspended myself in the 'space' created by this 'white band'
(a band without a boundary) that stretches across the bottom and up
both sides. I could talk about a 'sky area', relatively dark, loosely but
closely worked over with intertwined swirls and horizontal slashes,
weighing down oppressively on the vegetal masses spread out into the
white openness beneath. But this would barely touch how the drawing
works me over, withdraws me. Description falls prey to representation,
to the representation of the viewing-as-journey. Better rather to put a
question back to the drawing about the first 'thing' that it strikes me with

– its decline of representation. This necessarily turns me aside from the analytical question of how to represent truthfully what the drawing does; for one cannot represent a lack of representation.

What it gives me as a condition of a relation with it, a condition of entry on its terms, is a space that is like no other (that cannot be assimilated to art's multitude of other spaces); it is a space of unlikeness, without resemblance, and yet I can see 'it', recognise it, as a landscape. This drawing needs that landscape yet it is not the landscape that touches me but the drawing in its dissimilitude: its difference cuts into me, forcing a void between sets of conventions which I inhabit routinely and this specific array of marks amongst which I flounder.

A possible space (becoming atmospheric) takes me over both in spite of and through the marks, a tension due entirely to the marks' lack of any descriptive or representational values. This is dizzying because the marks carry me beyond the ways in which we fix ourselves conventionally in nature, and that nature is 'itself' fixed within conventions. The drawing's work is an undoing of the memory's continuities, the metonymic chains of representation that sustain the identities of things and ourselves inhabiting the world together. The drawing challenges me to feel myself into 'treeness' or, rather, to become-tree, to image the way a tree might become. The central 'band' of the drawing offers me a vegetal-becoming: differences between trees, shrubs, and pastures are maintained and elided in an intermixing that proposes a radically other 'time–space' – those alien rhythms within which the vegetal becomes what it is. The coming and going of the vegetal (growth, decay) will remain forever elsewhere for us, yet Bonnard brings it before me here. I can never know what it is like for stems of grass to put on a metre's growth under two weeks' worth of Provençal summer sun, while the tree expands itself by half a centimetre under the same conditions, out of the same earth. But Bonnard pulls me into this difference through his delirious mark making. To be with, to approach these becomings in their radical inhumanity, Bonnard had to become other, to begin to become vegetal, to offer us a world where these becomings are taking their places entirely outside our time–space. It is this other coming–going which this drawing pulls me toward. It is a becoming of mutuality, of interdependence, where the marks give and withold identity (e.g. the range of 'trees' are constituted through very different kinds of marks, and yet the marks are unboundaried so that one 'tree' (how can we be sure that they are what we call trees?) flows into what surrounds it; it is inseparable from the context of its placing).

135

The drawing challenges me, seduces me, to see through, not to the tree itself, but to the becoming-vegetal that we call trees. Vegetation is given its place which is not ours; this 'place' is the atmosphere of the drawing. The drawing draws me out of the flux of this metamorphosis. The density that I sense in this drawing is absolutely without opacity: the marks overlay each other producing a mad weaving without structure. There is no underpinning; there are no given norms, ways of dividing/ organising/judging space. It sucks me out of structure. Unprincipled, centreless, the marks allow us, offer us, no means of distinguishing between form and content. The only content is pure drawing. I am taken in to its atmosphere and set floating with nowhere to settle. Near and far are in the balance. Nor is there a 'correct' place from which to stand and look in front of the drawing. The place of the viewer is undone, disputed, in favour of the tiniest free-falls; for, lacking the horizonal point of convergence and disappearance of any perspective, I cannot stand any-where, there is no alternative to this floating fall. So what I see is not a 'landscape' (that is to say an ordered recession of planes from the near to far within which one could place oneself at a given distance from the 'subject matter'); this is not a 'scape' we can observe or survey from the outside . . .

In his working practice Bonnard seems to have absorbed and accepted the possibility of everything being useful to him. He neglected nothing that happened around him as potential material for his work. His drawings do not segregate the sense from the non-sense, and by being a full part of the grossest present, he gives up the usual guarantees of the conventionally important. Each drawing becomes a quiet conversation of signs without being a smug transcendental dialogue; there is no Platonic sanctuary beyond. Each drawing is made up of modest improvisations that seem more like vague notes to remind ourselves of ourselves. The more unlikely the 'language' of each work, the more poetically true it becomes as it creeps tentatively towards the Real. He shows us that we can only possibly approach this impossible place through taking the greatest risks and creating for ourselves new works of art. These drawings pull hard at any anchors that rely on metaphysical guarantees. Their roots are in our becoming-human and not in categories designed to raise or idealise us away from the living plain across which we all move and wander. They both confirm and question the ways that becoming-human is to live below the clouds and on the earth. This thin compressed layer is the place of our existence and the subject of all his work.

And yet it is precisely this 'place', the place of our everyday existence, that Bonnard's drawings unsettle. It seems that all the conditions which Bonnard

assembled as the terms of his working practice culminate in ways of making that constitute his drawing as a strategy (but not a method) of avoidance. The little fixings that his marks are, are dedicated to the avoidance of the fixities of place and placing. For perhaps what Bonnard draws out in the intensity of his looking is not the Real as some thing 'over there', but what Deleuze and Guattari call the 'percept', which is the intensity of the sensible; this intensity is 'what acts in depth and is incarnated in the visible world'.[13] Intensity provokes not the resemblance of 1 + 1 (drawing as mimesis), but the affinity of a merging, a coalescing, an interpenetration via contiguity, a breaking down of boundaries – drawing's immersion participates in the Real. Bonnard is revealing to us that what drawing draws is not 'nature' but the percept whose intensity tears it away from the conventions of perception that tie the latter to resemblance. Drawing gives us the difference that the intensity of the sensible makes to our becoming. The marks set up not place but perhaps 'atmosphere', where 'atmosphere' is that which, while we can see through it, heats, cools, suffuses, and overwhelms us. Atmosphere has a thickness which encloses and supports our becoming. This is what we 'feel' in the drawings – the thickness and solidity of the atmosphere that we have to see through in order to recognise 'place'. We are already within the drawing's atmosphere (thrown into it) because we cannot locate ourselves in a position of governance or control in front of it. This atmosphere suffocates each of our descriptions. They cannot handle the indescribable; they give up when overcome by the nondescript.

To make an art form out of the nondescript, without being smothered by it, is an awesome prospect. It is a challenge which would normally be too cruel to contemplate. In his unusual delight for this, he shares much with Kafka and Rilke, to say nothing of Proust. He faced with them the sheer tedium and tension of living an extended moment in Time. He buried himself in an un-differentiated blanket of temporality from which he squeezed out the sensuality he so badly needed. This is the order of experience that Bonnard works through from within. He has a desire for incidents of discrete inertia, which is a drive and an ambition of a very particular kind. It does not show a relish for the dramatic, for events that come out of a cathartic crisis. Instead, there is a preference for the minuscule and the unspectacular, where the memorable is absorbed and lived with, until there is nothing spectacular to see, nothing remains of the dramatic.[14]

For each of these tiny events, there is a new drawing. Beyond each drawing, there is nothing certain, save a life lived, and a personalisation of time and space. Each drawing coincides with, but is not an illustration of the immediate, the pragmatic, the human. This is the thread moving through all the work which has become sensitised to the habitual and pragmatic in life. Bonnard did not seem to even require a specific space set aside to work, somewhere designed, determined and set aside for the part. His studios were rooms not *ateliers*, and this was a consistent fact all his working life. The distinction between the texture of his life and his art practice was forever blurred. From the small flat he shared

with Vuillard in the Place Pigalle, to the famous wallpaper backdrops in the hotel room at Deauville of his late middle age, he drew and painted wherever he happened to be. By being so generous to that which was given, he secured an endless source of space for his own work. By moving the furniture around and pinning pieces of over-large canvas on any convenient wall, the work remained forever independent of special needs and could be done anywhere, wherever he lived. His last studio is an allegory of limited means; a corridor, a domestic backwater at the top of a flight of stairs that usually houses the gas meter and the hot water tank. All he had was a folding table, a deck chair and an iron bed. He drew everything around him that moved, inside and outside, relentlessly. The cat purring on a window ledge, the morning wash, the evening shave; somehow it all fitted in. As it happened around him, things were simply changed, transfigured.

When Bonnard drew or painted Marthe, his companion and eventual wife, the whole experience became rich and complicated. In these pieces a moment of secret pain is revealed. He was involved in confronting an instance of profound desire and one that was forever slipping away from him into the daily mist. At this point a dark struggle went on between the viewer and the viewed, as an eternal, silent quest was lived out between them.

Bonnard met Maria Boursin when she was 16 years old and working as a shop assistant in a funeral florist's. Her job was to thread paper flowers onto wires which were then turned into wreaths. The atmosphere of dry 'desiccated exotica' in the shop contrasted sharply with Maria's idea of herself. She assumed the name of Marthe de Meliguy, a well-known courtesan, and by adopting her name, she possibly thought she could guarantee a similar life for herself as an independent and envied woman of the world.[15]

From the very beginning of the 30 years they lived together, the terms were set between Bonnard and Maria Boursin for a kind of intimate rivalry. A conflict existed between his need to pluck at an image from the daily flux and this phantom coquette who refused to be extracted from her social and inward fantasies. This complex state of affairs in their relationship together makes the works which focus on Marthe so compelling and odd.

While she coveted the combined centre of the social and domestic stage, her resistance to being ignored increased. It marked the start of subtle but provocative traumas in their lives together, and set in motion a train of events which both fed and exacerbated their irreconcilable desires. For Bonnard, the conflict was expressed in his desire for a Goddess and a Whore. For Marthe, it was for the power that came from knowing that she was desired, yet loathing the constant attention that was needed to confirm its existence. A rivalry was established for him with this forbidden beauty, this unattainable mirage that relied on and was hidden by their domestic world. The instability of this relationship pushed his work onwards into the realm of furtive voyeurism, where sight itself and the right to see and record were at stake. He stalked her every-where. There was no boundary respected between the public and the private.

He pictured her in their shared time together, and she came to represent Time itself to him. Her biological clock was ticking, and her depressions and eventual delusions were all noted as they magnified her somnambulant introspective world. He continued to depict her glowing facticity through it all, and mix it together with her emerging, confused interiority.

As Marthe's self-involvement increased, a self-absorption verging on the obsessive was providing Bonnard with ample opportunities to watch her dig deeper into her own private time. She seems to have regarded everything as extraneous that could not be satisfied within her short-term attention span and Bonnard pressed into service the complex interior life that twitched disjointedly within her. He produced series upon series of works that suggest a delirium of attraction and frustration, of fascination and disbelief.

Relief and relative peace came for Marthe with the absolution offered by deep, blue water in the steamy oasis of her new bathroom. Here she could talk to herself without the fear of having to answer or respond. Bonnard slips into the room, and draws. She floats in the bathwater like Ophelia, suspended between life and death. The subjects are full of repressed tension, not from taut action but the lethargic inertia of inaction. He pictures time off and the psychological time of day-dreaming: time protected from actions and decisions – fallow time, private time, one's own vital dead time.

Bonnard always seems to be heavy with the sad comprehension of all this, and as the late self-portraits of himself show so clearly, he painted his deepening awareness. He sat and worked all through this knowledge, for as he studied Marthe, he gazed at and drew an enigma, not a person. He was weighed down by a severe and intoxicating melancholia. Their private world provoked a record of an impossible addiction to seeing the person he loved and the passing of their time together coalesce. The secret was hidden deep in the observable, in the world that was always on view. Bonnard, in the these late works, stares out at a scene that compels him to look, searching for a sign of the durable that will allow him to break off in this endless gazing. By refusing to caricature a false metaphor of resolution, he is forever looking, trying to keep out of the narcissistic cul-de-sac which is the necessary dead end of fixed meanings. The more he draws and paints, the more the world around him glows with a temporal light. This light comes from his desire, concentrated in a poetic demon that works away in the darkness of his insatiable need, and fuels the fires of his love and his despair. All the light in his work comes from this dark passion, and is illuminated by an addiction which is forever in dispute with the attainable. He accepts no demi-god as an impossible object of emulation, and lacking this, he struggles with the envy and rivalry that replaces an exemplary model to revere. He knows that he must fail. To fail in this sense is not the same as being deficient. His search is both a hopeless quest and a wager against redemption. Like Don Giovanni, each lover (or drawing) cannot be seen as the fullness of woman, but only a number, one which might last, to then release him from the endless search for an impossible satisfaction.[16]

[Postcard] Notts, 10 August 1996

I change my mind so much about which drawing absorbs me most. In them all, every line is exciting, restless, inconclusive. A latitude and a wonderful original irregularity changes every mark. I am fascinated by Marthe lathering herself in the bath with the flannel (*c.* 1940) I imagine sometimes that she is Bonnard's Diana and he is about to become her bespectacled Actaeon as he hunts for her in their domesticity. For me, the drawing carries a special atmosphere . . .

Plate 6.4 Pierre Bonnard: *Nu à la baignoire, c.* 1940, pencil (11.4 × 15.2 cm)
Source: Print supplied by Chris Fisher; copyright ADAGP, Paris and DACS, London 1998

Bonnard is driven to seek out Marthe wherever she is, in the garden, on the terrace, pouring tea, or simply walking down the stairs. He is besotted by her, by the desire to see her but not to be seen 'seeing', not to be seen 'needing'. He draws her as a mangled cluster of lines, that carries no description of a particular identity, he does not reflect any recognition of her individuality. He draws an anonymous mass which slows instead the vice-like grip of needing to 'see' someone, of having to be near them, of being smitten. She seems just about to lift her head and notice him, and in that instance his fate will be sealed. The

drawing registers the groan of a lovesick man as he recognises that he is doomed to be in love and about to be seen to be so, by what he loves. It is an old story. Bonnard's fate is set in this drawing. Marthe is an ageing woman now, yet her body indicates no age whatsoever. She is as fresh as the day he first saw her on the Boulevards. When she died, two years after this drawing was made, he continued to draw and paint her as he needed her to be, as she never was. The painting, for which this is a study, was not started until Marthe was dead. The drawing is a moment of intimacy with an obsession, a record of a need to see that nearly became too real. This state could only be tolerated in the form of a drawing, could only exist in the form of a supplement.[17]

The drawing is a repudiation of the power of death and is a link to the depth of his need for an enduring physical body. Bonnard embalms Marthe in lines. He ties her with mesh as a spider does its prey, by producing a substance from within his being, just as the insect dissolves silk from inside its own body. The spider moulds exuded interiority shrouding the victim perfectly; it is kept suspended in time for a later space. Bonnard wraps Marthe in his own silk, through his own extruded linearity. Here in the drawing, she will live forever. There is something dark and beautifully mortal about this work. It comes so close to the excesses of necrophilia as a form of loving, at the very edge of the acceptable and the possible. It is an image that testifies to the extreme of such a human desire. It is an image of a need, a passion, a struggle to refute temporality while accepting that it has no equal in this world.

Notes

1 See Iwamija, T., Yashida, M. and Gage, R. (1979) *Traditional Japanese Craftsmanship in Everyday Life*, Kyoto: Weathermill/Tankosha.
2 See Terrasse, A. (1984) *Bonnard*, London: Thames and Hudson. This includes personal notes of the painter with explanatory comments. A selection of Bonnard's drawings, including those accompanying this paper, can be seen in Harrison, M. and Kimmelman, J., eds (1984) *Drawings by Bonnard*, London: Arts Council of Great Britain. Further examples of Bonnard's paintings and drawings can be found in Watkins, N. (1994) *Bonnard*, London: Phaidon, and The South Bank Centre (1994) *Bonnard at Le Bosquet*, London: Arts Council of Great Britain. His prints can be found in Bouvet, F. (1981) *Bonnard: The Complete Graphic Work*, London: Thames and Hudson.
3 See Lefebvre, H. (1991) *Critique of Everyday Life*, London: Verso, p.132.
4 See Douglas, M. (1966) *Purity and Danger*, London: Routledge, and also Girard, R. (1977) *Violence and the Sacred*, London: Athlone.
5 See 'The Limit Experience' in Blanchot, M. (1993) *The Infinite Conversation*, Minneapolis: University of Minnesota.
6 Ibid., p.256.
7 Ibid., p.262.
8 Ibid., p.239.
9 See Bonnefoy, Y. (1995) *The Lure and the Truth of Painting*, Chicago: University of Chicago.
10 Deleuze, G. (1987) *Francis Bacon: Logique de la Sensation*, Paris: Editions de la Difference, p.99 (quoted in Boundas, C. and Olkowski, D., eds (1994) *Gilles Deleuze and the Theatre of Philosophy*, London: Routledge, p.252).

141

11 See Watson, L. (1985) *Heaven's Breath*, London: Hodder and Stoughton.

12 See Nussbaum, M. (1986) *The Fragility of Goodness*, Cambridge: Cambridge University Press.

13 See Deleuze, G. and Guattari, F. (1994) *What is Philosophy?*, London: Verso, and for a discussion of the relation between 'intensity' and the 'sensible' in the context of the problem of 'difference' see Deleuze, G. (1994) *Difference and Repetition*, London: Athlone, pp.266–267.

14 See Rilke, R.M. (1949) *The Notebooks of Malte Laurids Brigge*, New York: Norton; Pawel, E. (1985) *The Nightmare of Reason, A Life of Franz Kafka*, New York: Vintage; Deleuze, G. (1973) *Proust and Signs*, London: Penguin.

15 See Vaillant, A. (1966) *Bonnard*, London: Thames and Hudson.

16 See Girard, R. (1987) *Deceit, Desire and the Novel*, London: Athlone.

17 See Josipovici, G. (1986) *Contre-Jour*, Manchester: Carcanet.

7

THE 'REAL REALM'

Value and values in recent feminist art

Diane Hill

The motivation for this chapter was a statement – made as the culmination of an argument – by the feminist art critic Griselda Pollock in an article written towards the end of 1993. Pollock stated that, when we engage with visual art – painting, sculpture and so on – indeed, when we practise visual art, 'the real realm is not that of optics, but graphics'.[1]

This position can be used to encapsulate not only Pollock's view but also the predominant approach to the reception, criticism and interpretation of art generally over the last couple of decades. It is an approach which, more specifically, has been evolving since the advent of the 'new art history' in the 1970s: an art history which challenged the authorial voice and restricted agenda of Formalist artists and critics, and which placed art in its social, political and cultural context – examining art as a discourse.

This essay will take up Pollock's claim and examine both her objections to the 'optical', and whether the 'realm' or critical model she proposes to put in its place is an appropriate and *sufficient* one to apply to certain recent feminist work. It needs to be stated that I am not choosing a type of practice which is unsympathetic to Pollock's approach, but one which shares with Pollock fundamental values and suppositions about patriarchy, traditional art, and the old art history.

What is clearly happening now is that a new development is taking place amongst some feminist artists who are wanting to continue to hold dear broad, new art history values and commitments to feminist values, but who perhaps believe there was a baby along with the scum-ridden and frothy bath water that seemed to drown women's creativity. Neither is the baby unreconstructively male and intrinsically patriarchal; nor is it incorrigibly reactionary or nostalgic. This new development is at odds with the uncompromising and apparently absolutist standpoint taken up by Pollock and others writers such as Francis Frascina.[2] The new development often springs from a desire to re-engage, in a *productive and non-reactionary way*, with the values which Pollock *et al.* wish to see banished from both the theory and the practice of art. I emphasise this

because it is so important not to see this new development as a rejection of fundamental premises of feminism and the new art history. It is a new development within its broad frame.

Having looked at Pollock's argument in relation to certain specific works, it is important to raise the question of *types* of engagement with regard to art. *Is* there a 'real realm' – in other words a 'true' or 'right' realm, which is the import of Pollock's statement? Or is the category of art now so broad as to require the operation of more than one approach or model of interpretation if art is not, as some are already suggesting, to be funnelled into another alternative but equally exclusivist and intolerant vessel of critical language and theory to that which has been rightfully overturned?[3] Indeed, is Pollock, and those who practise what she preaches, legitimately to be accused of the very critical colonising of art which she, and they, ostensibly counter? The charge is at least worth exploring.

Pollock argues, in the article just mentioned, that we must 'subscribe to the visualness of the visual arts not simply but critically'. This is quite right, proper and necessary. The visualness, the opticality of art was seen as unproblematical up to and including late Modernist times. What is more, the visualness of art was supposed to be the be-all and end-all. Literally so, as it was an art to end all, or at least to culminate a journey from Kant to the pure centre of the medium. Art critics and theorists had to challenge this assumption and re-examine the values on which it was based. Issues of gender emerge immediately.

Pollock states that feminist art criticism

> had to challenge one of the fixed ideas which still dominated both contemporary art and art history – namely that art is purely a visual experience, that it is not shaped in any way by language, and that it is independent of all social factors. Whether as formalism or aestheticism, these ideas made it impossible to raise the repressed question of gender.[4]

This is, no doubt, incontrovertible, and again it must be made clear that this chapter is written from a perspective of broad sympathy with such a critical project. Much valuable research by feminist art historians has, indeed, already been undertaken tracing that particular history (i.e., of feminist critical and historical intervention and its effects, which have been considerable, within the practice and theory of art).[5]

However, what interests me more is the point at which I begin to part company with Pollock's views – in terms of the conclusion she reaches – when, drawing chiefly on psychoanalysis and semiotics, she makes the point quoted earlier: that the major part of feminist criticism involves

> a major shift from traditional art theory. The art work, especially in the form of painting, is not treated as 'the window on the world' or the 'mirror of the soul' where vision is pure and the artist a kind of

visionary. Instead, art is perceived as something made, produced, by a social mind and a psychically-shaped body which 'writes' upon its materials to produce a series of signs which have to be read like hiero-glyphs or deciphered like complex codes. The real realm is not that of optics but graphics.[6]

What Pollock is asserting is that the work of art becomes a graphic sign, or set of signs, which has to be interpreted or *read* in order to 'decipher' its ideological and/or psychoanalytical subtext. Again, to try to underline the nature of my disagreement, I am not proposing that one can look at art innocently in the way that Greenberg and other late Modernists supposed, nor that one cannot always see beyond or behind the work in front of you and see it as a sign of something else – clearly you can and I do not consider that controversial. What is at stake here is the difference between observing the artwork merely as a means to that further level, and taking the *observation itself* as seriously as what is beyond it. In this latter sense, the observation requires study, scrutiny and is itself an experience. It requires sophistication in the viewer and even sensibility. It requires judgement and evaluation. But it is not an either/or situation – it is not either visual scrutiny or reading, but both.

Pollock is symptomatic of a tendency to reject the scrutiny because of its associations with Late Modernism, and so to reduce observation merely to a process of arriving at a reading. She concludes:

> liberated from the limited problematic of the visual as defined by traditional aesthetics, [art] can now be theorised and usefully analysed . . . Contesting the canonical discourse with art as pure and perfect object and artist as perfect imperial subject, feminists propose a different object – sexual difference – and a radically different concept of subjec-tivity whose processes are inscribed upon, traced in and fragmented by the cultural texts which compose the local but still hegemonic modern culture of the west/north.[7]

To repeat, this chapter is written from a perspective of broad sympathy with Pollock's thesis. Semiotics and psychoanalysis have been, and remain, important tools by means of which one can interrogate both the concepts and manifestations of art. However, in effect, what Pollock's argument amounts to – and this is borne out by her own critical analysis of particular works – is a *reduction* of work to text – of the visual to the textual. No *attention* is given to what is going on visually. Visual *characteristics* may be referred to, but these are immediately (or, perhaps, mediately) co-opted to the cause of 'textual' resistance to the 'dominant order'. Matisse, for example, is condemned for the covert violations in his work of depicted females, and Picasso is beyond redemption.[8]

Value, then, not only in Pollock's criticism, indeed not only in feminist criticism and theory, but in the general development of contemporary criticism

and theory since the 1970s, resides as much in the 'purely' graphic – the semiotic – as it did in the 'purely' optical/visual in the 'bad old days' before that time.

It is important here to raise the term 'value' not only to reinforce the suggestion that this is precisely what Pollock (and others) are staking out – a pretty clearly circumscribed territory of value in both art theory and art itself – but also to introduce the concerns of a number of recent feminist practitioners who feel increasingly hemmed in by that circumscribed territory. I have in mind practitioners such as Jessica Stockholder, Lydia Dona, Deborah Kass, Rebecca Fortnum, Emma Rose, Estelle Thompson, Gill Houghton, Helen Ireland, Rosa Lee and Beth Harland who have produced works, and in some cases made written statements, which are centrally concerned with what might be called a reclaiming of formal value. This, incidentally, has come after an earlier concern (late 1980s into the 1990s) with a reclaiming of the medium of paint for women, which until then had been rejected in feminist writing, and relatedly in much feminist art, because of its historical associations with, and implicatedness in, the sexualised representation of women. Thérèse Oulton is another artist who comes to mind in this context. However, in this chapter the emphasis will be on examples taken from more recently emerging feminist painters, who have consciously taken on board Pollock's critical comments about visual and textual value.

A concern with form and formal phenomena is not, of course, the same as a commitment to the programme of Formalism. Formalism – most obviously associated with Clive Bell – was an exclusive philosophy of art that relegated any area other than that of qualitative formal relationships as irrelevant in art. Subject matter did not bear thinking about, and certainly not writing about. Considering content and meaning was therefore a waste of the art critic's time. A concern with formal matters, on the other hand, is just one of the ingredients of a work of art – one of the mix that also includes subject matter, content and meaning. Formal values usually operate in relationship to meaning, and so form and content are in active dialogue with one another.

To underline how an interest in formal value is not the same as Formalism, reference can be made to a statement by Emma Rose, who considers herself, justifiably, a feminist artist. Rose argues that her work, and that of some other contemporary practitioners,

> constitutes a practical rejection of the false antithesis between 'modernist formalism' and the 'theorised practice' sometimes associated with postmodernism. Neither does it seek a 'middle ground' between 'theory' and 'form', both highly abstract notions, but rather a positive, rigorous response to individual experience, the demands of a dynamic tradition entailing radical renewal, and the practical imperatives of painting itself. A commitment to the importance of the appearance or 'form' of the work, far from rendering it vacuous or ill-informed about itself or its context, is a precondition of its identity and quality as art.

Yet many critics, curators and journalists chronically fail to understand this position, in part because the meaning and history of ideas about 'theory' and 'form' have been poorly understood, and as a consequence lead to reductive and misleading conclusions.

For example, as Martin Jay has recently pointed out, the ideology of much modern 'theory' is profoundly hostile to vision, seeks to purge itself of visual analogies and metaphors, and to install the word (or the text) as the only reality; historical and critical reflection on this phenomenon of ocularphobic discourse is only just beginning. Equally, the idea of form itself is very complex, ranging from highly generalised descriptions of logical or abstract relationships to a concern with particularised material qualities like texture and colour; 'form' is also inextricable from the ways in which all artefacts possess a dimension of meaning. Yet for many curators or critics the choice is between what they see as the self-indulgent vacuity of 'formalism' and works which supposedly respond to the challenges of contemporary debate, but which many of us see as pretentious, inanities protected from real critical inspection by a derivative relationship with half-digested intellectual fads.[9]

Artists such as Rose are neither ignorant of, nor uninterested in, the radical developments in cultural and critical theory over the last three decades. On the contrary, they often embrace the crucial importance of those developments for the interrogation of inherited cultural practices which has, as a result, been made possible and thinkable.

Accordingly, what is *shared* between the feminist artists just mentioned and those whose work is single-mindedly political, such as Barbara Kruger or Jenny Holzer, is a critical engagement with systems of power and gender differentiation, and with the discourses which underpin them. Where their work *diverges* from the latter group in its concerns, is that it arises from a belief that there is something beyond this deconstructive impetus, without which the work is reduced to meaning *per se* and, therefore, becomes impoverished. They reject the assumption that all that matters is for the artist to construct signs; they also seek that the particular work they produce has *visual quality*.

The notion of quality is, of course, problematical. To suppose it can be reduced to a formula is to fall into the trap of the unreconstructed rationalist. However, because it cannot be simply defined does not mean it does not exist. Traditionally, one of the key roles of criticism has been to determine, review and endlessly argue over quality. Rather than get side-tracked into the fascinating but, for this chapter, too abstract and philosophical issue of 'what is quality', it will be more pertinent to discuss quality in relationship to particular artworks. The following will, therefore, examine the work of two artists, Rebecca Fortnum and Emma Rose, in an attempt to highlight issues of quality as they are embedded in particular feminist contents, meanings and practices.

The work of Rebecca Fortnum has recently received attention from the feminist critic Rosemary Betterton.[10] Betterton's analysis is insightful in its speculations upon the possible inflections of meaning and signification in Fortnum's works, but this is precisely where the problem – or *in*sufficiency – arises. It confines itself to just that role: speculation on meaning. Betterton's criticism is, indeed, substantially speculative in its annexing of the visual characteristics of the pieces to Irigarayan theory. Having acknowledged the difficulties of 'transposing ideas [such as those of the feminist poststructuralist theorist Luce Irigaray] too literally into a visual art practice', and saying that this 'problem . . . lies in the *differences between* verbal and visual representation'[11] (my italics), she then goes on to treat the visual as if there were no differences between the two modes; indeed, as if the visual was entirely a sub-category of the verbal or, more accurately, the textual. The paintings, she tells us,

> like Luce Irigaray's extended metaphor of female sexuality . . . stand for a different set of relationships of women to their bodies, but also to the world and to language. For, if as Irigaray has argued, the morphology of the male body has given us the phallocentric logic and language of the symbolic order, the female body too is imagined within a phallic system of representation . . . [Fortnum's] works inscribe the female body as lack, the wounds of sexual difference which scar women within the symbolic order. Thus it is as dissonance from within rather than as proffering an alternative outside the system that the mobilisation of the female body may function in Irigarayan terms. The female imaginary body can be seen both as a product of and as a necessary counter symbolisation to the binary logic of patriarchal systems.[12]

She then goes on to translate form into meaning, informing us, for example, that the 'huge physical presence' of the paintings 'suggests the body's materiality'; and that 'A gridlike repetitive structure of verticals and horizontals' is 'suggestive of enclosure and imprisonment, of the body as imprisoned and imprisoning'. A key objection to this kind of criticism is not so much about what it says, as about what it appears to avoid. While Fortnum is, as has been indicated, concerned as a feminist with the interactions between visual perception, meaning, and power, the equally strong concern in her work with *visual quality* – with, in other words, formal value – goes unaddressed by Betterton.

Betterton's essay, while making thought-provoking connections with feminist issues and theory, is ultimately reductive in its import. She does not, in fact, address the issue of formal concerns – and certainly not the issue of visual quality which those concerns entail. There is, in other words, no looking at – no real *attention to* – the visual.

Fortnum works primarily with oil paint on canvas, and has revealed a consistent concern with the body – its presence and its significance, both in

a psychic and in a physical sense, in the making and receiving of art. Her earlier work (of the late 1980s) included a series of paintings called *Wounds of Difference*,[13] in which forms suggestive of internal body parts hover – both garishly immediate and simultaneously rendered unreal. There is clearly an emphasis in this early work, with its bold images and bold colour, on the visual as sign – and a concern with the power relationship generated between artist, the signifying object or work, and spectator. While semi-abstract, the works nevertheless make clear references to feminist issues centred on embodiment and materiality.

As her work develops, however, there has been a shift in priority, indicating a lessening of the concern with literal or textual meanings, and more concern, as she has confirmed in conversation,[14] with the tactility of the medium, the relationship between colour and surface, and with a functioning of the image which is less directly derived from theory. A concern with the body is still evident, but now, as in the series entitled *Performative Utterance* (Plate 7.1), there is a growing concern with what is perhaps appropriately described as 'visual particularities'.

In the paintings exhibited in her *Contra Diction* exhibition,[15] there is a clear concern with proportion and scale; with the relationship between 'gestural' and non-gestural marks, and certainly a concern with the interrelationship between

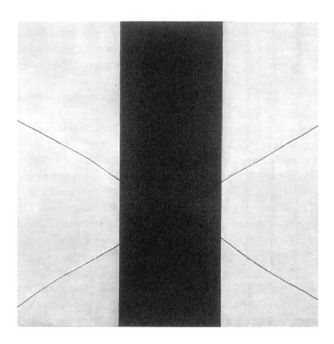

Plate 7.1 Rebecca Fortnum: *Performative Utterance*
Source: Reproduced with kind permission of Rebecca Fortnum

149

image and form. Evocations of the body remain central to the work, but are now visually reduced, as critic Angela McRobbie has pointed out, to the 'use of blood reds' and to subtle suggestions of tissue.[16] Far more evident, though, is the preoccupation with form and formal relationships – with line, plane, rhythmic scansion, inside/outside, surface/depth, solidity/space. These concerns, Fortnum argues, are inseparable from her concerns about embodiment, *and* inseparable from the traditions of practice which inform the paintings in the work of modernist predecessors such as Barnett Newman. Borderlines between the binaries named above become uncertain – an uncertainty which is exacerbated by such devices as the crossed lines, which simultaneously suggest depth (it is painted 'over' the vertical panels), and a cancelling of depth (scoring through what might otherwise be read as overlaid planes). Brushstrokes are deliberately applied in an intimate, discreet, often small-scale manner, thus 'contradicting' the heroic, painterly gesture usually associated with late modernist abstraction – particularly in the case of large-scale canvases such as these. The finely worked, often luminous textures thus built up also generate a tension between the emphatically flat and hard-edge geometry of the overall composition, and an implied softness and penetrability of surface which throws us back, sometimes uneasily, into that network of visual valences suggestive of the *im*pure, *un*geometric, engulfing presence and 'composition' of the material human body. These tensions and uncertainties reflect Fortnum's concern to re-engage *visually*, and not just in terms of sign and meaning – not just, that is, *textually*, as feminist criticism of her work has implied – with the values of modernism. Her critical engagement with those values indicates a new opening up of ideas about and responses to the formal in art – not least about its appeal to a purely immaterial and disinterested realm of engagement and appreciation. She endorses, along those lines, the artist Jacqueline Morreau's statement that, 'By understanding and manipulating the potentials of the picture, we, as artists, can reveal our experience as women to the viewer who is drawn to participate with this presence as to a real human reverberation'.[17]

This sense of 'real human reverberation' is instilled by Fortnum into her works. It is perhaps in her most recent series of works that this imbrication of formal concerns, levels of materiality and meaning, and the immediacy of physical and psychological experience, is at its most complex and compelling. Here, in works made for an exhibition entitled *Third Person*,[18] issues of gender and embodiment still saturate the work, but are more obliquely, more richly evoked than in her previous work. At first sight the presence of these paintings derives from their large, imposing scale and from the minimal, geometric clarity of image. As we look longer and more closely, however, we are obliged to reassess and reconsider the very notions of such matters as scale and composition in relation to the visual. For example, in *Where You Are, I Haven't Been* (1996), the viewer is inexorably drawn into a very different experience of these elements as s/he becomes aware that handwritten text, emerging under the gaze from a blue sea of painterly marks, makes up the central, vertical column (see Plate 7.2). (Obviously in a

Plate 7.2 Rebecca Fortnum: *Where You Are, I Haven't Been*
Source: Reproduced with kind permission of Rebecca Fortnum

reproduction of this size and in this context the text cannot be read on the painting.) The experience of the work, then, telescopes in from an awareness of the tensions of surface, plane, line and colour, to an embeddedness within that cluster of tensions: first, of the smaller, more intimate and decorative physical scale of the writing, which both vies and mingles with the similarly intimate, yet eddying brushstrokes and subtle tonal resonances of the surface it shares, while also functioning as image; and, second – once we begin reading the text – of a significantly different cluster of elements and tensions inherent in language/ words and their meanings. In the case of this particular work, there is no straight-forward meaning, but rather a syncopated, surreally disrupted series of words and phrases. Now we are transported to a sense of scale which is personal; to a tone which, while variegated, is dark and sombre, consistent with the visual mood of the canvas as a whole. Images conjured by the text seem to float, isolated and incomplete, in a neutral and indifferent conceptual limbo, like the body parts suspended in Fortnum's earlier works. The colour-washed panels on either side, which otherwise function as part of the abstract play of line and plane, now *become* that surrounding and contextual limbo, the scored but indistinct lines now suggesting the perspective of a room – empty and, again, of indefinite 'scale', opening into the space of the viewer.

Indeed, it is not only in terms of physical and conceptual scale that one becomes aware of the constantly shifting and intertwined experience of viewing

151

and interpreting. A subtly 'misaligned' horizontal line[19] and, in other works, an omitted 'perspective' line,[20] or a line which turns out, on a 'continuing'? 'corresponding'? panel, actually to comprise tiny words,[21] work to oblige the viewer to reorientate him/herself not only, as Greg Hilty argues in the catalogue introduction to the exhibition,[22] 'in front of each new work', but also 'within' each work – that is, within the duration of experience of that work. Thus, the experience of art becomes plural and emphatically durational – shifting but emphatically situated – both physically and conceptually. As the title assures us: *Where You Are, I Haven't Been.*

Here we have a situation where we seem both to be beyond time, drawn into contemplation of visual particularity and specificity in an engagement reminiscent of modernist notions of contemplation beyond time; yet simultaneously drawn back into temporality, into the 'reverberations of a real human presence' referred to by Morreau. However, this presence, unlike that to which Morreau refers, hovers diffidently somewhere between spectator and artist. The critic Charles Hall has commented about certain of Fortnum's previously exhibited abstract works that they constitute 'a determined attempt to re-embody the sublime'.[23] These works, relatedly, could be said to re-embed the act of visual contemplation, which is traditionally conceived as transcending time and place, into the complex matrix of raw, lived experience.

As one looks, one becomes increasingly aware of the implicatedness of textual and visual experience, of the difficulty of disentangling these orders of experience and imagination. However, what Fortnum remarkably accomplishes in these pieces is very different from most other work incorporating text. Far from reducing the visual *to* text and textual meaning, the strength of Fortnum's work is that, while the very pores of the works are saturated with competing and sometimes colliding orders of experience, the integrity and distinctiveness – the *difference* – of those orders of engagement is respected and felt. We become aware of the multivalent experience of form, scale, image, and of the profound difficulty of teasing out the different strands of that experience. Yet those strands *are* strands, and are not reducible to a homogenised sameness of experience, as critics such as Pollock argue. Beyond the subtle but compositionally crucial lines that Fortnum draws in her works, equally elusive and equally crucial boundaries of difference are recognised and even celebrated. The responsibility for recognising, as well as for testing, such boundaries of experience is expressed in a passage by the novelist John Barth, a contemporary of E.L. Doctorow, who is cited by Fortnum in her most recent catalogue:

> Things can be signified by common nouns only if one ignores the differences between them; but it is precisely these differences, when deeply felt, that make the nouns inadequate and lead the layman (but not the connoisseur) to believe that he has a paradox on his hands, an ambivalence, when actually it is merely a matter of x's being part horse and part grammar book, and completely neither.[24]

This is precisely what Fortnum, to repeat Barth's words, 'deeply feels': the distinctiveness – the particularity – of different types of engagement which nevertheless weave through and around each other in a manner which recalls another passage from the same novel by Barth, expressing the difficulty of exercising discrimination:

> 'It is possible to watch the sky from morning to midnight, or move along the spectrum from infra-red to ultraviolet, without ever being able to put your finger on the precise point where a qualitative change takes place; no-one can say, "it is exactly here that twilight becomes night", or blue becomes violet, or innocence guilt. One can go a long way into a situation thus without finding the word or gesture upon which initial responsibility can handily be fixed . . .'[25]

Fortnum's achievement is that she has taken up that responsibility and offers an experience which neither falls back into inherited practices nor collapses into reductivist homogeneity, but which develops the use of paint and abstraction in a way that profoundly engages with our contemporary situation.

The work of Emma Rose similarly demands, and rewards, careful scrutiny. It rewards, in other words, what the philosopher and novelist Iris Murdoch referred to as 'a just and loving gaze directed upon an individual reality'.[26] This is how Murdoch characterised the value of 'attention', which had in late modernist work and criticism, she argued, largely been superseded by a commitment to 'will' and relatedly to an exclusive preoccupation with 'crystalline' – that is with totalised and formally resolved – artistic structures. Issues of artistic will and resolution of structure infuse Rose's work, relating both to feminist concerns and, inseparably, to problems of value in art more broadly.

Rose, like Fortnum, has developed a practice which is primarily abstract or semi-abstract. Also like Fortnum, Rose is centrally concerned with what she has called 'the notion of an active and responsible subject'. As this has developed, invocations of gender issues have become more subtly enmeshed in the painterly surfaces Rose builds up. In certain earlier pieces, for example, the application of stencilled 'decorative' motifs and borders work to convey the observer from one conventional sphere of engagement to another – from the public to the domestic; from the 'serious' to the 'trivial' – raising questions about text and con-text; primary and secondary role and function, which are clearly related to ideas about gender. In the more recent work which will now be discussed, however, these themes and issues work up from within, rather than from what might be called the 'outside' of the picture surface, involving the spectator in a web of perceptions and associations which ramify into unexpected visual and conceptual avenues and implications.

The following will be restricted to an examination of two paintings, both of which form part of a group dealing with Rose's continuing concern with materiality and embodiment. These four works are of roughly uniform size –

Plate 7.3 Emma Rose: *Here and Now*
Source: Reproduced with kind permission of Emma Rose

approximately five feet square. Seen together, the works project the feel of an overall clarity of form and formal relatedness, both within and across the individual pieces. This apparent clarity or 'transparency' of intent and expression is, however, not borne out as one attends to the behaviour and functioning of mark, pigment, image and form.

The painting entitled *Here and Now* (1995/96), for example, involves a division of the canvas into three horizontal bands, which enter into a dialogue with vertical encroachments into the painting (Plate 7.3). Here we are confronted with bold forms which clearly, on one level, engage with traditional compositional concerns. On closer observation, however, these forms become less clearly defined, and reveal a complexity which might be missed if that 'attention' to particularity were not afforded. Having surveyed the bolder relationships of the work as a whole, one's eye is most immediately drawn to the form descending into the work from the upper right, with its departure from the predominantly red, black and white tones of the rest of the work, and with its suggestion of decorative patterning. One then notices that these decorative motifs, which are often partly or wholly obscured, seem reminiscent of fossils, shells – even diatoms – which are in the process of sinking into or emerging from a sediment of accumulated colour and marks. This associative inclination, with its overtones of gender, both in the evocations of the 'associative' and of ornament, is then strangely both undercut and reinforced, as one becomes aware

that the visual activity in which they are enmeshed – that sediment of mark and colour – actually comprises a strikingly Cézanne-like treatment of paint. Painterly practices, then, have become either part of that sediment, or themselves form the silt which engulfs other practices and values. There is a visual and conceptual tension here between major and minor which generates a further tension regarding the nature of the relationship between forms and images as well as between the formal and the decorative. This tension is echoed by the behaviour of a grey form protruding from the side of the same section of the painting. What at first appears to be an adventitious intruder, clinging into the side of the 'host' form like a growth, in fact insinuates itself into the 'body' of the bronze form – neither fully behind nor even 'woven into' this otherwise bold feature of the work, but rather producing, again, a tension between the two forms – and the colours – in which one appears to be dissolving into, or parasitically eating into (like the growth it invokes at first sight), the other. Conversely (and relatedly), an ambiguity arises with regard to the visual dependency of what is now perceived as two discrete forms. Whether in the process of mutual decay or growth, there is a determined uncertainty as to which of these forms 'underpins' or else 'holds together' the fragile substantiality of the other. The grey form seems to stabilise the visual agitation of paint strokes, colour(s), forms and motifs which make up the predominantly bronze section, and which already begin to leak out from the left side boundary which the grey form does not reach. On the other hand, the larger form anchors the other compositionally, giving it compositional weight and substance, preventing it from floating off into a visual limbo.

This brings us to a theme which permeates the whole work, that of fluidity/ solidity. The visual complexity of the section just discussed is reflected throughout the work – its title, as the experiencing of it, raising questions about the stuff of the *Here and Now* – which is so tangibly and so immediately present, yet which recedes into an uncertain complexity of emotion, perception and behaviour as soon as we attempt to grasp it. Issues of identity and identification inevitably arise, with marks and shapes seeming to emerge like individuals, caught in a deceptively unstable field in which major and minor roles become visually and conceptually entangled. Here feminist concerns have broadened, as in Fortnum's recent work, into a more generalised but, (arguably), more potent concern with issues of authority and power.

From the activity of the bronze/grey section, the eye is drawn down to the central horizontal band, into which it juts, partly by the drifting across boundaries of the decorative motifs (and shadowy traces of motifs), and partly because attracted by the contrasting red into which it plunges. Brush strokes, too, provide a subtle visual continuity into what at first appears to be a 'solid' monochrome block of red or territory. Consistent with the block which penetrates it, the red paint is applied less uniformly than in other parts of the work where a horizontal application reinforces the main compositional division of the canvas. What initially appears as a simple pictorial device, rewards

and surprises the observer's attention by revealing unexpected echoes and relationships.

From the agitated application of red pigment the eye is drawn towards a large rectangular form to the left, taking up most of the central band. Here the surface is busy in an apparently more ordered, less agitated way. This flag-like block is itself subdivided into horizontal bands or stripes, boldly delineated in alternate whitish and dark brown. Yet this form, unlike a flag, is no unambiguous vehicle of identity and identification. As in the work as a whole, the 'clearly drawn' characterisation of the form becomes less definite and less defined, on closer observation. From a distance, only four wavering rivulets of bronze break the geometric regularity of the striped section, seeming to reinforce the authority of its delineation by way of contrast. As we continue to look, though, we begin to notice indistinct red forms scattered across and slightly 'submerged' beneath the stripes of pigment, as if trying to get through the surface tension. This implication of depth is further mooted as, attracted by the discovery of the red forms (whose status, too, is uncertain, given the similar sized decorative motifs elsewhere – are they gestating or else stillborn decorative motifs?; or part of an abstract/geometric composition which have been inadequately painted over?), we then notice that the meandering bronze rivulets do not simply score through or even overlay the stripes, but in two places are broken by – or disappear under? – them, only to reappear at a corresponding point at the other side. These uncertainties of identity, status and authority are amplified as we are inexorably drawn into closer, more intimate scrutiny of the work. The extent to which the borders of the stripes just mentioned do not exhibit technological perfection, as one would expect on something like a recognisable flag (or, indeed, on a domestically decorative material such as wallpaper) becomes fascinatingly apparent; while the integrity of the rectangular block they comprise itself becomes uncertain as we become aware, at each end, of a column of lighter background paint which begins to insinuate itself into the form under our continuing gaze. Are these lighter columns part of the 'flag's' design or do they emerge to anchor the flag-like form's increasingly compromised status? Which is the primary 'agent' here? Finally, our gaze, now attuned to the activity of close scrutiny, begins to take in much more in the painting as a whole, while also chary of the notion of wholeness into which we at first appeared to be invited. The horizontal bands which make up the work now can be seen to give way to myriad suggested lines, tones, colours, forms, textures and degrees of pigment density which has the effect of unfocusing the spectator's habits of looking in a manner recalling Roland Barthes's description of the 'text of bliss' which 'un-settles the reader's historical, cultural, psychological assumptions . . . [and] brings to a crisis his relation with language'.[27] This, indeed, occurs in Rose's work, but in a way that preserves the distinctiveness of visual experience and visual value, interwoven, as it is, with inflections of meaning and interpretation.

Like *Here and Now*, the work entitled *Materiality* (1995/96) projects a bold geometric appearance and division of the canvas, which almost immediately

begins to break down, as we continue to look, into a complexity of relationships and tensions between, for example, elements and themes such as horizontal and vertical; fluidity and fixity; order and disorder; clarity and ambiguity (Plate 7.4). In this work there is a sense of forms and marks openly jostling with each other rather than insinuating another by stealth. A bright orange peeps from a band of gold pigment, while the turquoise forms below collectively engage as if in a dance with a column of gold and brown/blue forms against which they press. The overall rhythm of bands and columns, in fact, appears almost like a graphic musical score, except that this particular score invokes order and harmony, only to problematise those qualities from within. The forms which are so striking and assured – so 'solid' and firm – when one first takes in the work, are found not to follow any conventional order, but rather to fall into the disarray of, as in *Here and Now*, either fluidity or sediment.

The roughly rectangular form on the left of the work reflects this concern with fluidity/solidity as states of being and experience. It is less confidently erect than its partner on the right, leaning precariously to one side, while the brown-red, seaweed-like filaments just contained by the blue sections which partially comprise it similarly waver in limp, floating suspension, leaking out here and there from the 'sides' of the rectangular form, and implying a depth which is countered – though, again, not resolutely, not 'firmly' – by the apparent flatness of the white bands which partly define it. As with *Here and Now*, an ambiguity is generated between fundamentally different and conventionally 'opposite'

Plate 7.4 Emma Rose: *Materiality*
Source: Reproduced with kind permission of Emma Rose

elements. Depth and surface, horizontal and vertical, become elements which are themselves held in suspension but, in this case, an active suspension involving a live, mutual encroachment. The viewer thus becomes acutely aware of his/her responsibility for determining, at any moment of viewing, which elements in the work 'act' and which are 'acted upon'.[28] Indeed, the notion of authority itself dissolves into suspension as one continues to look at the work, between the strong visual presence of the 'material' object itself; the artist whose presence is plangently announced, not least in areas of thick, gestural working of paint and encaustic; and spectator.

Then, as our eyes inevitably move down the canvas, drawn, via an increasing evidence of waxy encaustic as we move down the white bands, to the 'deeper', more lavishly applied bronze tones and textures of the lowest section, we become aware of the piece as layers or strata. This lowest stratum is the most heavily worked section of the piece, appearing almost like a cast bronze base – complete with decorative motifs – supporting the relative order of the rhythmic activity taking place above. This impression of literal/physical support is complemented by a similar formal function, for the section visually 'grounds' and stabilises (without balancing in any Formalist sense) the play of colour, form and mark taking place above it. On a referential level, meanwhile, the 'decorative' motifs – shell, flower and leaf shapes and markings – combine with the thick, encrusted textures into which they are embedded, and with the apparent haphazard application of those textures, to suggest the accumulation of sediment. Here, then, arises another set of tensions between different states, between conventional, even traditional opposites which have here coalesced: those of the natural and the cultural; the artistic and the 'merely' decorative; between the geometric – with its resonances of 'the modern' and of technology – and the organic, with its resonances of the 'natural' and the 'essential'; and between 'history' and the raw materiality of the present experience. How does one disentangle these opposing forces?; have they become falsely separated?

What Rose's work communicates is not only a highly self-conscious awareness of the conceptual consequences and implications of our uses of the visual – and of the traditions and conventions from which those uses have grown – but also a response to the stuff of the visual and, by extension, its histories and traditions, which is something other than reductively conceptual. It is a response which sees past uses of the visual as practices not to be rejected or decanted into an all-consuming 'realm' of text and meaning, but rather for the artist rigorously to be, in her words, 'extending and renewing'[29] as well as questioning. As she has herself stated:

> the forms, meanings and processes developed within the tradition
> of fine art enable contemporary artists to make new images which
> matter . . . This 'language' – and the term is simultaneously useful
> and misleading – is not primarily one of words, sentences and texts.
> Words are of course part of the language of art, but must ultimately

play a subordinate role in making and understanding the images, the living tradition, of fine art. Anyone who wishes to become an artist, even those who seek to appreciate and enjoy what it offers, must learn to see – and learning to see requires what we might call a moment of discursive silence, in which the consuming force of words is deflected, allowing the particular qualities of the visual image to appear.[30]

For Rose, then, it is vital that the realm of the visual should neither be shorn of its distinctiveness as a realm of experience, nor be sucked into any essentialist paradigm which would lose sight of the richness and diversity – the particularities – of the individual elements which comprise and have comprised it.

Fortnum's and Rose's work is no theory-led didacticism, nor does it *simply* counter inherited practices and values. Both artists are led by a highly reflexive visual sensibility – by a responsiveness to form and visual experience which communicates a genuine love of, as well as suspicion of, its material implications.

Ironically, to return to the quote by Griselda Pollock which voiced the claim that, in art and art criticism, 'the real realm is not that of optics, but graphics', the objection made by Iris Murdoch to the impetus of modernism over thirty years ago could now be made about contemporary feminist criticism. Namely, that feminist criticism (along with much contemporary criticism in general), imposes a prescribed agenda. If the art of the modernist period revealed a will-to-crystalline form, the critical work of Pollock and others tends towards a will-to-semiotics, treating the work as text to be 'deciphered', to repeat Pollock's term. This is certainly part of what criticism valuably does, but to suggest that this function exhausts what is offered by art – by good art – is to slide into an extreme form of the very rationalist tradition, with all its colonising tendencies, which such criticism sets out to deconstruct, if not demolish.

Fortnum herself, in an article written jointly with the artist Gill Houghton, expressed the hope that feminist criticism might begin to '*contain* the work being done by women rather than control it' (my italics).[31] The feminist artist Rosa Lee, too, has commented that critics such as Pollock and Betterton, while 'perceptive and critical' within the framework of their 'particular critique', nevertheless tend towards the simplistic, largely because their 'looking' is 'highly selective'. Lee remarks: 'They are trying to fit the work into a particular political perspective', so denying the multivalence and quality of the work, and missing an entire dimension – or 'realm' – of experience of the work by reducing it to sign annexed to theory, whereas, Lee argues, 'where the theoretical side might inform the work, it does not necessarily actually explain it or is not the only thing underpinning the work'.[32] Recently the critic Martin Jay has also put forward the view that much contemporary criticism is ocularphobic in its inclination, harnessing works to its own critical-textual agenda rather than engaging in the effort of visual scrutiny and attention.

Only if this effort is made – if, in other words, some authority is ceded back to the work rather than all authority being vested in the spectator – can a more

embedded criticism develop which will indeed foster what Murdoch called for in art. That is, to repeat, 'a vocabulary of attention, not of will' which might enable us 'through [art to] discover a sense of the density of our lives'. It is this sense of the rich, live density of experience, and of what Murdoch refers to as the valuable 'opacity' of the human person, that permeates the work I have been discussing. And it is this crucial dimension – this 'realm' of experience and responsiveness – which is regrettably missed, indeed resisted, by the burden of Pollock's model.

Notes

1 Griselda Pollock, 'Trouble in the Archives', *Women's Art Magazine*, No. 54, September/October 1993, p.12.
2 For an example of Frascina's criticism see his 'American Art?', *Art Monthly*, November 1993, pp.19–21.
3 On questions raised about the possible limitations of recent/current criticism see, for example, Yves Alain Bois, *Painting as Model* (Cambridge, Mass.: MIT, 1990) – especially the introductory chapter; and, of course, Martin Jay, *Downcast Eyes* (Berkeley, Calif.: University of California Press, 1993).
4 Pollock, op. cit., p.11.
5 Pollock herself has played a significant part in this research. See, for example, Griselda Pollock and Rozsika Parker, *Old Mistresses* (London: Pandora Press, 1981).
6 Pollock, op. cit., p.12.
7 Ibid., p.13.
8 Pollock herself has spoken of, for example, the 'horrors' of Picasso's *Demoiselles d'Avignon* ('Who is the Other?': Feminism, the Mother and Modernism', paper presented at Museum of Women's Art conference: 'Reclaiming the Madonna', London, July 1994), but for a sustained argument unconditionally condemning much modernist art – including that of Matisse and Picasso – because of its depiction of females, see Carol Duncan, 'Virility and Domination in Early Twentieth-Century Vanguard Painting' (1973), reprinted in Norma Broude and Mary Garrard (eds), *Feminism and Art History* (New Haven: Yale University Press, 1982).
9 Emma Rose, document relating to a planned exhibition entitled *Sight Specific*, Department of Art, University of Lancaster.
10 See Rosemary Betterton, 'Brushes with a Feminist Aesthetic', *Women's Art Magazine*, No. 66, September/October 1995, p.9; and Betterton's catalogue essay for the group exhibition entitled *(dis)parities*, Mappin Art Gallery, Sheffield, April 1992.
11 Betterton, 'Brushes with a Feminist Aesthetic', op. cit., p.6.
12 Ibid., p.9.
13 These were exhibited in a solo exhibition of the same title at Southwark College Gallery, London, 1990.
14 Interview and conversations with the artist between February and April 1996.
15 Rebecca Fortnum, *Contra Diction*, Winchester Gallery, 1993.
16 Angela McRobbie, 'Room to Move', catalogue essay for *(dis)parities* exhibition, op. cit., n. p.
17 Jacqueline Morreau, quoted in Rebecca Fortnum and Gill Houghton, 'Women and Contemporary Painting: Re-presenting non-representation', *W.A.S.L. Journal*, No. 28, April/May 1989, p.5.
18 Rebecca Fortnum, *Third Person*, Kapil Jariwala Gallery, London, 1996.
19 Rebecca Fortnum, *Where You Are, I Haven't Been*, 1996.

20 Rebecca Fortnum, *We Have Created an Equilibrium*, 1996.
21 Rebecca Fortnum, *I Just Go Blundering Into It*, 1996.
22 Greg Hilty, catalogue introduction, *Third Person* (Norwich: Norwich School of Art and Design Press, 1996), n. p.
23 Charles Hall, catalogue introduction, *An Undiscovered Country: A new generation of British abstract artists* (London: Rebecca Hossack Gallery, 1993), n.p.
24 John Barth, *The End of the Road* (London: Granada, 1962), p.138.
25 Ibid., p.98.
26 Iris Murdoch, *The Sovereignty of Good* (London, 1970), p.34.
27 Roland Barthes, *The Pleasure of the Text* (London: Jonathan Cape, 1976), p.14.
28 This is reminiscent of Fortnum's *Agent and Patient* series of paintings (1992), which are briefly discussed by Betterton, but again in terms which directly relate visual characteristics to textual meaning, and which therefore tend to *translate* rather than *attend* to the visual specificity of the works. See Betterton, 'Brushes with a Feminist Aesthetic', op. cit., p.9.
29 Emma Rose, artist's statement in *Tradition and the Modern*, exhibition catalogue, Peter Scott Gallery, Department of Visual Arts, University of Lancaster, 1992, p.32.
30 Ibid.
31 Fortnum and Houghton, op. cit., p.4.
32 Conversation with the artist, October 1996.

8

THE DENIGRATION OF VISION AND THE RENEWAL OF PAINTING

John A. Smith

I

'The answer is: Let us wage war on totality; let us be witness to the unpresentable; let us activate the differences and save the honour of the name.'[1] So ends Lyotard's answer to the question, 'What is Postmodernism?' – and in it lies an implicit paradox, a contradiction which, I think, has now reached the condition of crisis. He speaks of 'the answer', of war waged against totality, of the dissolution of the 'nostalgic' modern aesthetics of the sublime, of:

> that which denies itself the solace of good forms, the consensus of a taste which would make it possible to share collectively the nostalgia for the unattainable; of that which searches for new presentations . . . in order to impart a stronger sense of the unpresentable.[2]

Or again: 'We have paid a high enough price for the nostalgia of the whole and the one, for the reconciliation of the concept and the sensible . . . '[3]

These sentiments – the denial of the solace of good forms and 'we have paid a high enough price' mark out the complex relationship in Lyotard's thought between the aesthetic and the political. Both are destined 'to have to furnish a presentation of the unrepresentable . . . The aesthetic supplements the historical-political and the theoretical in general . . . as a means of pushing the theoretical beyond itself in pursuit of what it cannot capture or present, that is, conceptualise.'[4]

The aesthetic, in effect, models an image of how the theoretical–political *ought* to function: in contrast to totalising and totalitarian impulses, the aesthetic shows how the task, the 'destination' is not consensus – whether imposed or 'freely' elected – but rather that of keeping the critical tasks unresolved; 'finding ways to phrase *differends*'.[5] This conflictual heterogeneity, then, is the central

necessity, the unrealisable destination that is at once the demise of metanarrative and the insistence upon an irreconcilable diversity of showing and phrasing that 'activates the differences'.

At this point, the contradictions begin to assert themselves. One might begin by questioning whether in forbidding or in 'waging war' against totality another metanarrative is surreptitiously authored. If conceded that leaves us in the depressing political stalemate of also conceding a sort of analytic identity between Lyotard's heterogeneity and the most fundamentally totalitarian 'consensus'.

More fruitfully, perhaps, we might begin by thinking whether Lyotard's *proposed* heterogeneity is instead rather more troubled by the fact that it simply describes a *potential* – a series of possibilities – and so merely *announces*, as it were, in *formal* terms the demise of metanarrative. The work of realisation – activating the differences – is promised but unrealised. This would of course not be a criticism but rather the proper outcome of his position, for which he explicitly calls. It does become critical, however (and fundamentally so), not on account of the hairsplitting metanarrative denial of metanarrative (for every allusion is inescapably determinate) but rather in Lyotard's caricatured prescriptions of aesthetic practice. And since the aesthetic models the political, this also descends to caricature. The caricature, the limitation and ultimately the *orthodoxy* of Lyotard consists in this.

His description of authentic aesthetic practice is too unified; it lacks modalities or genuine contradiction. Uncannily like dadaesque notions of the *modernist* avant-garde its functions are too simply *disruptive*. It is not bound, for example, by what we might think as the desires or disciplines of its own traditions, its own manifold versions of the 'solace of good forms', the relationship to a collectivity of practice (and its 'audience') – which Lyotard thinks as 'nostalgic'. And so the call to 'activate the differences actually falls by virtue of its own caricatures: neither discipline nor tradition is seen as *inaugural* but instead prejudicially – as the obstacle, the nostalgic object, the consensus that *substitutes for* the unpresentable.

The desire to paint, for example, is fundamentally ungroundable by the Lyotard represented by these selections. Certainly it is rather more groundable in the Lyotard who speaks of micronarratives, of a community living at the intersection of many such language games, of painting as 'libidinal machine'. But so far as the ortho-'doxy' of disruption takes ontological precedence – through the notion of the unpresentable – over the ortho-'praxy' of, say, painting – the difference represented by all of the characteristic terms of the practice is not at all *activated* but is rather *dissolved*. And the cause, the rightness, the *condition*, of that dissolution is the special energising status of the precisely named *unrepresentable*. One could cite its explicit relation to the sublime; one might attend to its resonances to the divine, or its structural position as the 'first' analytic principle (at times virtually the saviour of reason) but Lyotard is rather more exact a poet than this. The *un*representable is – and functions as – precisely

what it says: a first principle that analytically guarantees that differences, representations – for which we might read 'consensus' of any kind, political or aesthetic – are not only second-order but carry the moral requirement to exemplify that status. Simply put, this version of difference is certainly active, but as self-cancellation.

Conversely, we may infer that the notion of consensus – whether understood as referring to the elements of a discipline or as the conceptual components of a political regime – is central to any notion of difference that is *not* self-cancelling. Moreover, we should not draw from this the conclusion of consensual discipline as a kind of *stasis*. That of course is possible, but not necessary – as, again, the example of painting makes clear.

The situation in which difference is self-cancelling has, I said, reached critical proportions – specifically in relation to the visual. This is not solely or primarily on account of Lyotard *per se* but rather on account of the specific attention paid to the *denigration* of vision by Martin Jay in *Downcast Eyes: the denigration of vision in twentieth-century French thought*[6] – a denigration based, I shall argue, on an orthodoxy close to that outlined above and crucially influenced by Heidegger's account of the grounds of visibility. Stated in a preliminary way, the problem as I see it is the confused distinction between an ideological consensus, an 'ocularcentrism' codifiable as 'Cartesian perspectivalism', the 'observer paradigm', or (a term Jay uses to underscore the politicisation of vision) *super*vision – and the existential fact of visibility. One does not say that this existential dimension is therefore separable, readily identifiable, or in some naïve way 'unproblematically' representable: vision will always be confused or *practically* indistinguishable from its paradigmatic representations One can say, however, that if French *thought* feels the imperative of *anti*-ocularcentrism to be pressing, that is not necessarily the case for firmly, 'traditionally' ocularcentric disciplines such as painting. Nor do they necessarily bear the same 'Cartesian' relation to visibility.

In sum, then, if Lyotard's activation of self-cancelling difference authors a kind of dissolution based on the constant rejection of consensual identity in the exalted name of the unrepresentable, and is at times not unlike Joseph Kosuth's notion of art as tautology,[7] the result is a subsumption, or better, an imprisonment of art within this *discursive* frame. The denigration that Jay analyses threatens perhaps a more prosaic subsumption but with similar effects: that painting and the visual arts generally should abandon their ocularcentrism on the grounds of *discursive* anxiety. The implication is twofold: that visual art bears the same relation to the visible as verbal language; it *is* a kind of language. Or conversely – if the relation differs – then the 'theory' or significance of the visual *for visual art* may be different from that which appears necessary for discursive practice. This schism within theorising the visual seems to me what is both intended and precluded within Lyotard's *general* insistence on *discrete* standards of performativity. (Or perhaps, as above, the difference between the articulated generality and the unarticulated discrete is a consequence of

Lyotard's inescapable formalism.) It is certainly also part of the challenge Jay proposes when, following his analysis of vision's denigration, he calls for a plurality of scopic regimes.

II

This is not the place to detail the enormous scope and themes of *Downcast Eyes*. Instead I want to focus attention on those sections that deal with Derrida and Lyotard and (if somewhat indirectly) the distinction between 'visuality' as a discursive construct and the 'visual' arts.

Derrida is at times presented as radically anti-ocularcentric. Jay, for example, cites W.J.T Mitchell:

> Derrida's answer to the question, 'What is an image?' would undoubt-edly be 'Nothing but another kind of writing, a kind of graphic sign that dissembles itself as a direct transcript of that which it represents, or of the way things look, or of the way they essentially are.'[8]

Earlier, he claims himself, 'in so far as everything that goes under the rubric of "vision" might be understood as a textual construct for Derrida, rather than a perceptual experience, the hypertrophy of something designated vision per se could not be subjected to a critique'.[9] An interesting twist in the imprisonment that announces 'there is nothing outside text' perhaps – but one that offers an equivocation, in Derrida's critique of vision that Jay continues to pursue:

> Representations, Derrida argued were 'sendings' ... which never reach their final destination or reunite with the object or idea they represent. Because of their inevitable 'destinerrance', their interminable wanderings, representations can never be replaced by the pure presence of what they re-present. But neither can their difference from the 'things' they represent be completely effaced in the name of a realm of pure simulacra entirely without a trace of reference (as theorists like Baudrillard were to argue).[10]

Or again:

> paradoxically, by insisting on the rhetoricity of language, he also acknowledged that our metaphorically informed bias for illumination and transparency cannot be completely undone.
>
> Derrida's resistance to radical rejections of ocularcentrism, his unwillingness to countenance antivisual purism, did not, however, mean he lessened his hostility to the traditional privileging of the eye.[11]

The 'traditional privileging of the eye' is a problematic catch-all. It is one thing to criticise the discursive constructs of specific instances of ocularcentric philosophy in terms of its political effects, one thing to oppose the associations of vision, positivism and authority, one thing to oppose the totalitarian aspirations of supervision and surveillance, but quite another to suppose that similar objections may be placed against any aspect of the specular field, even against every instance of privileging vision. For visual art clearly *privileges* vision. Are we constrained therefore to say that Duchamp and Kosuth are somehow 'righter' than Cézanne or Velasquez because they privileged vision less?

So whilst I am anxious to agree with Derrida's critique of the admixture of eidetic vision and originary presence at the expense of both writing and visual images in Plato – and anxious to agree with the logic of the supplementary in the place of Rousseau's concepts of an origin degenerated by the social – I also feel a deep sense of unease when the justice of the instance immediately transforms itself into a careless, unjust, unjustifiable generality directed against the ostensible 'traditional privileges' of vision as a whole.

Stated in this way the acknowledgement 'that our metaphorically informed bias for illumination and transparency cannot be completely undone' may be interrogated differently. Perhaps – since we agree, I take it, that we share the impossibility of an access 'outside text' that would serve as a sort of standard – this bias for illumination and transparency ought *not* to be *completely* undone. Perhaps in failing to listen to the possible equivocations of this 'bias' we are again carelessly, unjustifiably extending specific critique of instances to the general. Perhaps we should not be quite so sure that this 'bias' is not itself well-founded in the relationships of language and the world. Perhaps – despite the literary tropes of this or that philosopher – this 'bias' is not entirely accidental, not comprehensively ideological, not absolutely 'phallogocularcentric', but perhaps also authentic to some degree.

I am aware of a degree of discomfort when the notion of authenticity is invoked, especially in the context of visual theory. We have, rightly, learned a degree of postmodern distrust of 'what we see' – a degree appropriate and opposite to our recent, modern infatuation. Nevertheless, as a writer whose discipline is critical sociology but whose subject matter is visual art, I am acutely conscious that in my approach to that subject matter lies a privileging of the visual that I cannot renounce and which is not really touched by specific critiques of ocularcentrism in discourse, except by the assumptions contested above that the specific can be unproblematically extended to 'everything that goes under the rubric of vision'.

'There is nothing outside text' – is a statement that can only be made from outside the text. A small point perhaps, but with significant consequences. A rather elaborate reading of the early Wittgenstein might allow us to say that it is really not a statement at all since the conditions for its truth are necessarily absent. Derrida could, of course, have nothing to do with the correspondential

notion of truth that underlies that conclusion – except that it inescapably lies there in the form of the statement: a clear reference point, a set of boundaries is premissed.

Or, on the basis of the late Wittgenstein, perhaps we could say that it is a different kind of statement; if not 'nonsense'[12] then an affirmative rhetoric rather than critical reason. Affirmative in what sense? A particular rhetorical order is provided with its cornerstone; it affirms the ensuing possibilities. In what sense is it *not* critical? It will not suspend belief in its affirmations. Ironically, of course it *passes for* criticism. It is the idiom which means 'critical'

And yet its affirmations are negative in the sense that what is proposed is a doubled non-relation: an exteriority which is concealed by textual metaphor; a textuality that conceals itself by proposing things like 'perception'. Despite Jay's point, then, that all that lies under the rubrics of vision or perception cannot possibly be isolated and thus opposed under the Derridean position – a radical anti-ocularcentrism is not commensurate – an orthodox *impulse* to denigrate vision persists. Crucially, however, this negative impulse persists as orthodoxy, as faith or as mood – since its origin is critically unsecurable. Rather than analytic necessity, what is essayed in this denigration is an image of humankind 'fallen' into textuality, forever required to deny the authenticity of (in this case) vision as indistinguishable from text, forever bound to the tragic reclamation of a visible exteriority to which we are (apparently) authentically related as a *product* – an inauthentic consequence of verbal 'imaging'. We may take the distinction between that fundamental image of humankind and subsequent 'imaging' as the creed that founds a criticism which sets out to show that what appears or discloses itself in mundane vision is recoverable (also) as dis-appearance and concealment.

On the basis of this orthodoxy it becomes possible for (what passes for) critical 'theory' to appropriate vision, not only as its 'subject' but fundamentally as the consequence of previous, *less* critical 'theory'.

Moreover, the way is then open for such 'theory' to reappropriate visual 'practice' as its subjected matter, as 'practice' that owes its allegiance to such theorising, to which it will evermore closely approximate. Hence the extra-ordinary popularity of Duchamp in poststructuralism. For a critical position founded in apparent opposition to the Hegelian impulse to totalise, this is an extraordinarily Hegelian outcome.

On the basis of Derridean criticism as rhetorical idiom – based on a set of visual images (arguably shared with in the history of philosophy) – it is, however, possible for painting to assert a quite different relation to the visible – or if you will – to assert a different kind of faith. But surely, whatever the general, manifold failings of Modernism, it can claim to have secured at least one unquestionable truth – that to paint is to take a determinate stand towards the visible which proposes a representative synthesis. Far from being 'open' to visual possibility, painting aims at pictorial possibility; its goal is paintings. And the mark of this closure, the icon of human determination, reconstruction, the

possession of the visual in painting, is the frame. Enframing stands corrosively *between* painting and the visual, just as much for painting as it does for Derrida.

For such reasons, formidable in so many different ways, contemporary visual theory has come to discard the phenomenology of the visual arts in favour of an emphasis on the functions of the 'decipherable' graphic trace in a co-responsive field of other semantic determinations. Put simply, Merleau-Ponty's argument in 'Cézanne's Doubt' that places the painter in touch with a 'primordial' nature,[13] or what Bernard calls Cézanne's 'suicide' in 'the chaos of sensation',[14] is now seen as an *impossible* innocence.

Derrida's way of handling this series of problems is characteristically complex. He begins: 'Cézanne had promised to pay up: "I OWE YOU THE TRUTH IN PAINTING AND I WILL TELL IT TO YOU"';[15] then distinguishes four senses this 'truth' might imply. First, the truth of the 'thing in itself', unmediated, but indicating the contradiction that it is *also* represented. Second, (therefore) truth 'doubled' in its representation, in its 'likeness' in painting. Taken together these two senses: 'presentation or representation, unveiling or adequation, Cézanne's stroke [trait] . . . opens up the abyss'.[16] Third: 'Truth could be presented or represented quite otherwise, according to other modes. Here it is done in *painting*: and not in discourse'.[17] But this separation is immediately undone:

> But that is what an idiom (painting) is . . . It does not merely fix the economic propriety of a 'focus' but regulates the possibility of play, of divergences, of the equivocal – a whole economy, precisely, of the trait. This economy parasitizes itself.[18]

Fourth: 'the truth in painting' understood as truth or knowledge 'on *the subject* of painting'.[19] With cryptic exactness Derrida says:

> I owe you the truth about the truth and I will tell it to you. In letting itself be parasitized the system of the language as a system of the idiom has perhaps parasitized the system of painting; more precisely, it will have shown up, by analogy, the essential parasitizing which opens every system to its outside and divides the unity of the line [trait] which purports to mark its edges.[20]

With contrasting, brief, clarity Jay summarises:

> Arguing against the integrity of the work of art (the *ergon*) he [Derrida] showed that it is always polluted by its framing contexts (the *parergon*), so that any purely aesthetic discourse cannot itself avoid intermingling with those it tries to exclude – ethical, cognitive, or whatever . . . Cézanne's pledge . . . is doomed to be betrayed. For what is inside and outside a picture is undecidable.[21]

I am not sure this clarity helps, however, in that its brevity tends to conceal that Cézanne's pledge as a *saying* permeates the possibility of what Derrida subsequently elaborates as what can be further *said* about painting. There is, for example, constant reference to language, the French language, the possibilities of construal and even grammatical, syntactical and . . . semantic 'normality'.[22]

To me, then, it is significant that Derrida began the section by remarking on 'I owe you the truth in painting' as a *saying* of Cézanne's – and opens the next section:

> The painter does not promise to paint these four truths in painting, to render what he owes: Literally, at least, he commits himself to *saying* them . . . he swears an oath to speak . . . to say truly the truth . . . In painting, don't forget.[23]

This nuance – the distinction between Jay's brief clarity and Derrida's compounded subtlety – is important. Let us also place in consideration Merleau-Ponty's discredited claim for painting's (or more precisely Cézanne's) autonomous, uncorrupted access to a more primordial reality.

Merleau-Ponty's position suggests that the idiom 'painting' not only has a discrete autonomy but a virtually unique access in Cézanne's 'usage' to (as Jay puts it) 'reality prior to the split between subject and object'.[24] On the face of it, this is impossibly contradictory: a sort of idiomatic practice, a set of agreed determinations that so radically differs from all its other namesakes, all other such determinations, that it can overcome the very obstacle that is their condition and consequence: the residues of representative conventions. Ironically Nietzschean: Cézanne as overman, painting as ur-language, if painted in gentler colours; and yet his 'usage' is presumably accessible to makers and viewers of his art? This position must unquestionably be rejected – not only for its 'impossible innocence' but equally for the loss of that innocence: Cézanne's very painting becomes the icon of the loss, the idiom of foreclosure, the icon that condemns all *other* representation and comes to threaten the very existence of painting itself by forming an authoritative corpus for a possible, highly constrained, convention. Perhaps the Nietzschean colouring is actually appropriately lurid.

What then of Jay? At first sight it seems to offer the opposite to Merleau-Ponty. Given the caution that it offers a summarised reading of Derrida, it is also active on its own account. It reinforces the notion that there is no 'innocent' nor autonomous painting but that every act within the normative definition 'visual art' takes its place within a specific, if not a dominant, scopic regime.[25] This interpenetration is, as it were, 'inevitable'. This represents the position, I suggest, not simply of the dominant scopic regime but also of the currently dominant critical regime. (I leave aside the question of which regime 'contains' – 'if it contains – the other.) I suggest further that there is little serious, developed opposition to its dominance, though some disquiet has been formally notified.[26] Nevertheless, distinct criticisms are possible; I shall return to those

shortly. For the moment let me say that the inevitability seems too inevitable, the definition too fixed, the specification of painting too dependent on an inspection and a surveillance ironically Cartesian (if not positivist), the description of painting too much like that of a fixed natural phenomenon rather than the capricious fluidity of the social phenomenon.

In Derrida, it is rather the *transgression* – Cézanne's transgression into a *saying* that opens painting up to the volatile complexities of its 'pollution', violation, fertilisation, community. The consequence is at least twofold: that the transgression is possible rather then necessary; that the violations–fertilisations may be carried back from cognition, ethics 'or whatever' and reconverted into pictorial concern. In sum, we no longer have the image of painting simply, 'inevitably' polluted, 'by definition' and so also inevitably implicated in both the interests of a regime and morally charged with recognising the problematic influence of that regime in its own practices. Instead we have, at the level of practical attention – whether as artist-maker, artist-viewer, viewer-critic, etc. – the most complex interplay between the *ergon* and the *parergon*. It is not simply nor inevitably the fate of the former to be convulsed by the latter but, on the contrary, so long as visual art is in any way identifiably different from discourse (so long as Cézanne's *letters* are distinct from his painting) there is a distinct possibility in *the specific instance* that the *parergon* is radically absorbed in the obsessive (or even 'specialist') interests, intentions and performance of the *ergon*. In other words the distinction *ergon/parergon* is not fixed by framing (as Derrida points out), but neither is influence fixed in one direction (which Jay implies and Derrida leaves unstressed).

The constriction of this series of interpenetrations, influences and inversions is a close counterpart to Lyotard's orthodoxy since it rests upon an implicit authority that decides that the painter is actually bound to be overwhelmed by the *parergon*, and so the identity of the *ergon* will tend to dissolve. It does not recognise the obsessive attention paid by the painter to his practice, whether exemplified singularly or in the context of an organised, intersubjective emphasis which may shape belief, intention, an economy of signs so that the *parergon* is obsessively dissolved and absorbed in the intentionalities of the *ergon*.

One can see why this orthodoxy might hold. Jay is, after all, in the business of review, formulation, definition. It would be hard for such a writer to conceive, far less to prioritise the *visual ergon* to this obsessive extent. Derrida, arguably more imaginatively inventoristic in this instance – and certainly less worried about clarity – is still concerned to review discursively the *series of possibilities*. But this is not simply a question of the difference between writers' and painters' interests (though that is significant enough) – for neither the clarity that defines and fixes nor the 'clarity' that lists the permutations is appropriate here. They would be appropriate, no doubt, to the analysis of natural phenomena – to the extent that the identity is fixed, to the extent that the infinity of permutations is relevant. But to make a rather obvious point, Derrida's series of nuances on the 'truth in painting' may be analytically relevant but not absolutely so – but

they are scarcely at all relevant to Cézanne's pictorial project. In this sense, the orthodoxy at work here is not unlike that of natural science, or at least an inquiry modelled on formal or 'objective' analysis rather than desire. As to visual art as a social phenomenon and the desires that shape its practice (for example, the domain of 'pictorial' possibility), as Durkheim might say 'they work in different ways; they have a different substratum'.[27] In short, this orthodoxy is reasonable in the sense of 'understandable' but it is *unreasonably* fixed in its foci and interests – precisely so far as does not concede that the visual arts and the visual artist not only have an identity (which may or may not dissolve), but that this identity and its possible dissolutions are constituted *for the visual arts* in and by and *as* the privileging of the visual *through the visual arts.* Now it is perfectly possible that this self-constitution could be abolished. Indeed it is arguable that the 'theorised practice' of the visual arts in postmodernity is precisely that. But that would be to displace one constitutive discipline for the sake of another; it is not the vindication of the discursively formulated primacy of the *parergon* over the *ergon* but a mark of the succession of discrete idioms.

In this sense, the 'impossible innocence of Merleau-Ponty seems more credible. Not on account of its wordings (I am after all a writer and terms like 'primordial realities' have all the surpassed claim of French academic painting), but as an index of the belief that Cézanne is (naïvely?, ridiculously?) prepared to invest in the (un)parasitized 'economy' of painting. By contrast with Cézanne's, with Merleau-Ponty's (ridiculous?) naïvety Jay's and Derrida's orthodoxy seems permeated and shaped by their own suppressed, impulsive beliefs whilst leaving unrecognised the impact of belief in the identity of the *ergon.*

This is a double irony in Derrida – since he is, *par excellence*, the critic of belief's constitutive functions. But – to redirect Derrida's point, 'to say truly the truth . . . In painting, don't forget'[28] – remember, he *is* a critic. (And so am I.) Suffice to say that the *ergon* of critical theory seems permeated by the *parergon* of faith. Suppose Derrida were to concede this. Would we then have a *better* critical understanding? Or a plurality of belief? Or both?

In an echo of the earlier argument, then, if the bias towards metaphors of illumination and transparency in *language* ought not to be completely undone on the grounds that its persistence may indicate instead an authentic relationship between language and being, perhaps the belief that Cézanne and Merleau-Ponty are prepared to invest in what we coldly call the 'economy of painting – given its ancient lineage – ought not to be dissolved in the acidic idioms of postmodern, anti-ocularcentric critical irony – still modelled, apparently, after the idioms, habits and prejudices of the Enlightenment.

Can I be suggesting, then, that painting is an authentic form of inquiry? Or, put more forcefully, that painting genuinely belongs to the relationship between being and human being? Well, very nearly – and my equivocation does not stem from the obvious censure that such a claim will invite from several critical modalities. The problem is still 'enframing' – or the dominant conviction of the 'serious' critic that humankind is estranged from Being through its commitment

to representation as control, as 'determination' in the senses of both specificness and intention, therefore as convention and forced consensus.

III

> Wasn't it Lyotard who criticised Derrida's notion of the 'trace' and arche-writing for failing to take into account the positive presence of the 'other' of discourse? And wasn't it Lyotard who insisted that painting should be understood as a libidinal machine in which the primary process becomes visible?[29]

It is time to return to the credence given to the sublime. I don't want to assign ontological or even onto-theo-logical functions; the trope, the rhetoric, interests me. But it is important to say that what *follows* from the sublime, follows because of the credence given to the sublime. This is where we hit hard going, for Lyotard refers to the unpresentable, as we have seen, whilst Derrida will insist (reading Kant) that: 'The sublime cannot inhabit any sensible form. It inadequately presents the infinite in the finite and delimits it violently therein. Inadequation, excessiveness, incommensurability . . . let themselves be presented . . . as that inadequation itself.'[30] Jay also comments, 'Derrida notes, as Lyotard also did, that Kant and Hegel associated the sublime with the Jewish taboo on representation.[31]

If I may borrow the methods of deconstruction for a moment, the terms '*cannot* inhabit' and 'inadequation' may *follow as* the supplementary logic of the sublime-as-unrepresentable, but when we note the association of anything so specific and distinct as 'taboo' we have a plainly doubled movement: the sublime is represented as the unrepresentable (though we might allow Goya the occasional colossus). At the risk of repetition, the redoubled move presents us with the impossible, irresolvable conflict between the suspension of *this* representation (which denies itself) and the affirmation of any *other* (which allows itself). We are again faced with the analytic identity of representation and non-representation, taboo and permission, the agnostic and the fundamentalist.

This is, I suggest, not simply the supplementary logic but the logical *limit* of deconstruction heard in its fundamental key. Or, as I termed it in the opening section, the 'cancellation' of difference. This is not the place to pursue its alarming political consequences; nor is it the place to perpetuate its critical agendas. I am more interested in the taboo as taboo, or, if you will, its rules and its rituals and not the endless nuances of its 'paralogics'. Standing aside, then, from the delicately linked chain of (un)representing and (de)signification, we find this blunt and unsubtle instrument:

> For Derrida, the act of drawing itself necessitates a moment of non-seeing in which the artist depicts the ruins of a previous vision. Or rather, there is no initial vision that is not already a ruin (a visual

analogy to his familiar argument that there is no original word or thing prior to its representation).[32]

Earlier, Jay notes: 'if one remembers what Ulmer has called his pictorialization of the word as well as his grammatization of the image, then a more complicated understanding of his position may result'.[33]

There is little chance: Whether pictorialised text or a textualised image, both – as 'ruins' – fall under that overarching denigration as arbitrary frames; neither makes any genuine difference. Enframing names a pervasive estrangement, which rests on rather more than the (un)representation of the sublime. The resonance with another Jewish metaphor is acute; namely, that of expulsion. 'Text-image' occurs pervasively akin to the post-Edenic condemnation to *homo laborans*, to labour in representation as ruin, as loss, as estrangement from being. But of course, this site of expulsion viewed oppositely is not simply the *absence* of what went before (the constant focus of Derrida's thought on origins), nor simply the *beginning* of an agonised re-presentation of the former ruin. It is also the origin of a diaspora of modes, specialisms, interests dispositions and compulsions. All 'represented' no doubt, but beyond that uncollectable. Perhaps Derrida's pessimism rests on this un-col-lect-ability,[34] but, to be sure, the pessimism is a question of *mood* and not critical rigour; for there is nothing in the conflictual heterogeneity of diaspora to suggest the unity of either 'ruin' or 'progress'.

Presumably, then, when Cézanne proposes to 'redo Poussin from nature'[35] Derridean criticism would find it difficult to see Poussin as a visual model of compelling veracity; so compelling, in fact, that Cezanne – a painter working within that discipline and tradition – finds that to *really* look at Poussin is to illuminate both strength and weakness, to provide 'practical' foundations and *also* to provoke questions of development, points of departure; to ground both the basis of a disciplined orthodoxy and a 'conflictual' heterology.

At its worst – in terms of the concept of 'ruin' – Derridean criticism would arguably find in Poussin an ironic, complex depiction of 'actual' (that is, 'represented') ruins, which themselves present the nostalgic panorama of an arcadian origin, in the self-conscious form of an 'image of an image' – whilst concealing the fictive project of painting 'in general' substituting for an absent foundation: all that 'passes under the rubrics' of visual perception. Enter Cézanne – heir to this doubled concealment of vision 'itself' as construct – who proposes to revitalise the ruin of Poussin's foundational images by 'redoing them from nature'. And what does he find? Not nature, not vision, but the rectangle, the frame, the self-conscious, opaque, brush-stroked, painted surface of practice; not nature nor visual perception but a field of human abstractions. And what of nature and the visual sensations by which he sought to rediscover and develop the spirit of Poussin's imagery? Well, that was the *parergon* of science and modernism, the observer paradigm and the society of the spectacle – even the politics of supervision – invading the *ergon* of Cézanne's practice.

173

If we are prepared to grant a little more grace (to cite a renaissance concept[36] to Cézanne's *double* commitment to both painting and to 'nature' – by which (unless 'nature' is a most cynical literary device) we *must* understand 'nature' as the *author* of Cézanne's visual sensations – then an alternative complex becomes possible. I stress 'complex' because it is appropriate; what follows has nothing to do with the simplicities of positivism and the observer paradigm. This question immediately arises: If nature authors Cézanne's visual sensations, then what *is* painting? What is the *function*, or the *necessity* of painting? Is it simply the relic of a previous scopic regime – one for example that believed in the artist's 'grace' as the ability to see 'beyond' appearances and painting as the site of its presentation? This is a question I can only argue 'around'. In principle, it is not my task, but *painting's task* to show that it belongs to the community between the artist and visibility; (in this case) between Cézanne and nature as the author of visibility. There is in my mind no doubt that Cézanne's painting is surpassingly able and open to this task. The rectangle – the *declared* rectangle – marks out a mediate space of attention where Cézanne's 'suicide' in visual sensation is as apt as it is ridiculous. The rectangle, and all of its characteristic practices and materials, marks out the mediate space, precisely of a suicide, a willed self-suspension in the chaos of visibility, a *controlling* space in which the visual trace is allowed to illuminate the terms of a convention, a convention which – in Cézanne's hands and eyes – is itself the very means of interrogation. 'In painting, don't forget' – and therefore complicit rather than 'impossibly innocent'; but where Cézanne's complicity is hugely desirable, others' may not be. And if the *parergon* is marked by science and photography and the society of the spectacle, and if it invades and shapes the possibility of Cézanne's art, that is not to say that the brute, raw for of science, or capitalism, or surveillance is transposed, unalloyed, from the stridency of politics and technology to the gentler and more socially insular space of the canvas, the gallery, Provence and M. Cézanne. On the contrary, it is likely (could we but attend to it) that the generality of the *parergon* is ruthlessly subjected by the impossibly obsessive, innocent complicity of the specific *ergon*. This is roughly the same as saying that Cézanne is a memorable *painter*.

Jay's account (as does Lyotard's own) suggests that Lyotard is more open to conflictual heterogeny that would be the result of expulsion, diaspora, the various performative imperatives of representation. Beginning with the familiar postulate of 'the figural as an internal principle of disruption. The desire expressed in figurality . . . is rather a primary phantasm that disrupts the intelligible.'[37] Jay also cites the approval of Deleuze and Guattari: 'He shows that the signifier is overtaken towards the outside by figurative images, just as it is overtaken towards the inside by the pure figures that compose it.' And 'To overturn the theatre of representation into the order of desire-production . . . this is the whole task of schitzoanalysis.'[38] I have already commented on the orthodox consequences of the internal principle of *disruption*. It is now time to sharpen the focus: How does the motive force of desire shape, determine and

displace the orthodoxy of indeterminate disruption? In this libidinal economy, what is actually permitted and what is prescribed?

Quite a tight constitution – a corset set around the libidinal operation of 'primary' processes (one can only guess that Lyotard knows exactly what they are) – is set in train in 'The Sublime and the Avant-Garde'. He can allow Cézanne his 'little sensations', but not this debt to Poussin: 'These elementary sensations are hidden in ordinary perception which remains under the hegemony of habitual or classical ways of looking.'[39] Then:

> Recognition from the regulatory institutions of painting – Academy, salons, criticism, taste, – is of little importance compared to the judgement made by the painter-researcher and his peers on the success obtained by the work of art in relation to what is *really* at stake: to make seen what makes one see and *not* what is visible.[40]

An interesting translation of these imperatives occurs in Lyotard's 'Newman: The Instant':

> Occurrence is the instant which 'happens', which 'comes' unexpectedly Any instant can be the beginning provided that it is grasped in terms of its *quod* rather than its *quid*. If then there is any 'subject matter' [in Newman's art, which he insists there is] it is immediacy. It happens here and now. What (*quid*) comes later. The beginning is that there is . . . (*quod*) . . . '[41]

And on the following page:

> When we have been abandoned by meaning, the artist has the professional duty to bear witness that *there is*, to respond to the order to be. The painting is evidence and it is fitting that it should not offer anything that has to be deciphered, still less interpreted.[42]

Connected to the orthodox priority of the unrepresentable, this priority of *quod* over *quid* nevertheless constitutes a decisive inflection. Related also to modernist avant-garde formalism – 'The task of having to bear witness to the indeterminate carries away one after the other the barriers set up . . . by . . . the painters themselves'[43] – it may be grasped as the immanent form of the major part of twentieth-century aesthetics. By no means confined to modernism, there appears to be, then, an inescapable conviction that 'we have been abandoned by meaning', and its idiomatic form is the priority of *quod* – ('that it is') over *quid* ('what it is').

'We have been abandoned by meaning' may be taken equivocally. Its most radical form occurs in Heidegger in the sense that the 'we' of mundane order is so obsessed by meaning *qua* intentionality, control, technocracy that the 'we' of

fundamental ontology has been abandoned; the human 'we' that is authentically determined out of the nature of Being.

Analysing Heidegger's position, Levin asks: 'What takes place when our visual perception is not yielding, when it is so willful that it cannot give way, and does not visibly give thanks?'[44] And answers:

> Thinking which merely re-presents . . . is metaphysical thinking . . . Our particular concern is with vision insofar as it either embodies or is capable of *freeing itself* from that body of thinking . . . It is important to bear in mind the inherent *aversive and aggressive character* of re-presentation. As the prefix itself informs us, representation is a repetition: a process of delaying, or deferring, that which visibly presences. It is a way of *positing at a distance*, so that vision can 'again' take up what presences – but this time on ego's terms.[45]

Heidegger argues that this process of representative enframing is especially characteristic of the structuring of the visual in modern society. No doubt he has in mind the invasive organisations of techno-science, but despite his attempts to theorise the work of art (unconvincingly) differently,[46] it is clear that unless we are to return to the least credible features of Merleau-Ponty's impossible innocence – and its clear implication of artists as a will-less subgroup of society somehow inured to the pollutions of the technocratic *parergon* – that the work of art (representative or not) is being formulated as 'egological'. Lyotard (unconvincingly) offers the absence of a representative 'content' as 'fitting'; but it is utterly clear that such an absence is equally the painter's 'contrivance': the visible in the instance and the form of *this* painting. This is of course why the priority of that (*quod*) over what (*quid*) can only be satisfied in Lyotard's discursive field by the continual *succession* of forms. It is also a chilling reminder that, as Lyotard says, the postmodern 'is undoubtedly a part of the modern'.[47] But which part? The very worst part; that which is committed (by several liberal impulses) to the most illiberal denigration and supersession of one form by another *ad infinitum*. It is therefore quite incapable of *not* denigrating *specific* aesthetic – or for that matter moral – value.

In this sense the priority of 'that it is' over 'what it is' expressed in the idioms of succession is not simply the relic of a Jewish taboo on representation but – quite opposite to Lyotard's intention – a consensus to which twentieth-century critical and philosophical thought has committed itself *unreasonably* – arguably as an unintended consequence of a reasonable criticism of Hegelian 'totality'.

IV

To identify the priority of 'that it is' over 'what it is' expressed in the idioms of succession is to recognise a grammatical function or perhaps a temporal figure that shapes twentieth-century aesthetics. Its spatial and visual figures must be of

176

equal importance here – partly out of the requirements of an enquiry into the visual and partly because in the constitution of its spatial-visual imagery, aesthetic theory cannot so easily conceal its arbitrariness. Here, the crucial concept in Heidegger is horizonality.

In Levin's interpretation:

> We need the presence of the horizon. When the horizon is forgotten, the space of enchantment, the clearing of light which allows vision to open and beings to presence as they are, gets diminished: diminished, finally, as we are now seeing, to a point where the historical psychopathology begins to insist upon recognition.
>
> Violating the preserve of the visible, enframing is a mode of perception which reduces the horizon to a collection of objects available for total comprehensive control.[48]

In 'The Question Concerning Technology', Heidegger writes:

> The rule of enframing threatens man with the possibility that it could be denied to him to enter into a more original revealing and hence to experience the call of a more primal truth.[49]

Elsewhere he says, '[Through the "posturing" of the *ego* cogito] . . . the horizon no longer emits light of itself. It is now nothing but the point of view posited in the value-positing of the will to power.'[50] This transformation of the question of the origins of disclosedness, the ground of visibility, from the grammar of the distinction between Being and beings into the figure of the 'embrace' of the horizon threatens the composure of Heideggerian ontology. For whilst his early position – which stresses the relation of belonging between 'Being' and 'beings'[51] – can nevertheless be squared with the relentless emphasis on Being *qua origin* of the existence and (proper) 'disclosure' of beings, the corresponding presentation of the visual field of the horizon and its 'contents' resists that relation absolutely. Thus, when Levin says, 'We need the presence of the horizon'[52] its inalienable visuality insists that this need is not met in the form of the *absence* of its contents. The chronology of 'source' (I do not say 'cause')[53] will not operate in this unresponding field. And yet how is human being able to hold itself in proper attention to this infinite field of disclosure, except by the recognition and in terms of aspects, posture, viewpoint, the 'narrowing' of a determinate focus?

In that sense the horizon, if taken as the field of disclosure, *also* announces *itself* as showing the essential finitude of every instance of human concern. In this sense, to say that the horizon occurs as 'nothing but the point of view posited in the value-positing of the will to power' is to equate 'the point of view' and 'the will to power' quite absurdly, even cruelly. For, 'the point of view'

– whilst recoverable as the determined eye of manipulation – may also be taken as that in which humankind and its communities shelter in (from) the vastness of Being. To say 'enframing blocks the shining forth'[54] is too univocally a condemnation of technology: It may be taken as the manipulative restriction, but equally as the sheltering gathering of an identity and a place, a 'home'. Crucially, however, we should not produce the caricature (in Heidegger, in Lyotard) of the work of art in the latter position with politics, science, techno-logical 'consensus' in the former. Nor should we operate that specious clause that has 'good' (disruptive) art in the latter position and 'bad' (consensual) art in the former. All of that is too much like the stuff of a bad novel. In truth, painting should be allowed both its innocence and its culpability, its sheltering and its manipulations, Cézanne his 'suicide' and his canonical importance – whilst always remembering that bad painting can be innocent and good painting thoroughly manipulative.

V

The *possibility* of the renewal of painting (and it is possible that 'painting' could be replaced in this proposal for an entire series of aesthetic, moral or even political modalities) places two sets of requirements on socio-critical thought, on artists, on art critics and historians, on theorists of the visual – one general and one particular.

The general requirement, stated at its briefest, amounts to the requirement to delimit the corrosive effects of formalism. Put more fully – and perhaps more plainly – the unreasonable habit of providing a general critique of what might be called 'representation' and all of its cognates – enframing, the will to securable knowledge, the conventions of the *ergon*, etc. – whilst failing to distinguish between the kinds, attributes and ambitions of specific representative traditions must be resisted. There is no just cause for transferring the critique of technological or political or philosophic representation – as ethnocentric, egocentric, ocularcentric, logocentric, phallocentric and so on – to every other form of representation (such as painting) simply on the grounds that it is *another* form of representation. Or, because the common noun makes a kind of crude sense. How crude a sense? How far is the formalism that habitually links *every* political consensus and *every* solace of good form *qua* 'representations' – (Lyotard does it all the time) and so 'requires' the disruptive action of 'aesthetics' – justifiable as a discursive characteristic or censurable as the suppression of difference?

The particular requirement is the re-opening of *visual* enquiry, not on the basis of paintings' historical modes of classification and surely not on the bases of the several incredible ideologies that, whilst defunct, still shape the perceived connections between painters, so that Cézanne *stays* a modernist and his attention to the rectangle and the stroke *still* link directly to abstract expressionism and beyond, despite the fact that nobody has the slightest interest

in modernist formalism. So I suppose this is another call to delimit formalism, this time within the 'community' and *against* the 'category' of painting. Such a task might be begun in terms which concede critical priority to the 'libidinal economy' of the *ergon* – not uncritically, not in such a way that its identity is both unproblematically 'there' for the asking and also inviolable, but rather that the *formulation* of that identity as painting, as 'good' or bad *painting* is the origin of the enquiry for painters and writers alike. This position allows us some ground, then, to rethink Derrida's complex of 'four senses' that (re/de)-construct 'the truth in painting' as Cézanne's spoken-painted commitment.

First – the truth of the 'thing in itself',[55] unmediated – but indictating the contradiction that it is *also* represented – reconstrued as the 'thing in itself' gathered in that particular set of enquiries and ambitions that painting allows to be revealed or causes to be concealed. So the contradiction is not 'there' as the distinction between the 'obviously' immediate and the 'clearly' represented but whose lucidity as the distinction between revelation and concealing is always in contention, through painting and in understanding painting.

Stated in terms of the discipline of painting this implies a reflexive (re)consti-tution of the relationship between the 'object', whether understood as the represented object or as the physical properties of the work and the revelatory (or dissimulating) effects of the work as process. Set against Lyotard's virtual guarantees that – so long as the process is disruptive, anti-consensual – 'every-thing will be all right', there is an extraordinarily high risk that much of the work will be wasted, or preparatory, or uncompletable, or ineffectual, with or without consensus.

For Cézanne: the continual testing of the mark against the motif, and the conventions of the mark as an enquiry into the motif. The question: 'What can be seen?' – asked through the rectangle, (some of) the conventions of painting (but not others), even through the *rituals* of painting.

Second, (therefore) truth 'doubled' in its representation, in its 'likeness' in painting. Taken together these two senses 'presentation or representation, unveiling or adequation, Cézanne's stroke [trait] . . . opens up the abyss'.[56]

Reconstrued as: 'Presentation' cannot simply follow from the self-presencing of the unified 'thing in itself' for this perpetuates the ossified, objectionable split of object–subject. Taken, however, and without prejudice as the distinction between Being and human being, the trait of painting as the re-presenting place in which truth 'unveils' itself *for painting*.

Stated in terms of the discipline of painting: 'adequation' becomes instead the question of quality within the discipline – and therefore the continuing re-opening and closing of what 'quality' might mean; whether, if conceded, it might also be withdrawn.

Third – 'Truth could be presented or represented quite otherwise, according to other modes. Here it is done in *painting*: and not in discourse':[57] needs no reformulation except to undo the irony of the shift between the spoken pledge and the painted work. The former is the *lesser* – the rhetorical declaration that

counts for absolutely nothing by itself and can only be significant on the basis of the painting that follows, surpasses and absorbs it.

And – 'But that is what an idiom (painting) is . . . It does not merely fix the economic propriety of a "focus" but regulates the possibility of play, of divergences, of the equivocal – a whole economy, precisely, of the trait. This economy parasitizes itself.'[58]

Reconstrued as: The regulation of the divergence and therefore of the idiom itself is a matter to be wrested out of (re)thinking–painting the relationship between writing and painting. To speak of 'parasitization' is merely a habitual and orthodox negation. The relation *may* be fertile. It has no a priori designation.

Stated in terms of the discipline of painting: What is the 'abyss' that opens in the action of taking up the terms, the brushes, the canvas, the paint – and refusing the commonplaces of words that point and name, but do not dwell on the surfaces and structures of things as images may do?

For Cézanne: to risk and declare this 'abyss' as the place in which the chaos of sensation may be contemplated, but to wryly note this 'managed suicide' in 'making marks' in stressing the 'rectangularity' of the outcome; to trust anything so risky as suicide in painting.

Fourth – 'the truth in painting' understood as truth or knowledge '*on the subject* of painting'[59] shows, 'by analogy, the essential parasitizing which opens every system to its outside and divides the unity of the line [trait] which purports to mark its edges'.[60]

But the *subject* of painting for discourse and the 'same' subject for painting is *not* the same. The 'opening to the outside', whether understood as the opening of painting to 'its' discourses or, more problematically, as the opening of discourse to 'its' painting (as Lyotard essays), does not mean that the other of the relation is absorbed without transformation; and this transformation is both purposeful and idiomatic.

Stated in terms of the discipline of painting: to recognise that the discipline of looking-through-painting is to open the 'subject' of painting to a scrutiny made possible through the process of painting. For Cézanne: to redo Poussin from nature *and not* some other *and not* without visual reference to nature.

This seemingly small point heard in its fundamental key means: to risk everything on the possibility that the relationship between painting as process and as tradition or 'subject' may be authentic; for Cézanne, to risk an entire life on the possibility that *his* painting may be authentic.

Notes

1 Lyotard, J.-F., *The Postmodern Condition: A Report on Knowledge*, Bennington & Massumi (eds), Manchester, Manchester University Press, 1984, p.82.
2 Ibid., p.81.
3 Ibid., pp.81–2.
4 Carroll, D., *Paraesthetics: Foucault, Lyotard, Derrida*, London, Routledge, 1989, pp.182–3.

5 Ibid., p.169.
6 Jay, M., *Downcast Eyes: the Denigration of Vision in Twentieth-Century French Thought*, Berkeley, University of California Press, 1993.
7 Kosuth, J., 'Art after Philosophy', first published 1969, cited in Harrison and Woods (eds) *Art in Theory*, London, Blackwell, 1992, pp.840–50.
8 Jay, *Downcast Eyes*, pp.515–16.
9 Ibid., p.497.
10 Ibid., p.508.
11 Ibid., p.511.
12 Wittgenstein, L., *Tractatus Logico-Philosophicus*, London, Routledge, 1961.
13 Merleau-Ponty, M., 'Cezanne's Doubt', in *The Merleau-Ponty Aesthetics Reader*, Johnson, G.A. (ed.), see espec. p.64.
14 Ibid., pp.62–3.
15 Derrida, J., *The Truth in Painting*, Chicago, University of Chicago Press, 1987, p.2.
16 Ibid., p.5.
17 Ibid., p.6.
18 Ibid.
19 Ibid., p.7.
20 Ibid.
21 Jay, *Downcast Eyes*, p.516.
22 Derrida, *The Truth in Painting*, p.6.
23 Ibid., p.8.
24 Jay, *Downcast Eyes*, p.157.
25 See Jay, M., 'Scopic Regimes of Modernity', in *Force Fields*, London, Routledge, 1993.
26 See, for example, Summers, D., 'Real Metaphor: Towards a Redefinition of the "Conceptual" Image', in Bryson, Holy, Moxey (eds) *Visual Theory*, Cambridge, Polity, 1991.
27 Durkheim, E., *The Rules of Sociological Method*. See author's preface to second edition, p.xlix (New York Free Press, 1938).
28 See note 23 above.
29 Jay, *Downcast Eyes*, p.545.
30 Derrida, *The Truth in Painting*, p.131.
31 Jay, *Downcast Eyes*, p.517.
32 Ibid., p.522.
33 Ibid., p.516.
34 That is, a 'diaspora' that cannot be re-col-*lect*-ed (i.e., reunited in or by *words*).
35 See Reff, T., 'Cezanne and Poussin', *Journal of the Warburg and Courtauld Institutes* (London) XXIII, 1960.
36 For the usage of 'grace' as a neoplatonic concept and as legitimisation of artists' practice, see Summers, D., *Michelangelo and the Language of Art*: Part One, 'Fantasy', Princeton University Press, 1981.
37 Jay, *Downcast Eyes*, p.568.
38 Ibid., pp.568–9.
39 Lyotard, J.-F., 'The Sublime and the Avant-Garde', in *The Lyotard Reader*, Andrew Benjamin (ed.), Oxford, Blackwell, 1989, p.207.
40 Ibid., p.207, my emphases.
41 Lyotard, J.-F., 'Newman: The Instant', in *The Lyotard Reader*, Andrew Benjamin (ed.), Oxford, Blackwell, 1989, p. 247.
42 Ibid., p.248.
43 Lyotard, J.-F. 'The Sublime and the Avant-Garde', op. cit., p.207.
44 Levin, D.M., *The Opening of Vision*, New York and London, Routledge, 1988, p.63.

45 Ibid., pp.66–7.
46 Heidegger, M., 'The Origin of the Work of Art', in *Basic Writings*, Krell, D.F. (ed.), London, Routledge, 1993.
47 Lyotard, J.-F., 'What is Postmodernism?', in Bennington & Massumi (eds) op. cit., 1984, p.79.
48 Levin, *The Opening of Vision*, op. cit., p.76.
49 Heidegger, M., 'The Question Concerning Technology', in *Basic Writings*, op. cit., p.333.
50 Heidegger, M., 'The Word of Nietzsche: "God is Dead"', pp.106–7, cited at greater length in Levin, *The Opening of Vision*, op. cit., pp.85–6.
51 This is an important and horribly complex matter in Heidegger's thought. I offer these selections from *An Introduction to Metaphysics*, New York, Doubleday-Anchor, 1961 (first German edition 1953, but actually a reworking of lecture material from 1935): 'Appearing is not something that sometimes happens to being. Appearance is the very essence of being', and 'being, appearing, causes to emerge from concealement . . . and stands in *unconcealment, alethia*' (p.86). Set this against his censure of later 'phenomenology': 'From the standpoint of the idea, appearing now takes on a new meaning. What appears – the phenomenon – is no longer physis, the emerging power, nor is it the self-manifestation of the appearance; no, appearance is now the emergence of the copy . . . *mere* appearance . . . a deficiency . . . the *phainomenon*' (p.154).
 Levin's and the later Heidegger's positions seem to me identical with this sense of the phenomenon as *in*authentic – not through the 'metaphysical' priority of the idea but because of the influence of the will to power. But *every* human act of survival implies a kind of power and a kind of will.
52 Levin, *The Opening of Vision*, op. cit., p.76.
53 See Heidegger's objections to the (re)formulation of source as cause in, for example, 'The Question Concerning Technology', op. cit.
54 Ibid., p.333.
55 Derrida, *The Truth in Painting*, p.2.
56 Ibid., p.5.
57 Ibid., p.6.
58 Ibid.
59 Ibid., p.7.
60 Ibid.

Part III

TOWARDS AN ETHICS OF
THE VISUAL

MY PHILOSOPHICAL PROJECT
AND THE EMPTY JUG

David Michael Levin

My philosophical project

For quite a few years, I have been questioning vision, the gift of nature we call sight. My thinking in this regard has been guided by the hermeneutical method of phenomenology that Heidegger worked out in *Being and Time*, already announcing his decisive break with Husserl in the potentially very radical, very subversive formulation of his Introduction, because this method alone, I believe, truly and appropriately *respects* the reality of our experience as lived: it alone enables us to articulate this experience in a way that dynamically and creatively *carries it forward*; and it alone, therefore, appropriately *legitimates and empowers* subjectivity – beyond essentialism, beyond the will to power, beyond nihilism.

Since, for me, respecting experience involves questioning it, my thinking has not only been concerned with the articulation of our experience with sight, but has also attempted to *put it into question*, subjecting our experience as beings gifted with the capacity for looking and seeing to problematizations and challenges that draw on many different discursive domains of thought and enquiry.

This gift of nature – sight – is a capacity with a potential that can either be appropriately realized, developed and fulfilled or else be neglected, repressed, violated and denied appropriate cultivation and fulfilment. Since its realization, development and fulfilment are not predetermined by the conditions of nature, this task becomes the joint responsibility of the individual and society. Beyond the biological development of this capacity, there is also the ethical, moral, political and spiritual development of our vision – a *telos* which has been inscribed from time immemorial in the secrets of the flesh, and for which we as individuals must certainly assume some responsibility, but towards which we cannot hope to progress without the enabling conditions of our society and culture. Thus, when we ask, with Foucault, what kind of body – or what kind of gaze – our society and culture require of us, we must also ask what kind of society and culture the fulfilment of our potential for vision might need. With this question, of course, we can subject the conditions of our society and culture

to a radical critique, deploying the needs and dreams latent in our capacity for vision as its touchstone.

Vision is, above all, a capacity for responsiveness. This responsiveness, taking place, as Levinas would put it, 'prior to all freedom', prior to all acts of volition, is the beginning of all responsibility. But we are responsible, responsible both as individuals and as members of a society and culture, for the ongoing development of the responsibility implicit, or latent, in this responsiveness. Developing, cultivating our responsiveness, whilst at the same time sharpening the critical powers in our perception with regard to the visibility of oppressive and repressive conditions of our society and culture, could become what I would like to call, drawing on Foucault, a 'practice of the self'. A practice of caring for the self that, *a fortiori*, would also be a practice sharpening the self's awareness of others and its ability to care about, and for, the welfare of others.

As a philosopher, I am especially concerned about the *character* of the philosopher's gaze. What kind of gaze is it? What kind of gaze is called for? What does the philosopher notice, what see, what observe? To what is the philosopher blind? To what do we shut our eyes?

I am interested not only in the individual's self-development and self-fulfilment as a being capable of vision, i.e., in the relationship between our self-development and self-fulfilment as individuals and the realization, development and fulfilment of our potential as beings capable of vision; I am equally interested in the implications of such development for the critique and betterment of society and culture. The project of Enlightenment can, I think, be continued in this way.

For me, as for many philosophers before me, sight and its principal virtues – clarity, for example, and insight, foresight, and the power to gather beings into a state of simultaneous co-presence – are in large measure responsible for the construction of the ontology dominant in our time. What, then, is the connection between this vision-generated ontology and the ethics, morality and politics by which we have lived? What is the connection between the will to power driving our technology and the predominant character of our vision? To what extent is the character-tendency which has prevailed in the vision of modern times complicitous in, and responsible for, the cruelty and violence, the suffering and misery, that some of us can see in the world? To what extent do the terrible things we see *manifest and reflect* the character of our culturally favoured way of looking and seeing? To what extent does this way of looking and seeing *reproduce* itself – and, correspondingly, the evils that some of us can see? To what extent does the gaze of the philosopher not only *reflect upon* the human condition, but also immediately *reflect*, and thereby itself reproduce, its prevailing historical form?

The gift of vision is a challenge; it is also an opportunity. But only, I believe, if we are prepared to root our looking and seeing in the body of feeling. For the root of vision is weeping, our vulnerability, our openness to being touched and moved by what we see. This is the thought that has been guiding my philosophical work.

In the past, hermeneutics has been understood exclusively in relation to the interpretation of texts or, say, cultural discourses. Here, however, in 'The Empty Jug', I will be thinking about our vision as a capacity for engaging hermeneutically with whatever we may be given to behold. The problematic at stake in the hermeneutics of texts and cultural discourses – namely, the avoidance of an imperialism of the same in our relation to what is other – is no less at stake, I believe, when it is a question of our sight. Here, too, the violence inherent in the logic of identity all too easily dictates the conditions of our vision.

The empty jug

> I placed a jar in Tennessee
> And round it was, upon a hill.
> It made the slovenly wilderness
> Surround that hill.
>
> Wallace Stevens, 'Anecdote of the Jar'

I

There is a verse attributed to Lao-tse which speaks in simple words of seeing the emptiness of a vessel. Calling attention to the most ordinary things of our daily life, it is a verse that brings out what is extraordinary and uncanny:

> Thirty spokes unite around the nave;
> From their not-being (loss of individuality)
> Arises the utility of the wheel.
> Mold clay into a vessel;
> From its not-being (in the vessel's hollow)
> Arises the utility of the vessel.
> Cut out doors and windows in the house (-wall),
> From their not-being (empty space) arises the utility of the house.
> Therefore by the existence of things we profit.
> And by the non-existence of things we are served.[1]

The philosopher's words, here, make the emptiness visible: visible as a space that embraces and inhabits things, but that also – more than this – is that out of which things arise, emerging into the light of being. For most of us, this emptiness, this space, is nothing: nothing of value, nothing to think about, nothing worthy of attention. For, to their misfortune, 'The five colors', as he says in another verse, 'blind the eyes of man'.[2] But the philosopher's gaze is *struck* by this that others do not see. The philosopher's gaze is drawn, not to that which is (most) visible, but to that which is (most) invisible. It is a gaze that lets the invisible shine in its uncanny beauty, precisely *as* the invisible. It is a gaze

that practises *not* seeing, in order to let itself be held, held as if spellbound, by what most deeply holds it in its favouring – held by what it has always already beheld, if only it can recollect the event of its original encounter, long before it has cast *its* favour upon the particular thing it is given to see.

> Looked at, but cannot be seen –
> That is called the Invisible (*yi*) . . . [3]

In his commentary on this verse, Chuangtse observes that, 'All things appear, but we cannot see the gate from which they come.'[4] We see things that are in the light, that come to light; we see things by grace of the light. And occasionally, our gaze may even be claimed by this light, drawn away from the things it makes visible. But when is our gaze drawn beyond this light to the giving, the coming, of this light? When is it drawn into the *darkness* of the light? Lao-tse's verse thus continues:

> Not by its rising, is there light,
> Nor by its sinking, is there darkness.
> Unceasing, continuous,
> It cannot be defined,
> And reverts again to the realm of nothingness.

What light can be cast on this nothingness? Chuangtse's commentary turns to telling a story:

> 'Do you exist or do you not?' asked Light of Nothing.
> 'Light received no reply and he stared hard at him. Nothing was dark and empty. All day, Light tried to look, but could not see him; listened but could not hear him; and tried to touch him, but could not find him. 'Alas,' said Light to himself, 'this is the highest limit! Who can attain to such ultimate height! . . . '[5]

II

In 'The Thing' (given as a lecture, 6 June 1930), Heidegger gives thought to the world of difference that separates the object (*Gegenstand*) from the thing (*Ding*). Beginning with some thoughts on the near and the far, he is led to reflect that, 'Near to us are what we usually call things.' 'But,' he then asks, 'what is a thing?' And this leads him to consider why it is that 'Man has so far given no more thought to the thing as a thing than he has to nearness.' The jug, for example, is a thing. But 'what', he asks, 'is the jug?' His thinking perseveres:

> We say: a vessel, something of the kind that holds something else within
> it. The jug's holding is done by its base and its sides. This container

itself can again be held by the handle. As a vessel the jug is something self-sustained, something that stands on its own. This standing on its own characterizes the jug as something that is self-supporting, or independent. As the self-supporting independence of something independent, the jug differs from an object. An independent, self-supporting thing may become an object if we place it before us, whether in immediate perception or by bringing it to mind in a recollective representation. However, the thingly character of the thing does not consist in its being a represented object, nor can it be defined in any way in terms of the objectness, the over-againstness, of the object.[6]

The jug, he says, 'is a thing as a vessel – it can hold something'. But what is a vessel? This, he says, 'is something we can never learn – let alone think properly by looking [only] at the outward [visible] appearance, the *idea*'. Thus, 'no representation of what is present, in the sense of what stands forth, and of what stands over against, as an object, ever reaches to the thing *qua* thing'. For the jug's thingness

resides in its being *qua* vessel. We become aware of the vessel's holding nature when we fill the jug. The jug's bottom and sides obviously take on the task of holding . . . Sides and bottom are, to be sure, what is impermeable in the vessel. But what is impermeable is not yet what does the holding. When we fill the jug, the pouring that fills it flows into the empty jug.

Thus we are brought to the insight, the *aletheic* dimension of the truth, that the 'emptiness, the void, is what does the vessel's holding. The empty space, this nothing of the jug, is what the jug is as the holding vessel.'[7]

Pursuing this insight, Heidegger sees that,

if the holding is done by the jug's void, then the potter who forms sides and bottom on his wheel does not, strictly speaking, make the jug. He only shapes the clay. No – he shapes the void. For it, in it, and out of it, he forms the clay into the form. From start to finish, the potter takes hold of the impalpable void and brings it forth as the container in the shape of a containing vessel. The jug's void determines all the handling in the process of making the vessel. The vessel's thingness does not lie at all in the material of which it consists, but in the void that holds.[8]

In the world of today, however, this void is not seen, not recognized and acknowledged. Thus it happens that the non-objective, invisible dimension of the presencing of things is denied and things are reduced to ob-jects of re-presentation. 'Science makes the jug-thing into a nonentity in not permitting

things to be the standard for what is real.'⁹ That by grace of which the thing is a thing 'remains concealed, forgotten. The nature of the thing never comes to light.'¹⁰ Moreover, carrying this further, Heidegger wants to say that 'not only are things no longer admitted as things, but they have never yet at all been able to appear to thinking as things'.¹¹ For we are able to encounter 'only what has previously come to light of its own accord and has shown itself' to us 'in the light it brought with it'.¹²

It may seem that we have mastered the question of the jug's thingly being when we have 'represented the effective feature of the vessel, that which does its holding, the void, as a hollow filled with air'. But, although this is what physical science would call a correct or true understanding, Heidegger denies that this gets at the ontological experience of the jug's void. 'We did not let the jug's void be *its* own void,' he says.¹³ Obedient to the radically hermeneutical phenomenology that he formulated for the first time in the Introduction to *Being and Time* but that he then, with a gesture that can only be described as ironically repeating the very error of foreclosure for which he faulted the history of metaphysics, immediately betrays in the *Daseinsanalytik* that follows, Heidegger here, after the so-called 'turning' of his thought (which essentially turned him back to realize, if only belatedly, *nachträglich*, the implicit radicality of the conception of phenomenology he had already formulated), finally holds himself *open* to the phenomenon and lets the phenomenon show itself from out of itself. Heidegger's *hermeneutical* phenomenology, a radical recasting of Husserlian phenomenology that makes it more faithful to Husserl's two most fundamental methodological principles ('back to the things themselves' and 'accept the given only as, and within the limits that, it gives itself'),¹⁴ makes the most strenuous demands on the philosopher's gaze.¹⁵

What then shows itself, co-responding to the openness into which the philosopher's thinking prepared itself to receive the phenomenon, is a jug which, as thingly, gathers in and around its emptiness the fullness of life, the radiant splendour of the *Geviert*, earth and sky, gods and mortals.¹⁶ (Heidegger's word 'gods' continues the ontotheological tradition; still thinking with, but also beyond this tradition, we might therefore take this word to refer to local events of unconcealment, through which something of the significance of beings as a whole is made manifest and visible.)

Near the end of 'The Question Concerning Technology', Heidegger observes that,

> There was a time when it was not technology alone that bore the name *techné*. Once that revealing that brings forth truth into the splendour of radiant appearing was also called *techné* . . . In Greece, at the outset of the destining of the West, the arts soared to the supreme height of the revealing granted them. They brought the presence [*Gegenwart*] of the gods, brought the dialogue of divine and human destinings to radiance. And art was simply called *techné*. It was a single, manifold

revealing. It was pious, *promos*, i.e., yielding to the holding-sway and the safekeeping of truth.[17]

What is in question, here, is the capacity of our gaze to be *aletheically* poetical: 'The poetical brings the true into the splendour of what Plato in the *Phaedrus* calls *to ekphanestaton*, that which shines forth most purely.'[18]

III

In the presence of the jug, the philosopher's gaze practises no-thingness, the openness of *Gelassenheit*, a way of seeing not bound to the process of objectification. Attempting to see things without stereotyping, without fixation, without reifying,[19] the philosopher's gaze would be a *releasing* of the thing from the objecthood and commodification that is its condition, its destruction, in the political economy of the modern world. To the extent that this gaze can overcome and transcend the universal imposition (*Gestell*) of this economy and, most of all, today, its commodification, even if only for the briefest moment, it may encounter the thing in its phenomenal, hermeneutical presence, letting it show itself from out of itself.

In *The Eclipse of Reason*, Horkheimer observed that 'Negation plays a crucial role in philosophy. The negation is double-edged – a negation of the absolute claims of prevailing ideology and of the brash claims of reality.'[20] Negation is the very heart of philosophy, because it represents the critical attitude, questioning conventional wisdom, questioning the common experience of reality. No doubt, some of the things encountered in this way would not be at all enjoyable. Having produced a world in which there are many ugly, sinister and dangerous things – things of demonic countenance – we must be prepared to let such things show us their truth.[21] We must be prepared to see, without ideological distortion, the truth in what we have wrought. In the attitude, the attunement of *Gelassenheit*, 'letting-be' and 'letting-go', one would see more clearly not only the radiant beauty of things that are beautiful, but also the sinister nature of those things that surround us with a wrathful and demonic presence. Far from being an attitude of passive indifference or resignation, *Gelassenheit* makes possible the clear-sightedness that can penetrate the aura of ideological enchantment in which things are enveloped, to see things in their naked truth – just as they show themselves from out of themselves.[22] In effect, *Gelassenheit* is a deliberate *Entfremdung* (estrangement), a neutralization of engagement, an endistancing *epokhé* which enables vision to achieve some degree of autonomy and register what can be seen from its critical, dialectical position. And what it can then register is indeed strange and uncanny. For in the attitude of *Gelassenheit*, the endistancing estrangement takes place in conjunction with an experience of the thing's no-thingness, the thing's ultimate insubstantiality, impermanence, and groundlessness. But this only *strengthens* the critical power – or say the 'negative dialectics' – of the philosopher's gaze. For the thing

191

shows itself from out of itself against the nothingness and groundlessness of a background that confirms the inherent contingency of the thing – and over-whelmingly reminds us that historical things could always be otherwise. If *Gelassenheit* can heighten the visible beauty of things, if it can make the gaze open to the sublime invisibility of things, it also bears the potential – a potential that Walter Benjamin always recognized – to make them visible in their decay and ruination – and indeed to foresee their final moment of destruction. Thus, surprising as it may seem, this critical vision is not, after all, so different from the vision taught by Lao-tse as the Way of the Tao.

The philosopher's gaze is learning the art of poetizing, learning to see the earthen jug coming out of the emptiness and enclosing it, coming out of emptiness and receiving its gathering embrace in the fourfold (*Geviert*) of earth and sky, deities and mortals gathered around it. Learning this way of seeing is learning to see every *thing* as a site of such gathering. 'Earth', here, names the matter, the substance of the thing; 'sky' names the openness, the no-thingness, that receives and embraces its presence; 'gods' names the events of unconceal-ment that the thing inaugurates – names the ways in which the world is made visible (to those with the eyes to see it) by the presence of the thing; 'mortals' names, calls and gathers together all the human beings whose destinies, lives and deaths are intricately intertwined in the history, the fate, of the thing, recalling the simple justice (*diké*) of mortality whereby every human life is assigned its measure of time, recalling also, therefore, the earth-bound, perishable nature that we share with all things.[23]

We have said that the jug *is* hollow, that the jug *is* empty, that it *is* a thing, *is* an artefact, and *is* made of earth. We have said that the jug *is* surrounded, embraced, by space – that a certain openness receives it. Returning again and again to reflect on this 'is', Heidegger argues that it says the very *being* of the thing. In *Basic Concepts*, he observes that, 'Whenever, whichever way, and to whatever extent beings become questionable and uncertain to us, we do not doubt being itself. Whether this or that being is, whether this being is so or that being is otherwise, may remain undecided, indeed undecidable in specific cases. And yet, through all of the wavering uncertainty of beings, being, by contrast, offers reliability. For how,' he asks, 'could we doubt beings in whatever respect if we could not rely in the first place upon what is called "being"?' From this reflection he concludes that 'Being is the most reliable, and so unconditionally reliable that, in all spheres of our comportment toward beings, we do not ever become clear as to the trust we everywhere place upon it.' However, this is not the whole story:

> Nevertheless, if we ever wanted to ground our plans and recourses among beings – our using and shaping of things – immediately upon being, if we wanted to assess the reliability of the everyday according to how being is grounded in its essence there, and how this essence is familiar to us, then we must just as soon experience that none of our

intentions and attitudes can be built directly upon being. Being, otherwise constantly used and called upon, offers us no foundation and no ground upon which we can immediately place whatever we erect, undertake, and bring about every day. Being thus appears as the groundless, as something that continually gives way, offers no support, and denies every ground and basis. Being is the refusal of every expectation that it could serve as ground. Being everywhere turns out to be the *non-ground*.[24]

Can the philosopher's gaze see, not only the 'isness' of the jug, its presencing, its that-it-is, but also its no-thingness, its groundlessness, its being-without-ground? Can this gaze see – and look into – the abyss (*Ab-grund*) that is given with the jug?

IV

Not only the socio-cultural value of the jug – for example, the value of the jug in the political economy of late bourgeois capitalism – but even its very being, ultimately rest on – nothing.[25] However, this emptiness or nothingness which the philosopher's gaze has seen through the presencing of the jug does not necessarily lead us into nihilism. It may instead eventuate in constructive forms of social and cultural critique. Far from securing the jug as a permanent worldly possession, the materiality of the jug, its earthly element, ensures – guarantees – its perishability. The only value that the jug 'possesses' is a value that *we ourselves* have constituted – or say brought forth – in the dimensionality of our life-world. But this life-world is of *limited* dimensionality, wrested by violence out of the no-thingness within which it takes place. Thus, to see the emptiness of the jug, to see its *being* grounded in no-thingness, is to see the jug with a potentially *critical eye*. Indeed, I would argue that, from this way of seeing it, an ontologically radical critique of society and culture is possible. Seeing the hollowness of the jug, seeing its emptiness, seeing it as having-come-forth out of, and also as having-come-into, the no-thingness of the openness of being, the philosopher's gaze detaches itself in a *critical* way from worldly temptations: not only forms of idolatry, forms of commodity fetishism, but also, and even more radically, from forms of materialism and forms of idealism. There is detachment from classical materialism, because all material forms, all forms of an earthly nature, are seen as impermanent, perishable: originating in the no-thingness of being, remaining forever dependent upon it, and ultimately dissolving back into it, all material things come into being, persist for a while, and eventually perish. Such, as Anaximander says, is the visible justice (*diké*) of their fate.[26] But there is also detachment from the epistemology and metaphysics of classical idealism and its legacy of power, because the emptiness of the jug cannot be contained, measured, controlled, valued, bought and sold. It precedes all human activities; it endures all human activities: it can be neither created nor

destroyed. To see the jug as belonging to this no-thingness, to see it as a temporary centre of gathering, a thingly form gathering the openness within and around itself, is to see it as belonging to, and therefore bearing, a fate or natural history that is beyond our grasp, beyond our will to power. The hollowness of the jug is the ultimate hollowness of all mortal ambitions in the face of nothingness. The hollowness of the jug reveals the hollowness of the mortal's phantasies of domination – the treacherous vision of the will to power, urging the mastery of nature, whatever its cost, whatever its violence. To see the hollowness of the jug, then, is to be reminded that the things of our world, the things around which we are gathered, belong, not to us, but to the presencing of being.

It should at least, I think, be noted here that the concept of the thing as gathering the 'fourfold' can likewise lend itself to a *critical* use, e.g. in critical social theory, as soon as we ask, concretely and specifically, who among those beings that Heidegger calls 'mortals' is included in the gathering, who is excluded, and under what conditions and principles of justification the inclusions and exclusions take place. Thus, for example, since every thing that we encounter *is* within the specific political economy that we have constructed and maintained, one might enquire into how our division of labour, social class stratification, and codes of gender influence the configuration of the gathering. We need to look with critical eyes at the *social relations* of the 'mortals' that the commodified thing gathers. We need to observe how the emptiness and hollowness of the jug is manifest in these social relations. We need to see, through the qualities and character of the space that surrounds the things of our present world, the *historical transformation* of the openness that the things of an earlier time made visible and tangible. The emptiness and hollowness of the jug, once a space hospitable to the enriching presence of spiritual energies, has become a commodified space, a dead space, bereft of spirit – a space that reveals something of the emptiness and hollowness that haunt our time. Heidegger's account misses an opportunity to understand, to see and make visible, the social conditions and material causes that figure in the historical reality he describes and diagnoses with – in a sense – such compelling accuracy.

V

Returning, now, from this brief excursion into critical social theory to take up once again the ontological concerns which figure in Heidegger's thought, I suggest that what the philosopher's gaze sees in the emptiness of the jug is its *sublime* truth: the truth that, like all the things of our world, it belongs in the keeping enownment (*Er-eignis*) of being – belongs, not to the realm of the visible, but rather, in the end as in the beginning, to the invisible, that realm of concealment into the care, or releasement, of which it silently, imperceptibly withdraws. For the philosopher's gaze, the empty jug is at once an earthly presence, something familiar and commonplace, and yet also something truly

sublime, a presence exceeding the imagination, drawing the gaze into the unrepresentable dimensionality of its concealment – into the protection of withdrawal into absence.

VI

In *Toast Funèbre*, the poet Mallarmé invokes with gifted words something of the spirit which we have attempted to recollect in thinking about the emptiness of the jug on our way through the philosopher's gaze. Let us read his words (lines 26–31):

Vaste gouffre apporté dans l'amas de la brume
Par l'irascible vent des mots qu'il n'a pas dits,
Le néant à cet Homme aboli de jadis:
'Souvenirs d'horizons, qu'est-ce, ô toi, que la Terre?'
Hurle ce songe; et, voix dont la clarté s'altère,
L'espace a pour jouet le cri: 'Je ne sais pas!'

In translation, the lines say:

Vast hollow carried in the mass of fog
By the angry wind of words he [the poet] didn't say,
Nothingness to this abolished Man of yesterday:
'Memories of horizons, O you, what is the earth?'
Shouts this dream; and, like a voice whose clarity fades,
Space takes for a toy the cry: 'I do not know!'[27]

I take the poet's words to suggest that, before we can see the *openness* of being granted to all beings, we need to be in remembrance of the horizon, measure of our finitude, and be held in the thoughtful beholding of nothingness – the nothingness into which all beings, even the most monstrous, are gracefully released. Only then, in such remembrance, may we be granted the wisdom – and the joy – that is spoken of in the ancient saying Heidegger takes to heart: *meleta tò pân*. 'Take into care beings as a whole.'[28]

In question is a gaze that is not just *looking at* the thingly presence of the jug, but is also *learning to let itself be gathered*, drawn into the dimension of the jug's invisibility, into the nothingness, the openness, that gives it (*Es gibt*) in unconcealment but still always shelters it in concealment. Learning how to *release* the jug into the hollow embrace of the invisible, the philosopher's gaze would learn what it means to take into care beings as a whole.

195

Notes

1 Lin Yutang (transl. and ed.), *The Wisdom of Laotse* (New York: The Modern Library, 1948), Verse 11, p. 87.
2 Ibid., Verse 12, p. 90.
3 Ibid., Verse 14, p. 101.
4 Ibid., p. 103.
5 Ibid., p. 103.
6 Martin Heidegger, 'The Thing', in *Poetry, Language, Thought* (New York: Harper and Row, 1971), pp. 166–7.
7 Ibid., pp. 168–9.
8 Ibid., p. 169.
9 Ibid., p. 170.
10 Ibid.
11 Ibid., p. 171.
12 Ibid.
13 Ibid.
14 Edmund Husserl, *Ideas: General Introduction to Pure Phenomenology* (London: Collier-Macmillan, 1931).
15 See Heidegger's Introduction to *Being and Time* (New York: Harper and Row, 1962). In my opinion, the conception of phenomenology that Heidegger lays out in this Introduction is so radical that his thinking never surpasses its radicality – and never needs to. In my opinion, the so-called *Kehre* does not involve a turn away from this conception of phenomenology, but rather a resolute (re)turn to its guidance, the realization that the *Daseinsanalytik* that follows this Introduction is actually a foreclosure of response in relation to the claim on our capacity for openness and responsiveness that the question of being presents, and that it is therefore a betrayal of our phenomenological responsibility – yet another in the history of metaphysics. The *Kehre*, then, indicates a readiness to be more obedient to the rigorous requirements of an ontologically responsive hermeneutical phenomenology.
16 See Heidegger, 'The Question Concerning Technology', in *The Question Concerning Technology and Other Essays* (New York: Harper and Row, 1977) and 'The Thing', in *Poetry, Language, Thought*.
17 Heidegger, 'The Question Concerning Technology', op. cit., p. 34.
18 Ibid.
19 Heidegger, *Conversation on a Country Path* (New York: Harper and Row, 1966), p. 63.
20 Max Horkheimer, *The Eclipse of Reason* (New York: Continuum, 1974), p. 182.
21 See Heidegger, *Parmenides* (Bloomington: Indiana University Press, 1992).
22 On the 'aura' with which late capitalism re-enchants the things it has turned into commodities, see Walter Benjamin, 'The Work of Art in the Age of Mechanical Reproduction', in *Illuminations* (New York: Schocken, 1968), pp. 217–51. Also see Susan Buck-Morss, *The Dialectics of Seeing: Walter Benjamin and the Arcades Project* (Cambridge: The MIT Press, 1989).
23 See Heidegger, 'The Anaximander Fragment', *Early Greek Thinking* (New York: Harper and Row, 1975), pp. 13–58.
24 Heidegger, *Basic Concepts* (Bloomington: Indiana University Press, 1993), §12, pp. 52–3, or, in German, *Grundbegriffe*, Gesamtausgabe, Bd. 51 (Frankfurt a.M.: Klostermann, 1981).
25 On emptiness and the nothing, see Heidegger's discussion in *Basic Concepts*, §§5 and 8–13.
26 See Heidegger's discussion of *diké* in 'The Anaximander Fragment', *Early Greek*

Thinking (New York: Harper and Row, 1975), or, in the original German, 'Der Spruch des Anaximander', *Holzwege* (Frankfurt a.M.: Vittorio Klostermann, 1950), and also in *Basic Concepts*, Part II, §§20–5.

27 Wallace Fowlie, *Mallarmé* (Chicago: The University of Chicago Press, 1953), pp. 176 and 190. Translation by Fowlie.

28 See Heidegger, *Basic Concepts*, pp. 3–78.

10

'EVER MORE SPECIFIC'

Practices and perceptions in art and ethics

Ian Heywood

I

It would be useful to sketch out here a tentative view of the territories – a cluster of ideas about art and aspects of social life – I aim to explore in this chapter. To think of these areas – artistic quality, the uniqueness of individual artworks, the ethical significance of art, the social value of individuality – as somehow related is not new, but the context in which these notions now appear is. Many old convictions, some of which have sustained more than a century of often brilliant modernist experiment, have been questioned and eroded to an extent that would have been difficult to comprehend even 20 years ago. To many theorists and practitioners ideas about quality, uniqueness, ethics and individuality now mean very little. In this critical climate revisiting these ideas and values may be not only interesting but also problematic.

Another impulse behind the chapter has been a strong feeling, especially vivid in the context of my studio teaching of fine art, that artistic practice and ethical issues of a certain kind are related. More specifically, it seems very difficult, impossible perhaps, to discuss with students how one might go about producing, or putting oneself in a position to produce, a good painting or sculpture without making reference to certain virtues – for example honesty, integrity, self-discipline, attentiveness. There is also the old conviction, again for me inseparable from not only teaching but also looking at, responding to and trying to understand art, that there is something ethically valuable about the successful work. This intuition seems to be about something other than the question of whether works of art contain virtuous messages, whether their creators were or are themselves virtuous, or whether they have moral effects. Yet what does this leave? Just the belief that *somehow* artistic quality is connected to the good. This 'somehow' is not of course very satisfactory as an explanation. It is also vulnerable to widespread contemporary scepticism about many aspects of art, that such views are the last, dying vestige of a nineteenth-century cult of art connecting its elevated position in a hierarchy of cultural practices to its

supposed civilising mission. To many younger artists and critics all this talk about art and ethics seems at best a hopelessly dated piety to ideals that, if they were ever worth while, are now incredible or perhaps just 'boring'.[1]

Another issue that emerged as the writing of the chapter progressed relates to a sensed connection between particularity as a feature of works of visual art and art as a practice. By particularity I mean that pieces are not only unique things but that their uniqueness is part of their artistic value. The fact that there is only one painting or sculpture 'like this' does not in itself greatly matter, at least artistically. But the precise *ways* in which a painting or sculpture is itself, and the efforts the artist has gone to in order to make its visible or sensible qualities specific, matter crucially. Another way of putting this view of particularity – the point at which factual singularity becomes something of value – would be to connect artistic quality with a kind of exactitude. The point is at least as old as Aristotle's famous remark in Chapter 8 of the *Poetics* that the parts (events) of the dramatic work of art

> should be so constructed that the displacement or removal of any one of them will disturb and disjoint the work's wholeness. For anything whose presence or absence has no clear effect cannot be counted as an integral part of the whole.
>
> (VIII, 30–36)

Something like this principle of specificity, this sense that in the successful work questions about what is present as well as what has been excluded have found a convincing, practical answer, still seems to apply. Even in the context of modernist and late-modernist developments when strict demands for formal unity or harmony have been long abandoned the work still needs to 'hang together'. It would seem reasonable then to connect the particularity of the work of art to its artistic quality; it is perhaps best understood as an aspect of quality. Particularity is also, at least in the context of visual art, something that has to be available through the senses; in the last analysis one has to be able to *see* it, at least potentially.

Finally, the idea of achieved particularity in a work of art connects it with a certain view of individual human beings, that they too may, perhaps should, aim at individuation or self-realisation. It is not enough simply to 'be oneself', rather the individual is called upon, has a responsibility, to realise his or her potential for individuality in such a way that the result is not only difference in the sense of absolute uniqueness but also difference as something of significance, both in itself and for others. This utopian vision – the great theme of Durkheim's sociology in particular – is a response to the characteristic modern problem of reconciling freedom with sociality.

So, we have a cluster of ideas: artistic quality, the particularity of artworks, the ethical significance of art, the social value of individuality. Some of these notions are difficult to pin down, and all have been subject to radically different

interpretations. Even more difficult to clarify, or perhaps now even imagine, is how they might relate positively to one another. Certainly, some influential theoretical and practical currents in contemporary visual art, which engender or strengthen profound scepticism about the importance of quality, particularity and ethics in relation to art, make pertinent a fresh look at these persistent questions.

How might these concerns relate to those of this collection of essays? Martin Jay has exhaustively and convincingly described a 'denigration of vision' in twentieth-century French thought. In his essay 'Scopic Regimes of Modernity' he summarises an important strand of this persistent critique:

> The modern era . . . has been dominated by the sense of sight in a way that sets it apart from its premodern predecessors and possibly its postmodern successor. Beginning with the Renaissance and the scientific revolution, modernity has been normally considered resolutely ocularcentric . . . Whether we focus on 'the mirror of nature' metaphor in philosophy with Richard Rorty or emphasize the prevalence of surveillance with Michel Foucault or bemoan the society of the spectacle with Guy Debord, we confront again and again the ubiquity of vision as the master sense of the modern era.
>
> (Jay, 1993: 114)

For many the villain of the piece is 'Cartesian perspectivalism . . . often assumed to be equivalent to the modern scopic regime per se' (ibid.: 115). Jay summarises its major features as follows. Linear perspective was taken to be a faithful representation for everything that could be visually represented; it was a way of harmonising three-dimensional space with a two-dimensional surface. It emphasised linear elements, measurability, detachment and control, it implied a fixed, monocular viewing position and reduced the importance of narrative or discursive content in favour of form or figural structure. The Cartesian way of seeing harmonised with or even led to an objectifying world-picture, a cosmos of knowable and malleable things or goods, the socially and historically constructed domain of the early modern natural sciences and of capitalism. Jay recounts how it has been widely attacked, in particular for 'its privileging of an ahistorical, disinterested, disembodied subject entirely outside the world it claims to know only from afar' (ibid.: 118). In sum, 'this tradition as a whole has thus been subjected to a wholesale condemnation as both false and pernicious' (ibid.).

Jay goes on to argue however that there are grounds for questioning the accuracy of this portrayal, suggesting that Cartesian perspectivalism was more internally complex than is often assumed. Indeed, Dalia Judowitz has powerfully argued that when one sets the *Optics* in the broader context of his work

> Descartes is in fact systematically undermining . . . the role of vision and its perceptual properties. Instead, the properties of the visible

200

will be transferred to the mental domain, whence they illuminate metaphorically the powers of reason to attain certitude as clear and distinct ideas.

(Judowitz, in Levin, 1993: 63–4)

Jay argues that the Cartesian way of seeing has always had to contend with rival scopic regimes. He mentions two in particular, the first more characteristic of northern than southern Europe, that Svetlana Alpers has called the 'art of describing'. This tradition, often associated with still-life and genre painting, is even more distant from narration than perspectival Italian art, and is concerned with the ways in which light is reflected and refracted by the surfaces and texture of objects rather than by their position in a consistent, readable space. Its paintings, typically small, are also invariably framed, and pictures themselves often include depicted framing devices (windows, curtains, doors, etc.). The most important mode of contact with the world to be found here is not abstract, conceptual and mathematical but concrete, sensory and fragmentary. Jay's second example is mainly informed by Wöfflin's and Buci-Glucksman's ideas about the baroque: 'Celebrating the dazzling, disorienting, ecstatic surplus of images in baroque visual experience' and its 'fascination for opacity, unreadability, and the undecipherability of the reality it depicts' (Jay, 1993: 122). Buci-Glucksman draws a contrast with the confidence of the Cartesian tradition in conceptual, spatial legibility and of the art of describing in material solidity.

So, instead of the simple hegemony of the single Cartesian way of seeing Jay proposes a plurality of different, perhaps competing scopic regimes. He concludes the main part of his essay with something of a defence of the Cartesian tradition, by suggesting that there can be nothing inherently superior – more accurate, more ethical, more useful – about descriptive and baroque modes of vision over the Cartesian. Few want to reject Western scientific rationalism in its entirety, and thus the connection between this heritage and the Cartesian viewpoint must in part at least be seen to contain something of significance and value. He wonders whether there are not dangers – theoretical and practical – of replacing the reification of the disembodied eye with fetishes of material surfaces or incoherent visual excess.

I have outlined Jay's useful summary of some of the debates about vision and its place in the constitution of modernity. The assault on the so-called Cartesian perspectivalism he discusses has been widely taken as part of a successful attack on vision, and if vision – the 'master sense of the modern era' – is firmly established as outmoded, 'false and pernicious', then so too must be the specifically visual aspects in visual art. I do not want to be anachronistic or to exaggerate here. There have been strong currents within visual art in this century, beginning with Dada and particularly with Duchamp, running through Surrealism into Pop, Conceptualism and postmodern Neo-Conceptualism, that have, from within art so to speak, attacked or rejected the primacy of the visual, the commitment to the intrinsic importance of optical, spatial and tactile

phenomena. Indeed, it has been argued that the development of postmodern theory itself has been much influenced, perhaps even made possible, by anti-visual ideas developed informally in the arts.[2] Once the ocularphobic strand of postmodern theory became established, however, it has undoubtedly had considerable reciprocal influence on the arts, strengthening and entrenching these attitudes by lending them the aura of theoretical sophistication and legitimacy. Jay's argument that Cartesian perspectivalism is internally more complex than has been widely assumed, that its sway has always been contested and off-set by other scopic regimes, and finally that to demonise Cartesian optics is to put at risk widely endorsed achievements and values, typically embraced in fact even by its critics, is a valuable corrective to ocularphobic tendencies. It discourages a rush to condemn the visual wholesale and encourages a more careful, reflective approach to these important questions about vision, art, ethics and individuality. This chapter is a small contribution to this task.

II

I enquire first into some accounts of the nature of moral 'perception'. In the next section I examine what it is that moral perception 'sees': ethical particularity. These two sections are then primarily concerned to present arguments from ethical theory not usually encountered in the context of a discussion of the practice of visual art. The following two sections try to relate ethical and artistic practices with respect to perception and particularity.

Iris Murdoch's arguments provide a useful introduction to the idea that perception is an important aspect of moral activity, for her systematically neglected or 'theorised away' by contemporary ethical philosophy. Her essays in *The Sovereignty of Good*, written in the late 1960s, attack a prevalent style of ethical theory which, she claims, made morality a matter of the public outcomes of willed acts by isolated subjects. Seeking to lift 'the siege of the individual by concepts' (ibid.: 32) she insists that at the roots of morality, almost its primary units, are the efforts of one individual to achieve the good of another, and a vital part of these efforts is 'attention' described as 'a just and loving gaze directed upon an individual reality' (ibid.: 34). 'Seeing' morally aims at

> a refined and honest perception of what is really the case, a patient and just discernment and exploration of what confronts one, which is the result not simply of opening one's eyes but of a certainly perfectly familiar form of moral discipline.
>
> (Murdoch, 1970: 38)

Murdoch is explicit, as one might expect of an eminent novelist, in her choice of metaphors; she imagines the efforts of a mother (M) to form a fair picture of her daughter-in-law (D), who initially she has seen in a poor light. She speaks of M as 'continually active', as 'making progress', and of her inner acts as

'forming part of a continuous fabric of being'. Despite prevailing philosophical opinion, which did not favour such metaphors, she insists upon their indispensability.

> Further, is not the metaphor of vision almost irresistibly suggested . . .
> Is it not the natural metaphor? M looks at D, she attends to D, she focuses her attention. M is engaged in an internal struggle.
>
> (Murdoch, 1970: 22)

'Perception' here, then, is a certain quality of awareness; it is not just being aware of something, taking it for granted, registering its presence at a superficial level. It involves rather a directed consciousness, trying to take in as much as possible, trying to be as open to what confronts one; that is, attempting not just to see what preconceptions or prejudices lead one to expect. It also involves an effort of will, in particular a struggle to be honest with oneself – a sometimes uncomfortable process.

In his *Moral Perception and Particularity*, Lawrence A. Blum elucidates and applies ideas about moral perception and particularity to contemporary ethical theory. Noting the continued relevance of the Murdoch essays he maintains that contemporary ethical theory still tends to 'theorise away' a crucial dimension of moral action: 'the true and loving perception of another individual' (Blum, 1994: 12), which itself involves 'an element of particularity not reducible to any form of complex universality' (ibid.).[3] Moral perception, he argues, involves seeing correctly that a situation one confronts has ethical implications, while moral judgement involves deliberating correctly about what should be done in the circumstances. He maintains of perception that: it necessarily occurs before judgement; that it can lead to direct, spontaneous moral action outside the processes of judgement; and that it contains capacities that do not belong to our normal notion of judgement. Taken together these arguments suggest that perception should not be overlooked or downgraded in favour of ethical theory's familiar concern for types of deliberation or reasoning.

Blum argues that moral perception is internally complex, not a unitary faculty. Different people confronted with the same situation can reasonably see different aspects as morally salient. Also, it is possible for there to be degrees of acuity in moral perception, from obliviousness through vague awareness to acute sensitivity. He notes that it is possible for someone to 'see' the moral significance of something but not to grant it the importance it deserves. In Murdoch's language this would be something like a failure of attention.

Finally, Blum insists that while moral perception is a necessary condition for moral action, it is also the case that perception can be, *ceteris paribus*, morally significant in its own right. Consistently sensitive perception in a person would be relevant to our view of that person's moral character. Keeping in mind the points made by Murdoch and Blum about the role of perception in ethics, what role does perception play in visual art?

III

To say that perception, and even more so the quality of perception, is important to visual art seems to be stating the obvious. Traditionally, in attempting to represent or, perhaps better, respond to something 'out there' in the world the artist needed to look carefully, retain something of what had been seen, manually record or react (how depended of course on the medium, specific intentions, the mode of image-making employed, etc.), look carefully at what had been done and either modify or return to the subject in hand. Even the artist not working from something in the external world needed as often and as carefully to look at and respond to what he or she was doing. There is, however, something more complex going on in these perceptual activities than 'just looking', or even directed, intentional looking. Descriptions of the role of perception in ethical practice may sensitise us to, or recall to our attention, the richness and complexity of looking and responding in art. It is perhaps a testimony to the rhetorical successes of ocularphobic theory that these qualities need reinstating in this way.

Murdoch emphasises the effort, the struggle, to pay attention. This has several aspects. It is an attempt 'to take in as much as possible', but in both art and ethics this differs from the kind of attention in which what is before one is surveyed from the point of view of some definite purpose in order to collect as much relevant information as possible, where the latter is understood to be a knowledge of factors and conditions relevant to this purpose. It is rather an opening-up, a moment of willed passivity,[4] a receptivity to dimensions of the seen that are usually overlooked or are irrelevant from the point of view of practical plans. Paying attention in the practice of art also involves the possibility of surprise, an effort not to repeat oneself, not to see what one expects to see, or what one knows to be there, simply because this is easier or more comfortable. The artist must be able to see what he or she confronts, the externality of the thing (subject-matter and the work itself), the thing's visible, material features, one might almost say despite the preconceived subject, the feeling, or whatever the work is 'about'.[5] Many artists seem to find it necessary to counteract a certain 'abstractness' of intention, the 'idea',[6] by supplementing visual attentiveness with touch. They look *and* feel. The hand helps the eye to see surfaces and forms. One might even go so far as to say that for many artists the incipient sovereignty of the mind's eye, as opposed to the embodied eye, is subverted (or even 'deconstructed') by the hand.[7]

Attentiveness also involves 'putting oneself on the line'. For Murdoch and Nussbaum the moral agent's self-conception, which entails the person's view of his or her own moral worth or integrity, and the evaluation of significant others, are in part dependent upon the quality of the agent's perception. An individual's capacity for moral perception (and then for appropriate action) is continually faced with new challenges. We often respect in people the capacity to see the ethical dimension, yet this aspect of 'good character' is always at risk in that the

individual may fail to see something quite evident to others. In a similar way the perceptual capacities of the artist are constantly tested, in that the quality of practical response and decision-making (often spontaneous and intuitive), reflected in the quality of the work, depends upon the quality of perception. They involve a constant assumption of responsibility for the quality of one's seeing.

Finally, I want to bring in something not discussed by Murdoch, Nussbaum or Blum. This is not a matter of being sensitised to features of artistic practice through reflection on ethical practice, but the other way round. I refer here to the idea that what might be called qualitative developments of seeing are built into traditions of making art, by which I mean that within practices of production in visual art are contained complex relationships between perceptions, values and ideas which constitute enriched ways of seeing. For example, the achievements in the use of colour made by Impressionists and Post-Impressionists represent not just new ways of using and creating colour in painting (through, for example, 'optical mixing') but new ways of seeing and enjoying and being moved by colour in the real world. It is not that different ways of using colour developed by various artists and movements form stages in a linear, progressive sequence, each stage rendering the previous ones obsolete, but rather that each achievement may become part of new efforts to see and create, usually being combined with formal and semantic elements which differ significantly from the original context. The point of achievements of this kind is never their sheer novelty but the determinate quality of the works and modes of perception within which they appear.

Applied to the life of practical reason the idea that qualitative developments in moral perception are carried by traditions of practice might suggests at least two things. First, it supports the persistent belief that the moral significance of cultural forms like literature and art[8] rests on the efforts they contain and articulate to set out new moral insights, and second that the capacity of upbringing and pedagogy to stimulate ethical development is contained not only in exhortation and rational argument but also in their tradition-like features.

IV

Turning to what moral perception 'sees' we come to the notion of 'particularity'. Many recent works in ethical philosophy have placed considerable importance on the idea of particularity.[9] Nussbaum's work is useful in this context, enabling the extension of the line of argument initiated above towards specific features of the visual arts.

Particularity and its perception are, for Nussbaum, relevant to both a certain kind of ethical philosophy and art, specifically the art of the novel. What is 'particularity' in this context, and why does Aristotle – upon whom Nussbaum draws extensively – say that awareness of particularity is like a kind of 'perception' (*aisthesis*)?[10] The 'perception' of the particular must have priority in ethical

reasoning because of the nature of what it confronts. Aristotle insists on this because he is more vividly aware than most philosophers of what Wiggins calls 'the lived actuality of practical reasoning and its background' (Wiggins, 1987: 217). Practical matters are mutable, indeterminate or indefinable, and what frequently matters about them is some feature unique to the specific case. They demand close attention to their singular features, and are not amenable to techniques of handling based on general rules or 'recipe knowledge'.

The mutability of the practical means, for Nussbaum, that the situations facing the ethical agent can change from one moment to the next, often in unpredictable ways. Not all situations call for profound ethical reflection, and the ones that do may not be initially obvious. A situation may resemble in its general character other familiar situations and may differ sufficiently to raise profound or urgent ethical questions. Emotions are frequently better able than intellect to alert us to problems calling for ethical deliberation. In all these ways the unpredictable changes of practical existence demand that practical reason attend to particulars, that it is not over-reliant on general rules (although these do have a part to play[11]) and that it is flexible and responsive. A second aspect of the practical is its indeterminate or indefinable character. Practical reason is often concerned with situations in which the ethical significance of various courses of action is highly context-dependent.[12] Finally, Nussbaum outlines a third dimension of Aristotle's view of practical reasoning. While the concrete circumstances of ethical deliberation are usually highly complex they may still conform to general descriptions and contain factors found also in other similar situations. For example, the cases dealt with by an examination board will often resemble one another quite closely. Under consideration are marks, grades, scripts, regulations and so forth, Procedures are bound by a set of regulations or rules and the assessment is conducted by examiners with known duties and roles. At the level of actions there is often a general requirement to make an assessment of a student's performance across a number of papers or subjects, the need to come to a reasoned resolution of disagreements between examiners, and the 'rule' or 'usual procedure' of weighting unresolved doubts or marginal results towards the benefit of the student, and so on. All these factors lend a degree of repetition and routine to the work of a board as it considers each student. Against this, however, there may be cases which are unique and where this uniqueness is important; where, for example, the history or circumstances of a particular student's performance is so unusual that the board cannot be guided by precedence or the application of the usual procedures or rules.[13] Ethical deliberation must therefore be open to the demands exercised by this third element of practical existence: wholly unique situations which render the usual approach, principles and procedures partially invalid.

The picture of particularity and perception we get from the discussions summarised above is complex. The person of practical wisdom will attend carefully to the concrete, situated character of the moral problems he or she confronts. Schematically then, there is a distinction between two levels or orders

of particularity. At the first of these levels practical reason is a capacity to 'see' and respond appropriately to the mutable, unpredictable nature of moral phenomena, their context-embeddedness, and the uniqueness of people and events constituting the life-world. Here particularity seems essentially to mean a kind of inherently ungovernable complexity characteristic of the world that practical reason confronts. Additionally, practical reasoning means perceiving and acting properly with respect to two more features of particularity: what Nussbaum calls 'the noncommensurability of valuable things' and the possibility of conflict between values.

Nussbaum seeks to link perception and particularity – in all its forms – with philosophy and art, specifically the art of the novel. Philosophy, as a historical practice of reflection and writing, has, unlike the novel, rarely been 'friendly' towards particularity and its affective perception. Turning to visual art however, the line of argument which presents the arts in general as naturally sympathetic towards this aspect of the ethical is much more difficult to sustain. While some visual works might be a little like novels in relevant ways – through narrative, highly specific representations of time, place, character, and so forth – many clearly are not. The comparison between literature and visual art quickly becomes strained or implausible in too many cases. The advent of modernism seems to have widened important differences between literary and visual arts – notably through the relative decline of narrative painting and sculpture and the ascendance of more perceptual and formal concerns – and the phenomena of mutability, context-embeddedness and uniqueness as dimensions of practical particularity only rarely appear in works of art at the level of represented content.

V

In everyday life human beings occupy a world full of particular things and events, including of course particular people.[14] These particulars are the subjects not only of individuating descriptions but also of methods or techniques of handling or manipulation based on generalised knowledge. For many activities it is possible to schematise what is involved in order to specify and communicate procedures capable of producing at least an adequate or satisfactory performance or outcome. But beyond this rudimentary level, however, there are many complex activities and higher levels of performance in others where particularity matters, where generalities, abstract knowledge or following a recipe are not enough. In such cases the quality of an activity and its results depend to an important degree upon acute perception, upon awareness of the details and circumstances of the performance and upon flexibility in the light of unexpected developments. Most people would probably think of the making of art as requiring this intensity of involvement – Murdoch's 'attention' – and this complexity of response. I want to argue, however, that particularity is more decisive still in the case of art.

I need at this point to make an important qualification. Once could maintain that particularity in the sense used here is definitive of art, that a work cannot be a work of art without it. There is not the space to argue this here. Rather, I make the more limited claim that particularity is a quality to which works of art may aspire, and that we have got a lot of examples of them doing so successfully.

More specifically then, I want to make three points about particularity with respect to some works of visual art. First, that the visual-material artefact, the work of art, is often particularised: specific visual and material features have been made to matter intrinsically. Second, that its meaning may be particularised. The work of art often transforms what it represents and how it represents into a meaning existing fully only within the work, this giving rise to the familiar problem of translation or paraphrase. Third, the process of production may also be particularised, with respect to both the artist and the process or practice of making.

I now want to consider the work of art with respect to these three dimensions: the work itself, its meaning and its process of production. First, the visual work of art concentrating on its visible, material particularity. In works of visual art discernible features – such things as marks, forms, scale, materials, surfaces and colours – are decisive. In other words, the question of visible, material particularity – *whether* the visible material features matter and if so *how* – is often central. Looking at a work of art requires paying careful attention to these features. This is not an arbitrary act by a spectator, but rendered rational by the fact that the artist has made the work in such a way that these features matter, and are meant to matter. To reiterate, the possession of a unique position in time and space or of unique distinguishing features is not enough; particularity occurs when unique, visible features are made to matter intrinsically. It is not possible here exhaustively to categorise or describe the myriad ways in which this transformation has been achieved. It is clear however that artists have historically managed this process by using the characteristic properties of their medium: such things as line, tone, composition, motif, colour and scale in the cases of painting and printmaking, and space, volume, the structure of masses, gravity and scale with sculpture. The history of art provides literally thousands of different but equally successful examples of this complex alchemy. This is not to argue of course that visual, material particularity is *all* that matters about the work, that it encapsulates or replaces all other dimensions of meaning and aesthetic effect.

It is necessary however to go beyond an exclusive concentration on visible, material features, and thus to reject a somewhat artificial restriction. Works of art also have meanings, and this dimension necessarily demands a response that incorporates, but also exceeds, an assessment of their material features in terms of a visual response alone. Wollheim's discussion of varieties of pictorial meaning[15] is useful here. A 'proper account of pictorial meaning', rightly expelled from language proper by Wittgenstein, is 'at home in painting':

what a painting means rests upon the experience induced in an
adequately sensitive, adequately informed, spectator by looking at the
surface of the painting as the intentions of the artist have led him to
mark it.

(Wollheim, 1987: 22)

The artist conveys not just perceptual beliefs but also attitudes, feelings,
thoughts; there are two sides to pictorial meaning here: representation and
expression. Further, it is often said that the artist seeks to do justice not only to
what is seen but also to how it is seen. For Wollheim this is not quite right
because

in producing an ever more refined image of how the represented thing
looks, the artist is in effect representing an ever more specific kind of
thing. There is within the representational task no line worth drawing
between the what and the how: each fresh how that is captured
generates a new what.

(Wollheim, 1987: 52)

After distinguishing between broadly representational and expressive meanings
and insisting on a drive in both form and content towards 'specificity', one
might identify different ways in which content has appeared. For example, there
are obvious differences between works which depict existing and visibly present
objects or events relying in part at least upon observation, and works which
depict historical or mythological objects or events relying significantly on
imagination. There is also an important class of works which depict, or perhaps
better evoke or engender, visual phenomena unrelated to possible objects or
events in the ordinary visible world; many 'abstract' and semi-abstract paintings
and sculptures belong to this category.[16] With expressive content a distinction
can be made between works which convey recognisable or familiar feelings and
those which stir unfamiliar emotions, or ones which are difficult to place or
name.

While distinctions like these may be important in understanding how different
works of art operate with respect to meaning, they do not of themselves take
us much further towards particularity, and they are potentially misleading in so
far as they suggest that the meaning of a visual work of art depends upon its
content in the sense of its capacity to convey mental events or pick out things
in the world. It might even encourage the view that if particularity is an impor-
tant feature in works of art it can only be because what the work represents is
particularised. For example, this would make Manet's *La Prune* (*c.* 1877) which,
as Wollheim observes, depicts a certain contemporary type of young Parisian
woman, and the monumental figures painted by Picasso in the 1920s and 1930s,
for example *The Race* (1922) or *Bather with a Ball* (1932), less successful
artistically than Ingres's *Madame Moitessier* (1851) or many of Picasso's drawings

209

and paintings which clearly depict individuals, for example his 1937 painting of *Dora Maar*. It is apparent that this line of argument is not going in the right direction. It becomes even more obviously strained when it is applied to abstract or semi-abstract styles, like cubism for example. Clearly many works of art, while they are representational, are not 'about' something which is itself particular. While works where specifics of time, place, atmosphere, light, incident and so forth are central (e.g., Vermeer, Turner, Constable, Monet) are not difficult to find, equally there are many works which do not seem focused on particularity at the level of subject-matter, or where it would be difficult to say what the particular content was.

Some artists and thinkers have maintained that the proper subject-matter for high art is a level of reality transcending ordinary experience and which represents instead events or forces taken to be both more profound and more general.[17] Others have preferred subject-matter that is more specific, more local, more qualified. With expressive content, for example, some artists have dealt with supposedly higher affects – the tragic emotions that Aristotle calls 'pity and fear' – or feelings of sublimity like awe, wonder and melancholy. More mundane emotions (such as jealousy, sexual desire, greed), as well as less volatile feelings (for example pleasure in familiar, everyday scenes and events), have also coloured works of art. But there is no necessary distinction here between representations of 'higher', more abstract and 'lower', more concrete subject-matter or affects in terms of particularity. Both types of subject-matter and both types of emotional response are capable of being particularised.

To summarise, the factual uniqueness of the artefact is often modified or amplified into a kind of uniqueness that matters intrinsically. This does not depend on the specificity of subject-matter nor does it pertain simply to 'expressive' formal properties. There is, however, in such works a transformation of form and content into a singular expressive moment that resists paraphrase. There is no exact equivalent.

Third, we turn to the artist and his or her practice. This is a large, complex area and once again my limited claims can only be asserted rather than argued fully. I want to say that the relationship between the artist and the work is often subject to a process of particularisation. The sources of the work are often highly individual; how a specific person has experienced something which, at another level, is commonly available, is here very important. Equally, the material and practical process of making is often shaped by the artist into something quite unique over a period of years. The pattern of imagination, sensibility, judgement and action is again highly specific. The work may have an assertively hand-made appearance or it may not, it may be obviously autobiographical and personal in its style, or it may be more private or initially impersonal, it may be overtly romantic or severely restrained. To say that the relationship between work and artist is particularised is not to assert that the work necessarily discloses anything about the life, personality, beliefs, likes and dislikes, psyche or drives of the artist. It has often been noted that really great art frequently leaves our curiosity about

the person who produced it almost wholly unsatisfied. The view of the world it expresses somehow exceeds our ideas of the everyday individual who created it. Yet it remains plausible that works of art, including great, exceptional works, spring from what can only be understood as a deep and powerful activity of the self at many levels.

If one cannot 'see' this relationship in the work then on what basis is it possible to argue for its existence? One approach here is to revisit the idea of expression. Both Charles Taylor and Charles Larmore[18] have argued that ideas with a clear Romantic provenance, like expression, creative imagination and irony, are deeply embedded at many levels in contemporary culture, and that their influence is complex and often equivocal. This stands against the ways in which, in the context of postmodernism and poststructuralism, such ideas have been widely discounted.[19] Here I propose to consider briefly what the idea of expression might mean for contemporary art practice.

To think that expression, and even more what Taylor calls 'expressive individuation', is important to works of art seems to involve the idea that the unique, individuated inner depth of the subject is or may become something of value and significance in its own right. At one level, and as Taylor and others have pointed out, this is perhaps a response to the rise of the Cartesian subject, an intended contrast to the glassy essence, the universal eye, the cogito, the identical apparatus of transcendental subjectivity or the self cleansed of specificity by the application of method and thus elevated to the level of the subject of knowledge. As Taylor reminds us, this subject also involves certain values or social goods related to the context of modernity to which the self of disengaged reason belongs. It should not be forgotten that it too can be seen in terms of the effort to give human beings a novel kind of autonomy and dignity, involving the assumption of new powers and responsibilities for themselves and their world. Having said this, it remains true that the Cartesian subject, understood as the subject of knowledge so important in the development of modernity, is not one whose accidental difference, whose specificity of upbringing, tempera-ment, character or sensibility, whose subjective interiority, is intrinsically and objectively valuable; indeed, it must be put to one side, rendered 'private', in order to release the knowing subject proper.

Thus, the notion of the expressive subject meets two related needs. First, it makes it possible to think about the subject, released by various disembedding processes from ascriptive, communal social structures, as an 'individual' in the modern sense. Second, the individual is able to be seen as a source of meaning, a point from which could flow into an objectified, calculable world, other compensatory ideas and ideals: beauty and feeling, poetic, affective relationships, realities belonging to other realms of value and significance. The importance attributed to this link between the individuality of the artist and the work would be difficult to grasp without the belief that this inwardness of the subject – in all its utter contingency – may be valuable in itself, or a possible source of meaning and value, perhaps the only such source.

211

It was noted above that for Taylor the subject becomes uniquely important in part because modernity requires the demise of 'ontic logos', a decisive shift from the cosmos, nature or divine being as sources of meaning and value to the self. I want to suggest, *pace* Taylor, that the idea or image of a journey to inner depths contained within historically derived notions of artistic practice, a search that sometimes demands or results in a particularising of the self, is a journey that seeks to discover – even at the risk of straying beyond – the limits of sociality, tradition, intersubjectively available meanings and values, the public structures of practice and language, Taylor's moral–ontological frameworks and the like. In this trope, then, the place of the deep self is a kind of unpredictable well-spring, which may run dry and which, even when flowing, may prove toxic. The artist's inward search is thus a hazardous and fateful journey to the limits of, or even beyond, public reflective and reflexive selves, beyond tradition and practice.

What happens during this search? At some point in this quest the artist revisits those things which make him or her unlike anyone else. These are the forces, scenes or events that have shaped the artist into a specific subjectivity. The artist seeks to confront a kind of defining externality, not for any 'reason', and certainly not for the thoroughly instrumental reason of discovering and then 'mining' his or her subjective uniqueness. Sadly, however, the exploitation of contingency has often been mistaken for the real thing. The genuine drive, perhaps even the compulsion, to revisit scenes of individuation is simply one of the things that *makes* someone an artist.

VI

Why seek an affinity between the perceptual capacities required to make and appreciate works of art, and the perceptual capacities required for moral responsiveness? For Murdoch, Nussbaum and Blum it is important to defend critical features of ethical response and action – which they associate with the ideas of moral perception and particularity – systematically neglected because of what they see as the excessively abstract or calculative outlooks characteristic of contemporary ethical philosophy. As ethical particularists these critics of Kantian and utilitarian approaches argue that an inordinate concern for rules and principles or the reckoning of utility narrows and distorts our understanding of ethical processes. Clearly this view, even if accepted, cannot simply be transferred to the relationship between theories and practices of art. No one is suggesting that the erosion of key art values could be due to the effects of Kantian or utilitarian theory. The point is that the effects seem similar even if the immediate causes differ.

The credibility of the cluster of ideas about art and aspects of social life I have tried to explore – artistic quality, the uniqueness of artworks, the ethical significance of art, the social value of individuality – has been weakened in the context of visual art, it seems to me, by the impact of much recent theory,

initially the New Art History, and then poststructuralism and postmodernism. One thinks here of the shibboleths of the new orthodoxy: the 'death of the author', the 'end of art', institutional theory, art as the ideology of race, class and gender oppression, the corrupting 'consolations of good form' and the resulting 'death of painting' and critical hegemony of 'disaffirmative art', neo-conceptualism and so forth. All this has been buttressed and supplemented by the attack on vision exhaustively described by Jay, aspects of which I summarised at the start of this chapter. It might be argued that some of this recent theory – from its great predecessor Nietzsche through to Deleuze, Barthes, Derrida, Kristeva, Lyotard and Baudrillard – when read carefully displays complex yet often positive views about the nature and role of art in the late-modern world. I have only space for two comments. First, whatever the nuances, the overall effect of the positions associated with them on the ideas and values I have discussed has often been negative. Second, and this would need considerable space to demonstrate, the precise ways in which these authors valorise art is often much more to do with the needs and interests of their theories than it is to do with the art itself; for example, Lyotard's *jouissance*, a fundamentally disruptive and fugitive 'force', the manifestation of the unrepresentable other is, I would argue, a projection upon art of what his theory, consistently enough, cannot express. The problem here, from the point of view of art, is that this highly abstract idea is utterly at odds with the simple yet decisive determinateness of the work – its particularity.

To raise the question of the relationship between perception and particularity in the areas of art and ethics is an attempt to explore important conditions for both practices. This seems to be less to do with establishing strictly logical conditions, as in a transcendental analysis, than with a kind of practical recovery of certain concrete socio-cultural requirements. In art the approach has important implications. To say that the practices and products of art require a certain quality of perception attuned to various levels of particularity is to suggest something definite about the production and experience of works of art. It suggests that it would be possible to discriminate between approaches and works with these characteristics (and which are significant works of art) and those which do not. Also, we have seen Blum make the point that ethical perception, being highly particularised, has in the past often been seen as relying upon a capacity that is wholly innate and thus outside influence and pedagogy. His persuasive arguments against this view readily apply to art and its teaching.

The idea of the practical recovery of the visual for contemporary art, capable of encompassing questions about the relationship between artistic and ethical perception, particularity and so forth, raises many issues; for example: what is it that needs recovering?, why is the recovery necessary?, what is the relationship between new approaches and artefacts, and the recovered practice? It also raises larger questions about 'practical reason' and the socio-political relationship between the arts and other cultural practices, and how it is that much recent theory seems to weaken the cultural status and viability of ethics and art, given

that its primary targets are declared to be grand narratives of Enlightenment, totalising technoscientific reason and so forth? None of these lines of enquiry can be pursued here.

The more limited but still important question, however, with which I conclude is that of the relationship between late-modernity and those theories of ethics and art against which the practices of ethics and art may need to recover and reassert themselves. We have seen how some ethical philosophers have sought to revive a more concrete sense of the demands of ethical practice. With visual art there will perhaps always be tensions between word and image, between 'discourses' of the body and of the intellect. More specifically, I suggest, influential approaches to the theory of art which discourage or marginalise issues like the quality of perception, particularity and the connections between art and virtue, prevent these tensions being recognised and thus militate against the appearance of a more reflexive, dialogical relationship between theory and practice.

Notes

1 One thinks of the ways in which Rorty's influence has made the accusation that something is 'boring' almost philosophically respectable.
2 Ritzer remarks: 'The roots of postmodern social theory lie in the arts and literary criticism' (1997: 35). See also Bertens (1995: 53–108). Jay describes influences from the arts on ocularphobic theory in the third and fourth chapters of *Downcast Eyes* (1993).
3 Blum contrasts a 'Murdochian' view with two broad, influential streams of contemporary ethical philosophy: 'impartialism' within which Kantian and utilitarian approaches find a significant amount of common ground, and with a view, critical in some ways of impartialism, which he associates with Thomas Nagel, Bernard Williams and Michael Sandel. Despite profound disagreements these approaches concur in 'the identification of morality with an impersonal, impartial, objective point of view' (1994: 27). For Blum, neither approach is sensitive to particularity and perception as important dimensions of moral agency.
 I am also aware that the whole idea of ethical perception is controversial, raising as it does the continuing disputes between ethical cognitivism and non-cognitivism. It is unnecessary to enter this debate here. I restrict myself to the contention that the aspects of ethical performance discussed by Murdoch, Blum and others are real and important, and may have some connection with related features of artistic performance.
4 Nussbaum mentions 'passivity' in the context of ethical perception, and links it with literary activity. See Nussbaum (1990), Chapter 6.
5 Cf. Wollheim (1987) on 'seeing-in', pp. 46–75 *passim*.
6 It has been pointed out to me by the painter Kevin O'Brien that artists may often begin a work certain (perhaps even clear?) about what they want it to *be*, without necessarily having much idea of what it is going to *look like*.
7 Cf. Wollheim's account of the Wolf Man, Picasso and the omnipotence of the gaze in *Painting as an Art*, (1987: 286–95).
8 Some would see art as a whole in this way. For example, when Murdoch urges a return to 'what we know about great art and about the moral insight it contains and the moral achievement it represents' she does not seem to want to restrict her claims

to literature. Yet this argument is surely at its strongest in relation to literature, and perhaps specifically in relation to drama and the novel. Many have noted that applied to most of music and some important types of painting and sculpture it seems much less convincing.

9 See Phillips and Mounce (1970), Winch (1972), MacIntyre (1981), Sandel (1982), Lovibond (1983), Taylor (1985), Williams (1985), Wiggins (1987), Phillips and Winch (1989), Diamond (1991), Gadamer (1975, 1983), Marquand (1989). See also Onora O'Neill's useful summary and criticisms in O'Neill (1996). My use of 'particularity' in this context is informed by but not identical with what is now known as 'ethical particularism'. Another possibly fruitful line of enquiry, which cannot be pursued here, would be into so-called postmodern ethics and its connections with particularism in various forms; a key figure here would of course be Levinas. See also Bauman (1993).

10 For Aristotle (and as we have seen argued by Murdoch and Blum), perception in this context refers to the requirement on the ethical actor to 'see' the rich complexity characteristic of moral life. See Wiggins's discussion in *Needs, Values, Truth* (1987), Chapter 6.

11 Cf. Putnam's reply to Nussbaum and comments in *New Literary History* (Volume 15).

12 Aristotle provides the example of humour.

13 See Gadamer (1983: 82) on the law.

14 For Strawson's 'descriptive metaphysics' the particularity of material things and people is a primary reality. See Strawson (1959), *passim*.

15 See *Painting as an Art*, a work of considerable insight into painting as a practice, as well as into specific works.

16 See also ibid., p. 65.

17 For example, Schopenhauer (1969, vol. 1: 185), Bell (1961: 36).

18 See Taylor (1989, 1991) and Larmore (1996).

19 Irony has of course been a favourite postmodern mood for a long time, although its complex significance for the Romantics has often been overlooked.

Bibliography

Antonaccio, Maria and Schweiker, William (eds) (1996), *Iris Murdoch and the Search for Human Goodness*, Chicago and London, Chicago University Press.

Bauman, Zygmunt (1987), *Legislators and Interpreters*, Cambridge, Polity.

Bauman, Zygmunt (1992), *Intimations of Post Modernity*, Routledge, London.

Bauman, Zygmunt (1993), *Postmodern Ethics*, Oxford, Blackwell.

Bell, Clive (1961), *Art*, London, Chatto and Windus.

Bernstein, J.M. (1992), *The Fate of Art*, Cambridge, Blackwell.

Bertens, Hans (1995), *The Idea of the Postmodern: A History*, London, Routledge.

Blum, Lawrence A. (1994), *Moral Perception and Particularity*, Cambridge, Cambridge University Press.

Budd, Malcolm (1995), *Values of Art*, London, Allen Lane, The Penguin Press.

Collinson, Diane (1992), 'Aesthetic Experience', in Hanfling, Oswald (ed.), *Philosophical Aesthetics: An Introduction*, Oxford, Blackwell.

Diamond, Cora (1991), *The Realistic Spirit*, Cambridge, Mass., MIT Press.

Gadamer, Hans-Georg (1975), *Truth and Method*, New York, Sheed and Ward.

Gadamer, Hans-Georg (1983), *Reason in the Age of Science*, trans. Frederick G. Lawrence, Cambridge, Mass., MIT Press.

Giddens, Anthony (1990), *The Consequences of Modernity*, Cambridge, Polity.

Herwitz, Daniel (1993), *Making Theory/Constructing Art: On the Authority of the Avant-Garde*, Chicago, University of Chicago Press.

Jay, Martin (1993), *Downcast Eyes: The Denigration of Vision in Twentieth-Century French Thought*, Berkeley, University of California Press.

Jay, Martin (1993), *Force Fields*, London, Routledge.

Jenks, Chris (ed.) (1995), *Visual Culture*, London, Routledge.

Kant, Immanuel (1987), *Critique of Judgement*, trans. Werner S. Pluhar, Indianapolis, Hackett Publishing Company.

Larmore, Charles (1996), *The Romantic Legacy*, New York, Columbia University Press.

Levin, David Michael (ed.) (1993), *Modernity and the Hegemony of Vision*, Berkeley, University of California Press.

Lovibond, Sabina (1983), *Realism and Imagination in Ethics*, Oxford, Blackwell.

MacIntyre, A. (1981), *After Virtue*, London, Duckworth.

McNaughton, David (1988), *Moral Vision*, Oxford, Blackwell.

Marquand, Odo (1989), *Farewell to Matters of Principle*, trans. R.M. Wallace, Oxford, Oxford University Press.

Murdoch, Iris (1970), *The Sovereignty of Good*, London, Ark Editions.

Nussbaum, Martha C. (1986), *The Fragility of Goodness*, Cambridge, Cambridge University Press.

Nussbaum, Martha C. (1990), *Love's Knowledge*, Oxford, Oxford University Press.

O'Brien, Kevin (ed.) (1995), *Artists From Europe*, Leeds, Leeds Metropolitan University.

O'Neill, Onora (1996), *Towards Justice and Virtue*, Cambridge, Cambridge University Press.

Phillips, D.Z. and Mounce, H.O. (1970), *Moral Practices*, London, Routledge and Kegan Paul.

Phillips, D.Z. and Winch, Peter (eds) (1989), *Wittgenstein: Attending to the Particular*, London, Macmillan.

Putnam, Hilary (1983), 'Taking Rules Seriously. A Reply to Nussbaum', in *New Literary History*, Volume 15 1.

Ritzer, George (1997), *Postmodern Social Theory*, New York, McGraw-Hill.

Sandel, Michael J. (1982), *Liberalism and the Limits of Justice*, Cambridge, Cambridge University Press.

Schopenhauer, Arnold (1969), *The World as Will and Representation*, trans. E.F.J. Payne, New York, Dover Publications.

Strawson, P.F. (1959), *Individuals: An Essay in Descriptive Metaphysics*, London, Routledge.

Taylor, Charles (1985), *Philosophy and the Human Sciences: Philosophical Papers* (vol. II), Cambridge, Cambridge University Press.

Taylor, Charles (1989), *Sources of the Self: The Making of the Modern Identity*, Cambridge, Cambridge University Press.

Taylor, Charles (1991), *The Ethics of Authenticity*, Cambridge, Mass., Harvard University Press.

Wagner, Peter (1994), *A Sociology of Modernity: Liberty and Discipline*, London, Routledge.

Wiggins, Colin (1987), *Needs, Values, Truth*, Oxford, Blackwell.
Williams, Bernard (1985), *Ethics and the Limits of Philosophy*, London, Fontana.
Winch, Peter (1972), *Ethics and Action*, London, Routledge and Kegan Paul.
Wollheim, Richard (1987), *Painting as an Art*, London, Thames and Hudson.

11

APORIA OF THE SENSIBLE

Art, objecthood and anthropomorphism

J.M. Bernstein

I

Imagine, if you will, a Second World War bombshelter: typical concrete construction, cold, damp, the few lights attached to the walls are directed at the ceiling. Scattered on the floor are white marble chips, from the sort of marble the great sculptures of the past were made. Lying before you as you enter the bunker are three more or less coffin-shaped blocks, approximately 8 feet long and 3 feet high and across. The three blocks are set one behind the other. They are made of jell-o! Hence the sharp edges of the marble chips dig into them, scoring their flesh; their gross, raspberry colour vibrant, too vibrant; they are translucent, solids that yet are a medium through which light passes.

This wonderful installation piece, by the Norwegian artist Jeannette Christensen, is almost too successful, almost a piece of conceptual art. Although visually powerful, amusing and disturbing, it appears to be making statements, or better, we cannot avoid approaching as if it were making statements: it asks us, on the one hand, to connect the hardness and monumentality of classical sculpture, its implicit celebration of power, its identification of power and beauty, as now only chips on the floor with, on the other hand, the need for hardness, the monumentality of the bombshelter. The bunker and the blasted beauty, the chipped trace of the classical, form a constellation of power, timelessness, and destruction. Further, there is a gendered affinity between the ruined classical sculpture and this bunker, the desire for immortality and the outrages of war which reduce it to rubble. The work urges the configuration of war and its devastation with the classically beautiful, those artistic perfections of the human Kant celebrated in his ideal of beauty. Christensen accomplishes this constellation through the work's oppositional structure: compare those masculine notions of art and worth with the fleshy, uncanny vulnerability of the gelatine blocks. There is here a call and a claim for transience and embodiedness, an act of mourning and an act of ironic revolt.

In saying that this piece is almost too successful, I mean that it lends itself so fully to statement that its visual spectacle is in danger of being (indeed will be!)

overwhelmed by what can be said about it. I can, or could, elaborate a whole discourse about this work. Serious reflection about Christensen's work reveals that there is an aporia here between the conceptual and the sensuously particular, a token of the type of aporetic relation between truth-only cognition, call it philosophy, and art; above all, I want to claim, an aporia that is systematic and categorial in social-cultural practice. This aporia can be, on occasion, mitigated or abbreviated, reflexively acknowledged or evaded, but remains. Its cause is societal rationalization and disenchantment; its fundamental effect is nihilism: the condition in which our highest values lose their value, their ability to be routinely formative in the lives of individuals.

The price Christensen's piece pays for her work's cognitive striving is that a discourse about it can overwhelm, over-reach and become independent of the piece itself; the work then becoming a mere illustration of a general theory. The reasons for this are overdetermined. In part, one is inclined to say that Christensen's piece so powerfully solicits discursive articulation because it is thetic; but in being thetic now, one is also inclined to say that the work is ideological, a counter in the debate about gender, history and art. But to the extent the work is ideologically potent, it loses its aesthetic compulsion, its power to hold and demand our visual attention simply in virtue of its sensible characteristics and arrangement. If the work is truly drenched in interests and ideology, then its authenticity is parasitic on our agreeing with the interests and values the work promotes. All this will drum the work itself out of sight and into reflection.

Somewhat differently, one might explicate the work's flirtation with discursivity as a consequence of the art community's immense powers of interpretation and critical elaboration. We have become adepts at reading the visual, decoding it, interpreting and overinterpreting to the point where the work itself barely registers. Christensen is aware of this danger – what Adorno calls 'neutralization' – and its present unavoidability. By making this piece of material that will rot and decay, dissolve, she is both urging our visual attention against the work's passing, and hence underlining the work's temporality, its standing as an event. The event of this work is real: as the days move on a white mould forms on the surface, and then there is a brownish discolouring of the mould. Each day the work is different, its beauty and difficulty something apart from Christensen's control. The fate of this work, its duration, is a condensed history of Western art in six weeks: it dies before our eyes. And yet, employing a different temporal matrix, the process of dying is incredibly slow, since unlike a classical sculpture or easel painting it cannot be taken in at a glance. The work is never present, but always passing, dying, dead; always framed in a history it despairs but without which it would lack meaning. And the process of the work's dying is its awkward beauty. Beauty is not other than this work's mortality; only in its decay is its beauty to be found. Finally, gone, the work can live only as a piece of memory and narrative, as the trace of a tradition that is, was, never present, never visible, as, from the beginning, a hostage to the depths of personal memory and the endless words we elaborate around its missing presence.

The work as history, the work as political statement, the work as aesthetics, the work as allegory. In all these ways, Christensen's installation piece eludes and fails visual and perceptual claiming. The subtlety and power of this piece is that these forms of failure are what it is. Christensen relates to the tradition of art through acknowledging its *failure*, and lets that failure be the visual matter of her construction. Only by failing monumentality, classicality, presence, can the work succeed; and in succeeding it fails; in failing, it succeeds. Without dishonour to Christensen, I want to give the work a name of my own: 'The Fate of Art'. But other names are possible, each as right and as distorting as the next: 'Vile Bodies', 'The Refuge', 'Every Day is a Miracle', 'Lost Love', 'His and Hers', 'A Chip Off the Old Block', 'Kitsch Deferred', 'Art Was Here', etc. These name or pseudo-names suspend the work's visual presence, subjecting it to the anxiety of allegorization, its own power of proliferating discourse as what it wants and refuses. Christensen, I am suggesting, locates and identifies the aporia of the sensible for us, and rather than seeking to avoid, evade or resolve that aporia, places her art in its service, inhabits the aporia, making the aporia, the impossibility of sensuous presence, the impossibility of a perceptual claiming, the matter of her art, its mode and manner of being visually present (absent) to us.

In contrast to Christensen's work, but equally its immediate antecedent, is the last systematically successful project to sustain the claim of sensuous particularity against conceptual claiming: abstract expressionism.[1] Here the price paid for inhabiting the aporia of the sensible was cognitive opacity; those works, from *Excavation* to *Lavender Mist*, appear as an indecipherable writing, meaning beyond or without discursive redemption, allegories without referents, meaning always being solicited and refused, so that finally nothing sayable can arise from them. Abstract expressionist works seek to haunt the mind or memory the way a trauma might: presence without assimilability. The artistic sublime then is an aestheticization of trauma, its safe re-enactment. And these works will fail just in case they lose their power to disturb, to be traumatically present. The worse thing that could happen to a Rothko or a De Kooning or a Pollock is that it might become beautiful.

Abstract expressionism's singular solicitation and dissolution of discursive meaning can still cause bafflement and outrage: how can an item mean but not discursively mean? Socially and practically, as well as philosophically, Enlightenment rationality stipulates that meaningfulness, discursivity and communicability without remainder are to be identified. Michael Dummett takes these identifications or equivalences as patent contraints on a theory of meaning.[2] Anything else, he avers, would be a private language, and hence no language at all. What if, however, Dummett's account of language and meaning can be satisfied only by the loss of the material world? And what if what is at stake here is not a theory of language but the fate of the material world itself, so that the predicament of modern art, the emergence of the aporetic of sensible particularity, is not a narrow problem for art about its possibility of continuing, but the reflective articulation of the aporia of the sensible *überhaupt*, the

220

immanent disappearance of nature from sight, which would be just its disappearance as the acknowledged material medium of human life? What if the extremes of abstract expressionism's cognitive opacity and traumatic unassimilability, and Christensen's richly allegorical presentation, formed the poles of a continuum without a middle; semiotic and symbolic extremes that could touch one another but never infiltrate or mediate one another? And is this broken middle nothing less than our broken modernity? The entwining of the aporia of the sensible as societal fate consequent upon the rationalization processes of modernity and as the dominant constraint underlying the discontinuous development of modernist art presupposes the construal of art as the reflection of its time in the two-dimensional domain of paint on canvas and the three-dimensional practices of modern sculpture.

These are exorbitant claims. But I know of no way of processing them than through art, its possibilities and impossibilities, its momentary centrality for culture as a whole between, say, Picasso and Pollock, and the present waning of that centrality as a consequence of art's loss of its potentiality for systematically sustaining the tension between visual meaning and discursive meaning. A philosophy that argues this thesis is bound to appear suspect since in it conceptual comprehension and sensible claiming will remain divided despite the abstract urging of their belonging together. Thus, Jim Elkins has charged that my *The Fate of Art* fails the radicality it insinuates, betraying the insights it pronounces by remaining so removed from visual works and their claiming.[3] Implicitly, Elkins treats my failures, and those of Derrida and Adorno as if they were flatly failures of will or intellect, failures to find the right mode of filling a space just there to be filled: finding the word that would fit but not subsume beneath a welter of historico-philosophical reflection what particular works solicit or present. Hence, he must assume Jeannette Christensen, on one side, and say Jackson Pollock on the other were also failing differently to fill that same space. If there is a difficulty about the tendential impoverishment of the visual in postmodernism (the extreme of this being Danto's end of art thesis in which art just becomes philosophy – of art[4]) in relation to the the materialistic hermeticism of high modernism, then this is because there isn't a space, yet, any longer, that can, routinely and liveably, be filled. Art is bound to the sensuous extreme or gives in too quickly to conceptuality, while philosophy remains bound to a conceptuality it can only conceptually master, and thus fails sensuous particularity. What Michael Kelly has called modernity's iconoclasm, the destruction of sensuous particularity at the hand of the concept (call it: reason, capital, technology), which takes distinct and specific forms within art and philosophy, just is a socio-historical movement that gets played out indefinitely within art as its own private fate. But the problem of art and philosophy is not a problem of art or philosophy, it is about the abstraction of modernity, and hence about the categorial disposition of universal and particular governing everyday life.[5] The difficulties of art and philosophy token and repeat that aporia, they do not make it. Disenchantment is real.

221

II

Perhaps the moment when the force of the aporia of the sensible impacted on the artworld was when the exhaustion of abstract expressionism became palpable. How would art continue? Could it continue? At this precise moment a variety of movements and responses emerged: minimalism, pop art, the austere shaped and striped canvases of Kenneth Noland and Frank Stella, the somewhat different albeit analogous colourfield work of Jules Olitski, Larry Poons and Ad Reinhardt, the sculpture of David Smith and Anthony Caro. I take the all but definitive registering of this moment to be found in two essays by Michael Fried: 'Art and Objecthood' and 'Shape as Form: Frank Stella's New Paintings'.[6] These brilliant essays negotiate the relation between criticism, art history and philosophy in an almost exemplary manner; Fried's response to the works then emerging is as thoughtful and replete as can be imagined. Above all, his critique of minimalism and its fading of art into objecthood seems to me prescient and almost unanswerable. Yet Fried does go wrong in his championing of Stella and Caro because while half-acknowledging the aporetic condition of art – how else could he stake himself on the claims of such an austere and self-limiting high modernism? – he fails to let the aporia of the sensible and the process of exhaustion and disintegration it tokens inform his judgement. Success, presence, is still the criterion. As Fried famously concludes 'Art and Objecthood': 'We are all literalists most or all of our lives. Presentness is grace'.[7] This remark has been disparaged as misplaced theology, which to my mind slides off the difficulty of Fried's assertion. The issue is not, too rapidly expressed, a theological inflation of art, but rather what kind of condition would make us all 'literalists', persons who regard the things surrounding them as *mere* things, most or all of our lives? Is the condition of being literalist the human condition, things only or at best ever mere things, without sense or meaning? Are the bodies of human others most or all of the time mere bodies? Is literalism an even intelligible position in regard to everyday things and objects? Is this literalism not too much in thrall to the scepticism about meaning and objecthood that Fried means to be struggling with and against? Fried is too easy about literalism, too accepting of it as the ontology of the ordinary. Conversely, art becomes in his thought too rarified and separate, too disconnected from the formations and deformations of our present mode of inhabiting the world. The absence of the aporia of the sensible in Fried engenders a disengagement of the relation between art and world; as a consequence his criticism forfeits the existential pathos of art's failures and successes.

Anthropomorphism is the central term around which the meaning and boundaries of art and objecthood are contested. Beginning with Descartes' methodical doubting of appearances, modernity has construed its rationality as a critical overcoming of the endless displays and temptations of anthropomorphic understanding – the projecting of human meaning onto an inhuman or indifferent material world. If, the argument runs, things only have meaning

through what we project onto them, then in themselves things are meaningless, and thus to be understood in the visionless medium of pure mathematics. Hence the same movement of demythologization that fashioned the death of God is carried forward by a rationalism that limits meaning and value to the satisfaction of human desires and interests as processed through a practical reasoning that is instrumental, means–ends rational, through and through. All else is mythology and illusion. No distance at all separates Cartesian scepticism from Hobbesian liberalism.

Without quite comprehending its own sceptical stance, high modernism was equally a movement of demythologization of overcoming anthropomorphism. If, as a consequence of demythologization outside art, 'all the verities involved by religion, authority, tradition, style, are thrown into question',[8] then the artist must forsake reliance on the symbols and references that formed the bond and medium of communication with her audience. These now belong to the domain of desires and interests only, and hence cannot, except in the most narrow sociolect, be relied upon to provide works with their objectivity. In their stead, as Clement Greenberg argued, the medium of art itself becomes the source of discipline and authenticity. Thus

> the history of avant-garde painting is that of a progressive surrender to the resistance of its medium; which resistance consists chiefly in the flat picture plane's denial of efforts to 'hole through' it for a realistic perspective . . . Painting abandons chiaroscuro and shaded modelling. Brush strokes are often defined for their own sake . . . Line, which is one of the most abstract elements in painting since it is never found in nature as the definition of contour, returns to oil painting as the third colour between two other colour areas . . . But most important of all, the picture plane itself grows shallower and shallower, flattening out and pressing together the fictive planes of depth until they meet as one upon the real and material plane which is the actual surface of the canvas; where they lie side by side or interlocked or transparently imposed upon each other. Where the painter still tries to indicate real objects their shapes flatten and spread in the dense, two-dimensional atmosphere.[9]

Amongst other things, Greenberg certainly intends the movement of art into abstraction to be a form of defending anthropomorphism. Indeed, such anthropomorphism is the point of his Kantian construal of abstraction. Kantian, immanent criticism is the mode through which practices justify themselves from the inside:

> Each art [must] determine, through the operations peculiar to itself, the effects peculiar and exclusive to itself. By doing this each art would, to be sure, narrow its area of competence, but at the same time it would make its possession of this area all the more secure.[10]

While the representational and symbolic contents of traditional painting might be subject to a demythologizing critique, painting itself cannot be:

> But the making of pictures, as against images in the flat, means the deliberate choice and creation of limits. This deliberateness is what Modernism harps on: that is, it spells out the fact that the limiting conditions of art [i.e., the flatness of the picture-support] have to be made altogether human limits.[11]

Painting, Greenberg contends, is a fundamental human practice which, properly refined, inscribes a domain of the purely optical, a reflective articulation of the world as purely and restrictedly something *seen*, without addition or substraction. But the world *as seen*, the seen-world, is not the world as a thing in itself, but precisely the world as the internal correlate of the seeing eye. Hence, the optical space which easel painting uncovers transcends whatever images have been historically inscribed within it; the optical space of abstract art performs a limit condition of human interaction with the material world as such.

Greenberg's essentialism is open to obvious complaints. Most directly, his optical account of painting abstracts the human eye from the human body, seeing from touching, the optical from the tactile, and all these from the torsions of desire in seeing: to see or not to see?, to look or stare?, to spy or behold? Even the restrictedly 'seen' world as articulated in art must insinuate a phenomenological (sensible) physics and erotics of seeing. Without quite pressing the matter in this direction, Fried is guided by a suspicion concerning Greenberg' essentialism, and thus takes a more Hegelian or Wittgensteinian line. In opposition to Greenberg, he denies that it makes sense to search for the timeless conditions of a practice, to even attempt to abstract that practice from the history of which it is so evidently a part. But, he continues,

> this is not to say that painting *has no* essence; it *is* to claim that that essence – i.e., that which compels conviction – is largely determined by, and therefore changes continually in response to, the vital work of the recent past. The essence of painting is not something irreducible. Rather, the task of the modernist painter is to discover those conventions that, at a given moment, *alone* are capable of establishing his work's identity as painting.[12]

By placing the emphasis on those 'conventions' that can compel conviction, Fried underscores the anthropomorphism of his criticism. The defeat of nihilism is not to be found in an a priori bedrock of opticality as given through the practice of painting, but, under the pressure of changing historical configurations, the essential is that which encounters and defeats scepticism through conventions which defy the suspicion of arbitrariness or subjectivity to which conventional practices are now subject. In 'Shape as Form', Fried compares this notion of

essence to the Thomas Kuhn's conception of a scientific paradigm.[13] In making this assertion, Fried is not departing absolutely from the Greenbergian vision; Fried too believes that the limits of art are 'altogether human limits'. His demure is nuanced: altogether human limits are indeed limits, but they are none the less a matter of history and convention. The very idea of the historical a priori with which Fried is working takes the difficulty of the human, the difficulty of sustaining compelling anthropomorphism, as always a crossing where the apparently merely conventional projects and inscribes a truly limiting condition. Aesthetic judgements, judgements of value and conviction, are articulations of that fragile crossing, finding in the contingent something that is more than contingent, more than mere fact – in truth, an encounter with altogether human limits.

Fried's blithe confidence in the human capacity to defeat scepticism and arrive at compelling conventions cannot be accepted as stated. One may worry that Fried is too conventionalist is his defence of modernist painting, as if the kind or type of historical pressures impinging on art had no intelligible structure or tendencies; as if it were some strange world-historical contingency that the process of purification that Greenberg first traced was not the one that continually found in the conventional as such a threat of arbitrariness that sceptically consumed any hope of objectivity. Which is to say, modernist art has, knowingly or unknowingly, suffered a double pressure: not only uncovering compelling conventions, but in so doing showing that those conventions, and by implication conventions as such, can bear the weight of essentiality. But art need not accept the burden of that double demonstration. The alternative of denying anthropomorphism has been available to modernist art from its inception. Perhaps, unknown to itself, modernism has been a creature of Enlightenment scepticism; perhaps the best way of construing its progressive demythologization, its sceptical attack on image and representation, is to align it with what that demythologization has been all along in the modern epoch: anti-anthropomorphism. This project possesses an intriguing heroic complexity: to remove from art all traces of (mere) anthropomorphism while yet producing *works*.

This while 'yet producing works' is the nub of the problem. What locates both Greenberg and Fried as defenders of anthropomorphism is their presumption that *art* matters, that there is art, that there is this human practice that even under the most intense sceptical pressures can discover forms of resistance, forms of authentic sensible appearing. Whether in achieving an a priori bedrock of optical appearing or as discovering conventions that hold against the nihilistic onslaught, what both find is a formation of object that, however minimally or fragilely, silhouettes human intercourse with the material world – with eye or hand or body, always an inflection of the size of the body, its upright posture, the hand that grasps with its opposing thumb, the forward look, the eye's response to distance, colour, shape and form. These ineliminably belong to an anthropomorphic contouring of world, to the world as lived by a human body that can engage in practices that transcend the minimal projective structures that

flow from embodiment itself. Hence, for both Greenberg and Fried modern art has had the unique task of inscribing this anthropomorphic minimum, of salvaging the world as the forever internal correlate of material persons.

So much, one might have thought, could be taken for granted. But, in the wake of modern science, technology and bureaucratic rationalization, none of this can be taken for granted; art's apparently constitutive anthropomorphism cannot be taken for granted. If the standard view of modern art is that it is a critical defence of minimal anthropomorphism, there has been and remains a reading of modern art that interprets it as continuous with the critique of all anthropomorphism, and thus aligns it with high Enlightenment rationalism. So, for example, while Robert Rosenblum interprets Barnet Newman's *Onement I* as a Kabbalistic-inspired reworking of the romantic sublime in the tradition of Friedrich, Donald Judd describes *Vir Heroicus Sublimis* in these terms:[14]

> *Vir Heroicus Sublimis* was done in 1950 and the colour of one stripe was changed in 1951. It's eight feet high and eighteen long. Except for five stripes it's a red near cadmium red medium. From the left, a few feet in, there is an inch stripe of a red close in colour but different in tone; a few feet further there is an inch of white; across the widest area there is an inch-and-a-half of dark, slightly maroon brown that looks black in the red; a few feet further there is a stripe like the first one on the left; a foot or so before the right edge there is a dark yellow, almost raw sienna stripe, the colour that was changed. These stripes are described in sequence but of course are seen at once, and with areas.[15]

In describing Newman's work, Judd eliminates from it not only all psychological associations and connotations, but equally any reference to it as something seen and experienced. Or rather, his 'are seen at once' attempts to flatten the seeing; something that Newman must have been aware his painting invited since he insisted that to see it properly the viewer should stand up close to the painting.

I do not wish to deny that Judd intends his account as anti-sceptical, and hence as salvaging objectivity for art; this is what makes his art and criticism belong to the tradition of Enlightenment rationalism. However, the terminus of art's anti-sceptical strategy on Judd's interpretation is a material item which no longer depends for its holding in the visual field through anthropomorphic assumptions, but appears literally, as an object, a mere thing, in the same way in which natural objects appear for the natural scientist as constituted through quantities that escape the vagaries of human perceivings and doings. Judd wishes to achieve for art works an analogue of the perspectiveless appearing that is the telos of absolute knowing: a view from nowhere. Of course, art cannot utterly remove the viewer from the viewed, but it can aspire to neutralize viewing by decentring the viewer, and thus disorienting and dehumanizing the visual field. The neutralization of individual orientation on and through a visual field is (one inflection of) artistic anti-anthropomorphism.

Judd and Robert Morris are explicit about their anti-anthropomorphism. For example, in his 'Notes on Sculpture, 3', Morris states:

> Surfaces under tension are anthropomorphic: they are under the stresses of work much as the body is in standing. Objects which do not project tensions state most clearly their separateness from the human. They are more clearly objects. It is not the cube itself which exclusively fulfils this role of independent object – it is only the form that most obviously does it well.[16]

Not only does the machinic sheen of minimalist works make otiose (direct) reference to the human hand, but the forms used – cubes, simple rectangles, etc. – by being tensionless, almost material equivalents of Platonic forms, establish a separateness – or is it just a feeling of separateness? – from the human in general.

For Judd, traditional painting is seen as on the verge of exhaustion; he associates this exhaustion with painting's being bound to anthropomorphic imperatives which have lost their power to compel. Any 'part-by-part' complexity in a work, any overtly 'relational' character of elements will sign the presence of the human hand and mind, sign a will to order and arrange, and thus create a purposiveness however without intelligible purpose, whatever that purposiveness may be. Even the most austere post-abstract expressionist painting is still a painting, and thus still at the behest of human ends. Hence, the minimalist painting as such remains caught in a web of anthropomorphic signification that requires elimination.

> The main thing wrong with painting is that it is a rectangular plane placed against the wall. A rectangle is a shape itself; it is obviously the whole shape; it determines and limits the arrangement of whatever is on or inside of it . . . [In contemporary painting by Pollock, Rothko, Newman, and co.] the shapes and surface are only those which can occur plausibly within and on a rectangular plane. The parts are few and so subordinate to the unity as not to be parts in an ordinary sense. A painting is *nearly* an entity, one thing, and not the indefinite sum of a group of entities and references [needing to be arranged and ordered]. The one thing overpowers the earlier painting. It also establishes the rectangle as a definite form: it is no longer a fairly neutral limit . . . The simplicity required to emphasize the rectangle limits the arrangements possible within it. The sense of singleness also has a duration, but it is only beginning and has a better future outside painting. Its occurrence in painting now looks like a beginning . . . [17]

Anti-anthropomorphism requires the establishment of works which are all but indistinguishable from mere things. What constitutes authentic objecthood is

a work's independence, separateness, from anthropomorphic conditions of meaning and appearing.

III

Fried's pointed critique of minimalism unearths its internal contradiction. In so far as minimalist works are works and not mere things, then they will continue to carry the full baggage of anthropomorphic projection however hidden, sublimated, disguised this anthropomorphism is. In the hands of the minimalist, Enlightenment rationalism becomes a secret misanthropy, an unconscious misanthropomorphism. The subtlety of Fried's critique turns on demonstrating, first, how the affects of the minimalist work, its working, necessarily *simulate* for the perceiver the affects of the traditional work as a condition of its authentic holding of the visual field; and second, how this simulation, in fact, involves an always dissimulated anthropomorphism. Fried denominates minimalism's dissimulated anthropomorphism 'theatricality'.

The first element of simulation is size. Following Greenberg, Fried notes how size is used by the minimalist in order to purchase presence for his work. By placing a large object in any ordinary setting, it comes to demand our attention; it crowds in on us and asserts itself as something to be looked at, taken in, acknowledged. This deployment of size presupposes the scale and orientation of the human body; what comes to 'feel' like it is crowding or overwhelming depends on both the body's scale and the setting. Even a very large work in the middle of a expansive open field can be diminished by sky and the receding horizon. Only by being placed 'here', say in this exhibition space, does the size of the work function as a mechanism of claiming.

Second, the size or, better, scale of the object can be further inflected through how it structures our relation to the object in terms of distance. Large objects in standard spaces press our bodies away from them as a condition for their being seen at all. This structuring of space, the minimalist contends, creates a 'nonpersonal or public mode',[18] a sense that we are in space *with* things rather than surrounded by them. The nonpersonal or public mode – the neturalization of perspectival viewing – thus intends a certain equiprimordiality of persons and objects which is taken as criterial for anti-anthropomorphism.

These deployments of scale and distance are not, as the minimalists suppose, mechanisms for a public and nonpersonal art. As Fried contends, if something has presence only if we are forced to take it *seriously*, then the appropriate question about minimalist works is why do we take them seriously (if and when we do)? Fried's answer is that the actual manner of their imposing themselves on us, crowding us, has its precise origin and analogue in our feeling crowded and distanced by 'the silent presence of another *person*; the experience of coming upon literalist objects unexpectedly – for example, in somewhat darkened rooms – can be strongly, if momentarily, disquieting in just this way'.[19] Such objects are slightly looming presences, portentious; all the more so to the degree that

their simple structures but large scale appear as not merely separate from but significantly indifferent to us. In this respect, minimalist works create a situation in which we are subjects by being 'subjected' to them, defined in our reach, power and vulnerability by their indifferent largeness.

Because Fried defends anthropomorphism, his objection to minimalism is not that it is anthropomorphic, or even that it ideologically disputes anthropomorphism, and thus must hide or dissimulate its employment. Rather, what is wrong is that 'the meaning and, equally, the hiddenness of its anthropomorphism are incurably theatrical'.[20] By 'theatrical', Fried means a structuring of the work and the situation it creates that *exhausts* itself in its effect on the beholder. This structuring generates as an effect the sense of a human situation – an object demanding to be taken seriously – as the totality of its working; minimalist works create what might be termed 'the art effect' without anything substantial corresponding to that affectivity. The 'theatre' is the situation generated, which *a fortiori* includes the spectator. If the sense of such works *is* the situation they compose, then not only are they not separate or independent from the viewer, but also they *are* relational: poles or elements of a relational situation. Being only elements of a situation, deriving their identity from the situation they create, minimalist works lack any 'inside', any internal complexity or depth which would token their separateness or autonomy. They exude a sense of hollowness, emptiness. They simulate the manner of an aesthetic encounter without there being anything of significance to encounter. Hence the perplexity and disappointment they generate: the works demand a certain stance and attention, but the demand is empty, the work realized and exhausted in placing the demand.

Another aspect of minimalism's empty theatricality is its endlessness. Traditional works intend an entwinement of the sensible and the conceptual, the semiotic and the symbolic, such that ideally the conceptual cannot be prised off its sensible presentation. Ideally, no verbal recapitulation, paraphrase or account of an art work provides what the work itself provides. Only an intransitive understanding of works that permits their sensible features to enter into their full cognitive affectivity can capture what works promise. Abstract works which insinuate meaning without releasing an object-independent thought are designed to effectuate, isolate and realize, intransitive sense. Minimalist works simulate the experience of intransitive meaning through their empty insistence; it is only their insistence and the repeatability of their forms that holds our attention. Their sense is endless, a repetition of the same, not intransitive.[21] Thus Fried comments on Tony Smith's black cube, as the exemplary literalist work, that it

> is *always* of further interest; one never feels that one has come to the end of it; it is inexhaustible. It is inexhaustible, however, not because of any fullness – *that* is the inexhaustibility of art – but because there is nothing there to exhaust. It is endless the way a road might be: if it were circular, for example.[22]

IV

Pace Fried, because literalist works do possess and employ an, albeit disavowed, anthropomorphism, they can be uncanny, and that uncanniness provides a haunting sense of power. Their very simulation of artistic fullness and their insistent emptiness can feel like a particular and horrifying fate of the human; as if all that remained was the wholly empty form of the human, the general idea of anthropomorphism without a content to fill it. The emptiness and theatricality of literalist works, because not apparently overcontrived, can feel 'right', can feel like a proper and adequate response to preceding art and its inability to provide a convincing fullness. The endlessness of minimalist works exemplifies and creates an insistent boredom, an ennui that is unnerving in virtue of its insistence. The precise theatricality of minimalist works cannot be quickly dispatched: in them there appears the power of a looming emptiness.

In contesting Fried's judgement of minimalism, in claiming that its survival is not accidental and that it articulates a certain formation of the modernist sensibility, my aim is to put pressure on the dualistic categories licensing his criticism: art versus objecthood, art versus theatricality. For Fried, for now, 'modernist painting has come to find it imperative that it defeat or suspend its own objecthood, and that the crucial factor in this undertaking is shape, but shape that must belong to *painting* – it must be pictorial, not, or not merely, literal'; 'the imperative that modern painting defeat or suspend its objecthood is at bottom the imperative that it *defeat or suspend theatre*'.[23] Objecthood is a mode of the theatrical; Fried also criticizes surrealism for its theatricality, but surrealist works are not literalist. Theatrical works take their measure from their effects on the beholder. They are wholly for the beholder, for the other, without any 'ownness' proper to themselves. Theatrical works are spectacles, performances designed to please, enchant, unnerve the spectator. Their lack of reserve or inwardness is their specific kind of emptiness. Lacking autonomous sense or value, they in fact make the entire meaning of the visible a matter of affect. Theatrical works are advertisements for art.

While I would not necessarily want to demure from Fried's Rousseauian critique of theatre, his chastisement of the literalist drive towards objecthood as a mode of the theatrical is too simple and direct. However potent the categories 'theatre' and 'objecthood' are as critical tools, they suppress the dynamic, if discontinuous unfolding of modern art. Fried is of course correct in claiming that it would be a misconstrual of modernist painting to perceive it as consisting in 'the progressive revelation of its essential objecthood'.[24] But this delusive comprehension of the history of modern painting is not without point. What *forces* have been pressuring art, from within *and* from without, to find its resources within the medium itself? What forces have been sceptically impinging upon the symbolic and representational elements of art, removing them from the repertoire of advanced painting? Why has modern art been forced to become ever more 'minimalist', in the broadest sense of that term? While no single answer to

these questions is either possible or necessary, it would be unintelligible to suppose that the deracinating anti-anthropomorphism of modernity generally has not, discontinuously, impacted on art's inward turning, and that with the achievement and lapse of the opaque cognitivism of abstract expressionism the once external pressure of anti-anthropomorphism could establish itself as a form of artistic rationality. A pertinent, Wittgensteinian way of making this point would be to say that while, necessarily, anti-anthropomorphism is self-defeating as a general mode of artistic comportment (because art is instrinsically anthropomorphic), there is a biting truth in minimalist scepticism. Minimalism reveals the truth of artistic scepticism: no human fullness is given with anthropomorphism as such.

The idea of an emerging aporia of the sensible better captures the complex of forces working on art, from within and without, than do Fried's categories. Unlike his categories, a tendential aporia of the sensible overlaps in an almost one-to-one relation with the problem of anthropomorphism: anti-anthropomorphism is the systematic intention of prising off from the visible any intrinsic human intelligibility. Because anti-anthropomorphism can be connected with either a search for trans-subjective objectivity or anti-subjective technicism, it makes a claim to rationality. Because that claim to rationality found purchase for itself within many forms of social reproduction, its sceptical movement affects all the major subsystems of social life. The disintegration of the visible world as an autonomous source of meaning flows directly into the practices of modern art. Because Fried's categories are so emphatically disjunctive, they must remain insensitive to the incremental exhaustion of artistic materials, to the encroaching sense that art's capacity for visual statement is draining away.

Fried's dualistic categories make objecthood what is to be defeated or suspended. But if the forces of anti-anthropomorphism are real, then victories over objecthood that do not acknowledge it as a potential *threat*, a virus within the visual destroying its capacity to sustain autonomous sense, will themselves feel empty – *merely* aesthetic. This formation of artistic failure is, arguably, another type of emptiness and formalism. It is, then, not necessary to dispute Fried's claim that Frank Stella's stripe paintings, especially those executed in metallic paint, 'represent the most unequivocal and conflictless acknowledgement of literal shape in the history of Modernism',[25] since the worry about them is exactly their 'conflictless' character.

In Fried's narrative modernism develops from a concern for acknowledging the flatness or two-dimensional quality of the picture-support, through an exclusively optical illusionism in which the flatness of the surface becomes essentially a creature of its being painted, an effect of pigment on canvas, to the shape of the support becoming a source of ordering and conviction. In making the literal shape of the support a principle or source for the ordering of the canvas, Stella can defeat the distinction between literal and depicted shape. What is depicted in the canvas is its literal shape. If we are unable to isolate some

depicted shape that is sitting inside and being constrained by the enclosing, literal shape of the picture-support, then the efficacy of distinguishing literal from depicted shape dissolves. The categorial indeterminacy between literal and depicted shape in Stella's shaped paintings, especially the multi-shaped works, amounts to discovering in shape a source of artistic conviction and authenticity, and hence of new conventions through which art can carry on.

The dissolution of the distinction between literal and depicted shape in Stella's paintings was embraced by the literalists. But Fried believes this embrace to be a misunderstanding, and thus seeks to drive a wedge between what the literalists took from Stella and what Stella actually achieved:

> But it ought also to be observed that the literalness isolated and hypostatized in the work of artists like Donald Judd and Larry Bell is by no means the *same* literalness as that acknowledged by advanced painting throughout the past century: it is not the literalness *of the support*. Moreover, hypostatization is not acknowledgement. The continuing problem of *how* to acknowledge the literal character of the support – *of what counts* as that acknowledgement – has been at least as crucial to the development of Modernist painting as the fact of its literalness; and this problem has been eliminated, not solved, by the artists in question. Their pieces cannot be said to acknowledge literalness; they *are literal*. And it is hard to see how literalness as such, divorced from the conventions which, from Manet to Noland, Olitski and Stella, have *given* literalness value and *made* it a bearer of conviction, can be experienced as a *source* of both of these – and what is more, one powerful enough to generate new conventions, a new art.[26]

However eloquent and compelling, the fragility of this argument is overt: it abruptly presupposes that the history of modernism from Manet can be told in wholly endogenous terms, as if the forms of neutralization that forced painting to purify and refine itself, that kept making the apparently new just a longing for the new, old before it was new, were solely artistic forces. This is implausible. Amongst the forces that have impinged on art and pressed it towards discovering new sources of conviction and authenticity for itself have been industrialization and mechanization (including here the emergence of photography), the growing dominance of the commodity form with its production of novelty as a means of reproducing the same, the rationalization of values making them creatures of subjective desire, and, as a corollary of all these, a tendential movement from the concrete to the abstract.[27] Hence, the very idea of art *having* to establish itself, having to find new resources for conviction, has been a product of art having to distance and distinguish itself from a diversity of others (photographs, commodities, information, etc.) that have been encroaching on its traditional turf. Once this effort of discrimination is placed in conjunction with progressive demythologization, then the constraints on modern art can come into view. It

232

is this scenario which makes sense of the project of artistic essentialism, art's having to acknowledge the flatness or shape of the picture-support as more than the material condition for its activity. The totality of these forces, internal and external, is just the aporia of the sensible, the fading of the grip of habitable anthropomorphism.

Once the forces disintegrating traditional art are acknowledged, then Fried's separation of an endogenous history of modernism from its exogamous conditioning appears suspect. The endogenous history of modernist art is its ongoing struggle with those exogamous forces against the background of the artistic achievements of the past. This would make the difference between Stella and co. and the literalists a matter of *emphasis*: Stella focusing on the endogenous history of modernism without adequate acknowledgement of the forces of disintegration besetting it, and the literalists consumed by the external threat to human conventionality as such under the guiding presumption that there is not enough meaning left in painting to make its continuance worth urging. Both sides of the equation are wrong, but only as a matter of emphasis.

Literalism is not a mere or simple 'by-product'[28] of the development of modernist painting; the threat of the collapse into objecthood, the collapse of compelling convention, has been a fate hovering over art almost from the beginning of modernism, whether we identify that sense of threat with Duchamp's ready-mades or Rodchenko's three monochrome panels (1921). What makes Fried even more emphatically wrong is that he conflates literalist ideology and manifesto with the works themselves. The best literalist works are not, in fact, literal, mere things. They are the *artistic presentation of objecthood*, anthropomorphism at the limit of its power to inform. Whether intentionally or not, they take the aporia of the sensible to a limit of intelligibility: the wholly empty yet anthropomorphically demanding claim of material objects.

In their dryness, minimalist works are not so very far from Stella's stripe painting. As Stella himself has argued:

> the biggest problem for abstraction is not its flatness, articulated by brittle, dull, bent acrylic edges and exuding a debilitating sense of sameness, unbearably thin and shallow, although this is serious enough. Even more discouraging is the illustrational, easily readable quality of its pictorial effects.[29]

Stella then goes on to instance Noland's offset chevrons and the 'inert' space of Olitski's Acqua Gel textures. I take it that what Stella means by easily readable pictorial effects is their availability to firm critical comprehension – say, the idea of shape as form. To the degree to which pictorial effects are easily readable, they no longer possess an autonomous visible demand. The strained character of Stella's later work derives from his urgent desire to defeat the reach of concept domination. That only by *straining* is this now possible underlines the dilemma in a manner independent of Stella's own diagnosis.

What Fried seems not to notice, what he must remain insensitive to, is how the exhaustion of visible meaning affects Stella's work, how its dryness or ready availability to critical comprehension tokens the exhaustion of sensible meaning as emphatically as does the tedium of minimalist works. So while Fried can acknowledge that the modernist requirement that value and quality now can only be located *within* and not between individual arts – the equivalent within the arts of Weberian rationalization as dictating a radical separation of spheres – is 'certainly harrowing',[30] nothing of that harrowing enters into his support for Stella. But if the condition of art is indeed harrowing, what are we to make of a body of work and its critical self-consciousness if nothing of that harrowing is evinced?

In categorically construing the 'other' of painting as objecthood, Fried has carefully located the limit of one fundamental practice in which anthropomorphism is sustained in relation to the material world. His subtle mapping of that categorial space is what gives his criticism its undeniable depth. Because, however, easel painting is so evidently just one conventional way of realizing anthropomorphism, criticism like Fried's is always going to be open to the charge of conservatism. That charge is indigenous to any argument like Fried's, like the one being pursued here, that seeks to raise categorial claims for a conventional practice. No one set of conventions are necessary or ineliminable for securing the anthropomorphic ties articulating the material world as also, and not arbitrarily, a human one, of explicating human nature as an intrinsic part of nature in general. Any adherence of the human to the natural and the material will be conventional, saturated with social and historical contingency. Contingency is not itself a sign of the arbitrary or the privatively subjective – but it always can appear so. In the midst of a relentlessly reflective culture like our own, the sensuously particular appears as always in danger of being lost, sensible meaning always in danger of splitting into the extremes of an empty linguistic sociality and a blind sensuousness. The thin if salient reminder – call it deconstruction – that linguistic practice is also a material practice, a matter of sound, body and gesture, forms a desperate philosophical bridge between the collapsing extremes. Or one despairs of the idea of sensible meaning altogether by letting the rampant character of linguistic meaning proliferate until the world becomes nothing but a theatre of an uncontrollable symbolic.

What provides evidence that these are indeed extremes, and the aporia of the sensible indeed the bearer of a categorial fate, is the sheer *insistence* of these extremes within the art of this century. No reckoning with modernism can ignore how visible meaning and the sensible itself have been consistently set upon by a culture without compelling sensuous moorings. The extreme of this tendency is the fine arts as a whole losing their centrality for culture, so that even the question of the sensible becomes in danger of losing its voice. The fine arts, individually and collectively, have been up until now the place within culture in which societies have sought for themselves a manner of securing visible meaning, of acknowledging, implicitly or explicitly, the anthropomorphically

articulated sensible world as a source of meaning. We have discovered that sensuous particularity, the material object as intrinsically meaningful, is given only through conventions. Once this is recognized, the sceptical wind of anti-anthropomorphism can enter. There is no a priori limit that can be used to shield us from this wind. If the forces of anti-anthropomorphism are, in truth, not merely intellectual forces, but the dynamic forces of modern social reproduction itself, then the condition of art, our condition as sensible creatures, will continue to be harrowing.

Postscript

After completing the first draft of the piece out of which this chapter emerged, I sent it to Jeannette Christensen. She replied:

> I am pleased and amused by the use of my work to make your statement. In your memory you have synthesized 3 different installations into 1 piece! I have used World War II bunkers on two different occasions and marble chips on a third occasion. What you probably remember is the first installation in a bombshelter in Bergen (1990) where I had a 4 meter long ladder together with 2 mining helmets and a stack of dynamite all moulded in raspberry jell-o, resting on stones covered with a white powder! *Horizontal vertical*, my next installation with raspberry jell-o was in New York (1993) 2 ladders each 4 meters long resting on *marble chips*, but in a gallery space.

There then follows a lovely description of the second bombshelter installation from a Finnish Journal. Christensen goes on to describe a more recent work in New York, *Waiting for Columbus*, in which gelatine and jell-o are used. The difference between the two is important: 'The gelatine grows mold because it has no preservatives but the jell-o doesn't grow mold for the opposite reason, it just dries and wrinkles and finally petrifies.'

Notes

1 The present chapter is a companion piece to my 'The Death of Sensuous Particulars: Adorno and Abstract Expressionism', *Radical Philosophy* 75 (March/April 1996), pp. 7–18.

2 M.A.E. Dummett, 'Frege's Distinction Between Sense and Reference', in *Truth and Other Enigmas*, London: Duckworth, 1978, pp. 116–17.

3 In the November 1995 meeting of the American Society for Aesthetics in St Louis there occurred a session devoted to my *The Fate of Art: Aesthetic Alienation from Kant to Derrida and Adorno*, Oxford: Polity Press, 1992. The present chapter grew directly out of my reply to just one of my critics, Jim Elkins. In part Elkins was concerned at the lack of concrete discussions of art works in a text that argued that philosophical discourse about art could not be self-sufficient. But, more emphatically, he believed that my thesis that art works had lost the capacity to be bearers of truth

claims inflated; and, in consequence, that however visually impoverished aesthetics now is, there is no necessity in this impoverishment. It is merely the consequence of bad aesthetic theorizing. This and my essay referred to in note 1, begin the business of testing the thesis of what I am here calling the 'aporia of the sensible' in relation to painting in the last half century. In this respect, these two essays can be seen as furthering the argument of *The Fate of Art* from the direction of art and art history rather than from the point of view of philosophy. Jointly, the two approaches make up the speculative core of Adorno's philosophy in which present-day art and philosophy are two halves of an integral freedom (of the concept) that do not add up.

4 Arthur Danto, 'After the End of Art', *Artforum* 31 (April 1993), pp. 62–9.
5 The full diagnosis of this predicament of conceptuality, image and anthropomorphism is the subject of my *Adorno: Of Ethics and Disenchantment*, forthcoming.
6 'Art and Objecthood' originally appeared in *Artforum*. June 1967. It is reprinted in Gregory Battock (ed.), *Minimal Art: A Critical Anthology*, London: Studio Vista, 1976, pp. 116–47. 'Shape as Form: Frank Stella's New Painting' appears in Henry Geldzahler, *New York Painting and Sculpture: 1940–1970*, London: The Pall Mall Press Ltd, 1969, pp. 403–25.
7 Fried, in Battock, op. cit., p. 147.
8 Clement Greenberg, 'Avant-Garde and Kitsch', in his *Art and Culture*, London: Thames and Hudson, 1973, p. 4. This essay was originally published in 1939.
9 'Towards a Newer Laocoön', in Francis Frascina (ed.), *Pollock and After*, London: Harper and Row 1985, p. 43. This essay originally appeared in the *Partisan Review* in 1940.
10 Clement Greenberg, 'Modernist Painting', in Francis Frascina and Charles Harrison (eds), *Modern Art and Modernism*, London: Harper and Row, 1982, p. 5. This relatively late essay of Greenberg appeared first in *Art and Literature*, 1965.
11 Ibid., p. 9.
12 Battock, op. cit., p. 124, note.
13 See Geldzahler, op. cit., p. 422, note.
14 Robert Rosenblum, *Modern Painting and the Northern Romantic Tradition: Friedrich to Rothko*, London: Thames and Hudson, 1975, p. 210. I am borrowing this reference from Richard Hooker, 'Sublimity as Process', *Art and Design*, no. 40, 1995, p. 49.
15 'Barnett Newman', in Frascina and Harrison, op. cit., p. 130.
16 In Charles Harrison and Paul Wood (eds), *Art in Theory: 1900–1990*, Oxford: Blackwell, 1992, p. 821.
17 Ibid.
18 Morris, in Battock, op. cit., p. 126.
19 Fried, in ibid., p. 128.
20 Ibid., p. 130.
21 Ibid., pp. 134–5.
22 Ibid., pp. 143–4.
23 Ibid., pp. 120, 135.
24 Ibid., p. 136.
25 Fried, in Geldzahler, op. cit., p. 414.
26 Ibid., pp. 413–14.
27 One interesting version of the story of the relation between social forces and art is found in Yves-Alain Bois, 'Painting: The Task of Mourning', in his *Endgame: Reference and Simulation in Recent Painting and Sculpture*, Boston: Institute of Contemporary Art, 1986, pp. 29–49. Although it is a topic for another occasion, I would want to defend the nuance of Bois's closing paragraph where the task of painting for us is to escape the melancholic repetitions of late modernity in order to

achieve a standpoint of mourning. Yet we should not be too quick in embracing these categories since, at first glance, the mourning/melancholy distinction appears to overlap, considerably, with the art/objecthood distinction. How else might we take the repetitions of minimalism than as a melancholic? And would not the blurring of literal and depicted shape be a sublimation of fixity, an achievement of mourning? What if the *possibility* of drawing a firm, categorial line between mourning and melancholia were dependent upon the *conditions* of painting being non-pathological? While I would want to agree with Bois that painting can evade subsumption by the market in unpredictable ways, the meaning of that evasion is equivocal. If mourning is the best possible fate of art in late modernity is it still mourning? Can there be an identifiable state of mourning when, for art, that state is endless, melancholic? For an analogous, equivocal take on art, mourning and melancholy see Julia Kristeva, *Black Sun*, translated by Leon S. Roudiez, New York: Columbia University Press, 1989.

28 Fried, in Geldzahler, op. cit., p. 413.
29 *Working Space*, London: Harvard University Press, 1986, p. 43.
30 Fried, in Geldzahler, op. cit., p. 414, note.

APPENDIX

The original project

The following schematic 'map' was circulated to contributors as a heuristic device to orient their thoughts about the present status of thought and research in the field of visuality and visual culture

Mapping the hermeneutics of visual culture

The following schematic cartography is intended to cut across these issues by inviting those concerned with the 'hermeneutics of vision' to relate their own perspectives and research to this emerging 'landscape', and, perhaps, by critically transforming existing frameworks, extending, deconstructing, and 're-envisioning' new terms of reference for further research and enquiry in the field of visual interpretation.

Of course, the received notion of 'mapping' an ongoing and dynamic field is itself indebted to a visual metaphor and probably, for some, suggestive of an 'ocularcentric' and perhaps a 'Eurocentric' representational bias. Other concepts or metaphors might well lead in different directions. What, for example, would it be to 'draw' or 'paint', or to 'touch' or 'shape', or even 'hear' the visual? The task of 'overcoming' ocularcentric modes of reflection needs to be thought more empirically and radically in terms of its reflexive consequences for our own favourite modes of thought and praxis. Part of the fascination of this topic, which we hope the collection will convey, springs from the creative possibilities it offers for encounters with different ways of envisioning vision and further possibilities of transforming the dominant canons and discourses of our visual culture.

Beyond Cartesian problematics

Many theorists of the visual have recognized the way in which philosophical and metaphysical categories and schemata have become embodied in contemporary common sense and the practices it sustains. Here the historical point of origin is in the epistemology elaborated by René Descartes in the seventeenth century. The Cartesian origins of modern epistemology and philosophical reflection –

especially exemplified by Descartes' *Meditations* and *Discourse on First Philosophy* are, not surprisingly, taken to represent a turning point in the ascendancy of a particular way of thinking about human experience, and particularly the 'ocularcentric' experience of the isolated cognitive agent or 'modern self'.

In this reading, Descartes effectively reformulated the classical language of philosophy – of Reason as a critical faculty of the human spirit – in optical terms, creating an unbreachable binary opposition between classical and modern forms of rational enquiry (knowledge, methodology, rationality, and so forth). The main themes that flowed from this shift of optic are well known: the ocularcentric turn to the knowing subject, the primacy of consciousness (the *cogito*; *res cogitans/res extensa*), the Mind as Mirror of Nature (Rorty), the pre-eminence of 'clear and distinct perception' as a certain measure of truth, the subject–object metaphorics of thought, and so on. Cartesian dualism: matter/spirit; body/ mind; materialism/idealism, etc. Overcoming the Cartesian legacy. The question of the subject; the *cogito* as the 'subject of knowledge'; the self as the locus of the human sciences. The metaphysical character of contemporary thought based on the primacy of the cognitive subject, Cartesian ontology, and 'reflective' metaphysics of knowledge and truth. Paths beyond the Cartesian and classical ages. The crisis of the subject. Post-subjectivism or new forms of subjectivity?

Phenomenology

Here we take a wider conspectus of the term 'phenomenology' than is usual; although recognizing that the provenance of the term lies in the work of philosophers such as Edmund Husserl, Martin Heidegger, and Maurice Merleau-Ponty, we also conceptualize phenomenology as a decisive theoretical movement concerned with the descriptive analysis of modern experience – in this sense, the writings of Georg Simmel, Walter Benjamin, Norbert Elias, and indeed some of the most evocative passages of Marx, Durkheim and Weber betray the characteristics of a profoundly phenomenological vision of human experience. Furthermore, the various schools of contemporary phenomenology have themselves been forced to come to terms with the 'linguistic' or 'rhetorical turn' in many of the recent forms of reflexive enquiry. Phenomenology is increasingly displaced by 'hermeneutic phenomenology' or even 'post-phenomenology' (cf. Ihde, 1993).

In general, however, phenomenological analysis stresses the fundamental role of networks of meaning as the constitutive texture of lived-experience – in transcendental phenomenology this is usually presented under the rather forbidding title of 'transcendental subjectivity' and the intentionality problematics of pure consciousness; for the more generic attitude, however, it refers to the ubiquitous presence of meaning and mediation, consciousness and subjectivity in human activities and arrangements.

Traditionally phenomenology attempts to transcend all forms of empiricism and rationalism as an inadequate theory of human experience. The Husserlian

critique of psychologism, for example, is centred upon the active role of visual categories, metaphors, and presuppositions in defining the 'natural attitude' of everyday consciousness and ordinary, life-world modes of comportment and interpretive praxis. Indeed visual metaphors became both a topic and resource of classical phenomenological theory, creating new thematic ideas and foci; to summarize this point very briefly, for example with respect to:

- the mediate nature of everyday consciousness;
- the programmatic idea of an 'eidetic' science of every domain or 'region' of possible experience (Husserl's regional ontologies to Heidegger's analytic of *Dasein* in *Being and Time*);
- the *époche* as a methodology design to disclose the natural attitude as a significant formation (precursor to the 'world' of later hermeneutical theorizing);
- the noema/noesis correlation as a descriptive device for exploring the meaningful character of perceptual life;
- the activities of transcendental subject(ivity);
- the possibilities and problematics of a clear and distinct 'view' of a fundamental ground of experience preceding subject–object relations, and the implications of this foundational project for the concepts and methods of the sciences.

Heideggerian and Gadamerian ontology in this respect can be approached as deepening and extending the visual ontology of classical phenomenology:

- ontological difference;
- 'spacing' of Being;
- the *Vorhandenheit/Zuhandenheit* distinction;
- Being as presence, aletheia, logos;
- poetry, poiesis, art and truth.

The turn to the life-world and the embodied character of perceptual life in Sartre, Merleau-Ponty, existentialism and phenomenology:

- consciousness and the sensory order, embodied and disembodied experience (the articulation of a field of experience involving language, perception, and the body);
- the look and gaze as one modality of lived experience;
- the consequences of a one-sided visual relationship with the Other (unintentionally traced in the belligerent 'sociology' of human relations that can be found in Sartre's *Being and Nothingness* and, in a more historicized form, in his *Critique of Dialectical Reason*);
- the possibilities of a richer, historically oriented phenomenology of perception (exemplified in the later writings of Maurice Merleau-Ponty such as *The Visible and the Invisible*);

- incarnation and the lived-body as the point of intersection between 'subjectivity' and 'history', self and social world;
- the central functions of visual art – especially painting – and the model of phenomenological (self-)experience.

The guiding principle of Maurice Merleau-Ponty's structural revision of Husserlian phenomenology is that embodied experience is always-already interpreted, that the 'body' is always inscribed in a fabric of meanings and a history; the dimension of 'interpretation' is not, so to speak, superadded to experience and consciousness, but more like the material condition of all forms of consciousness. Human being-in-the-world is primordially perceptual and hermeneutical.

Georg Simmel on the city as an experiential structure of lived experience reshaped under the particular imperatives of urban consciousness and the structuring constraints of urban space and time.

Benjamin on the archaeology of modernity and modern experience.

Hermeneutics

Hermeneutics in this context should also be defined more broadly than in normal philosophical discussion; we might say that the term serves as a label for a diverse range of post-Cartesian modes of thought, forms of enquiry, and critical analysis, particularly those associated with the work of Martin Heidegger and Hans-Georg Gadamer, but also extending to the structural phenomenology of Merleau-Ponty, the symbolic hermeneutics of Paul Ricoeur, and the 'linguistic turn' in the work of 'ordinary language' philosophy deriving its inspiration from Ludwig Wittgenstein and John L. Austin.

In its more recent incarnations hermeneutical thinkers have placed great emphasis upon the constitutive work of language, the formative powers of rhetoric and discourse in organizing the contexts of life-world experience. 'Meaning' and ' interpretation' are no longer to be treated as isolated 'domains' or 'spheres' of human interaction. They are, rather, considered to be inextricably connected with all human practices. In this sense to 'live interpretively' is the one constitutive and universal feature of concerted human activities. Human beings are condemned to read and interpret the textures of their experience within the verbal resources of discourse. And 'language' here should also be expanded to embrace the vast array of sense-making practices involved in constructing social worlds. In other words, the life-world that formed the operative theme of classical phenomenology is understood to be irreducibly linguistic and symbolically mediated.

With this deconstruction of the philosophies of consciousness the central themes of the hermeneutical perspective come into vivid focus: the problematics of sense and meaning, the constitutive role of 'practical' interpretation in experience, human reality as discursive being-in-the-world, the primordial role

241

of language, the ontological categories of sociality, symbolism, historicity, narrative, and intertextuality. The displacement of purely phenomenological models of consciousness cleared a space for the 'interpretive turn' in contemporary social and philosophical thought.

It would be an understatement to claim that some of the central themes of philosophical hermeneutics and 'linguistic phenomenology' have a direct bearing upon the 'force-field' of visuality. The human sciences today have been forced to rethink their traditional frameworks and research programmes in non-dualist, rhetorical, and hermeneutical terms; among these the pervasive and active role of 'significance' in all human practices; the application of this 'hermeneutic ubiquity principle' to the critique of Cartesian modes of thought and knowledge; the elaboration of non-Cartesian conceptions of subjectivity; the redefinition of structuration in linguistic and textual terms; the deconstruction of ocularcentric metaphysics in Heidegger's later work and the deconstructive analyses that have emerged from the Heideggerian corpus; the dissolution of the antinomial opposition between 'fact' and 'theory', 'observational' and 'theoretical' languages in post-analytical philosophy of science (Thomas Kuhn, Stephen Toulmin, Paul K. Feyerabend, etc.); the more general impact of hermeneutic modes of thought in overcoming the dualisms of objectivism and relativism within the human sciences; the radicalization of the 'linguistic turn' in the development of explicitly communicative, dialogical, and rhetorical theories of the self, experience, communication, and society (Mikhail Bakhtin, Jürgen Habermas, Hans-Georg Gadamer, Paul Ricoeur, John Searle, J.M. Bernstein, etc.); the revival of a more interpretive and rhetorically oriented 'practical philosophy' as a basis of rethinking visuality in terms of a much broader interpretive theory of everyday life practices and activities (dialogue, conversation, seeing-as, discourse formations, etc. as embedded in definite modes of experience and social practices).

In very general terms, then, we can say that the hermeneutical turn has added increasing impetus to those thinkers who have promoted the metaphor of text, textuality, and reading processes as an alternative and more appropriate paradigm for the analysis and exploration of human practices and forms of life. The increasingly insistent concern for the 'voice' of the Other within the more critical exponents of hermeneutics – the 'otherness' of other speakers, cultures, traditions, margins, difference, etc. is one of the consequences of generalizing this textual ontology to all processes of meaning creation and transmission. These general hermeneutical theorems are intimately connected with the emergence of 'poststructural' forms of enquiry.

To briefly summarize these observations, we can say that contemporary hermeneutic theory and research has occasioned a radical 'revisioning' of the pervasive role of discourse and language as the medium and framework of all human semiopraxis. This extension and radicalization of the question of language and meaning takes us into the vicinity of poststructuralist theory or, defined in its most generic sense, the realm of postmodern reflexive thought.

Poststructuralist problematics

'Poststructuralism' is a useful if indeterminate general category to designate a wide range of thinkers who have attempted to question and deconstruct the categories of phenomenological presence, perception, the subject and 'visual metaphorics' from philosophy and the human sciences, but who have, despite this programme of 'denigrating' vision (Jay, 1993a), made the configuration of subjectivity, visuality, experience, and sociality even more central to contemporary thought. To reduce a complex field to its most prominent positions, we can distinguish four dominant currents of poststructuralist thought: radical semiology, psychoanalytic discourse, philosophy of difference, and deconstructive theorists of figuration, mimesis, alterity, narrative, and 'ecriture'.

Radical semiology

The semiological critique of presence and logocentric thought; problematizing the Cartesian *cogito*; the closure of Western metaphysical conceptions of subjectivity, world, truth; phallocentric traditions of the 'seeing I'; logocentrism; phallologocentrism; 'regimes' of objectifying vision (colonial Eye; neocolonialism; grand narratives; meta-theory, etc.); Empire of the Eye/'I'; the continuing hegemony of onto-theological language games; phallologocentric forms of seeing, thinking, writing?; the dominance of visual ideologies of the Other: alterity (deviance, sexuality, etc.), Orientalism, the East, etc.

Psychoanalytic discourse

Here we begin from the impact of Jacques Lacan's revisionary psychoanalysis and its influence upon the development of poststructuralist positions towards psychoanalytic practice, the question of the subject and discourse in society. Lacan is particularly important for opening up the complex terrain of consciousness and unconsciousness in the processes by which subjectivity is formed. Here the theory of the specular subject has been particularly influential, with its dominant concern for the dynamic relationships between Imaginary and Symbolic relations. As Martin Jay has observed, the mirror stage

> is a drama whose internal thrust is precipitated from insufficiency to
> anticipation – and which manufactures for the subject, caught in
> the lure of spatial identification, the succession of phantasies that
> extends from a fragmented body-image to a form of its totality which
> I call orthopaedic – and, lastly, to the assumption of the armour of
> an alienating identity, which will mark its rigid structure through the
> subject's entire mental development. The therapeutic goal of a strong,
> integrated ego, therefore, is misguided, for rather than proving an
> escape from the vicissitudes of alienation, it is itself the greatest

alienation of all. Produced by identification with a specular image, a dead image of a body like a film 'suddenly stopped in mid-action', it is nothing less than an instantiation of what Sartre called 'bad faith'.

(Jay, 1993a: 348)

But we also think of the subsequent 'metacritiques' of Lacan and his obsessive focus upon Oedipal relations to the detriment of pre-Oedipal formations; 'visuality' and the 'primal scene'; radical versions of 'the split subject'; seeing and objectification; the 'male-I' (formation of the ego); the divided self; Lacanian phallocentrism; developments of Lacanian theory/Marxist/Feminist critiques. Here theory must begin from a radical reworking of the dialectics of the Imaginary and Symbolic in the course of human self-development and societal self-reflection:

what Lacan called 'the Imaginary', the dimension or realm of images, perceived or imagined, conscious or not, is a constant dimension of the human psyche, which can never permit unimpeded access to 'the Real', the realm of raw, unrepresentable fullness prior to the organization of the drives. But there is nonetheless a difference between normal and psychotic behaviour which depends upon the partial transition from the Imaginary to a further stage, which Lacan termed 'the Symbolic'. Coincident with the resolution of the Oedipus complex, the Symbolic meant the child's entry into language. Lacan's clear preference for the Symbolic over the Imaginary has been widely recognized . . . Lacan thus remained preeminently a critic of ocularcentrism.

(Jay, 1993a: 349–50)

Philosophy therefore displays, according to Lacan, the conceptual symbolic that is at work in our entire system. The privilege that the Cartesian subject attributes to introspection – which constitutes, from the psychoanalytical perspective, the conscientialist obstacle – reveals philosophy's endemic belief in the hegemony of the rational self. What is guaranteed by the dualism of the Cartesian distinctions is the subject's continuity as a rational entity.

(Braidotti, 1991: 23–4)

Feminism

Here we can simply define 'feminism' in the context of poststructural theory as a wide range of critical interrogations of the social and cultural forms of phallocentric experience, perception, and thought. Feminist research and writing revolves around the deconstruction of the binary oppositions, hierarchies, and dominant discourses espoused by patriarchal and phallogocentric forms of life.

No-one would deny that the differences between the sexes are cultural, in that they have been constructed into a system of hierarchical domination as a result of thousands of years of exclusion of women from history. It is nevertheless true that this absence, this ancestral exclusion is directly connected to women's bodies, to feminine sexuality, to women's *jouissance* and reproductive capacity . . . Feminism has revealed the fact that our socio-cultural order rests on the exchange and silence of women; it follows that the project to express an *other* feminine coincides with the invention of an other relation to feminine sexuality. In this perspective, it is impossible strictly speaking, to talk about the feminine independently of the lived experience of women, of their social, sexual and textual reality.

(Braidotti, 1991: 139)

The dominant socio-logics, modes of perception, and belief systems of the dominant culture as complicit with the 'male gaze' and phallocentric ways of seeing and experiencing (Irigaray, Kristeva, Cixous, etc.).

Philosophies of differences

Attempts by poststructural thinkers to develop alternative conceptions of experience and analysis in the wake of the dominant modes of theoretical and philosophical representation: schizoanalysis; molecular philosophy; the differend and nomadic significations: the hyperdevelopment of the 'society as spectacle' problematics, imploded in the circuitry of signs and simulations (most prominently, in the explosion–implosion of visually based semiotics within modernizing and postmodernizing societies). These 'positions' are variously associated with the writings of Gilles Deleuze, Guatarri and Deleuze, Jacques Lacan, Julia Kristeva, Luce Irigaray, Hélène Cixous, Jean Baudrillard, Michel de Certeau, and others.

The return of repressed figuration, mimesis, narrative

- Figuration: Lyotard.
- Mimesis: Lacoue-Labarthe.
- Narrative: Ricoeur.
- Ecriture: Derrida and deconstruction.
- The politics of vision.

Art and critical sociology

Visual art and its social and historical conditions and consequences, with reference to, for example:

- questions of aesthetic perception, values and ideology;
- visual practices and visual theory;
- visual discourse and textual production;
- the integrity and autonomy of art;
- form, the history of forms, and formalism;
- the aesthetic as a sociological category;
- aesthetic reflexivity;
- modernity, postmodernity, and the aesthetic;
- the aesthetic sign in economies of signification.

Post-ocular theory

Post-ocular or post-metaphysical theorizing has as its central objective the criticism and 'transcendence' of the fundamental assumptions of ocularcentric language and modes of thinking characterizing the Western European philosophical tradition. Here we would emphasize the heterogeneity and multiplicity of the contemporary search for forms of expression and forms of life beyond the stale aporias and fixed oppositions of the modernity/postmodernity debate. While this 'debate' is no doubt unavoidable, perhaps the mourning for the past has to be ended and other options initiated. At the present conjuncture we require radically new forms of theorizing and discursive structures. Again this *desideratum* has been expressed in a number of variant ways, for example:

1 The crisis of metaphysics and its sustaining 'ocularcentric' categories and concerns.
2 Post-analytical philosophy (W.V.O. Quine, Donald Davidson, Stanley Cavell, Stanley Rosen, Richard Rorty, Charles Taylor, Alasdair MacIntyre, etc.).
3 The crisis of late modernity; the prospects of a postmodern culture.
4 The crisis of ocularcentrism/ocular regimes of self and society (Clifford Geertz, Martin Jay, Hubert Dreyfus, David Levin, Paul Rabinow, etc.).
5 The critical rejection of subject–object dualism (subject-centred; object-centred and subject–object dialectical frameworks) in phenomenological philosophy, existentialism, ordinary language philosophy, hermeneutics, critical theory, etc.
6 Attempts to move beyond the dominant visual metaphors and schemas of intelligibility informing Western epistemology and towards a richer, dialogical-conversational conception of experience and knowledge (particularly associated with the work of Ludwig Wittgenstein, Hans-Georg Gadamer, Mikhail Bakhtin, Martin Buber, Emmanuel Levinas, Jürgen Habermas, Alasdair MacIntyre, Richard Rorty, Charles Taylor, and others).
7 Critical historiography of Western modes of seeing, experience, perspectivism, visual regimes linked to economic formations and political structures.

8 The re-envisioned self: the return of a concern with the role of the self and the manifold problems of self-knowledge and cultural formations in socio-cultural life:

- self, dialogue, power (interfaces between subjectivity, discourse, modes of domination: Foucault): technologies of the self;
- radical hermeneutic versions of the self;
- self and citizenship/modern and postmodern person;
- postmodern selfhood (versions of dissonant selfhood, post-Cartesian subjectivity, post-masculinist identity; post-Eurocentric culture)

Ethics of seeing

The recent revival of interest in cognitive ethics raises the issue of moral perception, of 'seeing' the complexity and specificity of ethical relevant situations. Some of the topics raised by this connection between ethical behaviour, ethical philosophy, and various forms of perception are:

- moral cognitivism and non-cognitivism;
- 'seeing' values and 'inventing' values;
- 'looking' (being aware of) and 'seeing' (attending to, qualitatively superior modes of moral awareness);
- moral perception as a precondition for moral deliberation and social conduct;
- ethical perception (*aisthesis*) and practical reason;
- moral perception and artistic perception;
- the arts and learning how to see;
- pedagogies of seeing/vision (ocular pleasure and instruction);
- seeing and the 'ethics of virtue'.

Visual technology

Investigations of the artefacts, instrumentaria and apparatuses of visual culture; analogue technologies; telescopes, microscopes, film, moving pictures, sonar imaging; digital technologies; TV image, VDU, electronic images, photography.

> Its 'realism', however, retains within itself a distinct difference between it and what it represents: the very fix which fixes space–time, often metaphorically called 'dead', gives the permanence of the photograph its own kind of *irrealism*. Its immobility, however close to the Greek or even scientific ideal of a 'fixed truth', remains only that which is 'represented'.
>
> (Ihde, 1993: 48)

Regimes of the visual: the politics of vision

Explorations of the interrelationships between visual culture, technology, power and authority.

The central concern for investigating the origins and workings of representation and visual technologies has arisen from a range of criticisms of Western regimes of the visual representation. The presence of different forms of symbolic representations, alternative 'scopic regimes' (Jay) and contestatory projects of visual knowledge in non-European cultures. Visual experience as a field of social practices. The reconceptualization of visual experience as the point of articulation of knowledge, power, and technological configurations within the social systems of modern societies. The dominant role of visual information and control of the visual field in political systems. Interrelationships between political control and knowledge systems. The linkages between visual dominion, security, and hegemonic power: the powers of security/the security of power in pre-modern, modern and postmodern societies.

Technologies of power, social experience as enmeshed in visual programmes and apparatuses, the modern state as extended organ of observation, monitoring, definition, classification, information, meaning, control, regulation, manipulation, centralization (power as 'subjection'): the Law whose eye never sleeps; the ever-watching inner eye of morality; institutions that never switch off: different socio-cultural articulations of *Information–Regulation–Security–Power*.

How discursive practices engender the development of particular visual technologies and cultures. The role of visuality in different institutional settings. The study of institutionalized modes of seeing: the 'eyes of institutions' (groups, organizations, bureaucracies, corporate bodies, states, etc.): 'I'll be watching you' (the importance of social constructionism applied to the history and social dynamics of visual culture).

The place of visual problematics in Western and non-Western societies. How do different discourse practices shape different types of visual experience? The links between power, discourse and self.

1 From the panopticon to the emergence of the surveillance society and technological mechanisms of visual monitoring and incorporation (media technology, communications, intrusive cultures, global knowledge industries, etc.).
2 New forms of reflection as social control (the visual technologies of law and order).
3 Risk and actuarial societies: the emergence of actuarial organizations goes hand in hand with the expansion of ever-wider and more consequential systems of risk (cf. Ulrich Beck). Here the link is between (a) technologies of surveillance, (b) new modes of reflection/seeing/monitoring, and (c) new forms of social control agencies/institutions. These novel societal–technological ensembles produce qualitatively new forms of social organization

that function solely in the services of monitoring, information-gathering, spying, and reflectively regulating other individuals, groups, social agencies and institutions. The characteristic profession of the late twentieth century is thus not the Weberian iron-cage of bureaucracy, but the reflective organization operating across national borders and in the context of global corporate competition. Thus we have a fine example of the globalization of surveillance and information-gathering in the development of geo-political struggles (from the cold war onward).

Risk, criminality, moral panics and surveillance (Britain in the 1980s and 90s. the criminalization of landscapes with no separation between rural and urban; criminality; underclass; private security systems; private security firms; alternative policing; video surveillance; the control of public sites/spaces/urban mind-scapes). What are the technological and social preconditions of the 'vandal-proof' city centre?

Conditions of the good society in the 'globally threatened society' (ecodisaster, unstable nuclear installations, inner city decay, terrorism, etc.).

Pushing the frontiers of acceptability back: the lowering of civil liberties and obstacles to universal monitoring.

Who surveys who? (pan-disciplinary themes: gender, class, ethnicity, age, disability, etc.).

From the society of the spectacle (Guy Debord) to simulacral and fatal culture (Baudrillard): the world as a mirror of mirrors or, coining a phrase, a culture of *hyperreflection* but minimal *reflexivity*:

- bio-politics;
- erosion of private life;
- post-colonial envisioning;
- difference/heterogeneity/plurality;
- gendered ways of seeing, envisioning, imagination;
- modern visual culture in science and advanced technology (the concept of technoculture).

Rational regimes of vision

From the 'rationalization' of the world (Weber) to the disciplinary society (Foucault): advanced technologies for extending rationalization regulation and instrumental logics of reflection to every domain of space and time (Renaissance observation, perspectival space, doctrines of objectivity, etc.). The obsession with visual classifications, typologies and hierarchies as part of the modern 'will-to-knowledge', related in political life with the will to control and dominate the 'other'.

The regulation and self-regulation of the totality of social life (the colonization of everyday life by modern bureaucracies and advanced technological

instruments). Imposition of European 'ways of seeing' upon non-European space. Resistance to these forms of cultural domination. We have, so to speak, Foucault's 'panoptical' regime generalized throughout the major institutions of modern society.

Visual imperialism; the worldwide impact of high-tech visual technologies; ideology; theories of the closure and totalitarian impulses/imperatives at work in the period of late modernity:

- corporate power;
- military expansion;
- public administration/bureaucracies;
- institutions of consumer-led capitalism (continuous active or self-reflective consumerism as social control and manipulation of needs and desires);
- the changing concept of 'shopping': collective or rationalized consumption: the emergence of shopping centres, malls, computer/TV shopping;
- information-based consumerism – the new frontiers of collective consumption;
- global self-monitoring;
- image technologies in reflexive capitalism.

SELECT BIBLIOGRAPHY

What follows is a sampling of recent literature on visuality and visual culture. The purpose of this bibliography is not to seek comprehensiveness, reminding colleagues, for example, of classic or standard texts. Nor do we wish to predefine issues and themes. Rather we have concentrated, for the most part, on recent works which are concerned explicitly with different aspects of visuality, or which seem to present interesting possibilities for application to the field of visual culture, crossing conventional boundaries between disciplines and intellectual areas. We wish to invite participants and readers to add to and construct their own 'working bibliography' in response to the questions raised in rethinking the visual in theory and practice from within their own concerns and disciplinary perspectives.

Introduction to the field of visual culture

K. Baynes, *et al.*, eds, *After Philosophy: End or Transformation* (Cambridge: Mass.: MIT Press, 1987).

S. Benhabib and D. Cornell, eds, *Feminism as Critique* (Minneapolis: Minnesota University Press, 1987).

J. Bernstein, *The Fate of Art: Aesthetic Alienation from Kant to Derrida and Adorno* (Cambridge: Polity, 1992).

C. Jenks, ed., *Visual Culture* (London: Routledge, 1995).

M. Jay, 'Scopic Regimes of Modernity', in Scott Lash and Jonathan Friedman, eds, *Modernity and Identity* (Oxford: Basil Blackwell, 1992); also in Hal Foster, ed., *Vision and Visuality* (New York, 1988).

M. Jay, 'In the Empire of the Gaze: Foucault and the Denigration of Vision in Twentieth-Century French Thought', in D.C. Hoy, ed., *Foucault: A Critical Reader* (Cambridge: Basil Blackwell, 1986).

M. Jay, *Downcast Eyes: The Denigration of Vision in Twentieth-Century French Thought* (Berkeley: University of California Press, 1993).

M. Jay *Force Fields: Between Intellectual History and Cultural Critique* (London: Routledge 1993).

D.M. Levin, ed., *Modernity and the Hegemony of Vision* (Berkeley: University of California Press, 1993).

251

D.M. Lowe, *History of Bourgeois Perception* (Chicago: Chicago University Press/ Brighton: Harvester Press, 1982).

J.-F. Lyotard, *The Postmodern Condition* (Minneapolis: University of Minnesota Press, 1984).

S. Melville and B. Readings, eds, *Vision and Textuality* (London: Macmillan, 1995).

Beyond Cartesian problematics

D. Judovitz, 'Vision, Representation, and Technology in Descartes', in D.M. Levin, ed., *Modernity and the Hegemony of Vision* (Berkeley: University of California Press, 1993).

J. Llewelyn, *Beyond Metaphysics: The Hermeneutical Circle in Contemporary Continental Philosophy* (New Jersey: Humanities/Macmillan Press, 1985).

D. Michelfelder and R. Palmer, eds, *Dialogue and Deconstruction: The Gadamer–Derrida Encounter* (Albany: State University of New York Press, 1989).

R. Rorty, *Philosophy and the Mirror of Nature* (Oxford: Basil Blackwell, 1980).

M. Ryan, *Marxism and Deconstruction: A Critical Articulation* (Baltimore, Md.: Johns Hopkins University Press, 1982).

H.J. Silverman, ed., *Questioning Foundations: Truth/Subjectivity/Culture* (London: Routledge, 1993).

Phenomenology

T.W. Basch and S. Gallagher, eds, *Merleau-Ponty, Hermeneutics and Postmodernism* (Albany, N.Y.: State University of New York, 1992).

P. Burke and J van der Veken, *Merleau-Ponty in Contemporary Perspective* (Boston, Mass.: Kluwer Academic Books, 1993).

M. Dillon, ed., *Merleau-Ponty Vivant* (Albany, N.Y.: SUNY Press, 1991).

G.A. Johnson and M.B. Smith, eds, *Ontology and Alterity in Merleau-Ponty* (Evanston, Ill.: Northwestern University Press, 1990).

E. Husserl, *Ideas Towards a Pure Phenomenology and Phenomenological Philosophy* (New York: Macmillan, 1931).

E. Husserl, *The Crisis of European Sciences and Transcendental Phenomenology* (Evanston, Ill.: Northwestern University Press, 1970).

E. Husserl, *Ideas Pertaining to a Pure Phenomenology and to a Phenomenological Philosophy. Third Book: Phenomenology and the Foundations of the Sciences (Ideen III)* (The Hague: Martinus Nijhoff, 1980).

D. Ihde, *Postphenomenology. Essays in the Postmodern Context* (Evanston, Ill.: Northwestern University Press, 1993).

M. Merleau-Ponty, *The Phenomenology of Perception* (London: Routledge and Kegan Paul, 1962).

M. Merleau-Ponty, *Sense and Non-Sense* (Evanston, Ill.: Northwestern University Press, 1964).

M. Merleau-Ponty, *Signs* (Evanston, Ill.: Northwestern University Press, 1964).

M. Merleau-Ponty, *The Primacy of Perception and Other Essays* (Evanston, Ill.: Northwestern University Press, 1964).

M. Merleau-Ponty, *The Visible and the Invisible* (Evanston, Ill.: Northwestern University Press, 1968).

M. Merleau-Ponty, *Consciousness and the Acquisition of Language* (Evanston, Ill.: Northwestern University Press, 1973).

M. Merleau-Ponty, *The Prose of the World* (London: Heinemann, 1974).

A. Plomer, *Phenomenology. Geometry and Vision: Merleau-Ponty's Critique of Classical Theories of Vision* (Aldershot: Avebury, 1991).

Hermeneutics

R.J. Bernstein, *Beyond Objectivism and Relativism: Science, Hermeneutics Praxis* (Philadelphia: University of Pennsylvania Press, 1983).

H. Dreyfus, *Being-in-the-World* (Cambridge, Mass.: MIT Press, 1991).

M. Heidegger, 'The Age of the World-Picture', in *The Question Concerning Technology and Other Essays* (New York: Harper and Row, 1977).

M. Heidegger, *The Question Concerning Technology and Other Essays* (New York: Harper and Row, 1977).

R. Hollinger, ed., *Hermeneutics and Praxis* (Notre Dame, Ind.: University of Notre Dame Press, 1985).

G.B. Madison, *The Hermeneutics of Postmodernity: Figures and Themes* (Bloomington: Indiana University Press, 1988).

H. Staten, *Wittgenstein and Derrida* (Lincoln: University of Nebraska Press, 1984).

G. Warnke, 'Ocularcentrism and Social Criticism', in. D.M. Levin, *Modernity and the Hegemony of Vision* (Berkeley: University of California Press, 1993).

Semiotics ·

S. Melville and B. Readings, eds, *Vision and Textuality* (London: Macmillan, 1995).

F. Saint-Martin, *Semiotics of Visual Language* (Bloomington: Indiana University Press, 1990).

Poststructuralism

K. Baynes, *et al.*, eds, *After Philosophy: End or Transformation* (Cambridge, Mass.: MIT Press, 1987).

R. Braidotti, *Patterns of Dissonance. A Study of Women in Contemporary Philosophy* (Cambridge: Polity Press, 1991).

S. Critchley, *The Ethics of Deconstruction: Derrida and Levinas* (Oxford: Basil Blackwell, 1992).

G. Deleuze and F. Guattari, *Anti-Oedipus: Capitalism and Schizophrenia* (London: Athlone Press, 1984).

G. Deleuze and C. Parnet, *Dialogues* (London: Athlone Press, 1987).

J. Derrida, *Writing and Difference* (Chicago: University of Chicago Press, 1978).

L. Iragaray, *Speculum of the Other Woman* (Ithaca, N.Y.: Cornell University Press, 1985).

P. Lacoue-Labarthe, *Typography: Mimesis, Philosophy, Politics* (Cambridge, Mass.: Harvard University Press, 1989).

J. Llewelyn, *Beyond Metaphysics: The Hermeneutical Circle in Contemporary Continental Philosophy* (New Jersey: Humanities/Macmillan Press, 1985).

253

C. Metz, *Psychoanalysis and the Cinema: the Imaginary Signifier* (London: Macmillan, 1983).

D. Michelfelder and R. Palmer, eds, *Dialogue and Deconstruction: The Gadamer–Derrida Encounter* (Albany: State University of New York Press, 1989).

C. Norris, *What's Wrong with Postmodernism?* (Brighton: Harvester Wheatsheaf, 1989).

C. Norris, *Truth and the Ethics of Criticism* (Manchester: Manchester University Press, 1994).

M. Ryan, *Marxism and Deconstruction: A Critical Articulation* (Baltimore, Md.: Johns Hopkins University Press, 1982).

H. J. Silverman, ed., *Questioning Foundations: Truth/Subjectivity/Culture* (London: Routledge, 1993).

G. Vattimo, *The End of Modernity* (Baltimore, Md.: Johns Hopkins University Press, 1988).

G. Vattimo, *The Transparent Society* (Oxford: Blackwell, 1992).

G. Vattimo, *The Adventures of Difference* (Baltimore, Md.: Johns Hopkins University Press, 1993).

D. Wood, ed., *Derrida: A Critical Reader* (Oxford: Basil Blackwell, 1992).

Art and critical sociology

T. Adorno, *Aesthetic Theory* (London: Routledge, 1990).

R. Arnheim, *Art and Visual Perception: A Psychology of the Creative Eye* (London: Faber and Faber, 1969).

R. Barthes, *Camera Lucida: Reflections on Photography* (New York: Hill and Wang, 1981; London: Jonathan Cape, 1982).

R. Barthes, *Empire of Signs* (New York: Hill and Wang, 1983).

A. Benjamin, *Object, Painting* (London: Academy Editions, 1994).

Y.-A. Bois, *Painting as Model* (Cambridge, Mass.: MIT Press, 1993).

N. Bryson, *Vision and Painting: The Logic of the Gaze* (New Haven: Yale University Press, 1981).

N. Bryson, *Tradition and Desire: from David to Delacroix* (Cambridge: Cambridge University Press, 1984).

N. Bryson, *Looking at the Overlooked* (London: Reaktion Books, 1990).

N. Bryson, *et al.*, eds, *Visual Theory* (Cambridge: Polity Press, 1992).

R.E. Krauss, *The Optical Unconscious* (Cambridge, Mass.: MIT Press, 1993).

S. Lash, 'Reflexivity and its Doubles: Structure, Aesthetics, Community', in U. Beck, A. Giddens, and S. Lash, *Reflexive Modernization* (Cambridge: Polity, 1994).

C. Metz, *The Imaginary Signifier: Psychoanalysis and Cinema* (Bloomington: Indiana University Press, 1982).

J. Meyrowitz, *No Sense of Place: The Impact of Electronic Media on Social Behaviour* (New York: Oxford University Press, 1985).

M. Phillipson, *Painting, Language and Modernity* (London: Routledge, 1985).

M. Phillipson, *In Modernity's Wake* (London: Routledge, 1989).

J. Rose, *Sexuality in the Field of Vision* (London: Verso, 1986).

J. Rose, 'Sexuality and Vision: Some Questions', in H. Foster, ed., *Vision and Visuality* (Seattle: Bay View Press, 1988).

J. Tagg, *The Burden of Representation: Essays on Photographies and Histories* (London: Macmillan; Amherst: University of Massachusetts Press, 1988).

J. Tagg, 'Globalization, Totalization and the Discursive Field', in Anthony D. King, ed., *Culture. Globalization and the World-System* (London: Macmillan, 1991).

J. Tagg, *Grounds of Dispute* (London: Macmillan, 1992).

J. Urry, *The Tourist Gaze* (London: Sage, 1990).

Post-ocular theory

A. Blum, *Theorizing* (London: Routledge and Kegan Paul, 1975).

A. Blum, *Socrates: the Original and its Images* (London: Routledge and Kegan Paul, 1978).

S. Buck-Morss, *The Dialectics of Seeing: Walter Benjamin and the Arcades Project* (Cambridge, Mass.: MIT, 1989).

S. Buck-Morss, 'Dream World of Mass Culture: Walter Benjamin's Theory of Modernity and the Dialectics of Seeing', in D.M. Levin, ed., *Modernity and the Hegemony of Vision* (Berkeley, Calif.: University of California Press, 1993).

C. Classen, *Worlds of Sense: Exploring the Senses in History and Across Cultures* (London: Routledge, 1993).

J. Clifford and G.E. Marcus, eds, *Writing Culture: The Poetics and Politics of Ethnography* (Berkeley, Calif.: University of California Press, 1986).

J. Crary, *Techniques of the Observer: On Vision and Modernity in the Nineteenth Century* (Cambridge, Mass.: MIT Press, 1993).

M. Heidegger, *The Question Concerning Technology and Other Essays* (New York: Harper and Row, 1977).

M. Jay, *Downcast Eyes: The Denigration of Vision in Twentieth-Century French Thought* (Berkeley: University of California Press, 1993).

M. Jay, *Force Fields: Between Intellectual History and Cultural Critique* (New York and London: Routledge, 1993).

M. Jay, 'Sartre, Merleau-Ponty, and the Search for a New Ontology of Sight', in D.M. Levin, ed., *Modernity and the Hegemony of Vision* (Berkeley: University of California Press, 1993).

E. Kohak, *Jan Patocka: Philosophy and Selected Writings* (Chicago: University of Chicago Press, 1989).

C. Larmore, *Patterns of Moral Complexity* (Cambridge: Cambridge University Press, 1987).

S. Lash and S. Whimster, eds, *Modernity and Identity* (Oxford: Basil Blackwell, 1992).

D.M. Levin, 'Visions of Narcissism: Intersubjectivity and the Reversals of Reflection', in Martin Dillon, ed., *Merleau-Ponty Vivant* (Albany, N.Y.: SUNY Press, 1991).

D.M. Levin, *Modernity and the Hegemony of Vision* (Berkeley: University of California Press, 1993).

D.M. Lowe, *History of Bourgeois Perception* (Chicago: Chicago University Press/ Brighton: Harvester Press, 1982).

W.J. Mitchell, *The Reconfigured Eye: Visual Truth in the Post-Photographic Era* (Cambridge, Mass.: MIT Press, 1992).

Charles Taylor, *Sources of the Self: the Making of the Modern Identity* (Cambridge, Mass.: Harvard University Press, 1989).

Ethics of seeing

M.M. Bakhtin, *Rabelais and His World* (Bloomington: Indiana University Press, 1984).

M.M. Bakhtin, *Art and Answerability: Early Philosophical Essays* (Austin: University of Texas Press, 1990).

L.A. Blum, *Moral Particularity and Perception* (Cambridge: Cambridge University Press, 1994).

C. Larmore, *Patterns of Moral Complexity* (Cambridge: Cambridge University Press, 1987).

D. McNaughton, *Moral Vision* (Oxford: Basil Blackwell, 1988).

I. Murdoch, *The Sovereignty of Good* (London: Ark Editions, 1970).

I. Murdoch, *Metaphysics as a Guide to Morals* (Harmondsworth: Penguin, 1992).

M. Nussbaum, *The Fragility of Goodness* (Cambridge: Cambridge University Press, 1986).

M. Nussbaum, *Love's Knowledge: Essays on Philosophy and Literature* (Oxford: Oxford University Press, 1990).

P. Singer, *Applied Ethics* (Oxford: Oxford University Press, 1986).

P. Singer, ed., *Ethics* (Oxford: Oxford University Press, 1994).

Regimes of the visual

J. Beger, *Ways of Seeing* (London: BBC Publications, 1972).

P. Bourdieu, *The Field of Cultural Production: Essays on Art and Literature* (Cambridge: Polity Press, 1993).

P. Bourdieu, *The Rules of Art: Genesis and Structure of the Literary Field* (Cambridge: Polity Press, 1995).

P. Bourdieu and H. Haacke, *Free Exchange* (Cambridge: Polity Press, 1995).

J. Bremmer and H. Roodenburg, eds, *A Cultural History of Gesture. From Antiquity to the Present Day* (Cambridge: Polity Press, 1993).

C. Calhoun, *Social Theory and the Politics of Identity* (Oxford: Basil Blackwell, 1994).

C. Calhoun, E. LiPuma and M. Postone, eds, *Bourdieu: Critical Perspectives* (Cambridge: Polity, 1993).

M. de Certeau, *The Practice of Everyday Life* (Berkeley: University of California Press, 1984).

R. Chartier, ed., *A History of Private Life*, Volume 3 (Cambridge, Mass.: The Belknap Press, 1989).

R. Chartier, *Cultural History: Between Practices and Representations* (Oxford: Polity Press, 1993).

S. Cohen, *Visions of Social Control* (Cambridge: Polity, 1993).

C. Dandeker, *Surveillance, Power and Modernity* (Cambridge: Polity, 1990).

S.Y. Edgerton Jr., *The Renaissance Rediscovery of Linear Perspective* (New York: Basic Books, 1975).

N. Elias, *The Civilising Process*, 2 vols (Oxford: Basil Blackwell, 1982 and 1987).

N. Elias, *An Essay on Time* (Oxford: Basil Blackwell, 1990).

M. Featherstone, *Consumer Culture and Postmodernism* (London: Sage, 1991).

H. Foster, ed., *Vision and Visuality* (Seattle: Bay View Press, 1988).

M. Foucault, *The Order of Things: An Archaeology of the Human Sciences* (London: Tavistock, 1972).

M. Foucault, *The Birth of the Clinic: An Archaeology of Medical Perception* (London: Pantheon, 1973).

M. Foucault, *Discipline and Punish* (Harmondsworth: Penguin, 1977).

I. Hacking, *Representing and Intervening* (Cambridge: Cambridge University Press, 1983).

Lynn Hunt, ed., *The New Cultural History* (Berkeley: University of California Press, 1989).

C. Jenks, ed., *Visual Culture* (New York and London: Routledge, 1995).

S. Lash and J. Friedman, eds, *Modernity and Identity* (Oxford: Basil Blackwell, 1992).

S. Lash and J. Urry, *Economies of Signs and Space* (London: Sage, 1994).

D.M. Levin, *The Body's Recollection of Being* (London: Routledge, 1985).

D.M. Levin, *The Opening of Vision* (London: Routledge, 1987).

D.M. Levin, *The Listening Self* (London: Routledge, 1989).

D.M. Levin, ed., *Modernity and the Hegemony of Vision* (Berkeley, Calif.: University of California Press, 1993).

D. Lyon, 'An Electronic Panopticon: A Sociological Critique of Surveillance Theory', *The Sociological Review*, 41, 4, 1993.

D. Lyon, *The Electronic Eye: The Rise of Surveillance Society* (Cambridge: Polity Press, 1994).

L. Nochlin, *The Politics of Vision: Essays on Nineteenth-Century Art and Society* (London: Thames and Hudson, 1991).

T. Polemus, *Social Aspects of the Human Body* (Harmondsworth: Penguin, 1978).

M.C. Taylor and E. Saarinen, *Imagologies* (London: Routledge, 1994).

Technoculture and visual technology

R. Barthes, *Camera Lucida* (London: Vintage, 1993).

J. Berger, *Ways of Seeing* (London: BBC Publications, 1972).

J. Buick and Z. Jevtic, *Cyberspace for Beginners* (Cambridge: Icon Books, 1995).

J. Crary, *Techniques of the Observer: On Vision and Modernity in the Nineteenth Century* (Cambridge, Mass.: MIT Press, 1993).

M. Davis, *City of Quartz* (London: Verso, 1990).

M. Davis, *Beyond Blade Runner: Urban Control, the Ecology of Fear* (Westfield, N.J.: Open Magazine Pamphlets, 1992).

De Landa, M., *War in the Age of Intelligent Machines* (New York: Zone Books, 1992).

D. Gernsheim, *The History of Photography* (New York: Oxford University Press, 1955).

D. Haraway, *Symians, Cyborgs and Women: The Reinvention of Nature* (London: Free Association Books, 1991).

D. Ihde, *Technology and the Lifeworld: From Garden to Earth* (Bloomington: Indiana University Press, 1990).

D. Ihde, *Postphenomenology. Essays in the Postmodern Context* (Evanston, Ill.: Northwestern University Press, 1993).

S. Jones, ed., *Cybersociety* (London: Sage, 1994).

T. de Lauretis and S. Heath, eds, *The Cinematic Apparatus* (London: Macmillan, 1985).

S. Neale, *Cinema and Technology: Image, Sound, Colour* (London: Macmillan, 1985).

H. Rheingold, *Virtual Reality* (London: Mandarin, 1991).

J Tagg, *The Burden of Representation: Essays on Photographies and Histories* (London: Macmillan, 1988).

INDEX

abstraction 233
Adorno, T.W. 219, 221
aesthetic(s) 3–4, 12; aesthetic experience 23–4, 162–3
Alpers, S. 201
Althusser, L. xii
Anaximander 193
anthropocentrism xvii
anthropomorphism 218–35
aporia of the sensible 218–35
Aquinas, T. 32
Archer, M. 114–15
Aristotle 12, 199, 205–6
art criticism 99–120
Atkinson, T. 116
Augustine 41
Austin, J.L. 241

Bakhtin, M.M. xiv, 31, 53, 57–71, 242
baroque 201
Barthes, R. xii, 156
Bataille, G. xii
Baudrillard, J. 74, 245, 249
Baumgarten, A. 4, 7–8, 14
Beck, U. 248
Bell, C. 12, 109, 146
Benjamin, W. 192, 239
Berger, J. 21
Bergson, H. xii
Berkeley, G. 34
Bernstein J.M. xvii, 242
Betterton, R. 148
Blum, L.A. xvii, 203, 212
Bois, Y.-A. 116
Bonnard, P. xv, 123–41
Bourdieu, P. 89, 90
Braidotti, R. 244–5
Breton, A. xii

carnival 67–70
Cartesian xiv–xv, 8, 61, 211; form of life xiii, 30–56, 200–1, 238, 242
Certeau, M. de 245
Cézanne, P. xvi, 155, 166, 168, 170, 171, 173–5, 178, 179–80
Chaplin, E. ix, 74
Chladenius 4
Christensen, J. 218–21, 235
Chuangtse 188
Cixous, H. 245
cogito 30, 37, 42–3, 50, 51, 61, 65–6, 177, 239, 243
consciousness 43–4, 45–52, 66
Cooke, L. 115–16
Crary, J. 57
crisis of ocularcentrism 246

Davie, N. xiii
death 141
Debord, G. xii, 249
deconstruction 172–3
Deleuze, G. 131, 174
denigration of vision xii–xiii, 162–80, 243
Derrida, J. xii, xvi, 165–70, 171–2, 179, 221, 245
Descartes, R. xiii, 33–7, 39, 41, 53, 238–9
Dewey, J. 30, 35, 53
dialogue xi; dialogical 10, 16, 23–4, 30, 57–71
Dilthey, W. 4, 17, 25, 60
discursivity 219
disenchantment 219
Dostoevsky, F. 64–5
Douglas, M. 92
Dreyfus, H. xi
Dummett, M. 220
Duncan, C. 102–3

Durkheim, E. xiv, 74–94, 171, 199, 239

Elias, N. 239
Enlightenment 186, 213, 220, 225, 226
ethics 65–6, 198–214
ethics of the visual 202–5, 213–14
everydayness 128–9

feminist art 106–7; 143–60
feminist art criticism 144–5
feminist theory xvi, 144–5, 244–5
Fisher, C. xv
Fortnum, R. 148–53, 159
Foucault, M. 185–6, 247, 249–50
Frascina, F. 111–14, 119–20, 143
Frank, M. 5
Fried, M. xvii, 222, 224–5, 228, 232–3, 234

Gadamer, H.-G. 5–6, 7, 8–12, 14–18, 20–1, 22, 24, 25, 240, 241, 242
Gardiner, M. xiv
Giddens, A. 4
Goethe, J. W. von 18
Greenberg, C. xvii, 101–2, 109, 223–6, 228
Guattari, F. 174

Habermas, J. 242
Haftman, W. 100
Haraway, D. 62
Hegel, G.W.F. xiv, 5, 8, 14, 23, 37, 46–52, 126, 167, 176
hegemony of vision x–xi
Heidegger, M. xiv, xvii, 5, 9, 17, 19, 36, 37, 52–3, 59, 164, 175–6, 177, 178, 185, 188–93, 194, 195, 239, 240, 241, 242
hermeneutics ix–xii, xiii, xv, 185–95, 241–2; history 4–29; of seeing 3–29; of vision ix, 63–4; of visual culture 238
Hermes 6, 63
Herwitz, D. 117
Heywood, I. xvii
Hill, D. xvi
Horkheimer, M. 191
How, A. 6
Hughes, R. 117
Hume, D. xiv, 33, 39, 42–3, 45–6
Husserl, E. 14, 36–7, 46, 49, 185, 239, 240

ideology 129

interpretation xi–xii
Irigaray, L. xii, 148, 245

Jay, M. ix–x, xi–xii, xvi, 40–1, 71, 76, 164, 168–9, 172, 173, 200, 202, 243, 248
Jenks, C. ix, xiv–xv
Judd, D. 226, 227
judgement 99, 109–11

Kant, I. 8, 13, 33, 36, 37, 39, 41, 89–90, 144, 172, 218
Kristeva, J. 245
Kuhn, T. 77, 225

Lacan, J. xii, 243–4
language 9–11, 164–5, 241–2
Lao-tse 187, 192
Larmore, C. 211
Lefebvre, H. 126
Leibniz, G.W. 37, 39
Lévi-Strauss, C. 69
Levin, D.M. x, xi, xvii, 3, 176, 177
Levinas, E. xii, 53, 57
life-world x, 241
Locke, J. 33–4, 39, 41
logological xiii
Louth, A. 4
Lowe, D. ix, xi, 70–1
Lynton, N. 107–8
Lyon, D. xi
Lyotard, J.-F. xii, xvi, 162–5, 172, 174, 175, 176, 178, 179, 213

Macmillan, D. 20–1
Mallarmé, S. 195
Marquard, O. 5
Marx, K. xiv, 37, 43–4, 239
Matisse, H. 100–9
Mauss, M. 86
McEvilley, T. 109–11, 113
McHugh, P. 79
McRobbie, A. 150
Melville, S. x
Merleau-Ponty, M. xii, xvi–xvii, 7, 40, 53, 59, 60, 168, 169, 171, 176, 239, 241
Mestrovic, S. 75
metaphor(s) 63–6; of seeing 166–7, 246
metaphorics of perception 57–71
Metz, C. xii
mind–body dualism 38–9, 69–70
minimalism 228–9, 230

modernism 144–5, 163, 167, 175, 178, 231, 234
modernity 30–56, 70–1, 176, 249
moral perception 202–5
Morris, R. 227
Murdoch, I. xvii, 159–60, 202–5, 212

Nietzsche, F. xiv, 7, 17, 18, 21, 22, 25, 36, 43–4, 169
Nussbaum, M. xvii, 205–7, 212

objecthood 218–35
otherness 242
Outhwaite, W. 4

Pannenberg, W. 4, 7
Parsons, T. 75
particularity 99, 106–9, 199, 205–12
perception x, 11–14; as ideology
Perry, G. 104–5
phenomenology 11–12, 23, 190, 239–41, 241–2
Phillipson, M. xv
Plato 7, 18, 136
Pollock, G. 105–6, 108, 110, 143–6, 159
post-analytical philosophy 246
postmodernity 94, 162, 166, 176, 247
poststructuralism 243–5
practice(s) xi–xii, 198–214, 241–2
psychoanalysis 243

quality 111–14, 198

Rabelais, F. 67–70
Readings, B. x
reflexivity ix, xii, xiv, 93
religion 88–93
renewal of painting 162–80
Ricoeur, P. 241, 242
Rorty, R. xi, 239
Rose, E. 146–7, 153–9
rules 79–84, 86
Ryle, G. 37–8, 39

Sandywell, B. xiii–xiv, 30–56
Sartre, J.-P. xiv, 44–5, 45–50, 59, 240
Schleiermacher, F. 4
Schopenhauer, A. 36

scopic regimes 248
Searle, J. 242
seeing xii, 3–4, 25–6, 93, 185–6, 202–3, 246; complexity of 173–4; ethics of 247
self 247
semiology 243
senses xii, 67–70, 131–2, 234–5
Simmel, G. 239, 241
Smith, J.A. xvi
Socrates 24
solidarity, mechanical and organic 76–8
Sontag, S. xv, 118–20
specular consciousness 40–1
Stella, F. 231–2, 233
Stevens, W. 187
subject–object dualism, rejection of 246
surveillance 249
Sutcliffe, F.E. 41, 53

Taylor, C. 211–12
theatricality 229–30
theoria 36
Thomas of Erfurt 32
Toulmin S. 58, 70
tradition 17–18
transgression 170

understanding 22–4

value 99–100, 144–5
videological xiii, 34
Virilio, P. ix, 93
vision 33–56, 178, 185–6; politics of 248–50
visual art xv–xvii
visual rhetoric 30–56
visuality; field of, x–xii; ideology x–xi; technology 247

Warnock, M. 12
Waterfield, R.A.H. 7
Weber, M. 234, 239, 249
Western culture x–xi
Whiteley, N. xv
Winch, P. 60
Wittgenstein, L. 7, 12–13, 57, 77, 166–7, 231, 241
Wollheim, R. 208–9